The Films of
Jack Chambers

Cinematheque Ontario Monographs

Shohei Imamura, no. 1
Robert Bresson, no. 2
The Films of Joyce Wieland, no. 3
Kon Ichikawa, no. 4

TORONTO INTERNATIONAL
FILM FESTIVAL GROUP

A Division of the Toronto International Film Festival Group

The Films of
Jack Chambers

Edited by Kathryn Elder

CINEMATHEQUE ONTARIO
Toronto

in conjunction with

INDIANA UNIVERSITY PRESS
Bloomington and Indianapolis

Toronto International Film Festival Group
2 Carlton Street, Suite 1600
Toronto, Ontario
Canada M5B 1J3

The Toronto International Film Festival Group is a charitable,
cultural, and educational organization dedicated to celebrating
excellence in film and the moving image.

National Library of Canada Cataloguing in Publication

Main entry under title:

> The films of Jack Chambers / edited by Kathryn Elder.

(Cinematheque Ontario monographs ; no. 5)
Includes bibliographical references.
ISBN 0-9682962-4-6

1. Chambers, Jack, 1931–1978 – Criticism and interpretation.
2. Experimental films – Canada – History and criticism.
I. Elder, Kathryn. II. Cinematheque Ontario. III. Series.

PN1998.3.C38F54 2002 791.43'023'092 C2002-903047-1

Distributed in Canada by Wilfrid Laurier University Press
75 University Avenue West, Waterloo, Ontario, Canada N2L 3C5
Website: wlupress.wlu.ca
Telephone orders: 519-884-0710, ext. 6124
Fax orders: 519-725-1399
E-mail orders: press@wlu.ca

Distributed outside Canada by Indiana University Press
601 North Morton Street, Bloomington, Indiana, USA 47404-3797
Website: iupress.indiana.edu
Telephone orders: 800-842-6706
Fax orders: 812-855-7931
E-mail orders: iuporder@indiana.edu

Book design by Gordon Robertson
Printed in Canada

Contents

The Films of
Jack Chambers

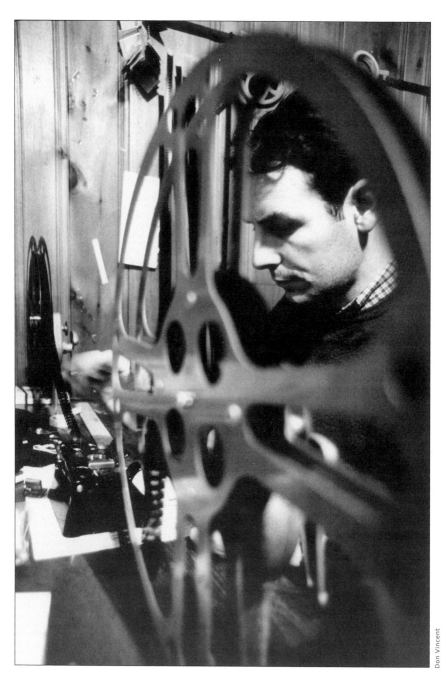

Jack Chambers, 1968

Introduction

Chambers sets us on a knife-edge between
contentment and tragedy, a place where we all
live every day, whether we know it or not.

— SARAH MILROY

ARAH MILROY's astute observation about the tension in Jack Chambers'
paintings and Ross Woodman's sense of him as "constricted energy waiting
to explode," are both from essays in this anthology. I quote them here be-
cause their insights belie the popular perception of Chambers as the unassuming,
straightforward realist from London, Ontario, whose sublime paintings of his fam-
ily and the Southwestern Ontario landscape made him one of Canada's best-loved
artists. The truth about Chambers and his realism is more complex and, I think, bet-
ter understood in the context of his films, which represent a singular achievement in
Canadian cinema. His feature-length film *The Hart of London* (1968–70) reveals that
for Chambers navigating the contradictions of daily life and the strain of artistic
ambition was painful and difficult. Unique montage constructions convert the un-
official records of family and community life—home movies, local television news
items and still photographs—into a universal story of self-awareness that is both
emotionally wrenching and formally challenging. *The Hart of London* opens a very
different window into the formation of the Canadian psyche than do the films by
Michael Snow and Joyce Wieland of the same period, *La Région centrale* (1971) and
Reason Over Passion (1968–69), respectively. And yet it and Chambers' other films,
Mosaic (1966), *Hybrid* (1967), *R34* (1967) and *Circle* (1968–69) remain peripheral to
avant-garde film history, while his paintings are central to the study of Canadian art.

The contributors to this anthology take up the issue of the status of Cham-
bers' films, pointing out that until very recently, the work has been less available

than that of his contemporaries—Chambers did not travel with the films, nor did he or his estate have the money to make distribution prints. More significantly, though, the essayists in this volume demonstrate through their research and analyses not only that Chambers played a crucial role in the development of the organizations that support independent film but that he was a seminal influence in the formation of a distinctive Canadian avant-garde film practice: the diary film, the landscape film and the experimental documentary owe much to Chambers' artistic sensibility. But if local recognition has been relatively muted, international respect, expressed here in the admiring and enthusiastic statements of curators, critics and filmmakers, has been consistent.

Jack Chambers was born at Victoria Hospital, in London, Ontario, on March 25, 1931, and died there on April 13, 1978, after a nine-year battle with leukemia. His father was a welder who had difficulty finding employment during the 1930s and so the family lived with Chambers' paternal grandparents for part of the decade. His grandfather, a retired artificer in the British army, was an avid horticulturist. Playing in his garden and experiencing rural life first-hand at the nearby farm of his maternal grandparents were important steps toward Chambers' recognition of life's beauty and cruelty. The imagery in *Mosaic, Hybrid, Circle* and *The Hart of London* speaks to the division between an Edenic garden and nature's grim realities.

Public school had little appeal for Chambers. It was time spent "waiting between recesses and the summer holidays." But his talent for drawing was first noticed here: at Victoria Public School he was asked to illustrate the history lessons with chalk sketches and in grade eight, he was awarded a box of oil paints as second prize in an art competition. High school was equally unattractive but he did have the benefit of formal art instruction with Selwyn Dewdney, a commercial artist and art therapist who was also a Canadian pioneer in the documentation of aboriginal petroglyphs. An abstract painting Chambers completed at this time was accepted by the Western Ontario Annual Exhibit. At the end of grade ten, he transferred into the commercial art program at H. B. Beal Technical School. Here, under the direction of Herb Ariss, a World War II veteran and professional artist, Chambers first experienced a genuine enthusiasm for learning. At the 1949 Western Ontario Annual Exhibit, his still-life painting *Lilies* won the Young Artist's prize over submissions from students at the more prestigious Ontario College of Art.

During the next three years, Chambers travelled to Quebec and Mexico, worked at odd jobs, including lens grinding, and even attended university. He was working toward his goal of becoming an artist, but he was increasingly frustrated at the inadequacy of his skill: "I could only go so far with what I was doing and then I felt I was wasting my time, coming to the same dead end again and again." And so in the fall of 1953, he extended his search to Europe, ending up in Madrid, where, after trying twice, he passed the entrance exam for the Escuela Central de Bellas

Artes de San Fernando. He spent the next five years studying traditional techniques in drawing, painting, modelling, engraving, mural painting and restoration. His descriptions of his state of mind during this period are interesting. He says he couldn't make any progress until he had learned to separate his personality from his work. Converting to Roman Catholicism focused his vision and influenced the tone and imagery of all his later art:

> One of the reasons I became a Catholic at this time was that moral rules provided me with a tangible spiritual discipline that I could work at, in much the same way that the academy provided standards to direct my anxieties into specific problems to be solved. . . . I was working on the assumption that the returns from such discipline would purify my vision. . . . But this discipline did not pursue as its end the love of God but rather it pursued, through the laws of Moses, the love of art.

Once Chambers had resolved this issue for himself, he proved to be an excellent student: he received the school's State Prize for Painting and the Paular Scholarship for Landscape Painting as well as grants from the Greenshields Foundation in Canada. After graduation, he moved to Chinchon, a small village thirty kilometres south of Madrid, and supported his painting by teaching art classes at the local American air force base, and working occasionally as a translator. In 1961, the year of his first solo exhibition in Madrid, Chambers returned to London because his mother was ill. He thought the visit would be brief. But on encountering the landscape of his youth again, he realized that despite his deep love and respect for the Spanish culture, he would never truly feel at home in that country. And so he remained in London, but the effect of the experience, like his religious conversion, would reverberate in his work. To the Spanish, death is omnipresent and Chambers' acceptance of this belief is evident in painted and filmed images of angelic mothers and children (corresponding to Christianity's first family), the ritualized slaughter of animals (a reference to the sacrificial lamb of God) and the bonding of the living to the ghosts of the past.

Chambers quickly established himself as a presence in the burgeoning London art scene. He renewed his friendships with Selwyn Dewdney and Ross Woodman (who had taught him English at the University of Western Ontario), and met other painters, sculptors and writers who, like him, were trying to make a living in a city that was openly hostile to artistic practice. Their efforts culminated in 1968 with *The Heart of London*, a successful touring exhibition that revised critics' opinions about the possibilities for original and intelligent artistic production outside major centres: "What London, Ontario, Has That Everywhere Else Needs," and "The Crisis in Art. For Canada the Answer Is . . . Provincialism" were typical responses to it.

Chambers' participation in this show, though, only enhanced a national profile that had been building since his first Canadian solo exhibition in 1963 at the Isaacs Gallery in Toronto. Av Isaacs was considered by many to be the country's leading dealer in contemporary art, and under his direction Chambers' work received wide exposure. At the same time, he expanded his range of artistic contacts. It was at the Isaacs Gallery that he met Michael Snow and Joyce Wieland and saw their early films at mixed media events that Isaacs sponsored. But these encounters seemed to have little impact on his painting aesthetic: he remained resolute in his rejection of the popular movements of the time—abstraction, Dada, Pop art, minimalism, conceptual art—continuing instead with representational art as the framework for a traditional Romantic belief in the visionary character of artistic insight. He wanted to articulate that moment of individual self-awareness when "our souls and the soul of things become present to one another." That goal characterized his work throughout his career, with 1969 marking an especially productive expression of it in the landscape painting *401 Towards London No. 1*, the landscape film *Circle* and the publication of his artistic credo, "Perceptual Realism." In that statement he referred to perception as the "sensory communication that occurs at a primary level between organisms: through the skin to the core and back through the skin again into the exterior world" and perceptual realism as the artwork that imitates that experience. *Circle*, which chronicles the daily changes to the landscape of his backyard, is the expression of "a 'forgotten' awareness that just *is* with the common naturalness of those common things seen out the window."

Chambers also explained in the manifesto that he used photography as a memory aid for his paintings because, unlike a sketch, it did not distort the original scene. His canvases, though, were not simple mechanical likenesses. For him, the moment of artistic insight encompassed a myriad of associations, past and present. In his early paintings, those associations took the form of spatial and temporal disruptions to the canvases' pictorial integrity. He would place family members in exotic locations, suspend historical figures in local landscapes, include references to classical paintings in contemporary still-lifes, and dissect or displace sequential actions. It is not surprising, then, that his films exhibit the same temporal and spatial disruptions. He rejected the notion of linear time advocated by popular cinema because he thought the narrative illusion that resulted misrepresented the synthetic character of human perception. To this end he employed various montage strategies—semantic and formal—to imbue the viewing experience with a sense of "presentness" so that we participate in the same process of self-awareness as did the artist in confronting the brutality of war and our complicity in it (*Hybrid*), the fragility of domestic happiness (*Mosaic* and *Circle*), the challenges of artistic expression (*R34* and *The Hart of London*), the schism between us and nature (*Circle* and *The Hart of London*) or the transience of existence (*Mosaic*, *Circle* and *The Hart of London*).

Mosaic

In the latter part of the 1960s Chambers' art garnered him much attention. At a 1968 national juried competition, he received awards in *both* the painting and film categories for *Regatta* and *R34*. Neither of the judges, the British artist Richard Hamilton and the American avant-garde filmmaker Jonas Mekas, knew of the other's decision. A year earlier, the Ann Arbor Film Festival selected *Mosaic* for its national tour. In 1970, at the age of thirty-nine, Chambers had film and painting retrospectives at two prestigious Canadian institutions, the Vancouver Art Gallery and the Art Gallery of Ontario. Mario Amaya, reviewing the show in *Art in America,* compared the artist's obsession in *Circle* with light and nature to the Impressionist painter Monet. Shortly afterwards, Chambers was on his way to London, England, to present *The Hart of London* at the Third International Avant-Garde Film Festival. At the same time, Chambers was active on the political front. He was among the first of his generation to believe in the artist's right to make a living wage from his work and so he led the successful challenge in 1967 against the museum practice of exhibiting and reproducing artworks without financially compensating the artist. His action laid the foundation for the creation of Canadian Artists' Representation and Chambers served as its first president. In 1968, he established the London Film Co-op, giving local artists control of the distribution of their films and improving access to the works of others. He managed the co-op from his home and developed a plan for a branch location in Europe.

The Hart of London appears to be Chambers' last completed film, although he was at work on another during the 1970s. He was less active in those years because of his deteriorating health but in 1972 he issued another version of his artistic manifesto, "Perceptualism, Painting and Cinema" in which he described a work-in-progress called *C.C.C.I.* He refers to that film again as "unfinished though not abandoned" in his 1978 autobiography, *Jack Chambers*, which appeared under the imprint of his dealer Nancy Poole. It includes excerpts from his journal, *Red and Green*, a compilation of material on perception culled from writers in religion, philosophy, the occult and psychology.

Chambers' films have always presented a bit of puzzle to viewers because of the unusual juxtapositions of the source imagery and their often gritty character. The material is not organized on the principle of associative montage, nor can it be admired for the visual beauty of its first-person camera revelations, nor does it possess the austere elegance of minimalist art. Consequently, critics have found Chambers' writings and interviews useful when responding to the work. Reprinted here are his 1969 artistic manifesto and several of the earliest assessments: Deborah Magidson's 1972 overview of the films and paintings, filtered through the language of the manifesto; Avis Lang's 1974 article on *The Hart of London*, which says the film's perceptual and autobiographical ambitions rank it alongside Stan Brakhage's *Scenes from under Childhood* (1967-70) and Hollis Frampton's *Zorns Lemma* (1970); and Ross Woodman's 1980 catalogue essay for a Chambers' retrospective, which explains that

Chambers took up filmmaking to escape the temporal restrictions of the canvas and that this accounts for his unusual collage style. The other essays build on this commentary and bring new ideas to the discussion. Michael Zryd, who co-organized *The Jack Chambers Project*, held in London, Ontario, in 2001, refocuses attention on *Hybrid*, demonstrating how it works as an "exemplary political essay." Brett Kashmere observes that Chambers enjoyed filmmaking because it was a respite from the demands of being a "professional" artist, and then applies the vocabulary of "amateur filmmaking" to his analysis of *Circle*. Bruce Elder, whose earlier writings conjoined Chambers' Romantic aspirations and realist ethos to suggest postmodernist attributes, uses Surrealism, especially the photographic realism of Salvador Dalí, as a different framework for analysing the work. Film artist Stan Brakhage has championed Chambers' films for twenty-five years. He is represented here by his introduction to the screening of *The Hart of London* at *The Jack Chambers Film Project* where he prepared the local audience for a sometimes harsh but extraordinary portrait of itself. A more recent commentator on the film is Fred Camper, whose article originated two years ago as a review for a Chicago screening. His depiction of the sprawling character of the film together with an earlier Brakhage description of it as an epic are picked up by Bart Testa, who traces how *The Hart of London* transforms a community's history and cosmology into poetic form. Peter Tscherkassky observes that the film straddles the boundary between the formalist and Romantic traditions that distinguish the histories of European and North American avant-garde film and speculates how this might have affected its reception. Preceding these essays are Ross Woodman's personal reflections on his friendship with the artist and Sarah Milroy's reconsideration of the distinctive features of Chambers' paintings. Her remarks about the influence of photography echo throughout the book as each writer speaks to the documental character of the films. The essays are followed by statements from individuals whose encounters with Chambers' works date from the mid-sixties onward and attest to the films' originality and impact. The book concludes with an annotated bibliography that summarizes the critical literature.

Greg Curnoe (1931–1992), Chambers' friend, artistic colleague and subject of *R34*, spoke about him at the 1989 Toronto International Experimental Film Congress. In his talk, transcribed for this publication, he said that Chambers was a very private person—that even his closest friends could not explain his actions. While this has made it difficult to account for Chambers' artistic decisions, the significance of the work demands that we continue to make the effort. This book coincides with improved access to Chambers' oeuvre: the films are now on video and his papers are housed at the Art Gallery of Ontario. I hope the ideas expressed here will be a catalyst for new scholarship into the contributions of this film artist.

Don Vincent

Jack Chambers painting *401 Towards London No. 1*

SARAH MILROY

Jack Chambers:
From Camera to Paint

J ACK CHAMBERS' paintings occupy a cherished place in the history of Canadian art. As an artist, he created startling images that convey the immediacy of experience with dazzling force. As a member of the art community, he was instrumental in creating Canadian Artists' Representation—a pioneering group that set out, in 1967, to improve the professional standing of artists in our culture.

All of this would make Chambers ripe for canonization, even without his untimely death from leukemia at the age of forty-seven, at the peak of his artistic powers. His initial diagnosis in 1969 gave him mere months to live, but he survived for almost ten years, pursuing unconventional medical treatments from Mexico to India and home again, finally dying in 1978.

The rapture and the lamentation over Chambers are understandable, but as the years go by one wonders if we are loving him for the right reasons, or for the full range of his accomplishments. For example, it has become the custom over the years to look at Chambers' work—his preoccupation with fleeting, delicate sensations and the fragility of life—as springing from his tragic personal situation. Indeed, the comparison of the epic painting *401 Towards London No. 1* (painted in large measure before his diagnosis and filled with an exhilarating sense of freedom and joy) and *Victoria Hospital* (painted afterwards) would seem to illustrate the point, making clear the distance Chambers fell from the sense of possibility that illuminates the earlier picture. In the later painting, Victoria Hospital rises above an expanse of snow—pale, bleak and immutable, the last-chance hotel on the highway to oblivion.

Unquestionably, the mood of this later painting reflects Chambers' sudden sense of shock and despair, but the work had in fact been planned well before his diagnosis. The painting is based on a photograph taken from the roof of Greg Curnoe's studio. The two had intended to paint their famous Victoria Hospital paintings side by side, but Chambers' illness meant that he had to work alone in his studio at

home. From the outset, it seems, he contemplated it as a winter scene. The tone of the painting, thus, had as much to do with his habitual cast of mind as it did his fate. To believe otherwise seems to deny him his volition.

A look back at Chambers' earliest work reveals a soul preoccupied from the outset with death and birth. At nineteen, while still a university student in London, Ontario, he was foiled in an attempt to break into a funeral home (presumably to inspect the corpses—perhaps a Renaissance homage to Leonardo). His self-portrait of 1952, a sombre, funereal likeness in the style of El Greco, demonstrates that he was already attracted to Spanish art. His elongated hand rests on a ceramic jar, and one can't help but wonder whose ashes repose within.

Chambers left Canada for Europe in 1953, eventually studying at the Escuela Central de Bellas Artes de San Fernando in Madrid. There his student work continued in a grisly vein. Touring country churches in search of crucifixes was a favourite pursuit. *Surrealist Composition* (1960), from his Spanish student days and now in the collection of the Art Gallery of Ontario, depicts a bouillabaisse of limbs, severed heads and mummified body parts against a charnelhouse backdrop. A drawing from the same period, now in the collection of Museum London, shows a shrieking pregnant woman, her face and form grotesquely distorted. Life and death are collapsed into one image. He titled the work *Angel*.

It's a world view that one still finds many years later in Chambers' last film, *The Hart of London* (1968–70). Here, the abattoir and the labour and delivery suite are grafted together in an unforgettable sequence of images that drive at the black, mysterious heart of life. According to Ross Woodman, who taught English to Chambers at the University of Western Ontario in the early fifties and would become a frequent writer on Chambers during the artist's lifetime, "In North America, he saw one kind of death that was mechanical and meaningless. In Spain, he discovered another kind of death, a metaphysical death—an abundance of life, the essence of which was death."

Chambers' first works after his return to London might seem to depict a sunnier world, but, while they are calm, it is an eerie calm, and the dead seem to hover around the living. *Sunday Morning No. 1* (1963), which stands at the beginning of the great series depicting his family and his home, shows a vivid green field sprinkled about with babies, old people and ancestors back from the grave. Another painting shows us an autumn landscape haunted by the figures of memory. A woman pauses and looks away in the midst of her cup of tea; a man turns to face the horizon; a Victorian lady holds her parasol to deflect the heat of the day. Beneath them, and the glorious panorama of autumn foliage over which they hover, lies the inscription, "All things fall and are built again/And those that build them are gay," lines taken from a poem by W. B. Yeats. Even when Chambers paints sunlit scenes of women and children standing in open meadows, as he does in *Olga near Arva* (which he painted in 1963 as a wedding present for his Argentine bride,

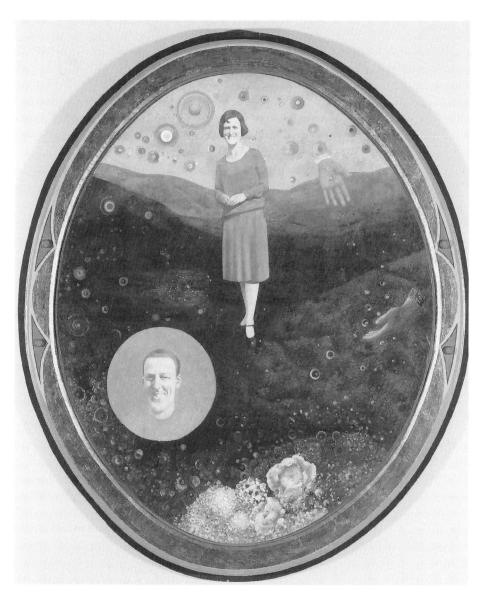

Messengers Juggling Seeds, 1962
oil on plywood
163.8 x 141 oval; image 137.5 x 115 cm
National Gallery of Canada, Ottawa

Olga Sanchez Bustos, whom he had met in Spain) or *Summer behind the House* (a painting of his future dealer Nancy Poole and her daughter, also from 1963), the figures have the weightless insubstantiality of phantoms.

If death was his mistress, so too was the photographic image. In 1963, Chambers started making films, and his fascination with photography was profound. (He had begun using photographs as a source in his art while he was still in Spain.) Given his sensibility, though, the infatuation with the photograph comes as no surprise.

"Photography," Susan Sontag has memorably written, "is an elegiac art, a twilight art. Most subjects photographed are, just by virtue of being photographed, touched with pathos. . . . All photographs are *memento mori*," Sontag continues. "To take a photograph is to participate in another person's (or thing's) mortality, vulnerability, mutability. Precisely by slicing out this moment and freezing it, all photographs testify to time's relentless melt."

Sontag's words provide the perfect frame through which to view Chambers' relationship to photography. His first paintings upon his return from Spain were fantasy pictures, presenting a cast of characters floating in an imaginary mélange of past and present. Often, as in *All Things Fall* (1963–64), a diaphanous film appears to settle over the image, giving the picture the look of a faded photograph. Other paintings seemed to raid the family photo album. *Messengers Juggling Seeds* (1962), in the collection of the National Gallery of Canada, is the best-known example of his work from this period. The painting is one in a series of images that deal with procreation, such as *Onlookers Over Winnipeg* from the same year, which is rampant with fertility symbols: a newt, some storks, a frog, a bride with her white bouquet and a pregnant, smiling woman who stands at the centre of it all.

In 1964, however, Chambers began a series of works that made an even more strenuous point of their photo-mechanical origins. It is here that he parts company with many of the photo-realists of his day. Where other artists were painting in the mode of a glassy, highly resolved realism, Chambers broke up the image, often dissecting the figure into peculiar segments, as he does in *Olga and Mary Visiting* (1964–65), repeating elements of the figures in various places on the painting's surface.

Olga and Mary Visiting was completed while Chambers was working on his first significant film, *Mosaic*, and it marked the beginning of a period of painterly experimentation that left many critics scratching their heads. The earlier surreal fantasy pictures were unprecedented—although with their dials of pure colour and dreamy atmospheres, they may in hindsight call to mind the work of European painters like Max Ernst, Robert Delaunay or even Gustav Klimt—but the newer pictures had an ungainliness about them that was uningratiating to say the least. Sometimes, as in *Antonio and Miguel in the U.S.A.* (1964–65), the dislocations in the visual field make the image downright baffling. Chambers seems deliberately to put himself between you and the thing you want to see, throwing a wrench in the perceptual works.

Olga and Mary Visiting is a pivotal picture. It incorporates the fantasy elements of the earlier work (the architectural setting and the fresco behind the pair of chatting women, including the swan-drawn carriage, are pure invention), but the banding of the image into horizontal segments seems to open the door to the mixed-media works of the mid to late sixties, such as *Madrid Window No. 1* (1968) and *Madrid Window No. 2* (1968–69).

Again, mechanical reproduction is alluded to. Some of the drawings incorporated into the image have the look of family snapshots; others appear to be drawn from the newspapers and still others from the history of art. (One is reminded of the inventory of photographs included in one montage sequence of *The Hart of London*, where it seems that Chambers was attempting an encyclopedia of every use to which the medium could be put. He had solicited these images from the London community in an open call.) In these paintings, the surface of the picture is broken up into various depths, with some of the images screened behind sheets of candy-coloured plexiglas, as if receding in memory, while others are thrust forward.

Here, Chambers delights in the effects of transparency and light with the appetite of a Flemish master. (It's worth remembering that he trained in the art of grinding optical lenses before deciding to pursue art full time.) In *Madrid Window No. 1*, for example, we see through a thin panel of plexiglas to a drawing of a long, low fortress by the sea. (The drawing was presumably based on a photograph taken during his travels in Spain.) We also see a glass platter holding peaches; both the transparent vessel and the fruit are exquisitely modelled in space with the masterful draftsmanship that was his signature. Reproductions of these paintings do not allow us to gauge the subtlety or the complexity of what Chambers was up to.

The mid-sixties also saw the creation of a series of silver paintings—Chambers referred to them as "instant movies"—which have about them the look of solarized negatives, often with colour bars appended. Again, the mechanically made image is evoked in such a way as to underscore the fleeting nature of appearances, which realism strives to capture. "Instead of replacing it," Chambers wrote in a 1969 *Artscanada* article titled "Perceptual Realism," "photography had inadvertently put new demands on representational painting." The silver paintings show his struggle to understand the implications of those demands.

Given the flamboyant experimentation of the sixties, *401 Towards London No. 1* (1968-69) comes as a surprise. With this painting, Chambers' overtly cinematic montage approach was abandoned, suddenly and permanently in favour of a more conventional realism. Yet the camera still lay at the root of his artistic process.

Working from his own source photographs, Chambers mapped out a painstaking grid for this picture, as he would for virtually all of his subsequent pictures, transferring the grid onto the larger scale of the plywood or canvas support, which he then scored with corresponding horizontal and vertical pencil lines, and filled in. In the finished painting, however, the photograph is sublimated. One wonders

why. It may be simply that Chambers came to the conclusion that the stylistic devices of the past decade had been too literal, too coarse, perhaps even gimmicky. Could he carry the same metaphysical freight without the bells and whistles?

With *401 Towards London No. 1* he proved that he could. Transience was his theme, and here he expresses it through the discipline of a more traditional painterly approach. The picture was first conceived in a flash of vision while Chambers was driving the highway near London en route to Toronto. He saw the image first, he said, in a backward glance in his rear-view mirror. In its very DNA, then, the picture is retrospective—a representation of the westbound 401 conjured from the vantage point of driving east.

The painting is a portrait of time going about its business. The picture calls to mind the revolution of the seasons (we see the leaves beginning to turn) and the slow movement of geological change evoked in the slanting angle of the terrain as it slopes down to Lake Ontario. This residual brow of land, left by the retreating glaciers, provides the most dynamic formal element of the picture. The seasons, like the drivers on the highway, cycle in an endless return of coming and going, but in the picture's wide embrace we are led to contemplate the unimaginable trajectory of the planet itself, evolving with imponderable slowness in cycles beyond our understanding. The harried business of moving from A to B is revealed as an illusion.

As in the earlier works, there are qualities here that reproduction cannot convey. Mysteriously, Chambers had inaugurated a new technique, back in the early sixties, of applying rabbit glue mixed with marble dust to the surfaces of his pictures before laying down the paint. The effect is very odd and often quite distracting, giving an uneven and rough stucco finish to parts of the pictures. More curiously, these patches of texture appear to have no relation to the imagery they support. Sometimes a rough patch will erupt beneath a floating cloud or an expanse of water.

There are several explanations for this technical eccentricity. First, given his love of all things historical and European, Chambers may simply have wanted to suggest the distressed surfaces of the frescoes he had seen there, in an attempt to add depth or a sense of time to the image. Perhaps he liked the way the texture picked up the light. But the effect is strangely cinematic, as if the image were being projected onto a rough wall. It makes the image seem fugitive—a fleeting shadow dancing on the wall of Plato's cave.

It was this painting, and the paintings that followed, that secured for Chambers his wide audience in the Canadian art world. During his later career he twice set a record for the sale price of a work of art by a living Canadian artist ($25,000 for *Sunday Morning No. 2* in 1970, and $35,000 for *Victoria Hospital* (1969–70) later the same year). There is a reason for this. They are works of enormous technical skill in an era when the skills of the artist were often expressed in ways that

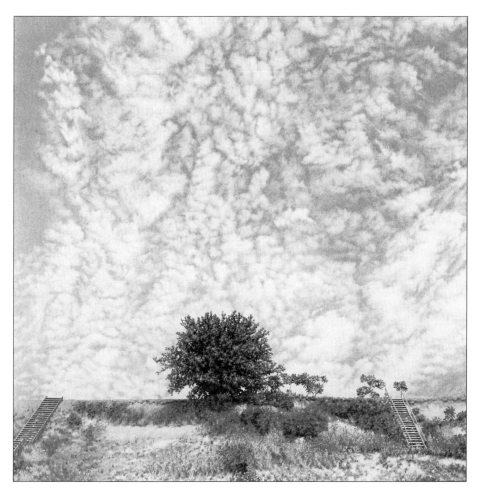

Lake Huron No. 4, 1972–76
oil on wood
121.9 x 121.9 cm
Private collection

were more difficult to appreciate. (Remember, the seventies gave us minimalism and conceptual art.) Yet Chambers still retained the respect of the most rarefied and intellectual of connoisseurs, and with good reason. He was an artist for all audiences, and one could enter the work where and how one wished.

The world that Chambers depicts in these last images has a very particular flavour. "It's not surprising," said Ross Woodman of Chambers' last decade of work, created under the threat of his illness, "that life, breathing, perceiving was a kind of miracle. Everything had the quality of one last look."

It's a cherished world, inhabited by his children and his wife, a place he looks on with a kind of painstaking, documentary passion. But it's also a hermetic, even claustrophobic world where the flow of life seems reined in by the strictures of domestic order.

Every little aberration screams out—the plastic King Kong action figure on the floor and the rumpled fringe of the carpet in *Diego Sleeping No. 2* (1971), the abandoned teddy bears piled in the foreground of *Sunday Morning No. 2* (1968–70). Again, in this last picture, we can see Chambers' fascination with light travelling through space and transparent material. The work is an inventory of frames—the window frame looking out onto the world outside, the framed Curnoe print of hockey sticks on the wall, the slanting rectangle of sunlight, the luminous screen of the TV, with its miniature convex reflection of the window—worlds within worlds of seeming and illusion.

Other beloved works from the last decade reduce content to a bare minimum, revelling in light and space. His series of four paintings of Lake Huron, begun in 1970 and ended in 1976, mostly show us empty sky, a void of mottled blue that Chambers invites us to study for signs of a cosmic presence. Instead, these skies yield a blankness that is terrifying, or liberating, depending on how you see it. Some look out to the lake, and we feel freed from gravity, our eyes swept out to the horizon. In other works, we look back from the shore up toward the dunes, our eyes lifted past the wooden staircases and stunted trees to the clouds and blue above.

In the final picture in the series, *Lake Huron No. 4* (1972–76), Chambers spliced together two photographic sources—one of the dunes, another of the sky directly overhead—and then compressed them together in one image, which gives us the dizzy sense of being rocked back on our heels. The rug is pulled from under us, but it is a blissful fall. The picture imagines the threshold between one world and another, a breathtaking roller-coaster ride into the wild blue yonder. It is one of the last major pictures he painted. The little bush would continue its vigil on this sunny dune, but the artist, Chambers knew, would not.

Chambers' conversion to Catholicism during his student days in Spain is often discussed in accounts of his art, and it's hard to overestimate its importance in his approach to the world. We see its literal traces in the postcard of the resurrected

Christ by Matthias Grünwald (from the sixteenth-century Isenheim Altar), which is taped to the glass window pane in *Sunday Morning No. 4* (1975–76), and in the cut-out Christmas stars in the picture window of *Sunday Morning No. 2*. We see it also in Chambers' sense of the sacramental beauty of family life.

But for all that Chambers' cosmology revolves around an omniscient God, a God of love, he also shows us a world where nature takes her course and we are her fodder, here for an instant only. There is thus, in Chambers' work, a deep stoicism about our human fate, and a loneliness that exists alongside his faith. There is nothing sentimental about it.

Similarly, he observes our human interactions with the natural world through dispassionate eyes. The mere pruning of a rosebush—in his film *Hybrid* (1967)—seems both matter-of-fact and unbearably brutal, the scissors relentlessly amputating the tender shoots, the blunt fingers prying apart the blossom and raping her for her pollen secrets. We are part of the brutality of the way things are; it's in our humanity, in our need to create order, to have mastery. In Chambers' film, the deformed, monstrous faces of napalmed Vietnamese children blossom from among the dark petals.

Through Chambers' eyes, we are led to worship by observing our gifts, counting our blessings and understanding that they will not go on forever. There's a scene at the end of *The Hart of London* where Chambers' small sons are observed feeding a group of wild deer. In the context of the film, it's as if the sacrificial lambs have gathered to break bread beneath the trees. In the background, we hear Olga's breathy whisper to her sons—seductive and mysterious—"Be very careful. He's going for your food. You have to be very careful."

And so we must. Looking at *Diego Sleeping No. 2*, we feel a little chill that connects us to that film's last moments. Here is tiny Diego lying on the sofa, bundled in his white blanket. You could miss him among the other objects scattered about the room. In the background, visible through the door, Olga chats on the kitchen phone, absorbed in her conversation and laughing. Is he sleeping? He is so very still.

Chambers sets us on a knife-edge between contentment and tragedy, a place where we all live every day, whether we know it or not. The sweetness of life is never to be taken for granted. Chambers knew this, long before he knew it would all end too soon.

R34

ROSS WOODMAN

The Act of Creation:
A Question of Survival

Standing before that picture, he finds himself in the presence of a great truth. He perceives that there is something in man which is always apparently on the eve of disappearing, but never disappears, an assurance which is always apparently saying farewell and yet illimitably lingers, a string which is always stretched to snapping and yet never snaps. He perceives that the queerest and most delicate thing in us, the most fragile, the most fantastic, is in truth the backbone and indestructible.

— G. K. CHESTERTON

I N 1952 Jack Chambers sat quietly but intently in the back row of my freshman English class at the University of Western Ontario. The steadily accumulating force of his silent presence came to a head when one day at the end of a class he approached me with some poems, which he said were written by a friend who would be interested in my opinion. I instantly assumed he was the "friend" and my reading of the poems confirmed it. I suggested that he consider publishing them. Much later, some of them appeared in James Reaney's *Alphabet*. Emboldened by my response to the poems, he invited me to his house on Dufferin Avenue in London to see some of his paintings. I recall portraits of himself and his sister, the self-portraits painted sitting on the edge of his bed gazing at his reflection in a bureau mirror no more than two feet away. Apart from a small closet, there was no room for anything else. My sense of him in that room was like my sense of him in the classroom: constricted energy waiting to explode. Before the end of the year, he dropped all his courses, took two jobs, one by day and the other by night, and saved

enough money to buy a one-way ticket to Europe. The night before he left, he brought me his paintings, which he had stored in a basement, and asked me to look after them until he got back. Years later, as if I didn't know, I asked him in an interview for Coach House Press (edited by Dennis Reid) why he left Canada. "Indifference," he replied.

> The part of Canada I knew was utilitarian, puritanical, indifferent to anything that was not a "safe job" and a "proper living." It was a question of survival. I worked, saved money and left. . . . I left Canada with no very clear idea of what I was after or where I was going, but with a determination not to have forced on me what I didn't want.

Chambers' life as I knew it was "a question of survival." This was as true of his decision to leave Canada as it was of his many failed attempts to find a cure for leukemia. Knowing at first hand the apparent recklessness of his ways, I also knew that survival was for Chambers a multidimensional matter that stretched all the way from the physical to the spiritual. More than that, I knew that the various levels were all intimately connected, that the struggle at one level included all the others. The result was a sense of urgency that could only be understood by someone who had some immediate access to what, in any given situation, was inwardly going on. In that same Coach House interview, Chambers describes how, in the seasonal landscape around London, he uncovered images of himself, "still gesturing in the invisible." One of these images was of himself as a boy diving from a train bridge into the Thames River. The plunge itself, which he described as a "vortex," carried within it a "periphery" of what he called "accompanying memories." These "memories," he explained, were "absorbed into the centre of the essential gesture." The urgency that informed Chambers' life was an almost daily plunge into the unknown that, as "the essential gesture," absorbed into it almost everything else. To be with Jack almost daily, as I was for a number of fruitful years, was to dive into the unknown only to find oneself being reassembled within it.

Our favourite meeting place was Gibbons Park, where we walked and talked among the trees. It was here that he first talked to me about what he would later call "perceptual realism," by which, among many other things, he meant that reality was the product of perception and that perception itself was a creative act. I, who taught the Romantics, thought I understood him, and he, for obvious reasons, was delighted that I did. I told him that Coleridge described the act of perception as a "repetition in the finite mind of the eternal act of creation in the infinite I Am." Though Coleridge's definition of what he called the "primary imagination" required an entire lecture for my students to understand, Chambers, who had dropped out in his first year, immediately grasped it as self-evident. He explained

to me that he could only paint a tree (and he painted several of them in Gibbons Park) if it had revealed itself to him in the instant prior to its settled presence, the instant when it was still a potential presence rather than an actual one. If, in his painting of the tree, its actual presence did not directly arise out of its potential presence, then *as a painting* it could not arise at all. At best (and worst) it could be nothing more than a copy of a tree rather than a painting. Perceptual realism was the reality of perception as an action of the mind.

Chambers lived on one side of the Thames, I on the other, and we would meet on the suspension bridge that joined them. In our daily walks together, we were within ourselves strangely god-like creatures, nature dissolving before our eyes as if waiting to be recreated. I had plenty of poems and he had his sketchbooks to affirm what was going on. Now, in retrospect, those sketchbooks appear to have had more to do with his films than with his paintings. "A painting gets put together just like an experience—in particles," he pointed out in the Coach House interview. "*Olga and Mary Visiting* [1964–65] isn't the description of a visual moment; it's the accumulation of experienced interiors brought into focus."

Chambers then went on to talk about the painting of Olga and Mary sitting on a sofa having tea together in a manner that equally describes his first film, *Mosaic*: "You are in a room, then in another room where you see an object being held this way, then you see it in motion, a week later a cup is tilting, the next day a finger curves in the air against a background, you hear a little clink . . . Sense combinations complement one another to enrich perception." Chambers here describes his painting of Olga and Mary visiting as if it were a series of frames spliced together to create in their very stillness an illusion of motion.

The transition from painting and drawing to filmmaking goes back to his use of photographs (preferably his own) as models for paintings. By imposing a grid on the photograph in order to focus on its minute particulars, he at the same time reshaped it in his mind into his painterly vision of it. Chambers with his grids was already working with the frames that in film negative make up the celluloid strip. The rhythmical continuity provided by the grid when it was transferred from the photograph to the canvas was also operative in a different way in the splicing of his frames. In making *Mosaic*, for example, he drew rough sketches of each frame before actually focusing the frame in the lens of his hand-held camera. He sketched the film frame by frame before he made it.

What particularly excited him in splicing his footage at the end of the day was the flow of the footage, as if before his eyes a series of still lifes (characteristic of his paintings) had suddenly been released from their frozen, sometimes death-like state into a moving picture whose motion was not simulated but real. For Chambers, what he witnessed was a kind of death and resurrection, about which in other contexts he had much to say.

Chambers began to make films at a time when he had come increasingly to identify painting with death. Nowhere was this more evident than in his positive-negative series, which constituted perhaps the darkest period of his all-too-brief career. Spraying silver lead-based paint directly from the can onto the wooden panel in an essentially unventilated studio, without using a mask, he became increasingly ill, not pausing to diagnose the environmental situation in which he was working or the way he was working. Visiting him in his studio, I was struck not only by an oppressive atmosphere, but by what I felt to be a mounting inner rage as if Jack were constructing the very prison from which he was also determined to escape. He seemed to be struggling with some inner contradiction that he could resolve only by negating what was, or had been, most positive about his work. Film, in some sense, became his refuge. In his final film, *The Hart of London*, the painful juxtaposition of the positive and negative, particularly in the long opening sequence in which what is released is simultaneously ploughed under, is a terrifying act of deconstruction in which "the periphery" of his life in London, Ontario, becomes an annihilating "vortex." This dark, mysterious "vortex" contains within its *massa confusa* an agonized vision of death and resurrection that held him not only within the ritual frames of the film strips hanging like slaughtered lambs from the ceiling of his studio, but within the ritual frame of the Catholic Church where for a time he daily received the Eucharist. Chambers' *film noir* as a contemporary version of Jan van Eyck's fifteenth-century Ghent polyptych, *The Adoration of the Mystic Lamb*, comes to mind.

Making, rather than mastering, films released him from many of the demands that his academic training in Spain had imposed upon him. Although in Spain he had willingly submitted to those demands, upon his return to Canada he found them increasingly oppressive. (As Stan Brakhage points out with reference to Chambers' films, "[t]here are no 'masters' of film in any significant sense. . . . There are only 'makers' in the original, or at least medieval, sense. . . .") Particularly in the work of his friend Greg Curnoe, Chambers confronted a "maker" whose art completely mirrored its creator's way of life; the making of a painting was as natural to the artist as breathing, or indeed any other of his fully embraced bodily functions. Struck by the astonishing freshness of Curnoe's work, which dealt directly with the fully acknowledged immediacy of his daily life in all its minute particulars, Chambers sought to loosen up in his own way.

Part of that loosening-up was to make a film about Curnoe's way of working. In *R34*, he focused on, among other things, Curnoe's collages, in which bits and pieces of unconscious information (what Chambers called "the periphery") became for Curnoe the "essential gesture" (described by Chambers as "the vortex"). In making a film that vividly enacted Curnoe's creative process, Chambers rediscovered something about himself that his training in Spain had taught him to forget. *R34* carried traces of himself that were still "gesturing in the invisible." In

Curnoe's work, they achieved "a fundamental legibility." In his oil painting *Diego Sleeping No. 2* (1971), Diego's toys are scattered on the floor and bits of clothing scattered on the sofa, all meticulously painted. Above the sofa hangs Chambers' equally meticulously painted copy of the poster of Curnoe's 1963 self-portrait, *Myself Walking North in the Tweed Suit*. The connection between Curnoe's cartoon-like self-portrait and Diego's scattered toys is perhaps apparent.

In *R34*, much of "the periphery" appears to emerge from garbage bins. From them Curnoe extracts whatever comes to hand, cuts it, and pastes it onto a sheet. Then he gathers up whatever remains, returns it to the bin, and takes it to the door, a ritual he repeats several times. In Chambers' interpretation of the process, it is as if the making of Curnoe's art involved the endless recycling of garbage in search of some hidden essence that constituted his daily life: Curnoe daily inventing himself with the help of scissors and glue. Much of what Chambers had fled in going to Spain—an improvised life on a daily basis—became in Curnoe's art a cause for celebration. It was not an easy pill to swallow. A brushstroke was Sheila, his wife, combing her hair. A home was a constructed triangular piece painted on both the inner and outer surfaces with Curnoe inside, his young son on his lap.

Chambers' film of Greg Curnoe moved beyond a celebration of Curnoe's life (which may or may not have been what he initially intended) into a celebration of a life in art that had become for Jack (in Spain) a life in art that he could only fully embrace by offering himself as a sacrifice to it. Curnoe embraced a very different conception of art, which he preferred not to call art. This vision, close to Dada, close to Pop art, contained within it the idea that art was not something extracted from life or raised out of it, but the very thing itself. And that vision became, in large measure, a blossoming of "art" in London in celebration of what had been, or was assumed to be, the antithesis of it. Jack making his films was his real entry into the new London "art" scene. It was also the entrance into what in Spain he had known was closed to him: an organism within an organism that had accepted him at its centre.

Something, however, still prevented him from accepting it for himself. Unlike Curnoe, Chambers never lost his sense of being an outsider whose real home was "elsewhere." Both his paintings and his films engage this "elsewhere," sometimes as death, and death sometimes as crucifixion. What is most intimately here carries within it a haunting otherness. However much a work by Chambers settles into itself, the spirit that informs it longs to escape.

The brutal accident that took Curnoe's life on a bright Saturday morning, a morning epitomized in the flashing spokes of his painted bicycle wheels, made the death of Chambers seem, by comparison, no accident at all. The accidental in which Curnoe rejoiced was always, for Chambers, an omen or a threat.

But to return to our walks in Gibbons Park. Now, in retrospect, they seem rather like Chambers rolling his negative filmstrip through his crude editing machine, cutting and splicing the frames into arrangements that dissolved and reshaped what

had been there. Talking to Jack in Gibbons Park was like watching the park dissolve and be put back together again in an arrangement that seemed perfectly to mirror the way our free-associating minds were operating. Suspended in time, exploring some inner space, we inhabited a creation that the trees in Gibbons Park seemed not simply to confirm but to celebrate, as if they somehow knew that at last they were being truly seen.

When in the Coach House interview I asked Jack if he wanted the viewer of his work to enter and share his own world of sensory association, he replied, "Not necessarily my world—better his own." "Most people," he then went on,

> tend to doubt the information and sources of their own perception. They will think that in order to experience an object they have to concentrate on it alone and suppress the periphery, things that are going on around it. They need to be reassured that the periphery is not a distraction, that their own subliminal sensations are right and should be made as conscious as possible. Painting shouldn't be dictating a particular response, but should be there as a pool of energy to set off reactions. If a painting works, you're more likely to trust your reactions and enjoy them.

For Chambers as for myself, the periphery that is called into conscious play by free association arose from the same "pool of energy" (as Jack termed it) that the Romantics identified with nature itself. We were together exploring in ourselves a creative process that repeats what Coleridge described as God's "eternal act of creation." What Jack took back with him to his studio on Lombardo Street, I took with me into the classroom. The poems I was reading with my students had, as one source of their life in me, my conversations with Jack in the park.

For Chambers, the act of perception as a repetition of God's "eternal act" transformed the physical event into a spiritual reality. Survival, understood as his awareness of nature as a living body always on the brink of becoming conscious *in* him and *as* him, was simultaneously his awareness of God. Spirit and matter were one and the same. Needless to say, this fragile awareness upon which his survival depended rendered survival a phenomenological issue[1] to which Chambers devoted considerable attention, particularly in his essay "Perceptual Realism" (*Artscanada*, October 1969). The essay, it should be noted, was partly written in Victoria Hospital in London after he was diagnosed with leukemia.

In Spain, particularly in his conversion to Catholicism, spirit as matter was for Chambers simultaneously omnipresent and absent. "The Castilian landscape was always impenetrable for me," he confessed in the Coach House interview.

> It was something I desired to become by entering it but never could or never did. The landscape was always a beautiful mystery: human odour seemed to

reside in it, so that a vista of several miles in that clear and machineless light seemed like a particle of torso under a microscope. The hills were rubbed bare by wool and hands had touched every inch of them. There was an organism within an organism that appeared as a landscape. But I knew I was not inside.

The "organism within an organism" that Chambers could not enter in the Castilian landscape he sought to enter instead in the crucified body of Christ, which, in his particular case "seemed like a particle of torso under a microscope." Spirit as body was the Incarnation. In Spain the Incarnation ("vortex") had absorbed into itself the entire Castilian landscape ("periphery") in which Chambers tried to live, but could not. He returned to Canada hoping to find the Incarnation in the landscape of his childhood, though in the Canada he had known it was more likely to be found in the Baptist Church. In his most powerful work, his film *The Hart of London*, the sanctified body of the crucified Christ becomes a deer that has wandered into West London and leapt through a window where, wounded, it is captured and shot. In the midst of making the film around this incident ("vortex") that absorbed the entire "periphery" of Chambers' London life, Chambers, now desperately ill, flew to Chinchon where he had lived after his graduation from the Escuela Central de Bellas Artes de San Fernando to film the slaughter of a lamb. In this way he united an incident in London with a more ritualized version of it in Spain that somehow joined them together in a complex symbolic representation that embraced Chambers' own imminent death from acute myeloblastic leukemia. To know Chambers at all is to recognize in the daily bread of his life the multidimensionality of creative perception that is his art.

Notes

1. The influence of such works as Maurice Merleau-Ponty's *Phenomenology of Perception* is discussed at some length in José L. Barrio-Garay's catalogue essay, "Jack Chambers' Paintings," in *Jack Chambers: The Last Decade*, ed. Paddy O'Brien (London Regional Art Gallery, 1980).

The Hart of London, 1968
graphite and oil on various papers,
mounted within four sheets of plexiglas
123.6 x 169.2 cm overall
National Gallery of Canada, Ottawa

DEBORAH MAGIDSON

The Art of Jack Chambers:
Photography as Visual Reference

I AM NOT INTERESTED in photography as such," said the London, Ontario, artist Jack Chambers in a recent interview. The camera is a "recording device, something mechanical."[1] Yet in the mode of his art since 1968, characterized by Chambers as "perceptual realism," the photograph has played a significant part. After all, perceptual realism's existence was not possible before the quality camera of today. The relationship of the photograph to Chambers' painting is bound up with the process of perceptual realism. Chambers has written the groundwork for perceptual realism in an attempt to clarify what is going on in his art. But the process is complex. And the photograph is only part of a much greater whole.

The essence of perceptual realism is the complete sensory experience. Although it is possible to talk about perception, what it is *like*, the difficulty arises in trying to get at what perception *is*. It is the old problem of trying to share a perceptual experience with somebody else. The closest that the artist can get to transferring his/her perceptual experience to anyone else is to package the experience, imitate it by art-craft. Perceptualism is that precious moment when something clicks, and we say, "Wow." In Chambers' own words: "It is conceived during that instant when the world is in focus but not yet moving, the moment before the names go on the objects . . . where reality is so imminent that one feels he has stepped off the conveyor belt of time momentarily and actually glimpses the world in pause."[2]

It was at such a moment that Chambers recorded the time of day, the light and weather conditions on the stretch of road leading to the 401 so that he could return with camera in hand to freeze the visual moment. The colour photo, or "visual description" as Chambers calls it, was used to record the perceptual experience. It was the photograph that remained faithful to the appearance of things, that prevented invention and style from superseding the experience.

But the photograph is not the end of the perceptualist process. Rather, it is the visual accompaniment that must be integrated with the sensory manifold of touch, smell, taste and sound necessary for the total experience. The camera's technical competence allows the artist to free him/herself from highly introspective memory constructions. The artist has only to look to the photograph for reference; he/she does not have to tamper with the mind's eye. There can be no distortion, given the camera's accuracy, only a rendering of the experience as it was, rather than as it might have been.

Acknowledging the debt of perceptual realism to the photograph, Chambers chooses to exploit the contributions of modern technology. But he firmly rejects the notion that the camera's invention has turned over to technology our entire perceptual field, "leaving to painting merely the subjective residue of an ill-defined response and a set of formal problems inherent in painting itself." The photograph is not the subject matter, nor is it a substitute for the original experience. It is a verification of the experience, a visual fact that prevents alteration. Because exactness of representation is desired and considered an essential element of perceptual realism, the camera's fidelity to the experience is cherished as a technique.

The camera gives Chambers an in-depth colour description. Printed on negative film stock and blown up to 8 by 10 or 16 by 20 inches, the photo's definitional area is extended, thereby making it easier for Chambers to read. He then studies the colour photo for relevant information, proportional relationships, colour qualities and contrasts.

In *401 Towards London No. 1*, a semi-wide-angle lens was used and the resulting three colour photos were joined together and squared up for copying. The technique used divides the photograph into half- or quarter-inch sections. The support, most often wood, receives a single colour tone of oil paint and like the photo is squared off. "As the painting develops the squares have to be drawn in again and again. Subsequent masses of lighter value subdivide the two larger generalized masses [of say, sky and land] and derive their own colour-tone orientation from them. In this way the structuring process gradually evolves into more minute divisions until through prolonged unifying and breaking up of colour areas, dimensional contrasts begin to emerge as defined objects. When this point is reached and realized the description has been intentionally analyzed and integrated with the experience."[3]

Out of this tradition has come *401 Towards London No. 1* and *No. 2, Victoria Hospital*, as seen from fellow artist Greg Curnoe's roof, *Sunday Noon*, set in Chambers' house with family gathered for Easter lunch, *Still Life*, a dresser with a vase of flowers and *Sunday Morning*, which has the artist's two sons dressed in nightclothes watching TV; beyond the comfortable interior a frozen winter landscape is seen through the living-room window.

Olga and Mary Visiting 1964–65
oil on wood
125.7 x 193.7 cm
Museum London
Art Fund, 1965

The subject matter of Chambers' work is taken from context, a felt environment that includes his wife, Olga, his children, close friends and the London landscape. The photo-likeness satisfies our appetite for easy identification. We can all share a piece of Chambers' family album and consequently have warm feelings toward his work. We want to get closer to his subjects, but as we move in on them, we are stopped, distanced by their stillness, silence and tranquillity.

Perceptual realism has been a recent introduction; there remains a large body of work that is pre–perceptual realist. The first Chambers work to use the photo in any way was a painting, *Farewell*, done while he was still a student at the Escuela Central de Bellas Artes de San Fernando, Madrid. The photo was employed as a reference point from which Chambers sketched.

On his return to Canada, the early works of 1962–64, *Olga at the South Pole* and *Olga near Arva*, incorporate the photograph in a highly idealized fashion. Invention plays a great part in a composite of photographs that were put together with Olga seated in what Chambers imaged as the South Pole. In *Olga near Arva*, a field of bright yellow is part of the London landscape; however, Olga and the children are transplanted figures from photos shot in Seville.

The synthetic sense of space, montage and repeated collage-like images in *Antonio and Miguel in the U.S.A.*, *Olga Visiting Mrs. V.*, and *Olga and Mary Visiting*—all from the "fractured images" period—seem influenced by formal qualities of cinema. Chambers denies the influence, saying his work from 1964 to 1966 was motivated solely by an interest in colour and shape.

The "silver canvases" of 1966–67 represented a cooling-out period for Chambers, a way to surface leaving behind the preoccupation with colour. The study of light and absence of detail in the silver works strongly affirm a cinematic resemblance. Only the extremities of absolute light and absolute darkness are visible and the degree of contrast between these is conditioned by the angle of illumination.

As an outgrowth of an interest in the space-time-light continuum in his wall art, a number of experimental films were completed concentrating on these elements cinematically. An example, *Circle*, made in 1968-69, records the passing of one year day after day. The camera is fixed, focused on a particular spot in the family backyard. The seasonal textures, colours, shapes and light patterns weave a detailed tapestry of life. As each day passes into the next, what is seen "out there," in the backyard, passes on. Nothing is ever the same. Each day brings new colours, light textures and objects. Unlike the film diary, the photo remains constant. After the few seconds during which the film is exposed nothing is changed. The photograph is a work from which light and colour conditions never vary from day to day.

The perceptual realism of Chambers' work today is a cumulative stage in his visual vocabulary. Just prior to beginning his perceptual-realist period, Chambers completed a series of "relief drawings" in graphite with oil glazes on paper mounted

on wood or plexiglas. The works are monochrome and multiple-imaged, largely derived from photographs and old still-life paintings. These include *Madrid Window No. 1* and *No. 2*, *Regatta No. 1*, *Cat* and *The Hart of London*.

It must be understood that Jack Chambers is neither a magic nor a photo realist. His perceptual paintings are not mere copies of his photos. Nor are they mental constructions that borrow much from dreams, memory and recollection. The difference is one of intention. The perceptual realist uses photography as a means of duplicating the physical reference point for perception. Chambers attempts to re-create the experience as it was, so that nothing is left out. The intention is measured, calculated, prepared and executed with an energy that is derived from the object of the artist's experience and attempts to give back to the object what it initially gave to him. It is a communion between artist and object that leaves the object untouched and valued for its own sake.

Notes

1. Taped conversation between Jack Chambers and Deborah Magidson, circa 1974.
2. Jack Chambers, "Perceptualism, Painting and Cinema," *Art and Artists* 7, no. 9 (Dec. 1972): 30–31.
3. John [Jack] Chambers, "Perceptual Realism," *Artscanada* 26, no. 136-137 (Oct. 1969): 12–13.

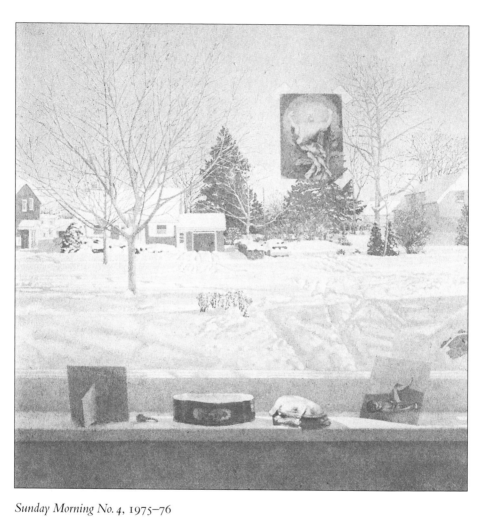

Sunday Morning No. 4, 1975–76
oil on wood
50.8 x 50.8 cm
Museum London
Gift of Mr. William James Moore, Barrie, Ontario, 2000

Perceptual Realism

ERE IN NORTH AMERICA there is a lot said about "technology" replacing art and doing the things it used to do; about North American culture as a phenomenon of acceleration but with no time-investment in art as a traditional feedback for the twentieth century. The visual-industrial heritage of North America does not include a tradition in sculpture or painting. Such a culture has a very different attitude and appearance from a culture within a tradition, like Spain.

Having lived in Spain for almost nine years and having studied at the Royal Academy in Madrid for the first six of those years, and as a North American actively attentive as an artist to both scenes these past nine years in Canada, I want to say something about the influence these two very different cultures have on me. I will do it by defining what I mean by the terms *art* and *technology* and go on from there to other considerations.

Art: 1. *Perception* 2. *Experience* 3. *Description*

Art is a lower-case word; it's a craft of the natural like fruit growing on trees is a craft of nature. Man as art is the image of his nature just as mankind is the fruit of the primary process animating the earth and all in which the earth as a fruit is rooted.

The primary process in each man is the art of his human nature which crafts him. Man as artist can communicate with nature and communicate that in nature to other men because men and nature share the same instinct. The organic process of nature which man shares is the *way* mankind as fruit is shaped on his tree and by all in which the tree is rooted. This process containing each man and animating him from within and from without is also the process he spontaneously emits to

the outside world again. I call this primary pattern that swings back and forth through man and nature and is the sense of all the moving parts of a moving whole, *perception*.

Perception

Perception is a sensory communication that occurs at a primary level between organisms: through the skin to the core and back through the skin again into the exterior world. The intention to imitate is natural to the process in that its own primary pattern spontaneously structures a world of secondary cultural expressions. The pattern or imitation of this process in man's own sensory organism as it responds to the external world, man's art, I call *experience* and the intention to imitate experience by art-craft, I call *perceptual realism*.

Experience

The perception of the natural world and its objects, creatures and people is the source of truth about oneself because not only what we project but also what we receive is ourselves. The involuntary natural selection by my sensory organs of what I as a system respond to is imprinted on the senses in unison. Any particular intentions one has about the object is abandoned to allow the sensory grid to operate so that the object is "given" within. The senses constellate to experience the impact as a total circuit, registering the entry as a complex, but in the particular way of each. Experience, like its animator, is also a complete circuit with an in-swing and an out-swing. Its out-swing passes through the mind as through a deciphering centre which translates the sensory impression into an intentionally structured communication with the exterior world. As an intentional out-going art, experience in its turn is crafted by means of a discriminating dialogue with what is seen: the *description*.

Description

The description is a still colour-foto taken by a high quality lens. It records my experience of the exterior world in an articulate visual.

Technology: 1. *Technology as history*
2. *Technique* 3. *Individual technique*

Technology is an historic process that learns from itself and perpetuates what it learns by a tradition, thereby passing on the accomplishments of its own history. Historic technology of art ripens into periods of fruitfulness and decays like any natural thing. The recurrent blooms of this organism to which I am attracted are the emergence of the forms of classicism and any art which advances these forms.

Technology as History

The technical process of history could be described as a curve setting out from nature where, perhaps, the first realism in prehistory was a survival communion of man totally engaged in an equality rite with the image of the beast that feeds him; up the curve to a transcendent world of forms; around to the Renaissance and its scientific interpretation of nature; then to Cézanne who took it a natural step further and completed the formal accomplishment of the Renaissance by giving to painting the dimensional structuring energy of colour. Cézanne's accomplishment also moves the formal lesson of the Renaissance up in time to embody its natural colour dimension.

Technology as a learning-teaching dialogue with its meaning in mankind should be passed on from culture to culture, otherwise we run the risk of an impoverished materialism through omitting the historical dimension.

Attempting to acquire a cultural characteristic such as classicism in painting and sculpture, as North America tried to acquire in the nineteenth and twentieth centuries, while not being able to transport the cultural process itself, fails because the transplant is a spatial one, an idea, the appropriation of an appearance. The transmission of such a process belongs to time; to the manipulative practice, to the adaptation of results to the nervous system. The conditioning influence of these requirements to motivation and one's own persistence take time: that kind of time is as necessary to learning as air is to breathing. The absence of the historical dimension in technology deprives us of a choice and of potential development.

Technique

The craft passed on traditionally should consist of an absolute mastery of objective representation in drawing, painting and sculpture. What one does with this learning or the degree to which he throws himself into acquiring it is his own concern. If the choice is there a decision can at least be made by having the opportunity to choose. We can certainly see and appreciate the art of the past and it seems an

unfortunate omission when there is no means around us to imitate and thereby absorb what we enjoy.

The attempt at integrating some cultural characteristic into a culture from which it did not grow is to possess only the apparent visual. The attempt fails in the essential dimension of technology and all its subsequent innovations. All the subsequent forms of North American representational painting are impoverished for reasons of cultural discontinuity. This is only my personal view in attempting to elucidate a situation by differentiating between what I believe are structural values of painting on the one hand and appearances on the other.

Individual Technique

What one develops as his own techniques depends on the likes and dislikes that motivate him and what he can choose from. Sufficient knowledge of what is relevant to oneself is enough to show the way to where and how to build. What made me feel good (that is, the kind of "doing" that in itself was pleasurable) was what got done. With the confidence that a certain amount of satisfaction can bring, inadequacies in the work began to appear that urged for more discriminate attention and objectivity. That was the beginning of several years of disciplining myself to think drawing so that the pleasure was also in achieving certain specific results. It became clear that two systems were interworking mutually to develop one another: one was my attraction to the beautiful in the body of art, to the art of certain periods, and the other was the accumulating resourcefulness to work objectively which allowed me to step out and include more and demand more on the basis of what I could already do. The why and the how of technique were in this way fused together as single working process.

Simultaneously a mass of Spanish strangers were becoming individual personalities and friends. I began to experience their nervous systems, the meaning in their movements and living rhythms. Speaking the language revealed the gamut of emphasis and release which is the feeling about what is being said or left unsaid by words. The values and flavour of the cultural climate soaked in, transforming and remotivating my own values and giving me more to choose from.

Painting Style

Before the camera was invented, painters developed a painting style to compensate for the lack of visual information available to them. A constantly changing scene with no way of freezing the instant offered the painter little alternative but to find some intentional means of expressing the unity he felt for the thing he was painting.

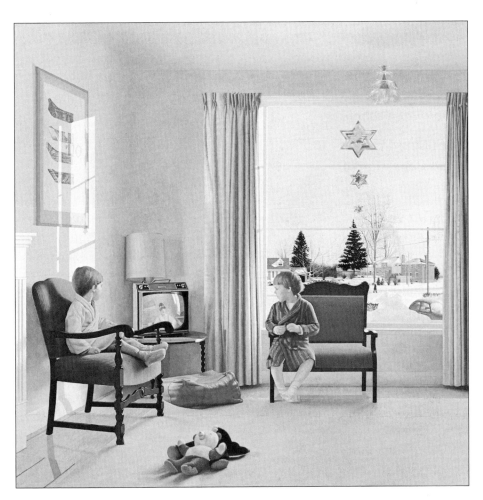

Sunday Morning No. 2, 1968–70
oil on wood
121.9 x 121.9 cm
Private collection

Style filled the gap as it were, where the artist had no more specific references to go on. The personality of the artist conceived stylistic innovations that became his hallmark; where style deteriorated into mannerism painting derived from the lyrical ego and the mind-aesthetic rather than embodying the primary impact. Where style is the intention and unifying element of a work the personality operating there draws the viewer's mind into the work and into the past. The aesthetic object fixed as it is in time does not embody a presence of *now*. Some Egyptian, some Greek, some Velázquez, some Cézanne works do embody an inevitable and natural presence that cannot really be understood except as motion as it gets absorbed through the skin.

Photography

The highly analogous appearance between the recurrent blooming characteristic of art and the advancing continuity of science allowed art and science to look like one and the same thing. Tintorettos and Titians and other heaven environmental paintings had convincing perspective of human forms and objects. But even before the

Olga near Madrid (photograph)

camera, people still read painting as a photograph and even when the camera did take pictures it was generally considered that as far as pictorial representation went the foto could do it better. This generally "fixed idea" about the function of art demanded that it entertain as well as inspire the imagination and employ a credible degree of realistic rendering in doing so. The "photographic" accomplishment of advanced Renaissance perspective representation paralleled the informative naturalness of the foto and its influence required no less of all subsequent realistic painting. Apparent in both technologies was a significative accuracy making it logical for an industrial-minded culture on the verge of cinema to assume photography to be an art-fruit of the times, since people already "experienced" the foto as heir to the Renaissance "still."

As an extension of the eye the camera certainly is a specialized device for freezing the visual with an instant and encompassing precision the human eye is incapable of. One has to realize the social function allotted to the eye as its specific and real utility. For society the value of the eye is for focusing on the right button: feeding information to the brain in a visual culture becomes an imposed condition of its usefulness so we can get on with the job. When the mind relinquishes its hold on the eye and the eye collaborates as a receptor in the sensory complex then its intention and in-take is of a different order.

Our experience of photography and its off-shoots will inevitably lucidate all its particular qualities and its spectacular limitations. Our continuing familiarity with the foto should help us to understand more about our special appetite for identification gratification and maybe suggest some notion of what the eye as a sensory collaborator in perception is missing on its own. Instead of replacing it photography had inadvertently put new demands on representational painting.

Camera and Photo

The camera records mechanically only what it sees. It *replaces real things* by a system of signs. It can be aimed by certain feelings to suggest more than it sees but the information is still read and understood by the mind, allowing that suggestive aiming may also expand the imagination.

What I want from the camera technically is a precision-in-depth colour description. Negative film stock prints better colour results than reversal stock. Blowing the print up to 8 by 10 inches or 16 by 20, or larger, extends the definition area, making it easier to read, and granulates the colour sufficiently to offer a wider selection of broken colour-tone, keeping the effect of the foto flexible and luminous.

Procedure: 1. *Integration* 2. *Application*

Integrating the experience with the description is a labour of analytical contemplation, of probing colour fotos for the relevant information they can yield to stimulate a reading of the experience back into the description. The mental operation analyzes and scans the information with a general as well as specific intent for the availability of effects of contrast, proportional relationships and colour articulation. If enough information is found and the foto is usable then it becomes the plan for a structure.

The mind becomes a theatre of mental operations submitting its findings to the experience for stimulation. What the experience responds to determines the

intentional synthesis and the subsequent structuring procedure. The experience is what I see the description *with*: it is a vision positioned between perception and the foto. The diligence and discrimination of the mental operation in analyzing and referring all the data for evaluation is what transforms the process by degrees into an object embodying the discharge of the experience and the identity of the description. Where the experience and mind concur, the eye-hand combination makes the appropriate selection of colour placement. The pictorial structuring itself takes shape and breaks down ceaselessly till the degree of consolidation is reached where the painting as meaning and the intentional process shaping it are an inseparable result.

Application

The usable foto is divided into quarter-inch or half-inch squares. The support (prepared wood or canvas) receives a uni-colour-tone surface of oil paint approximating the colour-tone of the largest generalized colour area: the sky in *401*. It is also divided into squares corresponding to those in the foto. A primary division between earth and sky is made by a straight line using the squares to determine where the line is made. The sky portion is left the colour it is and the earth portion is painted darker to approximate the generalized colour-tone in the landscape.

The intention of this approach is to reduce analytically all masses and their emergent forms to a primary colour-tone from which they evolve to weave the basic structure throughout the mass. Such a colour-tone is not the darkest but a middle dark which can itself be projected by the darkest areas and project from itself lighter ones. In any fragment the structuring procedure is the same as in the whole.

As the painting develops the squares have to be drawn in again and again. Subsequent masses of lighter value subdivide the two large generalized masses and derive their own colour-tone orientation from them. In this way the structuring process gradually evolves into more minute divisions until through prolonged unifying and breaking up of colour areas, dimensional contrasts begin to emerge as defined objects. When this point is reached and realized the description has been intentionally analyzed and integrated with the experience.

Aesthetics and Perception

In general "everyone" seems to enjoy scenes of vast sky and clouds and sunlit landscape. Its common recurrence on windshields and in "handpainted" paintings and calendars is the kind of picture people feel easy with and don't mind hanging up at home. A bright sunny day makes people feel good because their subjective attitude is the filter through which natural or "crude-oil" visuals are strained into

"being" something. A grey-washed day of minimum contrast is likely to bring out irritations one didn't know were there. It is a thing of negative appeal: negative because the subjective-evaluation filter says the grey day doesn't remove irritations or make one feel any better. Negative on both scenes really, because neither is perceived from the outside; both are projected onto nature from within. What happens in general is that natural phenomena remain invisible to the conditioned mind: it prefers a substitute-stereotype to making personal contact with visible experience.

The grey, dull scene may have impressed the sensibilities with an equivalent impact to the sunlit, contrasty one, but the short-circuit occurs where the mind interprets the impact as something it doesn't like or even something it does like *because. . . . Because* is the mental process of aesthetics, at whatever level of sophistication, where kinds of appearances trigger conditioned aesthetic responses to fade out an otherwise potential perceptual impact. The impact on the perceiver looking through the visible to a general vision-awareness of the whole will register impartially an experience because it is not intercepted by the mind. The aesthetic concern converts and manipulates its *own* energy according to its particular needs. The spontaneous and primary nature of perception cannot speculate in values.

Synthesis

The integration value of the foto as a new tool for perceptual painting resides in the camera being able to do its specific descriptive job so well. The printed colour description renders obsolete such time-style licence on lyricism, subjective selectivity and emotional impurities that haphazardly deform and exaggerate objective reality. Arbitrary formal and dimensional distortions, private and cult aesthetic-painting, dialectical extenuations, seem to me to constitute a regression, as contemporary art modes, in their inability to appropriate two systems of available technology: organic-tradition and visual-mechanical; dimensional-mobility and scientific-linearity; release and tension: in-out; breathing.

Any art form from prehistory to now that imparts its particular impact-communication onto the senses is a perceptual art: it is absorbed. That the form is not an objective realism or classicism does not alter what art *is*. But an aesthetic involving modes of ideas-painting, painting that laboriously changes the scale of photography, impoverished kinds of realism that have omitted the art experience of Cézanne in particular, are descriptive techniques that offer essentially the same service value as the photograph.

Perceptual realism incorporates two systems of technology (historic and industrial) and two systems of visibility (body and mind) to structure a reflector-object of experience. It has already been mentioned how two inter-working processes

motivate and advance one another intentionally to create this transmitter unit. Deploying the foto as an integrated visual component thereby completes the closure of these two extending systems which as closure creates its own object. It is an object to see with rather than a thing just to see. Before the developed camera such a closure and its object, perceptual realism, were impossible.

North American Aesthetic and M. Duchamp

North America's first import was her own settling people: a coherent mental system removed from its organic container-body in Europe and deposited as a mind-import of uprooted human beings carrying the industrial heritage of the Renaissance to a carte-blanche opportunity at God-given pragmatism. A profound sense of origin displacement at settling down in a strange organic container only aggravated the enthusiastic thrust ahead into ideas production.

Duchamp's "odd" objects in the "right" place appear to enact in art the divided status of body and mind in North America. But Duchamp's *displacement* is an integrated art process of organic-mind juxtaposition as in his two "found" systems: the organ-object urinal contained in the mind-moral art gallery. These two "found" cultural systems also express the two inter-working systems in his art: real-object and mental-object integration. The displacement aspect of Duchamp's art reveals to North America its deeper sentiments about itself: its uprootedness. North American Dada, random objects, factory-Art, earthworks, natural environment tours is its awareness of the submerged raw-longing about rooting its condition in origins as origin is perceived in Duchamp's art.

North American artists' response to equate the apparent embodiment of their dilemma with Duchamp's art releases their awareness, in their own works, of the "body" as a body of ideas: the mind performs an encircling tactic attempting a remedy of wholeness by reflecting itself as the container-body of its own ideas. Art, the process of integrating two systems (historic-present, organic-mind), is not art when having only the mind-system to work with. The one-system "take" is a significative manner by which we understand what influence is being elaborated.

The mannerism of North American art, so distinct from the politically obvious and academically dated kinds of international political painting, lies in its repetitious *effort* to become art; the effort reveals its own particular academism.

By taking North American art and standing it on its Dada end with its hard-edge "workability" painting at the top, the polarity so described assumes the singular quality of a totem, the projection of its own image from within into a sign. Its image is not found outside itself.

Duchamp's *New Piece* is an enactment of the two systems of art: a primary process animating an object.

The feeling I have about North American art *now* is that for its dollar value the various marketing industries and professions, pursuing their own interests of course, have been obliged to make much more of it than it really is. The confusion of art with production technology is not really a confusion, because that would mean a choice, but the sensation of progress springing naturally from its accumulations and prosperity.

With all there is to explore in electrical-science technology, as well as new meanings that will transform other things, the experimental characteristic of North America will eventually create its own historic dimension with its own technology. Where North American artists do embody an historic dimension is in the medium of personal filmmaking. They form a major part of film's "roots" and are making enormous advances in the organic-mind growth of this art.

Familiarity with Perception

Since the nature of perception and its experience is spontaneous, there is, in receiving some experiences, an enthusiastic response to the beautiful which enunciated can be: "WOW." The beautiful impact has the effect of bursting in and knocking you over before your door is all the way open. But its repeated, though irregular, visits sustain the relationship between you both to a point where such encounters eventually familiarize the house-keeper and the caller with their own enthusiasm and surprise. This domesticating or civilizing exchange has a settling and strengthening influence on both systems and they become more agile and versatile at perceiving the weaker impulses, the little presences, the whispers that are always there but only recently have become residents of an expanded family awareness. In short, everything and anything that one *sees* is in its actual presence also more than we can in any one way understand it to be. The more we become familiar with the experiences that perception brings the more we become aware of an inherent gentleness in the intercommunion of oneself with things. So gentleness of reception is also a communication that influences the outside world. Finally, perception itself becomes a "forgotten" awareness that just *is* with all the common naturalness of those common things seen out the window or inside the house or any place.

August 21, 1969

Mosaic

Jack Chambers as Filmmaker

The fact IS that the four films of Jack Chambers have changed the whole history of film, despite their neglect, in a way that isn't even possible within the field of painting. There are no "masters" of film in any significant sense whatsoever. There are only "makers" in the original, or at least medieval, sense of the word. Jack Chambers is a true "maker" of films. He needs no stance, or standing, for he dances attendance upon the coming-into-being of something recognizably NEW.

— STAN BRAKHAGE [*]

I N 1962, Jack Chambers published in *Alphabet* a short piece of lyrical prose entitled *Aircraft*, which he had first written in 1949. It deals with life in a garden that is at once the garden of Eden and a graveyard, where innocence is both celebrated and corrupted, allowed to thrive and buried in the earth. The narrator who inhabits this garden is the prisoner of it. He is an inmate, a convict, who longs to escape but cannot, because it is the place where he sows and is sown. It is a place of continuous dying and perpetual rebirth into a series of erotic images which have the nightmare quality of ungratified desire. It is Chambers in London, Ontario, before he left for Spain.

In certain respects this garden is the psychic scene or setting of much of Chambers' art up to the advent of "perceptual realism" in 1968–69. It dominates his films, reaching something like an apocalyptic climax in *The Hart of London* (1968–70), in which Chambers finally and fully orchestrates the nightmare vision of his home town that had haunted and pursued him all his life. In *Mosaic* (1966),

* From a letter to Edith Kramer, used as text in program notes for a showing of Chambers' films at Pacific Film Archive (Berkeley), November 15, 1977.

it is the graveyard where his young wife moves toward her newborn child while an old man moves toward a bench and a male athlete sprints along a road. It is a place, too, where she scatters petals from her womb onto a decaying raccoon. In *Hybrid* (1967), it is a rose garden where roses open to reveal the deformed faces of napalmed Vietnamese children. In *R34* (1967), it is the interior of Greg Curnoe's studio, where the artist-gardener assembles collages from the refuse of emptied garbage cans and holds his child inside the womb-like interior of one of his own artworks, a pyramid-like construction. In *Circle* (1968–69), it is the artist's own backyard shot for what Chambers described as "a couple of seconds" from the same spot every day for a year. In *The Hart of London*, it is the city itself seen as a trap that a deer accidentally enters to be captured and killed, a city that finally narrows to the London Zoo at sunset where a child moves unsteadily toward a deer as the camera revolves in circles from sky to earth and a voice warns, "Diego, you have to be very careful."

Chambers' films are what he himself called "personal" films. He began making them at a time when he felt the need to escape his professional commitment to painting, which he believed was now blocking the flow of his own feeling by arresting or freezing it into the resolution of purely painterly issues. He was becoming disturbed by the acceptance (not reflected, of course, in sales) of his art (partly because it was "realistic") by a society he still believed was "utilitarian, puritanical, indifferent to anything that was not a 'safe job' and a 'proper living,'"[1] and therefore fundamentally rejected everything for which he as an artist stood.

How strong this feeling was can perhaps best be seen in the silver paintings, which were in large part the outgrowth of his increasing interest in film as an exploration of the perceptual process. In commenting upon them, Chambers made it quite clear that he had grown tired of "painting space through interacting colours"[2] because increasingly the concern had become not the subject matter but the space itself. His concern was with the board or canvas, bringing it as board or canvas to life. "Painting realistically is creating space, not subject matter," he remarked.[3] The subject matter, recognizable objects, is really irrelevant or accidental. What matters to the painter is "descriptive space (perspective, colour modulation)"; objects are simply a description of space itself. To which Chambers added, with its impact on the viewer in mind: "In painting, descriptive space (perspective, colour modulation) equals illusion. It confuses self-awareness."[4]

Chambers believed his art was encouraging people to take up a temporary and aesthetic residence in a world of illusion that allowed them to avoid the necessity of "self-awareness." He was playing into the hands of the real enemies of art. In the silver paintings, which he described as "instant movies,"[5] Chambers attempted in his usual ruthless and uncompromising way to break out of the aesthetic trap into which his training and professionalism had led him. He was determined to destroy the image as a spatial form seducing the viewer into certain illusory notions about

the nature of reality. He would for one thing stop mixing colours and use instead aluminum paint directly from the can, spraying it onto the board. "My use of colour had become too subtle," he commented; "silver is a refreshing neutral from the tense calculating that goes into controlling colour effects."[6] As for the painted surface, he would destroy its fixed form, that peculiar stillness that had offered a resting place for minds that did not want to work. "The painted surface changes when you move," Chambers explained of the silver paintings. "It's a light medium —an optical medium." He then continued, drawing out the connection between the silver paintings and the film:

> I observed that silver gives a positive-to-negative image reversal depending on the source of light or where you view it from. As you move, the positive forms become negative and vice versa coming back. The shift is to the physical sensation of seeing—as in seeing double when you don't expect it. . . . Time as a new dimension has come into view. The temporal insistence (the time it takes to view the variations as a whole or the time spent in waiting for the variations to be revealed) is the real difference here. It's a different realism: space has become time.[7]

In his films, Chambers moved deliberately from space to time in an attempt to liberate the mind from the illusion of rest by forcing it to enter a temporal process in which change or flux is the condition of perception itself. Chambers' films explore the dynamics of the act of perception. They are attempts to wake up an audience that he feared his paintings might now be putting to sleep.

Part of Chambers' initial interest in filmmaking resided in his attempt to come to grips in a more immediate way with painting as a process rather than painting as a product, with painting less as a revelation of *what* is perceived than with *how* it is perceived. "A painting gets put together just like an experience—in particles," he once commented. "*Olga and Mary Visiting* isn't the description of a visual moment; it's the accumulation of experienced interiors brought into focus." Chambers then continued, describing the way a painting gets put together as if it were very much like a film:

> You are in a room, then in another room where you see an object being held this way, then you see it in motion, a week later a cup is tilting, the next day a finger curves in the air against a background, you hear a little clink, you swallow a cheese sandwich, something fragile, a cup touches its saucer, you see white . . . a woman rests one leg over the other, pink . . . , the thick rug is buff-orange. Sense combinations complement one another to enrich perception.[8]

This account of, among other things, the kind of perceptual experience that is brought into arrested focus in *Olga and Mary Visiting*, which he painted in 1964–65 when he was actually at work on his first film, *Mosaic*, suggests that the painting itself

derives from, and is a distillation of, a filmmaking process. What Chambers describes is really the filmmaker editing his own film by splicing and reassembling his footage to produce a certain effect that faithfully records his own complex act of perception. The film, unlike the painting, becomes a collage spread out in time, one image following another image in a time sequence, rather than a collage organized in space. Thus *R34*, which concerns itself with Greg Curnoe making collages by pasting images on pieces of paper, is itself a collage. The spatial arrangements in Curnoe's work become the temporal arrangements in Chambers' film. Curnoe, the artist, and Chambers, the filmmaker, intersect and interact as Chambers explores the relations between film and an art of a more traditional, spatial kind.

In the temporal collage which constitutes a Chambers film, Chambers was breaking out of the pictorial space of his own paintings in order to release his mind from the frozen moments in which, in his painting, thoughts or images were arrested. Returning to Canada from Spain, he had discovered that the so-called action painting that had begun with Jackson Pollock in New York had become the dominant North American style, dominating the Toronto scene, for example, in the years that Chambers was away. Chambers as a painter was not attracted to it, though the impact it had upon him may perhaps be seen in many of the paintings he did shortly after his return to Canada in 1961, *The Artist's First Bride* and *The Unravished Bride* among them. "At some time in 1961," he writes:

> I became aware of de Kooning and Pollock and Klee and Kandinsky. I had never seen their works before and that included whatever had happened in painting since Juan Gris and Picasso.

Chambers then continues, describing the very "eccentric" personal use he made of Pollock's drip method in particular:

> I began to texturize the surfaces of my panels with a mixture of rabbit glue and marble dust. Once dry, I could adjust the topography with sandpaper. These surfaces were covered with gesso and then I spilled various colours of hot enamels on the gesso surface and sprinkled it with turps to get it running. I then tilted the board this way and that till some interesting effect appeared, and then I laid it flat and let it dry or added more paint and turps. Once the surface was worthy of interrogation, I began to extend and curtail its colours and shapes with a small paint brush. The figure or objects I wanted to appear in the painting gradually took shape within the selected chaos of the splattered surface. They were not painted on the surfaces—they grew with it.[9]

Chambers, it will be noted, was experimenting not only with surface texture but with the relationship of images to it. He was transforming surface into a "motion"

picture that functioned as a "pool of energy" out of which images emerged in time rather than in space. The images, that is, became the forms growing out of "the selected chaos of the splattered surface"; they were the "interrogation" that was "worthy" of it.

Chambers, spilling various colours of house enamel on a gesso surface, sprinkling it with turps to get it running, tilting the board this and that way until interesting effects appeared, was deliberately breaking free of the methods of painting learned in Spain, which were now in Canada making him so tense, because of the concentration they required, that he was reacting physically to the strain. He was trying to find ways of physically as well as mentally loosening up by releasing his mind and imagination into free or spontaneous movement. He began to explore in painting the unconscious "body" language that had always governed his poems and creative prose. Chambers in the paintings of 1961–62 was trying to adjust his technique to something far closer to his natural way of thinking, a way of thinking perhaps best summed up by Paul Klee when he described his drawings as taking a line for a walk.

Chambers interrogating the "selected chaos of the splattered surface" was also Chambers interrogating his life, discovering in the memories flowing through his mind (like the seasons flowing through nature) what he called "a fundamental legibility." Thus, when he was asked why he decided to remain in Canada, he replied that:

> Over a couple of years the seasons uncovered images of myself still gesturing in the invisible. A few visual appearances possessed a fundamental legibility. There appeared memories of some boyhood incidents that had a dimension beyond the incidents themselves. Such incidents (diving from a train bridge into the Thames) divided into vortex and periphery, the periphery of accompanying memories being absorbed into the centre of the essential gesture. This synthesis, invisible in time, was an experience of reality, a revelation, an experience of an organism within an organism that had accepted me as its centre. That was the basis of my decision to stay in Canada.[10]

The "basis" of that decision to stay in Canada, as Chambers here describes it, is essentially cinematic, as if what he is suggesting is that he decided to stay in Canada to make films about himself, about his own "experience of reality" that had "accepted" him as its centre. The "experience of reality" in Spain had never done that. He could never be at its centre. Chambers in his "personal" films was not only working with "a few visual appearances" that "possessed a fundamental legibility," the "legibility" itself existed by virtue of the fact that they constituted the deepest, most fundamental, patterns or contours of his mind. The outer landscape was equally an inner landscape. What finally got projected onto a screen after the

shooting, editing and developing was finished was a more direct revelation of Chambers' psyche than painting now would allow.

There may be an obvious reason for this. Chambers was a highly disciplined artist trained in the old European manner of the academy which, on one level, inhibited the kind of inspired doodling he would later respond to in the work of Paul Klee and Greg Curnoe. As an amateur filmmaker using the crudest equipment, often splicing with masking tape and ignoring light readings for the entire year of shooting his own backyard for "a couple of seconds" a day, Chambers released himself from the impersonal demands of painting to create in a more spontaneous way that allowed him to tap sources of energy and vision that his training in Spain had for the moment blocked. Chambers' work in the film was the "stirring/of dull roots with spring rain" as a result of the "mixing" of "memory and desire." It was a response less to his return to Canada than to his painfully reached decision to stay. The major outcomes of that decision were perceptual realism and *The Hart of London*, which Stan Brakhage described as "among the few GREAT films of all cinema." Chambers' films affirm something far deeper in himself than anything the training in Spain could of itself release. He had in a sense to strip that training away to rediscover and reinvent what lay behind it. It was not easy; it involved accepting many of the things from which he had fled. "How can those interested in making life better in this country help our drama?" James Reaney asked in an editorial in *Alphabet* (June 1962):

> There should be a club that does nothing but seasons of plays by Canadians. It should do them in a bare, long room up above a store, probably infested by Odd Fellows or Orangemen on easily avoidable nights. . . . Five two hundred Mazda watters always turned on will do for any play that lights its own way, as a play should.

That was the new spirit abroad in London, Ontario, which confronted Chambers soon after his return and his own films were his contribution to it. Unlike his training in Spain, it brought him to that "organism within an organism that had accepted [him] as its centre." Filmmaking was like diving from a train bridge into the heart of himself.

The "personal" films that Chambers made, eight in all (one incomplete), brought him home to himself in a more immediate and unscripted way than the high professionalism of his painting could. It was a necessary and inherent part of coming to know himself, which in the final analysis was for Chambers always more important than art. Life, for Chambers, was the real form of art, painting itself being the indicators, signposts, inventories and probings along a more invisible way that conducted to the Self. Once the act of perception had received the acknowledgement that constituted both a revelation of the world and a revelation

of the Self it could then be forgotten. "Finally," Chambers wrote in his essay on perceptual realism (1969), "perception itself becomes a 'forgotten' awareness that just *is* with all the common naturalness of those common things seen out the window or inside the house or any place."[11]

The great advantage of film over painting is that being bound to time rather than to space it is best suited to communicating "a 'forgotten' awareness that just *is.*" The very essence of film is the swift passage of fleeting images, one departing as another arrives. It had, therefore, for Chambers that very quality of "'forgotten' awareness" that had made his home town a psychic storehouse of images that in some mysterious way contained, hid and nourished his own identity. That identity his "personal" films share with an audience that he thought of in the first instance as regional, an audience, that is, which could find in the fleeting images in time its own "periphery of accompanying memories." Thus when Chambers was asked if he wanted the viewer of one of his works to enter and share his own world of sensory association, he replied:

> Not necessarily my world—better his own. Most people tend to doubt the information and sources of their own perception. They will think that in order to experience an object they have to concentrate on it alone and suppress the periphery things that are going on around it. They need to be reassured that the periphery is not a distraction, that their own subliminal sensations are right and should be made as conscious as possible. Painting shouldn't be dictating a particular response, but should be there as a pool of energy to set off reactions. If the painting works, you're more likely to trust your reactions and enjoy them.[12]

Chambers, it will be noted, is speaking here of his paintings rather than his films. The painting he has specifically in mind is *Olga and Mary Visiting*, which he had, as already noted, described in cinematic terms. What Chambers is saying about the paintings, however, is far easier to achieve in film because it is the very nature of film—or at least the characteristic Chambers film—to escape the concentration on some particular object or image in order to release into the action "the periphery things that are going on around it." The immediate, all-at-once spatial presence of a painting which takes it, or tends to take it, right out of time, disallows some of those "subliminal sensations" that images forever disappearing more readily evoke.

The counterpart of frozen or arrested images in space (the "still" life that Chambers first in the silver paintings and then in his films was trying to escape) is narrative. Chambers had seen the way in which perspective in painting "confuses self-awareness." He was determined, therefore, not simply to translate perspective in painting to plot narrative in film. What he wanted to avoid in the film as much as possible was what he called "descriptive time."[13] He explained the phrase in the

following way: "Lawrence on his camel at sunset; Lawrence on his camel at dawn, equals Lawrence riding his camel all night."[14] It was this sense of narrative as linear duration that he believed was the chief characteristic of the commercial movie, the one that above all others conduced to deliberate distraction and wiped out self-awareness, allowing illusion to become all. Narrative as linear duration, locking the mind in chronological time, ruthlessly excluded subliminal activity by keeping the audience in line. Narrative or plot in commercial film, he argued, performed the same illusory function as perspective in painting. "Time," he commented, "gets foreshortened by descriptive images. Images again for the sake of the story. You're drawn away from yourself, your own self-awareness, to star in somebody else's fiction. Entertainment equals distraction equals false-life plot."[15]

Just as Chambers made use of Curnoe's collages, particularly the way in which they were put together, to say something of his own about the possible relations between art and film as they relate to space and time, so in the making of his other films there are clear indications of paintings of his own to which they are related. *Sunday Morning No. 1*, for example, exploits many of the images that Chambers was to put to a quite different use in *Mosaic*. What immediately strikes the viewer of *Sunday Morning No. 1* is the use of perspective. Probably no painting by Chambers provides a greater illusion of depth or distance. In *Mosaic*, Chambers was determined not to substitute narrative for perspective. He was determined, that is, not to transform his own life-plot as he was now living it with his pregnant wife into the "false-life plot" of the commercial film. He did not want to obliterate his own "self-awareness," the affirmation of which was the chief purpose of the films he was now beginning to make, though, at least at the outset, with little conscious knowledge of what as a filmmaker he was doing or even of what he was trying to explore. The discoveries he would make were discoveries along the way that became the very thing itself. At the invisible centre of a Chambers film is some newly revealed acceptance of himself. Chambers in his films was discovering his personal myth by breaking with the commercial film in ways that he had never attempted as a painter working in the academic domain of art.

If Lawrence on his camel at sunset followed by Lawrence on his camel at dawn was not to equal Lawrence riding his camel all night then what was it to equal? Chambers' cryptic answer was "self-awareness." But how could it equal that? Chambers' answer was as bold as it was obvious. It could be made to equal that if the images lost their centrality as a "vortex" of concentration and joined each other on the "periphery" of consciousness, where they could assume a subliminal presence that did not dictate a "particular response." Chambers did his editing in a small office in the front of his house using a second-hand viewer, pulling through the film strip without always bothering with gloves, and cutting and splicing in a manner that someone would often have to repair before it could be printed. Here at his editing table he gave shape to the periphery of his consciousness by cutting

again and again the thread of narrative to splice in what subliminally was there. Editing thus became an orchestration of consciousness itself to produce the film equivalent of a sonata or quartet, which Chambers sometimes described as a "pool of energy." His hope was that it would "set off reactions" in the viewer, rendering *him* the "hero" of his own associations. Chambers' way of disposing of the Hollywood star system was to invite the viewer to become the star, which is to say, to use the film to become self-aware.

Typical Chambers footage is cut and spliced and put together again "just like an experience—in particles." It is not so much "the description of a visual moment" as an "accumulation of experienced interiors," which now in the films became Chambers' own "interiors" projected in the guise of images that had accepted him as their centre. These images in the editing rooms of his mind followed as closely as possible the inner unfolding of Chambers to himself, providing him with small epiphanies, experiences of his own reality.

Consider an actual film: Chambers' *Mosaic*, his first. There is a familiar narrative present in *Mosaic*, even as familiar objects are present in Chambers' painting. That familiar narrative strung out in images like clothes on a line would look something like this: Olga on the back stoop taking the laundry from the line; Olga visiting the doctor's office; Olga at a baby shower; Olga having contractions in the front seat of the Volkswagen; Olga feeding her baby. Strung out this way, the familiar narrative is as insistently and expectedly there as the arrangement of snapshots in the wedding or baby album. To turn the pages is to see what does not even require the turning; it is there as illusion, drawing the viewer away from himself by placing him in someone else's fiction so numbing in its effect that it barely reminds him of his own. Indeed, it is the very "false life-plot"—"'safe job'" and "'proper living'"— from which Chambers had fled in setting out on travels that took him ultimately to Spain. That "plot" is there, as indeed it is there for everyone. Chambers' task was to dismantle it and put it together again in a form that was uniquely his own. The film is an attempt to remain true to himself while apparently settling down to what would obviously appear to be, or become, a perfectly conventional, middle-class North London, Lombardo Street life.

The first feet of the film show a woman opening a door, entering a doctor's office and taking a seat among other waiting women, one of whom is leafing through a magazine, which Chambers' Bolex closes in on to provide a close-up of a single page on which appears in very large print, "THE SEA." White shoes enter the room and move along the floor. Olga, pregnant, is throwing flowers. She runs in slow motion toward a baby in a field. A muscular runner sprints along a road. A religious statue can be seen. A dead raccoon lies upturned covered with ants and falling daisy petals. Olga now sits in the doctor's waiting room. Before she enters, however, she will again gather flowers, again the sprinter will run, again she will move toward her baby, again and yet again she will throw daisy petals in the air,

again they will fall on the dead raccoon. She will also remove the sheets and towels from the line and ride a bus.

Such words as "before" and "again" are in the "experience" of the film, the putting together "in particles," entirely misleading. Nothing in the film happens "before," nothing happens "again"; we are, despite the crude elements of familiar narrative, not waiting for the next event. Olga, unlike Peter O'Toole in *Lawrence of Arabia*, is not going to ride all night. She exists in the "organism" taking shape in the "particles" or footage, which cannot be spread out in linear time because Chambers in the cutting and splicing has destroyed the sequence of time. Olga is being released from time to enter something like an eternal now, which Chambers would later describe by one word: "Wow." In that eternal now, to which Chambers would return toward the end of his life with a quiet, unannounced intensity seldom if ever matched in Canadian art, Olga about to give birth is also Olga blessing the dead from which all birth arises, the old man in the cemetery being the sprinter in another guise intersecting his path as he comes to take up his station behind a nursing mother. Stillness as motion.

"Before" returning to the examining room "once more," an old man, as the film "progresses," crosses a road, the sprinter runs down it, a nurse appears in a doorway, Olga rises to go in, runs toward her child in a field, throws petals against a backdrop of sky, and rides a bus which stops to let people off. "Then" she is "back" in the doctor's office. "Then" she is at her baby shower, "though" the petals "still" fall on the dead raccoon, the sprinter "still" sprints, Olga "still" scatters petals, "still" picks up her baby. The old man stands behind her as she holds up her child. Tea is poured. A cup is raised. A parcel is opened. "Finally" Olga gives suck. Children watch, sitting in a circle around Olga in a field. The sucking continues until the "end," punctuated by empty footage: suck, void, suck, void, suck, void.

When asked to describe his art training in Madrid, Chambers characterized it as he characterized almost everything else that had a genuine meaning for him: "I underwent a series of births."[16] *Mosaic*, of course, is about giving birth, not only in the obvious sense of Olga having her baby, but in the rather more esoteric sense of Chambers making his first "personal" film in an effort to give birth to himself. To give birth to himself was in large measure Chambers coming to grips with whatever to be born had first to die. Death, as in the dead raccoon and the old man, was not only connected to birth; it was the same event viewed in a different way. Dying and rising would become even more mysterious to Chambers as he recognized it as "the organism within the organism" that had accepted him as its centre. Dying (and rising) was as mysterious as the memory in Spain of diving from the train bridge into the Thames. Apparently the image sufficiently gripped him to draw him back to the place where he began.

One of the haunting things about *Circle* is the uncompromising monotony of the film, which is so powerfully underlined by Chambers' refusal to take light readings

to adjust his lens for different kinds of weather, not to mention different seasons of the year. But adjustments are not made, because in a real sense there is no one there to make them. Chambers cut a hole in the outer wall of his house, built a small box to fill it, and left his camera there. Every morning as regular as clockwork he would run it for "a couple of seconds" in the most mechanical possible way as if he were entirely unconscious of having anything particular in mind. *Circle*, therefore, finally emerges as in some ways a terrifying vision because throughout its entire footage lasting twenty-eight minutes there is barely a human presence, except for the commercial footage at the end contrasting the mechanical and organic while suggesting that the one imitates the other. There are at times toys in the yard, clothes on the line, footsteps in the snow and just the suggestion of Diego slightly out of camera range. It is like Eden after the fall, nature in the absence of man continuing its monotonous round. If *Mosaic* is lyrical, *Circle* is elegiac and both of them are moods or phases of the artist that might, but for these faithful records, still be "gesturing in the invisible." Instead, Chambers has given them a "fundamental legibility." *Circle*, which few have seen (like all Chambers' films), is a visionary masterpiece of uncompromising monotony. The "images" Chambers "uncovered" in the "seasons" in this film of his own back yard are like the image of Merlin who in the legend of King Arthur is described as disappearing into the forest never to be seen again, though from time to time his anguished *cri de Merlin* can be heard. If one could single out one work by Chambers to which the word "mystical" might be applied, *Circle* might be the appropriate choice. "The more we become familiar with the experiences that perception brings," Chambers concluded his essay on perceptual realism, "the more we become aware of an inherent gentleness in the intercommunion of oneself with things. So gentleness of reception is also a communion that influences the outside world. Finally, perception itself becomes a 'forgotten' awareness that just *is* with all the common naturalness of those common things seen out the window or inside the house or any place."[17] *Circle* bestows "fundamental legibility" on "'forgotten' awareness."

The "gentleness in the intercommunion of oneself with things" is perhaps what best describes the work of Chambers' last years. It is indeed at times as if he had entered, as in *Circle*, a "'forgotten' awareness that just *is*," particularly perhaps in some of the small drawings that he did in India shortly before his death. On the whole, however, this "gentleness" does not apply to his films, least of all to *The Hart of London*, whose slaughterhouse sequence filmed by Chambers in Chinchon, the small town close to Madrid where he went to live after graduation, has outraged most viewers who have sat it out. These remarks on Chambers the filmmaker must conclude with some comment on that sequence not only as it relates to the film itself, but as it relates to his entire oeuvre. That Chambers should not only have flown to Spain for the express purpose of shooting the sequence, but that he should also place it within *The Hart of London* as if it were indeed the very

"heart" of Chambers' city suggests its utter centrality for an understanding of the man and his work.

Reviewing in *Canadian Art*, Chambers' first exhibition at the Isaacs Gallery in a four-man show in 1962, which included among other works *The Slaughter of the Lamb*, David Silcox described what he called its "nauseating insanities." "Jack Chambers' canvases," he wrote:

> testify to the complete freedom of the artist if not to his sanity or sense of responsibility. Although well-composed, his paintings portray horribly garish and symbolic figures. Nightmarish mutterings can be very vivid and disturbing, as they were, but that does not contribute, necessarily, to their instructive or decorative values. One can only, with aesthetic charity, hope for Mr. Chambers' rapid recovery.[18]

Chambers could not for long curb the contempt he felt for the "aesthetic charity" Silcox was bestowing upon him from the citadel of "instructive and decorative values." CAR was born from that. So also was *Hybrid*, made as a protest film against the napalming of the children of Vietnam. Chambers there took an "instructive" film on the "decorative values" of a rose garden and by splicing the discarded footage made something "horribly garish" of the roses, which were not "symbolic figures" but actual photographs of the young victims. Chambers became a Catholic convert in Spain because he sensed that for him the Crucifixion was at the heart of creation, that the life blood flowed from a wound that would never heal because its redemptive work was never done. Attending a Baptist summer school, Chambers had been taught this Christian truth as a child; the slaughtered lamb was one of his earliest images of God. In Spain that knowledge became a consciousness pervading the whole of life, giving it a ritual dimension it did not have in Canada. An El Greco crucifixion stood at one pole; the lamb writhing on the Chinchon slaughterhouse table stood at the other. Between them was a community of spirit that joined them both to the supernatural sacrifice upon the altar. In a letter to Olga dated September 11, 1959, Chambers describes the slaughterhouse in Chinchon:

> The butchers are butchers of three meals, the necks thick, strong and purplish, the hands and feet wet with blood. . . . A small light bulb illuminates a big store room; the light is sickly. The bare-chested butchers stab in silence. The blood runs red and luminous onto the black floor. The air is hot and humid. After leaving one smells like blood and sweat.[19]

A more innocent or "neutral" version of the Chinchon slaughterhouse, which helps to explain the very real differences between Canada and Spain, had actually taken place in London. A deer had made its way into the city, wounded itself by

smashing into a window, and then been captured by the police and destroyed. Chambers found in the story and the TV film footage of it (all of which he used) an emblem of his life that had a curiously reconciling effect, bringing as it did Chinchon and London together in the ritual sacrifice at the heart of creation, which, now in Chambers' filmed enactment, was also (and forever) at the heart of London. Footage of a trapped deer or a slaughtered lamb was also Golgotha in the marrow of the bone.

Notes

1. *Chambers: John Chambers Interviewed by Ross G. Woodman* (Toronto: Coach House Press, 1967), 3.
2. Ibid., 11.
3. Ibid.
4. Ibid., 15.
5. Ibid.
6. Ibid., 13.
7. Ibid., 15.
8. Ibid., 13.
9. *Jack Chambers*, published by Nancy Poole, 1978, 93–94. The actual process for preparing his ground was learned at the Escuela Central de Bellas Artes de San Fernando. The spilling or "dripping" may have been suggested by Pollock. Thus when asked in a taped interview for the Coach House Press book if he was influenced by Pollock, he replied: "Very much. I was influenced by his slopped-on texture."
10. *Chambers*, Woodman-Chambers interview, 7.
11. John [Jack] Chambers, "Perceptual Realism," *Artscanada* 26, no. 136–137 (Oct. 1969): 13.
12. *Chambers*, Woodman-Chambers interview, 13.
13. Ibid., 15.
14. Ibid.
15. Ibid., 15, 17.
16. Ibid., 5.
17. Chambers, "Perceptual Realism," 13.
18. David Silcox, review of Chambers' works in four-man show at the Isaacs Gallery (*Canadian Art* no. 19 [1962], 103).
19. Courtesy of the Jack Chambers Estate.

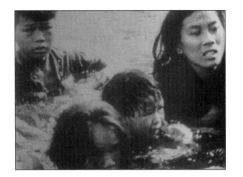

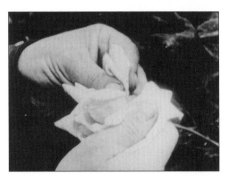

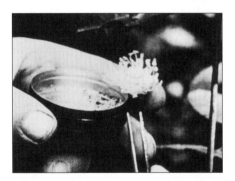

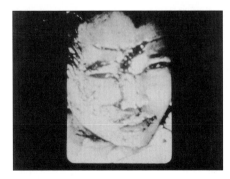

Hybrid

Cross/Cut: *Hybrid* as Allegory

The Vietnam War was very upsetting to me. I did not agree
with the American presence in Vietnam. . . . I thought that a
film showing some of the tragic aspects of the war
would serve as a useful tool for fund-raising.[1]

— JACK CHAMBERS

W ITH TYPICAL UNDERSTATEMENT, Jack Chambers articulates the anti-war
message of *Hybrid*, and its humble, even utilitarian, mission: to persuade
viewers to donate money for war relief. "The tragic aspects of the war"
that Chambers presents in *Hybrid* are graphic images of destruction and suffering,
especially images of napalm-burned Vietnamese people. But the film's use of these
overwhelming and unspeakable images is neither didactic nor manipulative.[2] Nor
does it fall into the sentimental rhetoric of what Brian Winston has called "the tra-
dition of the victim" in social documentary.[3] In this tradition of representation,
depictions of suffering serve more often to reassure the (necessarily removed) spec-
tator to think, as Jill Godmilow puts it, "Thank God it's not me"[4] than to inspire a
sense of responsibility and action. The central question for this earnest but often
counterproductive tradition of social documentary is how to show images of
human suffering that will not, in their horror, cause us to turn away, nor invite us
to succumb to what Susan D. Moeller has called "compassion fatigue."[5] Chambers'
deceptively simple film avoids "the tradition of the victim," inviting instead both
critical analysis of the causes of this suffering, and a sense of awful complicity with
events so seemingly removed from southwestern Ontario in 1967. I argue that
through the elegance of its structure (counterbalancing images of war and death
with images of banality and natural beauty), through the subtle rhythms of its
editing and image choices, and through the complex resonances of its conceptual

conflicts (based on similar principles, both formal and metaphorical, of "cross-cutting" film and hybridizing plants), *Hybrid* is an exemplary political essay film, and fully imbued with Chambers' sensibility.

The structure is simple: Chambers alternates two streams of found images, the first taken from an instructional film about gardening that he checked out of the London Public Library (and never returned[6]), the second a series of still photographs of the Vietnam war that he procured on a trip to New York.[7] Sections of the gardening film, in black and white, illustrate the hybridization of roses, a narrative that begins with an anonymous man planting rootstock, and follows the stages of growth through watering, pruning, spraying, fertilization, pollination and dissection. The black-and-white still photographs depict increasingly horrifying scenes of war, starting with shots of American soldiers and bombing, shifting to images of destroyed villages, Vietnamese peasants, and prisoners with American captors, and finishing with a series of shots of increasingly mutilated and burned Vietnamese people, especially children, cross-cut with time-lapse colour footage of roses opening in vibrant hues.

The central metaphor of *Hybrid* compares the gardener's manipulation of plants with the American invasion of Vietnam. In I. A. Richards' classic terms, the "vehicle" of the metaphor is the apparently benign work of the gardener and his spectacular results, and the "tenor" of the metaphor is the violent work of the military and the spectacle of suffering they create.[8] This perverse parallel connects the gardener and the military in a shared instrumental logic: each has the arrogance to play God. The first and last images of *Hybrid* are of gardening, which forms both the dominant narrative line of the film and the metaphor's vehicle. The war images first appear as barely perceptible flashes, between two and three frames long, but slowly they become more and more recognizable, until by the end of the film long takes of mangled faces assume prominence, and the tenor of the metaphor powerfully asserts itself.

Matthew Wherry, writing on the film in the independent London art publication *20 Cents Magazine*, describes some of the film's binary oppositions:

> *Hybrid* is only partially cinema—the river of its motion is continually blocked by barriers of motion-in-arrest, a gallery of still photographs. Not only is the production a hybrid of two media but of two games, the Death-game and the Life-game.[9]

Two media, still photography and moving-image cinema, modulate what Wherry calls the two "games" of the film: first, the pastoral "Life-game" of movement, gardening and nurturing; and second, the violent "Death-game" of stasis, war and destruction. For Wherry,

The hybridization of a rose, the growth of the hybrid through the changing seasons, this work of a Life-game player [the gardener], lovingly done, lovingly filmed, is the whole theme of the movie.[10]

Yet Chambers' work rarely separates life and death so cleanly, nor offers so reassuring a vision of life as simple "growth." Rather, *Hybrid*'s cross-cutting instantiates what Chambers himself has called his obsession with the "life-death-life cycle."[11] *Hybrid*'s images of cultivation involve destruction (cutting, uprooting, dissection, removal of petals to expose pistil and stamen) while the dominant sense that emerges from the images of destruction and suffering is that of persistent humanity, despite the grotesque deformities that make some faces almost unrecognizable.

Ron Benner, in "Biologisms, Metaphor & Answerability," a short essay written for a retrospective of Chambers' films in London in 1998, points to the ominous processes and consequences of agricultural hybridization, suggesting that Chambers' film critiques the scientific arrogance and ideological power of its title term. Unlike Wherry, Benner sees the gardener as a much more sinister figure, whose "creative" work shares the motivations of the destructive work carried out by the United States in Vietnam. As he states, the "hybridizer"

[b]etween 1961 and 1972 . . . was a government biologist in St. Louis, Missouri and a U.S. marine in My Lai, Vietnam. He was a military "field-worker" in Saigon and a Honeywell chemist in Minneapolis, Minnesota.[12]

How does Benner defend this equation of science with militarism? First, the ethos of control, which ignores both human and biological considerations in favour of power and economic wealth, is embodied in the hybridizer whose manipulations of genetic code allow him to play God.

He handles the rose with confidence; he knows what he wants; where it is located and how to get it. The hybridizer is more than willing to correct for deficiencies, for differences, for abnormalities. The hybridizer is after his own pure image. The world is open for his likeness and his business. The hybridizer is phenomenally global, pandemic.[13]

This same desire for control, and the arrogance to enact it, underlies the American ideologies of imperial reach and sense of racial superiority that made Vietnamese lives so expendable.

Second, science asserts an ethos of dispassionate progress and knowledge, disavowing its complicity with and ignorance of the ends to which its discoveries are put. The hybridization of roses may arguably create more intense floral beauty, but

the scientific ethos behind it can also create, as in Benner's example, the Monsanto corporation's "'terminator' hybrids," non-self-germinating plants that ensure farmers must buy seed from Monsanto yearly rather than use seed from their own plants. My point is not to suggest that hybridization (or science) is inherently destructive; such an attitude would romanticize nature, ignore natural processes of genetic mutation and diversity, and demonize human agency itself. Rather, what Benner and Chambers signal is the ideological operation that allows an uncritical attitude toward hybridization, seeing it as harmless, as innocent as rose gardening. Indeed, it is precisely the contrast between the horror of the war imagery and the banality of the gardening imagery that foregrounds the ultimate complicity that exists between the "hybridizer" and American military intervention, and challenges the North American viewer to question the contrast between their knowledge of the barbarity of events in Vietnam and the civilized, removed banality of "normal" life in London, Ontario.

These metaphorical parallels between the work of the hybridizer and the work of the United States military in Vietnam are brought out in the subtle nuances of meaning articulated by the rhythm of the cross-cutting. The first gardening images in *Hybrid* are long takes of digging and planting, the hybridizer precisely measuring soil levels, literally laying the groundwork for the roses. The first war images of the film, meanwhile, are repeated flash frames of groups of American troops and bombers, explosions and soldiers in trenches and with pitchforks, figuratively "laying the groundwork" for the American invasion. Watering of plants is ironically cross-cut with destroyed buildings and foliage. While the gardener digs up a small tree that had been buried, the war imagery shows Vietnamese peasants working in rice fields and planting with hoes (also repeating the shot of American soldiers with pitchforks). As the gardener shows soil running through his hands, the war imagery cuts to rubble.

Throughout *Hybrid*, Chambers constructs patterns of metaphorical parallels and ironic contrasts, sometimes emphasizing the parallel through formal techniques like camera movement and shot scale. For example, a shot of the gardener binding a climbing rose to a stake is followed by a shot of bound and blindfolded Vietnamese prisoners; Chambers uses a rostrum camera to "tilt up" a photo of a blindfolded and gagged old Vietnamese man in order to parallel a tilt up in the gardening footage of the bound rosebush. Images of the roses being pruned (with a close-up of thorns) are cross-cut with images of American soldiers vigilantly guarding and herding crowds of Vietnamese, including women and children. A shot of a soldier in a gas mask facing a cloud of smoke is followed by a shot of the gardener spraying a chemical mist; then, after Chambers shows a close-up of two Vietnamese children, he shows the gardener pruning undeveloped rosebuds. Just as plants' growth is directed through bud pruning and "protected" through chemical spraying, the Vietnamese people are being directed and "protected" by American soldiers—but the gardener and the soldiers must beware dangerous thorns.

These metaphorical correspondences, which seem obvious and didactic as I describe them, are much more subtle and effective on screen. The film's silence refuses to underscore meaning redundantly.[14] Moreover, rather than emphasize each metaphorical correlation on the cut, Chambers allows these connections to breathe. The parallels and contrasts sometimes take several cross-cuts to become evident, and set up broader connotations: the deliberate meticulousness of the gardener is matched by the deliberate subtleties of Chambers' own cutting. For example, a series of war images presents American solders with gas masks facing and then burning a grass hut, while the gardener enters a greenhouse and begins to examine and strip roses to expose the pistil. This enigmatic metaphor becomes clearer when the next series of images cross-cuts a meticulous demonstration of cross-pollination and rosebud dissection with shots of dead bodies and burned and bloodied children: just as the gardener moves into his laboratory to begin his invasive genetic work, so we see the violence of the American military theatre, the cut-up plants paired with mutilated children, both held up for display in close-up to the cameras that captured the action. This sequence concludes with the gardener's pointer showing off young growing plants while Vietnamese children lie dead next to their mothers, or grimace in hospital, the flesh on their legs burned to the bone. The gardening film returns to a final shot of the rosebushes under snow, their survival in dormancy counterpointed in the image of a Vietnamese man, his face mangled, walking, captured in motion.

As noted above, *Hybrid*'s narrative of gardening footage is divided into two parts (punctuated by a black screen), the first featuring black-and-white gardening images, the second featuring vibrant colour footage of roses, some opening through time-lapse cinematography. The editing pattern in the second part is followed rigorously until the end of the film: a cut to a shot of flowers (usually a close-up of one rose, but sometimes showing multiple roses) followed by a dissolve to a shot of Vietnamese people, usually children, whose burned and mutilated bodies are displayed to the viewer. Almost all of these people are still alive, and the majority face the camera, looking at us, a perverse portraiture whose objectification of suffering rivals the spectacle of the flowers that counterpoint to them. The pattern of war imagery in the first part, which begins by showing the American military and then showing the effects of this military machinery on Vietnamese people, gradually increasing the violence and horror, now gives way to an accumulation of images (more than twenty in total) that abandons a hierarchy of horror: all are shocking and difficult to watch. Chambers holds the images of violence on screen twice as long as the images of flowers (reversing the emphasis at the start of the film). The work of Benner's "hybridizer" is finished and we now see his "yield" vividly presented in colour; metaphorically, Chambers shifts from the narrative of intensification of military action to showing the consequences of that action. The choice of the dissolve instead of the straight cut underlines Chambers' sense of where responsibility

lies: the logic that underlies hybridization leads to the horrific science experiment that napalm in Vietnam became. The film ends with a long take of a red rose opening in time-lapse before fading to a black screen.

Wherry's account of the London screening captures the unflinching and seemingly excessive quality of this section, and returns us to the dilemma of the social documentary: is *Hybrid* yet another voyeuristic spectacle of suffering and violence?

> [Chambers] flagrantly tramples upon the sensibilities of the sensitive. He made his point with his first still, so why repeat it and repeat it? Why go on when, at last, the screen adds darkness to its silence, the viewer has such relief as a man might feel at the last assigned stroke of the Cat-o'-Nine-Tails? What does this fellow think we are? A set of masochists?[15]

Chambers abandons the comforts of narrative, of explanation, ending not on a final image of Vietnamese suffering but on the most conventionally beautiful image of the film—the rose—which returns the film to the place where it was made, and where its effect will be felt.[16] For me, the image of the rose functions almost as an accusation:[17] if we are capable only of seeing the rose as naturally beautiful and cannot see that the rose is managed and produced, then we remain blind to the logic that underlies its production, and we will remain oblivious to our own complicity and responsibility. As Benner says, "A basic amnesia exists concerning who allowed, allows and will allow the hybrid to exist."[18] Chambers confronts us, the viewers, with our amnesia, and dares us to evade our responsibility for our knowledge.

Hybrid is the black sheep of Chambers' oeuvre, often excluded from retrospectives and largely ignored in the critical literature. On one level, the omission is strange: like all of Chambers' films, *Hybrid* is a found-footage film about creation and death, the Life-game and the Death-game, and shares what Ross Woodman has called the dominant setting of all of Chambers' films, the garden, that ambiguous site of creation, knowledge and the Fall into history.[19] But *Hybrid* crucially lacks the timeless, metaphysical tone of *Mosaic, Circle* and *The Hart of London*. It is, as Chambers states above, a response to an urgent and specific historical problem: the Vietnam war. Not that the film is narrowly confined—indeed, it continues to resonate in its critique of scientific and instrumental reason and cultural arrogance, and an even broader articulation of the indivisibility of creation and destruction, the "life-death-life cycle." But the lack of a metaphysical dimension is crucial to the film's political critique: this is not a quietist response to the war universalizing the "life-death-life cycle" into a simple resignation to some kind of falsely cosmic inevitability of human violence. *Hybrid*'s historical specificity allows for no redemptive purpose to the violence in the Vietnam war, and the death-drive that motivates the war has no place in the cosmic cycles Chambers elsewhere explores.

Notes

1. Jack Chambers, *Jack Chambers* ([London, Ont.:] Nancy Poole, 1978), 105.

2. This is not to say that the film was ineffective. As Matthew Wherry's account of the screening in London, Ontario, suggests, even though "nobody clapped,"

 [t]he contribution for medical aid . . . was the highest, per capita, that I have ever seen at a meeting. It was not a meeting of the wealthy. I know that I myself gave more than I thought of giving. ("The Silence of Jack Chambers," *20 Cents Magazine* [London, Ont.] 1, no. 9 [May 1967]: 3).

3. Brian Winston, "The Tradition of the Victim in Griersonian Documentary," *New Challenges for Documentary*, Alan Rosenthal, ed. (Berkeley, CA: University of California), 1988: 269–87.

4. Jill Godmilow and Ann-Louise Shapiro, "How Real Is the Reality in Documentary Film? Jill Godmilow, in conversation with Ann-Louise Shapiro," *History and Theory* 36, no. 4 (1997): 83.

5. Susan D. Moeller, *Compassion Fatigue: How the Media Sell Disease, Famine, War, and Death* (New York: Routledge, 1999).

6. According to Ross Woodman, Chambers checked the 16mm film out of the LPL and cut it up for his film, figuring it would be put to better use and not be missed (personal interview, 19 February 2002).

7. Chambers, *Jack Chambers*, 105.

8. I. A. Richards, *The Philosophy of Rhetoric* (New York: Oxford University, 1936).

9. Wherry, "The Silence of Jack Chambers": 1.

10. Ibid.

11. Chambers quoted in Tom Graff, "Foreword," *Jack Chambers Films, Capilano Review* 33 (1984): 5.

12. Ron Benner, "Biologisms, Metaphor & Answerability," *The Silence of Jack Chambers* (London: London Public Library), 1998: n.p.

13. Ibid., n.p.

14. *Hybrid* is Chambers' only silent film.

15. Wherry, "The Silence of Jack Chambers": 2.

16. For his own credit title card, Chambers lists: "Produced by Jack Chambers, London, Ontario," pointing to the film's primary site of production and reception.

17. In the last six images of Vietnamese people, the subjects stare straight at the camera, directly addressing the viewer.

18. Benner, "Biologisms, Metaphor & Answerability": n.p.

19. Ross Woodman, "Jack Chambers as Film-maker," *Jack Chambers Films, Capilano Review* 33 (1984): 47.

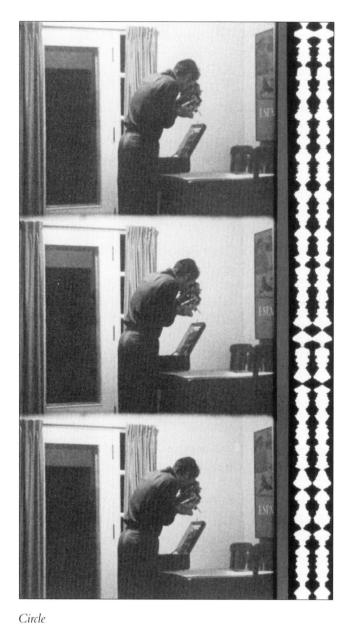

Circle

BRETT KASHMERE

Making the Anonymous Familiar:
A Reconsideration of
Jack Chambers' *Circle*

> Something can be so familiar that I see it as for the first time.
> Or maybe it is not being able to see especially what is most familiar so
> you reach out and shape it again and again in the hope of revealing it.
>
> — JACK CHAMBERS

IN A LETTER DATED September 16, 1977, the American filmmaker Stan Brakhage writes, "Jack Chambers is one of Canada's most famous AND greatest living painters." So why, he asks, "have his films been neglected . . . ?"[1] Brakhage's comments were made less than a year before Chambers' death, bringing into focus several interesting starting-points for an analysis of the early critical reception and subsequent response to Chambers' film oeuvre since the 1960s. For one thing, there have been significant renewals of interest in his films over the last twenty-five years, culminating in the late 1980s with two major events,[2] and continuing into the current millennium with a conference dedicated exclusively to Chambers' work in the film medium.[3] These additions to the discourse surrounding Chambers' films have yet to be addressed adequately in the literature, and the assumption persists that Chambers was, and remains, a neglected filmmaker. Brakhage's statements also underline a critical problematic regarding Jack Chambers, namely that he has traditionally been considered a painter/filmmaker rather than "interdisciplinary" artist, and this doubling or artistic split personality may have influenced the comparatively sparse treatment of his films over the years.[4] Finally, Brakhage's comments raise questions around the issue of who dictates (cinematic) taste in the cultural domain; the presumed neglect of Chambers' films

has, at least since 1977, been attributed to a lack of critical interest.[5] Although the committed film scholars Bruce Elder and Bart Testa would emerge in the 1980s to rescue Chambers' work, especially *Circle* (1968–69), from relative obscurity, numerous aspects of the film have gone unexamined; specifically, considerations of the film as text, its cultural, historical and economic circumstances, and its reception. My primary purpose in combining a negotiation of these contradictory aspects into a single exposition is to illustrate the complexity of *Circle*'s avant-garde legacy; a second, related objective is to recognize Chambers' groundbreaking work in the making and organizing of Canadian film.

Circle is a twenty-eight-minute film, structured in three parts. Appropriately described by Gene Youngblood as an "extended haiku," the film weaves elusive meaning out of simple form. Two slender black-and-white sequences—a prologue shot in Chambers' own living room, and an epilogue crafted from archival footage of London (Ontario), Chambers' home town—parenthesize the film's austere centre. This middle section, photographed in stark colour with fixed aperture and framing, records the same square of Chambers' backyard, one day at a time, over the course of a year. In four-second clips taken at approximately ten o'clock each morning, the flow of nature is grafted like a transparency onto urban space, offering us something that we can both see (in ephemeral flux) and see through (to the stability of a familiar setting). By giving form to the complex interplay of experience (the ingathering of "wow" moments, such as the sight of a first snowfall) and automatic "sensory perception," *Circle* fulfils the central tenet of "perceptual realism," Chambers' aesthetic credo written almost in tandem with the film's production. While the prominent middle section is at once a text of Canadian weather, a Romantic rendering of the human ambition to contain and order nature and a symbolic treatment of landscape, *Circle*'s introduction and conclusion also offer intimate (albeit brief) portraits of the private and public layers of Chambers' London environment. These sequences magnify the film's perplexing character: modest in ambition and design, and straightforward in its representation of place, *Circle* remains rich in personal mystery. Yet there is a near void of textual analysis of this important film.

The title of my essay "Making the Anonymous Familiar," inverts Jack Chambers' phrase encapsulating his artistic goal (as recalled by Ross Woodman[6]). This idea, of the familiar/anonymous, frames my reconsideration of *Circle* from the perspective of "home-movie-making." While amateurism has become an accepted line of critical inquiry in recent years, this aspect of Chambers' modus operandi has seldom been broached; the transformation of Chambers from "professional" painter to "amateur" filmmaker, however, is an important one when reevaluating the potential historical value of his films. By examining Chambers' progression into cinema from the field of painting in this light, we can begin to understand why he developed a filmmaking style that incorporated several elements of amateur film. As counterpoint to the technical rigour and smooth finish of his painting, *Circle*'s

"home movie"[7] sensibility, aesthetic strategies and sometimes amateur appearance provide insights into Chambers' dissatisfaction with the conditions of popular acceptance he had, somewhat unintentionally, achieved through his painting.

Moreover, when compared with the enterprises of Canada's professional film community, the Canadian Film Development Corporation (founded in 1967 to subsidize the feature film industry, now Telefilm Canada) and the National Film Board, Chambers' film practice appears central to the development of independent cinema in this country. His interest in personal, as opposed to professional, modes of film production, perhaps influenced by the work of Stan Brakhage and the American underground cinema, was clearly stated in 1968 (while he was working on Circle). "Hollywood and the NFB are the Academy," he explains (referring to the Impressionists' revolt against the French Academy). "So is Film Canada. Judy LaMarsh [who introduced the Canadian Broadcasting Act] is not interested in films made in the basement."[8] In the late sixties, artistic resistance to the bureaucratic structure of state- and industry-sponsored filmmaking was providing a catalyst for the growth of Canada's avant-garde cinema.

Although Circle is generally regarded as Chambers' most important cinematic work after his epic The Hart of London (1968–70), the critical response to these two films has been remarkably different.[9] Bruce Elder's essay "From Painting into Cinema: A Study of Jack Chambers' Circle" (1981) and Bart Testa's "A Movement through Landscape," published in 1989, remain the only scholarly texts that offer detailed analysis of Circle. In contrast, The Hart of London has been the subject of at least five substantial reviews, including Seth Feldman's article published in 1976 in Film Quarterly. A brief survey of the existing literature on Circle may help to determine why this film has received so little academic attention (especially recently).

Round Peg, Square Hole:
An Overview of *Circle*'s Critical Reception

A critic should be able to identify the work and place it as accurately as possible in the context of painting or in the broader context that includes painting and art: experience.

Criticism is a personal comment that should come as a result of meaningful stimulation.

— JACK CHAMBERS

The paltry critical recognition afforded Jack Chambers' films in the 1960s and '70s by Canada's film intelligentsia is typical of the avant-garde's marginalized status during its formative period.[10] It should not be surprising, therefore, that most

of the criticism of Chambers' film work of that time was published in visual art periodicals such as *Canadian Art*, *Artscanada* and *Artmagazine*, and usually integrated with commentary on his painting. Barry Lord, writing in *Artscanada*, suggests that Chambers' films have "begun to recapitulate the development of his paintings."[11] Gene Youngblood, also in *Artscanada*, states that "Chambers, in my estimation one of the most important painters at work today, manages to invest his films with that special quality of 'cosmic fantasy' that characterizes his paintings."[12] Mario Amaya, in a review of Chambers' paintings published in *Art in America*, observes that *Circle* "approximates the analysis of changing light on a particular subject that so obsessed Monet."[13] The expansion of Chambers' formal and thematic concerns from painting into filmmaking is also the theoretical underpinning of Bruce Elder's detailed analysis of *Circle*. His essay "From Painting into Cinema" is the most thorough and convincing example of this approach so far.[14] By expounding on Chambers' period of silver paintings (1966–67) as a key transitional passage in the development of his cinematic interests, Elder cogently traces the artist's preoccupation with light and time as manifested in *Circle*, and investigates the Romantic character of Chambers' ideas about art, nature and perception as set out in his artistic manifesto "Perceptual Realism,"[15] showing how these ideas, too, find a precise articulation in *Circle*.

The appearance of Elder's article in 1981 marked the beginning of a period of renewed interest in Chambers' films that would continue into the 1980s. During this decade Elder continued to publish intermittently on Chambers, prompting other critics, filmmakers and film programmers to engage with Chambers' film oeuvre (although none would approach it with similar rigour until Bart Testa did so at the end of the decade). A documentary detailing the artist's life and work, *Chambers: Tracks and Gestures*, produced by Christopher Lowry and John Walker, was released in 1982 to enthusiastic reviews. In 1984, under the guidance of Tom Graff, an entire issue of *The Capilano Review*, a Vancouver-based arts journal, was devoted to Jack Chambers' films. This issue was intended as an accompanying catalogue for a retrospective of Chambers' films that was to be presented by Pacific Cinematheque in Vancouver. However, legal issues contributed to the retrospective's delay and the exhibition was postponed until 1989, when a screening of newly restored prints of the five completed films opened the first and only International Experimental Film Congress.[16] Following directly on the heels of the *Spirit in the Landscape* exhibition, the Congress tribute attempted to further clarify Chambers' importance within the early period of Canadian experimental film to an international audience of filmmakers, cinéastes and scholars.

Bart Testa's analysis of *Circle* in the exhibition catalogue for *Spirit in the Landscape* was the second significant evaluation of the film to appear following Elder's 1981 essay.[17] Testa's study of *Circle* elaborates several of the ideas raised by Elder, and continues his consideration of the film's treatment of landscape. Having dis-

cussed earlier in the catalogue the tradition of English-Canadian art, literature and theory that has been shaped by a preoccupation with the Canadian landscape (the Group of Seven, Margaret Atwood, Northrop Frye, etc.), Testa shows how *Circle* fits comfortably into that wider cultural framework. This thematic continuity, he concludes, is what distinguishes *Circle* and a handful of other Canadian experimental films within the larger domain of Canadian cinema.

The resurgence of interest in the films of Jack Chambers that occurred in the 1980s was due in large part to Elder's and Testa's persuasive writing and conscientious film programming (assisted by Richard Kerr). Another important figure in the avant-garde film community, Stan Brakhage, also continued to voice support for Chambers' work during the decade.[18] The influence of this small coterie of Chambers critics/enthusiasts is central to Chambers scholarship, even now. This was clearly demonstrated at the recent *Jack Chambers Film Project* during a panel discussion moderated by Ross Woodman and featuring presentations by Elder, Testa, Brakhage and the film programmer Jim Shedden. Although well-intentioned, this event unfortunately introduced few *new* voices to the discourse surrounding Jack Chambers' films.[19] Shedden himself recognized how problematic this was during his presentation, when he admitted to feeling some intimidation being on a panel with Elder, Testa and Brakhage. His trepidation highlights a potential problem regarding the present (and future) study of Chambers' films.[20] As established authorities on Jack Chambers, Elder, Testa and Brakhage may have unintentionally discouraged a younger generation of critics from engaging with the work. This presents a secondary problem in the case of *Circle*, which has yet to be considered in a framework specific to its time and place.

Circling the Abyss: *Circle* in Context

Where North American artists do embody an historic dimension is in the medium of personal film-making. They form a major part of film's "roots" and are making enormous advances in the organic-mind growth of this art.'

— JACK CHAMBERS

Circle's position in the Canadian avant-garde cinema of the 1960s can be assessed by reference to the changing contours of Canadian cultural policy around the time of Expo 67 (held in Montreal). Other factors, such as the Canada Council's financial commitment to experimental film beginning in 1967, the emergence of the campus underground as a viable alternative exhibition network, the establishment of Canadian Artists' Representation (CAR), also in 1967,[21] and the development of independent film distribution co-operatives in Toronto, London, Montreal and

Vancouver, late in the sixties, all helped to determine the practical conditions necessary for a sustainable Canadian avant-garde cinema.

In 1957, following recommendations made in 1951 by the Royal Commission on National Development in the Arts, Letters, and Sciences (the Massey Report), the Canada Council was formed as an arm's-length arts council with full responsibility for its programs and grant decisions. However, Council funding was not available to filmmakers until the late sixties, when Chambers' received a grant to finish *R34* (1967), a film portrait of Greg Curnoe, a fellow artist from London, Ontario. Correspondence between Chambers and David Silcox, an officer with the Canada Council, beginning in October 1966 confirms Chambers' role in establishing a film subsidy program. In an early letter, Chambers asks Silcox, "What are the chances of C.C. [Canada Council] developing a unique collection of creative films, not referred to as films but as the visual-extension experiments of already subsidized painters?"[22] The language Chambers uses here is especially revealing. It indicates he clearly recognized the Council had no mandate for funding film and was not likely to take the initiative (hence his camouflaged term: "visual-extension experiments"); however, by trading on his status as an "already subsidized painter," Chambers was able to frame his request in terms that gave the impression his filmmaking and painting were synchronized practices, in effect interdependent and interchangeable. An internal memo written by Silcox on November 4, 1967, roughly one month after Chambers' initial request, relates support for the proposal from Hugo McPherson, commissioner of the National Film Board. In the memo Silcox reinforces Chambers' rationale for financial assistance with McPherson's observation that "filmmaking is central to Chambers' work as a painter."[23] In addition to the NFB's private endorsement of Chambers, the fact that the highly visible Canadian painters Michael Snow and Joyce Wieland (then living in New York City) were also establishing themselves as filmmakers at this time surely helped expedite the Council's acceptance of film as a credible artistic medium.

The initial commitment to experimental film on the part of the Canada Council combined with the cultural excitement that was rising around Expo 67 provided an economic base for the avant-garde cinema's growth in Canada. I include Expo 67 as a central factor in this configuration because, on a most basic level, the scale of Expo alone prompted huge increases in cultural funding, not to mention the creation of several new arts initiatives. An important spin-off effect generated by the event was that in the 1970s and '80s the number of cultural organizations in Canada expanded greatly, which meant that more grants became available for artists and filmmakers. Secondly, the success of the multiscreen experiments of Expo 67 such as *Labyrinth* (Colin Low and Roman Kroitor, 1967), and other artistic films that were screened during Expo, such as Chambers' *R34* and *Hybrid*, helped increase the audience demand for non-conventional films toward the end of the decade. The Canadian film scholar Seth Feldman identifies the success of

the Expo 67 films as a major stimulus (along with mid-sixties McLuhanism and the birth of the Canadian Film Development Corporation in 1967) for the increased demand for university film courses in the 1960s and '70s.[24] By the mid-seventies, film courses were offered at nearly all Canadian universities.

Since the avant-garde cinema was proposing a new kind of film, a new kind of viewing environment was also necessary. The 16mm projection equipment that had been integrated into schools and universities during the 1950s helped to provide an exhibition and distribution network for the Canadian avant-garde in the 1960s: college campuses essentially began to function as a ready-made parallel theatre chain. Chambers' primary motivation for forming the London Film Co-op in 1968 was to get his films distributed.[25] Promotional material for *Towards London: A Program of Films by and about Jack Chambers*, clearly demonstrates Chambers' ambition to have his work circulated not only in universities but in high schools and cultural institutions as well. The program, which included *R34*, *Circle* and Fraser Boa's "documentary-type film" *Chambers* (1969), was shown at two London-area high schools, the University of Western Ontario and the London Public Library and Art Museum (December 3–7, 1969).[26] In June 1968 Ross Woodman wrote that the London Co-op, "in its first month of operation . . . has provided some twenty films for programs in such centers as Kingston, Toronto and Ottawa."[27] In addition to Chambers' own work, the Co-op distributed films by Keewatin Dewdney, Greg Curnoe and Fraser Boa (among others), as well as a number of collaborative films, such as *Little Red Riding Hood* (1965), a film by Chambers, Curnoe and the London poet James Reaney.

The emergence of the campus underground as an alternative exhibition space was an important aspect of the avant-garde's growth in this country. In the 1960s, thanks in part to the New American Cinema's breakthrough success (not to mention Andy Warhol's international celebrity), screenings of avant-garde films on Canadian university campuses became quite common. Through these screenings, Canadian film experimentalists such as Chambers had an opportunity to network with and gain knowledge from their American opposite numbers. Chambers was especially influenced by Stan Brakhage's work; Brakhage's *Window Water Baby Moving* (1959) has been cited as a primary inspiration for Chambers' first film, *Mosaic*. Brakhage was also instrumental in getting Chambers' films some distribution in the United States, initiating Chambers' first American screening, held on November 15, 1977, at Pacific Film Archive. However, because Chambers was unable to travel due to his deteriorating health and myriad artistic commitments, his films were, even then, seldom noticed beyond the occasional passing reference in film festival or visual art overviews.[28] The contrast between Brakhage's ubiquitous presence and Chambers' near absence (except close to home) on the late-sixties university circuit helps explain why Chambers' films were not more widely seen and, therefore, written about. It is one of the unfortunate realities of experimental film culture that critical exposure is closely tied to active touring and self-promotion.

The emergence of the campus underground as an alternative exhibition network, coupled with the establishment of film co-operatives like Canadian Filmmakers Distribution Centre, London Film Co-op, the Intermedia Film Co-op (Vancouver), and the Independent Film Makers Co-op (Montreal), allowed an effective system of distribution to develop; this network of parallel co-ops also helped to establish lines of communication between filmmakers in different parts of the country who would otherwise have had no means of contact. In the 1970s film production co-ops such as the Atlantic Filmmakers' Co-op (Halifax), the Winnipeg Film Group, the Saskatchewan Filmpool (Regina), and the New Brunswick Film-makers' Co-op (Fredericton) were organized along these lines, providing a vehicle for filmmakers with some experience and knowledge of equipment, labs, editing, etc., to pass on their expertise to upcoming generations of young filmmakers. Jack Chambers' pioneering involvement with CAR, a national arts service organization founded on Chambers' belief in "fair exchange: payment for services," assured that filmmakers would eventually be compensated for the exhibition and reproduction of their work. It was within this cultural-historical milieu that Chambers worked to unite the various aspects of Canada's experimental film apparatus.

His most decisive contribution to the development of a sustained, alternative Canadian cinema, however, was in the films he made, expanding on his own artistic strategies and concerns. As an early example of subjective autobiography, Chambers' work anticipates the first-person, diary strain that erupted in Canadian avant-garde film during the 1960s, emerging simultaneously in films such as Chambers' *Mosaic* and *Circle*, Joyce Wieland's *Water Sark* (1965) and personal documentaries made by the NFB experimentalist Derek May.[29] The traces of this impressionistic diary mode can be located in a wide range of later films, including Rick Hancox's *House Movie* (1972), Bruce Elder's *The Art of Worldly Wisdom* (1979), Philip Hoffman's *The Road Ended at the Beach* (1983), Mike Hoolboom's *Was* (1989), and Ann Marie Fleming's *You Take Care Now* (1989), to name just a few examples. And the integration of quotidian subject matter and amateur tactics into film texts and formal repertoire by, respectively, Chambers and Wieland, effaced the boundary between avant-garde film and "home movie." Films such as Marian McMahon's *Nursing History* (1989), Gariné Torossian's *Girl from Moush* (1993), Elida Schogt's *Zyklon Portrait* (1999) and Hoffman's *What these ashes wanted* (2001) testify to the enduring influence of Chambers and Wieland on the fusion of art and life in Canadian first-person cinema.

From Professionalism into Amateurism:
Circle as "Home Movie"

. . . when you aim at art in life you will hit below the target. Art should somehow take care of itself in our primary pursuit of life.

. . . when you sit and watch a film, when you have the mundane shown to you you look for meaning in it that it might not have. But by looking for meaning you do find it.

<div align="right">— JACK CHAMBERS</div>

My analysis of *Circle* as a "home movie" is largely based on the shift in Chambers' artistic practice from painting into cinema, which I would theorize as a transition from professionalism to amateurism. By *professionalism* I mean simply the performance of a task or skill for financial gain, while *amateurism* "indicates doing something for pleasure, for the sheer love of it."[30] I do not mean to suggest that Chambers derived no pleasure from his painting. However, and this is where an important distinction should be drawn, his painting *was* professional, fulfilling all the requirements of skill, specialized technique and financial recognition: although his sales were not overwhelming until the end of the 1960s, all the signs indicate that Chambers did from 1961 on make enough money painting to live.[31] I have had access to Chambers' financial records for the years 1970–72, and the sales of his paintings were then generating revenues in the tens of thousands of dollars per year. His films, meanwhile, through the sale or rental of prints, were generating no more than a few thousand dollars per year—much less, on average, than they cost to make.[32]

The fact that Chambers deliberately made films as an amateur, "for the love of the thing rather than for economic reasons or necessity,"[33] has been noted by other critics. Ross Woodman, for example, writes that Chambers

> began making [films] at a time when he felt the need to escape his professional commitment to painting, which, he believed, was now blocking the flow of his feeling by freezing it into the resolution of purely painterly issues. He was becoming disturbed by the acceptance (not reflected in sales) of his art (partly because it was "realistic") by a society which he believed was "utilitarian, puritanical, indifferent to anything that was not a 'safe job' and a 'proper way of living,'" and therefore fundamentally rejected everything which he as an artist stood for.[34]

Chambers himself elucidated his interest in filmmaking as an amateur activity: in an article in 1971, titled "What Makes Jack Chambers Canada's Top-Priced Painter?" he describes his filmmaking as chiefly "a kind of relaxation—like the piano is for somebody else."[35] And in a conversation in 1972, Chambers acknowledged that he "would never make any money to speak of with films" but that "the medium is time-based and defies the restrictions of the canvas." And "that was the thrill."[36]

As Patricia Zimmermann observes in her book *Reel Families: A Social History of Amateur Film*, "Within the discourse of cinema, the terms *avant-garde* and *amateur* often collapse into each other, with amateur connoting creative freedom."[37] Amateurism as an aesthetic ideal has circulated within American avant-garde cinema since the 1960s. Maya Deren, a key filmmaker and polemicist of this period, was among the first in North America to recover amateurism as a positive, defining quality of independent/art cinema.[38] Deren positioned avant-garde filmmaking as an alternative to Hollywood, with its cumbersome technology and labour practices. She argued that only by circumventing the professional world of trained specialists, careful divisions of labour and financial motivations could a filmmaker fully realize the medium's potential.[39] Filmmaking for Chambers meant release from the professional demands of his painting, creative freedom and, in his own words, "a relaxation." He made films in his time off from painting, his "leisure time," and he made them without economic pressure or incentive.

Circle transposes various features of the "home movie" into the avant-garde milieu, including subjectivity, amateur aesthetics and a focus on everyday, ordinary subject matter. Subjectivity is evident from the very beginning of the film; in the first (of three) sections, Chambers assumes what Patricia Zimmermann has described as the "patriarchal prerogative" of amateur film.[40] In other words, the subjective position in the film is clearly that of Chambers himself, as the father of the household. His presence is imprinted in the shot selection, the camera positioning and movement, the angles and so on. Even though Chambers' wife and children never actually appear in this first section, they seem always to be lingering at the peripheries of the frame. We hear, for instance, the off-screen sounds of a children's television program, indicating the kids are nearby. There is also some unintelligible off-screen conversation, probably between the other family members. Perhaps the family is uncomfortable with the presence of the camera and trying to stay out of the way; perhaps they have been instructed to stay out of the way.

The subjective viewpoint is also made explicit in this first section through the shots of Chambers winding up and photographing with his Bolex camera. He is in effect *acting out* his own role as amateur filmmaker for another camera, plausibly one operated by his wife, Olga. We even see him literally performing "kitchen table work" as he carefully arranges snapshots of his backyard on the dining-room table and transcribes them onto motion picture film. These self-reflexive gestures position him as an archetypal do-it-yourself amateur, for he is clearly in sole control

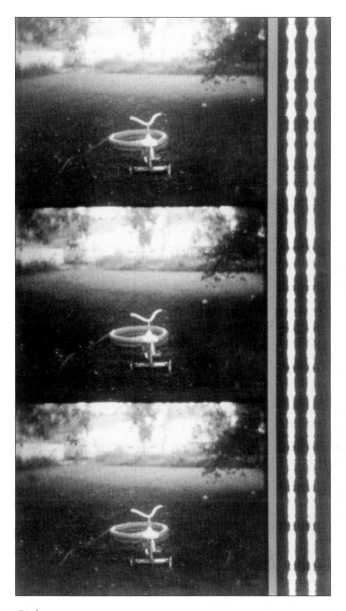

Circle

of what is seen and how it is seen. Even when he is visually absent, we *hear* him winding and running the film camera.

The second way that *Circle* approximates aspects of the "home movie" is in its aesthetics. Amateur, unskilful "home movie" aesthetics and avant-garde experimentation are very much intertwined in *Circle*'s cinematic vocabulary: the hand-drawn titles, as well as the sometimes out-of-focus, wandering camera of the first section, the wild sound of both the first and section sections and the frequent shifts in light and focus of the second section are all recognizable from both filmmaking modes. The self-awareness of *Circle*'s amateur composition is acknowledged (almost to the point of satire) during the opening prologue, where virtually nothing happens. We do not see an image, or at least, not an image we can easily name, until a minute and a half into the film, when the dark, possibly underexposed *Circle* title card (hand-drawn, no less) comes into focus. Until that point, the film presents us with the visual equivalent of someone videotaping with the lens cap on. When the camera finally comes to rest on an identifiable thing, an overhead light fixture, even that gesture seems awkward, the angle strangely canted. Returning to the analogy of home video, it looks as if our amateur vidéaste has set his camera on the ground, not realizing that it is still recording.

The fixed exposure that structures the middle section of *Circle* can also be read in amateur terms. Although the difficulties of "proper" exposure were alleviated for amateur filmmakers with the appearance of user-friendly motion picture cameras on the consumer market in the 1950s, inconsistently exposed imagery remains a tell-tale amateur signifier. Of course, in *Circle*, inconsistent exposure is an intentional and important formal device. Nevertheless, the strategy of not adjusting the aperture to changes in light adds another level to *Circle*'s "home movie" appearance. While it's possible to creatively mis/read the shifts of focus and exposure in *Circle* as mistakes, these examples clearly fall within the scope of the film's internal design. In other words, their purpose is not to simulate the accidental occurrences commonly found in "home movies" but rather to open up a space for the spontaneous potential of amateur film within a more disciplined and rigorous avant-garde form. The art is allowed to take care of itself.

Circle also resembles a "home movie" in its representation of the domestic environment. At the beginning of the film, after a period of initial disorientation, we realize that the grey mass we have been gazing at for nearly a minute and a half is actually the walls and ceiling of Chambers' own living room. Domestic signifiers such as hanging drapes, the dining-room table and the background noise of the television clue us in to the familial setting. Images of the back yard provide the final indication of social domesticity: this is clearly a middle-class environment, with a white picket fence and (sometimes) tidy lawn. *Circle* focuses on documenting the everyday. Stan Brakhage has identified Chambers' interest in "the most mundane, ordinary, everyday activities" as a framing device common throughout his films.[41]

Circle

The middle section of *Circle* affords occasional glimpses of Chambers family members performing their daily rituals, glimpses that more often than not are superseded by ethereal traces of activity, visualized by the dis/appearance of a child's toys, laundry, footprints in the snow and so on. The white sheets that routinely materialize and vanish are particularly interesting in this respect. They seem to function implicitly as an index for Olga, Chambers' wife, a further indication of her marginal position in the production of this "home movie" (and a reinforcement of Chambers' "patriarchal prerogative").

In *Circle's* final section, the majority of images are taken from newsreel footage given to Chambers by a local London television station. These TV "episodes" as Chambers described them, function in a similar way to the daily events photographed by Chambers himself; they are non-sensational and nondescript—we see, for instance, folks arriving and being greeted at a train station, people swimming in a river, children playing in the snow and making tracks in the dew. Because they present ordinary people performing ordinary activities the images assume a "home movie" quality, with the important difference that the found images of this final section provide evidence of everyday actualities, showing scenes that would be unlikely to occur under the very fixed conditions set by Chambers in the opening sections of the film, where activity is hinted at more often than revealed. This sets up, in the final section, an interesting and unexpected substitution of presence for absence. Considered against the dark, gloomy domestic interior of *Circle's* first section, in which Chambers' kids are *heard* and not *seen*, the luminous, muted sequence in the final section, an adolescent girl teaching her dog to count, provides the familial image that was withheld earlier. Read this way, the winter scenes of children playing outdoors that appear near the end of *Circle* can be understood as the displaced source of the footprints seen in the snow during section two. These ordinary scenes of daily leisure activity thus (ironically) familiarize the anonymity of Chambers' featureless home and vacant backyard.

Conclusion

> *In short, everything and anything that one sees is in its actual presence also more than we can in any one way understand it to be.*
>
> — JACK CHAMBERS

Part of the problem with approaching a film as idiosyncratic as *Circle* is that it resists classification: variously a lyrical film, a landscape, a structural and a found-footage film, it is simultaneously a "home movie"; it also possesses both Romantic and postmodern characteristics. On the other hand, *Circle's* openness to different modes

of critical interpretation and analysis (much of which remains to be done) underscores the need for its reconsideration. More than thirty years after its initial release its legacy can be evaluated from a distance that helps to put it in perspective. Despite the critical neglect it has endured, *Circle* has always been, because of its chronological position, an important film in the evolution of Canada's avant-garde cinema. Its right to a place in the wider Canadian film canon, however, has yet to be established. A limited number of prints are in circulation, and consequently, screening occasions either at home or abroad have been rare. Furthermore, although a thorough review of the Chambers film literature yields evidence of the de facto recognition of *Circle* as an influential experimental film, the lack of continued engagement by a younger generation of critics suggests it is underappreciated as well as under-seen. As one of the earliest experimental films made in Canada, *Circle* did not benefit from the arts council funding, screening fees and organized distribution that later filmmakers have had access to, but it proved that an independent artists' cinema was viable in Canada, despite Snow and Wieland's relocation to New York, the National Film Board's vacuuming up of talent and resources, and the government-subsidized commercial feature film industry that arose in the late sixties. As an early example of Canadian first-person cinema, *Circle* gave impetus to the pursuit of individual vision. By moulding a complex work of art from private environments and anonymous objects, Chambers clarified the richness of working from necessity, with the love of an "amateur."

Notes

1. Stan Brakhage, from a letter reprinted in Tom Graff, ed., "Notebooks and Ideas," *Jack Chambers Films*, ed. Tom Graff, *Capilano Review* 33 (1984): 43. The letter was originally addressed to Edith Kramer, a film programmer at Pacific Film Archive (Berkeley).

2. *Spirit in the Landscape*, a survey exhibition of Canadian avant-garde cinema conceived and curated by filmmaker Richard Kerr, was held from March 28 to April 24, 1989, at the Art Gallery of Ontario (Toronto). *Circle* was one of the films included in this five-part series. The International Experimental Film Congress, which opened with a retrospective tribute to Jack Chambers, was held from May 28 to June 4, 1989, also at the Art Gallery of Ontario. Both events produced accompanying catalogues that are in general circulation.

3. *The Jack Chambers Film Project* was held at the London Regional Art and Historical Museums (London, Ontario), 9-10 March 2001.

4. Brakhage subsequently answers his own question as follows: "I feel that it is because his films do NOT arise as an adjunct to his painting (as is true in the case of most other painter filmmakers) but that, rather, Jack Chambers has realized the almost

opposed aesthetics of paint and film and has created a body of moving pictures so crucially unique as to fright paint buffery" (43). Recent comments by Bart Testa at *The Jack Chambers Film Project* further reinforce this point. During his panel presentation Testa stated that Chambers' filmmaking "projected the sense of a complete artist in a wholly new medium. It was as if there were two Jack Chambers, one who made films and one who painted, joined you might say with the person of Chambers." Thanks to Christopher Doty for videotapes of the panel.

5. Richard Kerr reiterates this sentiment in regard to the entire Canadian avant-garde cinema. See Kerr, "Introduction," *Practices in Isolation: Canadian Avant-Garde Cinema* (Kitchener-Waterloo, Ont.: Kitchener-Waterloo Gallery, 1986), 4.

6. Ross Woodman, *Chambers: John Chambers Interviewed by Ross G. Woodman* (Toronto: Coach House Press, 1967), 21.

7. As the term *home movie* is being used conceptually here, I will keep it in quotation marks throughout the paper. I should also note that the Swiss-manufactured 16mm Bolex film camera Chambers used was a semi-professional camera not commonly used for shooting "home movies"; 16mm technology was supplanted by lighter, more affordable 8mm equipment in the 1950s. *Circle's* approximation of the "home movie" is largely by design.

8. Jack Chambers, cited in Ross Woodman, "Artists as Filmmakers," *Artscanada* 25, no. 118–119 (June 1968): 35.

9. This critical imbalance differs from the Canadian film reference literature, which has traditionally aligned *Circle* and *The Hart of London* as Chambers' major works, committing equal weight to each. See Peter Morris, *The Film Companion* (Toronto: Irwin, 1984). Cf. David Clandfield, *Canadian Film* (Toronto: Oxford University Press, 1987).

10. The only reference I have discovered regarding avant-garde activity in Canadian film literature of the 1960s is a column written by Marshall Delaney (a.k.a. Robert Fulford) in August 1967, describing Cinethon, a forty-five-hour festival of (mostly American) underground films held at Cinecity (Toronto). In one characteristic passage Fulford writes, "I've seen fourteen films at the Cinethon, and only three or four have actually engaged my imagination. I find myself examining the others with an almost clinical detachment. They are not interesting in themselves; what is interesting is that someone has gone to the trouble of making them" (19). The only Canadian filmmaker mentioned is Joyce Wieland. Although he snidely criticizes Wieland's mixed-media presentation, Fulford does allow that Wieland is "an impressively talented painter" (17). See Fulford, "The Canadian Scene," *Marshall Delaney at the Movies: The Contemporary World as Seen on Film* (Toronto: Peter Martin Associates, 1974): 15–23.

11. Barry Lord, "Let There Be Darkness," *Artscanada* 25, no. 124–127 (Dec. 1968): 27.

12. Gene Youngblood, "The New Canadian Cinema: Images from the Age of Paradox," *Artscanada* 27, no. 142–143 (April 1970): 9.

13. Mario Amaya, "Canada: Jack Chambers," *Art in America* 58, no. 5 (Sept.-Oct. 1970): 121.

14. Bruce Elder, "From Painting into Cinema: A Study of Jack Chambers' *Circle*," *Journal of Canadian Studies* 16, no. 1 (Spring 1981): 60–81.

15. John [Jack] Chambers, "Perceptual Realism," *Artscanada* 26, no. 136–137 (Oct. 1969): 7–13.

16. Until 1990, Chambers' first three films, *Mosaic* (1966), *Hybrid* (1967), and *R34* (1967), were long out of circulation (I suspect since the time of Chambers' death in 1978). Although little has been written about why this occurred, most signs point to an unco-operative Chambers estate. (While he was alive, Chambers handled the distribution of his films himself, under the name London Film Co-op, a one-man "company" that he operated out of his home.) All of Chambers' completed films, including *Circle* and *The Hart of London*, are now available through Canadian Filmmakers Distribution Centre (Toronto). However, a sixth film, *C.C.C.I.* (c. 1970), remains out of circulation completely; its current whereabouts is a mystery. Thought to be unfinished, *C.C.C.I.* was screened in public on several occasions during Chambers' lifetime, including the 1977 World Film Festival in Montreal. A purchase order from the University of Calgary dated 11 June 1973, to London Film Co-op for rentals of *Hybrid* and *C.C.C.I.* indicates the film was likely in distribution for several years before Chambers died. I discovered this document among various financial records in the archive of the Jack Chambers Papers located in the Edward P. Taylor Research Library and Archives, Art Gallery of Ontario. Thanks to Larry Pfaff for his assistance.

17. Bart Testa, "A Movement through Landscape," *Spirit in the Landscape* (Toronto: Art Gallery of Ontario, 1989), 19–32. Testa wrote all the essays for the exhibition catalogue; this particular essay addresses three films, *Circle*, Joyce Wieland's *Sailboat* (1967–68) and Michael Snow's *Seated Figures* (1988), which were programmed together.

18. In addition to his public support for Chambers' films, Brakhage also published two short pieces near the end of the decade in which he expressed his appreciation. See "Some Words on the North," *American Book Review* 10, no. 2 (May-June 1988): 5, 18; "Jack Chambers," *Independent Eye* 10, no. 1 (Fall 1988): 12.

19. This seems more a problem of budgetary considerations and logistical constraints rather than the fault of the presenters themselves. As Gordon Price, one of the organizers of *The Jack Chambers Film Project*, remarked on the conference's opening night, everyone the committee initially approached expressed a keen interest in participating; therefore they were able to invite only those deemed most qualified to speak on Chambers' life and work. The University of Western Ontario film professor Michael Zryd, another of the project organizers, confirmed this to me later, noting that the members of the film panel were chosen primarily on the basis of their academic qualifications and/or personal connection to Chambers, and then by their proximity to London.

20. *The Jack Chambers Film Project*, panel discussion.

21. Sometime in 1974 CAR added the French translation "Le Front des artistes canadiens" to its official title and became CAR/FAC, which it remains today.

22. Letter, Chambers to David Silcox, 9 October 1966, Jack Chambers Papers, AGO.

23. Memorandum, Silcox to file, 4 November 1967, Jack Chambers Papers, AGO.

24. Seth Feldman, "Film Education," *The Canadian Encyclopedia*, <http://thecanadian encyclopedia.com>.

25. Greg Curnoe confirms this in an interview he recorded with Susan Reaney, February 1982. "As a result of Jack making his own films," Curnoe states, "he felt that . . . the one way to get them distributed, particularly on the university circuit, was to have a film co-op and to have one here." Elsewhere Curnoe acknowledges "there was quite a big market for [avant-garde films in the late sixties]. I mean, underground film was in vogue. And all kinds of people were putting together programs. And there weren't any co-operatives in Canada that I can think of [at the time]." Audiotapes supplied by Richard Kerr.

26. Publicity materials, Jack Chambers Papers, AGO.

27. Woodman, "Artists as Filmmakers," 35. The Concordia University film professor Thomas Waugh remembers seeing *Circle* at the University of Western Ontario in the late sixties, at a screening no doubt organized by the UWO English professor and Chambers patron Ross Woodman; he recalls an audience of literature students and faculty all competing with each other to demonstrate how sophisticated they were in their appreciation of this avant-garde work.

28. Feldman's 1976 review of *The Hart of London*, the first critical study of Chambers' work published in a film periodical, was something of a turning point in terms of where, how and by whom Chambers films were written about. J. Hoberman, the film critic for the *Village Voice*, bridges the divide between Feldman's article and the later commentary with two complimentary short reviews printed in at the end of the seventies. See Hoberman, "A Bunch from Ann Arbor," *Village Voice* (11 Dec. 1978): 61; "The Best of the Apples and Pears," *Village Voice* (1 Jan. 1979): 41.

29. First-person subjectivity was unique within Canadian cinema in the 1960s, as it established an important break from the didactic, institutional form of the National Film Board's more widely circulated productions during this period. See, for example, Donald Brittain's *Fields of Sacrifice* (1964) and *Memorandum* (1965), as well as Eugene Boyko's *Helicopter Canada* (1967).

30. Patricia Zimmermann, *Reel Families: A Social History of Amateur Film* (Bloomington and Indianapolis: Indiana UP, 1995), 1.

31. In 1961, Chambers returned to London, Ontario, from Spain. Published biographical information indicates that he began receiving Canada Council grants in 1965 at the rate of one a year until 1968. He would not receive another (his last) until 1977. Although these grants would have helped subsidize the costs of his art-making during this period, most of his income came from sales of his paintings. The biographical

literature also suggests that Chambers never had a regular job besides painting after 1961, except for teaching at occasional artists' workshops around London. See "Jack Chambers: Biography," *Jack Chambers: The Last Decade*, ed. Paddy O'Brien (London, Ont.: London Regional Art Gallery, 1980), 69.

32. Financial records, Jack Chambers Papers, AGO.

33. Maya Deren, "Amateur vs. Professional," *Film Culture* 39 (Winter 1965): 45.

34. Ross Woodman, "Jack Chambers as Film-Maker," *Jack Chambers Films*, ed. Tom Graff, *Capilano Review* 33 (1984): 51, 64n. When Woodman says the acceptance of Chambers' art was "not reflected in sales," I believe he means that Chambers' paintings were undervalued during the 1960s.

35. Jack Chambers, cited in Alan Walker, "What Makes Jack Chambers Canada's Top-Priced Painter?" *Canadian Magazine* [*Toronto Daily Star*] (6 Feb. 1971): 21.

36. Jack Chambers, cited in Graff, "Foreword," *Jack Chambers Films*, ed. Tom Graff, *Capilano Review* 33 (1984): 5. Graff doesn't specify a source for the quotation. I suspect it was taken from an unpublished interview.

37. Zimmermann, *Reel Families*, 129. Her italics.

38. The role of amateurism in the development of a specialized art cinema goes back much further than this. In the 1920s Dada and surrealist filmmakers such as René Clair, Man Ray and Luis Buñuel were already exhibiting disdain for conventional aesthetic tradition. See, for example, Clair's *Entr'acte* (1924), Ray's *L'Étoile de mer* (1927) and Buñuel and Salvador Dali's *Un Chien andalou* (1928). There is also evidence of an American avant-garde cinema prior to Maya Deren. See Jan-Christopher Horak, ed., *Lovers of Cinema: The First American Film Avant-Garde, 1919-1945* (Madison: University of Wisconsin Press, 1995). As Horak notes, "In the earliest phases the American avant-garde movement cannot be separated from a history of amateur films" (18).

39. See Deren, "Planning by Eye: Notes on 'Individual' and 'Industrial' Film," *Film Culture* (Winter 1965): 33–38; "Amateur vs. Professional," 45–46. Stan Brakhage extends Deren's argument one step further, claiming "any art of the cinema must inevitably arise from the amateur, 'home-movie' making medium." See Brakhage, "In Defense of Amateur," *Brakhage Scrapbook*, ed. Robert A. Haller (New Paltz, NY: Documentext, 1982), 168.

40. Zimmermann, *Reel Families*, 112.

41. *The Jack Chambers Film Project*, panel discussion.

R34

R. BRUCE ELDER

Jack Chambers' Surrealism

A N UNIDENTIFIED MAN enters a yard carrying a cardboard box and a plant with its roots wrapped in burlap; he puts them down on the ground before a large metal pail and, kneeling, turns to open the box. But before he finishes, there is a brief flash of some other shot (which most viewers don't identify, but which is a historical photograph of a crowd by a river watching a boat). The effect of the brief, interpolated shot is one of momentary disorientation—a very brief *dépaysement*. When we return to the man, he has picked up the plant (perhaps a rosebush). He shears off the ends of two shoots and then puts the bush in the pail, which a close-up shows to be full of water. There is another flash of a different image of the crowd by a river (this time its content is a little more identifiable) and then a shot of the man, who we now surmise is a horticulturist, digging a large, shallow hole in the ground; after a few seconds that shot is disrupted by another still image, also disorienting in its brevity and the (*prima facie*) inscrutability of its relation to the depiction of the man. Then, once again, we see the man digging a hole. He takes the bush out of the pail, puts it in the ground, piles up some soil around it and tamps the soil down; the sequence of shots depicting these actions is intercut with still photographs of aeroplanes that have just released bombs, whose appearances become more frequent as their content grows clearer.

So begins Jack Chambers' *Hybrid*, a film made in 1967. The tone of the passage, and indeed of the entire film, is disconcerting: there is something strange and mysterious about this cutting between the plant and the bombers. Of course, there is no disputing that the feeling of "strangeness" the film elicits is contained, and that we can interpret the conceptual implications of such juxtapositions: the plant represents life and the bombers represent death—or should we say (as Peter Mellen insisted about Chambers' work, and as is suggested by the time-lapse photography of blossoming plants) they represent "the life-force" and the "death-force." Indeed, the idea that the juxtaposition articulates was more or less stock in trade from the time: Bob Dylan's "A Hard Rain's Gonna Fall" uses a similar juxtaposition to

express a similar idea. But even though the strangeness is contained, discerning the semantic meaning of the associations the film evokes does little to dispel it.

Gradually, we begin to recognize the source of the strangeness: Chambers connects objects that have an external, formal similarity: a shot of the horticulturist's shovel is made to rhyme with an image of a bomber's fuselage; a shot of garden stakes is juxtaposed with a disconcertingly brief and enigmatic still image of Vietnamese soldiers with spears raised diagonally toward the sky; a shot of the buried branches of a young tree being drawn out of the ground is set beside one of roots and branches of trees on the ground in Vietnam; a rope joining a tree to stakes for support is juxtaposed with a procession of Vietnamese (prisoners?) with their arms linked; a tilt up an elderly Vietnamese man's beard precedes a tilt, of similar speed, up the trussed tree; a shot of a hose that runs diagonally across the screen (from lower left to upper right) is linked to one of a family in the river, with a boy separated from them (or so one would be disposed to read the image) by a band of water that traces out the same diagonal; the shot of the horticulturist spraying the plant he just put in the ground with a fine mist of water is set beside a still image of a soldier wearing a gas-mask, presumably spraying a defoliant; a still image of the exterior of a house in Vietnam is followed by a shot of a man (not the horticulturist) walking into a greenhouse—the frame of the door he enters forms vertical lines that match the verticals in the Vietnamese house; the body of a dead Vietnamese matched exactly to the position of the inner parts of a rose, whose stamens are about to be harvested for pollen (the film depicts the process by which different strains are crossed). There are many more such matches: indeed, we could say that the juxtaposition of similar forms is the fundamental principle of the film's composition.

A little reflection on Chambers' use of juxtapositions brings to mind a group of painters and writers who used a similar technique. Michael Riffaterre, in *La Production du texte*, discusses the way that "the conjunctive" serves Surrealists as a substitute for the synonym; the conjunctive brings together terms that have no semantic similarity.[1] Indeed, in Surrealist texts, semantic ungrammaticalities—terms that seem not to fit together meaningfully (semantically incongruous images, for example)—are compensated for at the level of structure (the juxtaposition of similar forms).

The Surrealist conventions in Chambers' fourth film *R34* are, at one level, rather obvious. That film is a tribute to the neo-Dada artist Greg Curnoe, and makes use of the same collage principles that Curnoe employed in his art of the time. One of the most intriguing features of the film is the extension to the soundtrack of the principle of fragmenting the film's themes and recombining them. This is done largely through the breaking apart of Curnoe's recorded remarks on his work and putting them together in a new, startling order; but perhaps the most impressive are the Surrealist verbal collages that we hear Curnoe performing:

Owen steps on Mickey Mouse
Because
Seven ginger-snaps
And one arrowroot
On a white plate . . .
She has left the singers
Mickey Mouse squeaks
The javas cluck
Because
The lemon-yellow canary
Walks on the floor.

The film's first two passages indicate the importance that collage will have in the work: first, a number of Curnoe's collages are presented; the next passage shows the artist assembling yet another one. The film takes on neo-Dada attributes, coming to resemble the work of such collage artists as Kurt Schwitters and Francis Picabia, whose works straddle the line between Dada and Surrealist art.[2] Other Surrealist affinities are far more complex and less obvious. The film is structured by a series of motifs that are repeated time and again: Curnoe carrying a metal garbage pail out the door and up some stairs, a close-up of a light-switch being turned on and off, a cloth with a stylized infinity sign turning in the wind, an awning with shadows on it (that we eventually realize are shadows from the cloth with the infinity sign on it—a conjecture that makes us further surmise that the awning hangs below the window where the sign is hung), fingers, in close-up, turning a knob, hair being combed, Curnoe, in an overcoat, walking toward, then out of, a door (and, sometimes, into blackness), a close-up of a woman (Curnoe's wife, Sheila) smiling, Curnoe walking down an alley-way, Curnoe approaching mannequins silhouetted in a window (to the left of what appears to be an elaborate, ornate frame for a large mirror), a triangular form (representing a woman's pubis), images from Greg and Sheila Curnoe's wedding, a block of wood on a large metal bolt that has been drilled into a wall, being spun by being hit with a stick, a close-up of the plug on an electrical cord being repaired, a painted form that resembles a nipple, the leg of a figure that Curnoe has constructed whirling about, and a painted form that resembles a backside with the word "bum" painted on it.

The film shows how the mind assembles reality by forming congeries of particular elements. It depicts the manner in which the "external" world and the mind collaborate to produce reality (and this, as Breton and Dalí's interest in the double image makes obvious, was a key Surrealist theme).[3] Chambers emphasizes this collaboration by stressing the topical character of Curnoe's collages. Pieces in the film include images of the Manitoba Métis leader Louis Riel, a former Canadian prime minister, William Lyon Mackenzie King, the Toronto painter and erstwhile

member of Painters Eleven Harold Town, photographs of the breakaway Douk-hobor group that call themselves the Sons of Freedom ("Svobodniki"), the Beatles and the Rolling Stones, the renowned London (Ont.) psychiatrist and student of the psychology of mystical experience, Dr. Richard Bucke, the Toronto boxer George Chuvalo, shown in both newspaper photographs and a painted transfor-mation of that newspaper photograph, and Cassius Clay (Muhammad Ali), shown, as though to emphasize the reality of the images, in televised footage and in painted transformation. This passage is accompanied by a ritual reading of the names of many boxers, including the remarkable Dada writer and boxer, Arthur Cravan. There are also familiar brand identifiers (for example, the Quaker from the Quaker brand of cereals), tickets to local events at a London hotel and other such "real-world" items. Chambers even includes on the soundtrack a remark of Curnoe's, that he deals "to quite an extent with actual things" and "I am like an outdoor painter in that nearly everything that I paint has been seen outside or read in the news media or seen in a magazine, and I bring it back here and work on it." One recognizes, in the course of watching the film, that the unity of the finished collage serves as a model for the unity that the mind forges from sensa (as it brings things together within the mind which works on them), while the elements that it comprises stand for the noumenal objects which excite those sensa that the mind draws together to form the impression of an external world—Curnoe even remarks at one point, "I'm trying to put the whole thing together."[4]

One suspects, finally, that what drew Chambers to Curnoe's work, and impelled him to produce the film, is that for him Curnoe's work provided an example of the way the mind forges the reality it perceives by synthesizing discrete bits of percep-tual information—of how experience gets put together like a painting, in pieces.[5] A feature of Curnoe's work that raised this question in an especially interesting way is the use of words: Chambers intercuts between the word "hair," drawn from a collage, and an extreme close-up of Sheila Curnoe combing her hair, filmed so that the activity is impressively estranged, made to seem fascinating. The juxtaposi-tion of the word "hair" with the impressive close-up images of hair suggests the difference between the routinized apprehension (or, more accurately, construc-tion) of consensus reality and a more creative, more original construction of a new and different reality.[6] One recalls André Breton's remark in the first Surrealist Manifesto (1924): "Let us not mince words: the marvelous is always beautiful, any-thing marvelous is beautiful, in fact only the marvelous is beautiful."[7]

Like those in *Hybrid*, the images and their juxtapositions in *Mosaic* have a dis-cursive quality: we can interpret an image of an old man looking at a woman hold-ing a baby as suggesting old age confronting the marvellous vitality and mysterious procreative capacities of young people and the innocence of the infant or (imbri-cated upon that interpretation) as suggesting the male confronting the mysteries of the female. However, as appropriate as these interpretations are to the film's theme,

this propositional content does not dispel their mysterious quality: the exaggerated spatial features of the image ensure that the shot of the old man looking at the woman with her infant becomes no less mysterious when it is interpreted.

Mosaic begins with a panel of white—a wall and a door. The door opens and a young woman comes through. The woman walks across the room, picks up an issue of *Life* magazine, and sits, with a noticeable sigh, beside other women in a row of chairs in what we take to be a doctor's waiting room. The film cuts to a close-up of hands flipping through the magazine, stopping at an essay/photo-illustration piece entitled "The Sea." Another cut: a close-up of feet, in white nurse's shoes, walking across the room and past another pair of legs, those of a seated woman, in black stockings and black shoes. This close-up does not give way to an establishing shot and so it remains enigmatic, at least in some measure. Our puzzlement only increases with the next cut: an outdoor shot, very low angle, of the shoulder and head of a woman with long hair (the composition of the shot rhymes with that of the image on the cover of *Life*), clad in a striking white dress, with one hand clutching daisies to her breast and with the other picking petals from the daisy (we do not actually see the flower, but the gesture she performs is familiar from the "she loves me, she loves me not" game) and tossing them to the wind to help them on their way.

The next image again increases the estrangement we feel, for it is of a baby, lying on the ground, very close to the picture plane and occupying almost the entire lower portion of the screen, from its left boundary to its right, the head angled slightly away from the camera and the feet a bit closer. It is a deep-space image, like those familiar from Chambers' paintings of the early and middle 1960s; about two-thirds of the way up the screen is a row of trees, that mixture of deciduous and evergreen trees that Canadians know so well, while a woman in white, made tiny by an exaggerated perspectival effect, runs directly toward the picture plane. The next shot develops the theme of running, for it shows, first, a gravel path, then a man's feet in running shoes, jogging along a path. Then a low-angle shot of a white statue of an angel, which rhymes with the shot of the woman clutching flowers, appears; following that a shot of a raccoon, belly up, with flies buzzing over the corpse (even the face on the statue and the raccoon's face rhyme with each other). The film cuts to a close-up of clapboard siding, with petals falling in front of it—a completely flat image, in contrast to the deep-space image with the woman in white running toward the picture plane. Then, another shot of a woman reading a magazine—a different woman from the one we saw entering the doctor's waiting room, followed by a shot of a woman alone in the centre of a field, stooped over and picking flowers (this shot has more than a little resemblance to Chambers' paintings from 1963, *Olga near Arva*, *Olga along the Thames* and *Summer behind the House*). Then, after a "soft cut" (so the position of the figure we see after the cut matches that of the woman in the shot that precedes the cut), another shot

of the runner, this time more distant, clad in a sports jersey, running shorts and athletic shoes, then another of the deep-space image of the woman running toward the baby lying at the lower foreground of the screen. Then there is a shot of a woman in a streetcar.

The connections among the images remain enigmatic even when one begins to discern what ties them together—when, in the course of watching the remainder of the film, one connects the images of a woman on the streetcar and in the doctor's office with those of gifts stacked up on a table and of the woman in the passenger's seat of a Volkswagen Beetle, clutching the driver's shoulder as though she is in pain, and those of women having tea and cookies at some gathering, telling the story of a woman's pregnancy. The fact that these shots are separated by many that do not advance that story, and the fact that few of these shots have visual links to any other, preserve much of the mystery.

If I stressed the formal links, oppositions and rhymes among the shots in the opening section, it was to reinforce Michael Riffaterre's point about a sort of composition, pioneered by the Surrealists, in which "the conjunctive" serves as a substitute for the synonym, to create a textual system in which each element is equivalent to every other. The seeming isolation of the shots also creates the sense that the completed experience (the story) gets put together from parts.

The question of the relation of Chambers' films to Surrealism carries us to the heart of his artmaking, and so it is worth exploring. Chambers left London, Ontario, in 1953, for Europe with hopes of becoming a painter. After a brief time in Rome, he settled in Madrid and studied at the Escuela Central de Bellas Artes de San Fernando. The school's teaching method was based on a traditional approach to drawing. Students spent the first two years drawing from statues, the next three drawing from life—a pedagogical method that was disappearing elsewhere in Europe. In his book of autobiographical reflections, Chambers remarks that what he wanted from this training was "some visible standard that was not made distinctive by personal vision and accomplishment. I wanted a realistic standard of ability which was craft and not art."[8]

Chambers chose Spain as the place where he would learn to be an artist, and the training he received there leaned toward the precision of realism. That is not to say that it alone accounts for the realism of Chambers' oeuvre. The Canadian realist tradition also influenced him. One especially important Canadian predecessor is Paul Peel (1860–1892), a conventional Victorian painter and native of London, Ontario, whose paintings display the sentimentality characteristic of that era. He is best known for *After the Bath* (1890), which shows two nude children warming themselves in front of a fireplace and *The Modest Model* (1889), which shows a young boy posing as Cupid for an artist. Still, there are similarities between Peel's paintings and Chambers': both deal with domestic life, family, children and parental love, and show a real sensitivity for personal (transitional) space.[9]

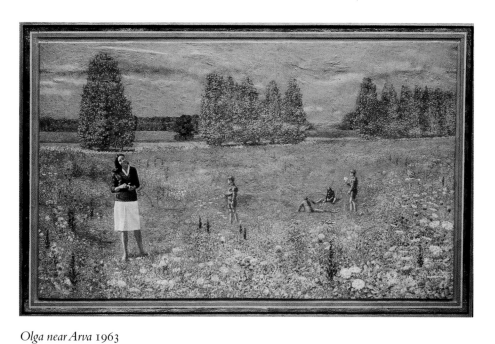

Olga near Arva 1963
oil on panel
84.5 x 141.5 cm
Montreal Museum of Fine Arts, purchase,
Saidye and Samuel Bronfman Collection of Canadian Art

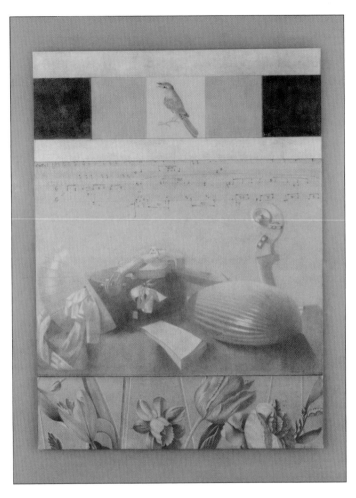

Music Box 1968
mixed media mounted on paper and plexiglas
58.4 x 55.6 cm
Museum London
Gift of Mr. & Mrs. John H. Moore, London,
through the Ontario Heritage Foundation

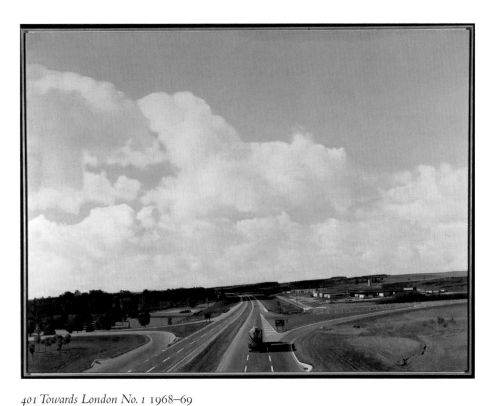

401 Towards London No. 1 1968–69
oil on mahogany
183 x 244 cm
Art Gallery of Ontario
Gift of Norcen Energy Resources Limited, 1986

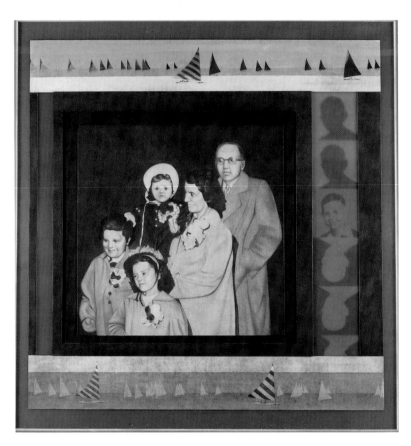

Regatta No. 1 1968
oil, graphite mounted on paper and plexiglas
129.5 x 122.8 cm
Museum London
Gift of the Volunteer Committee, 1969

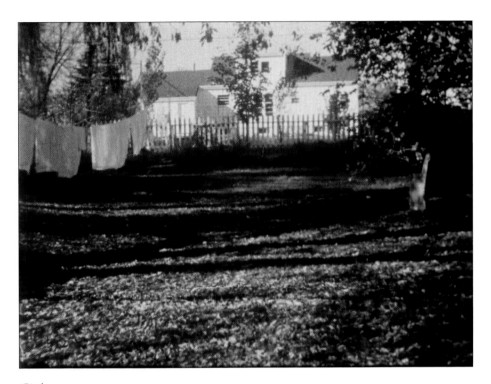

Circle

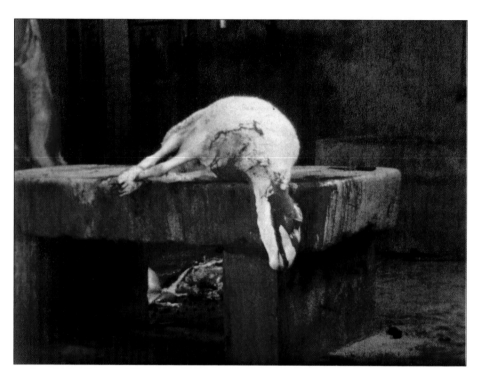

The Hart of London

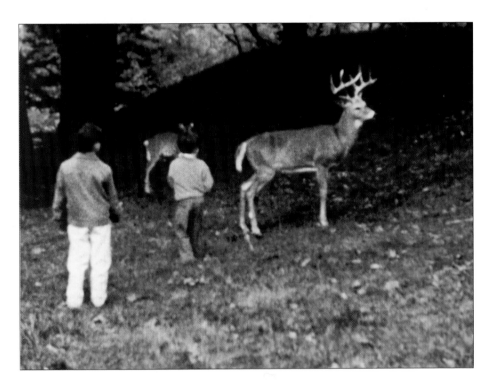

The Hart of London

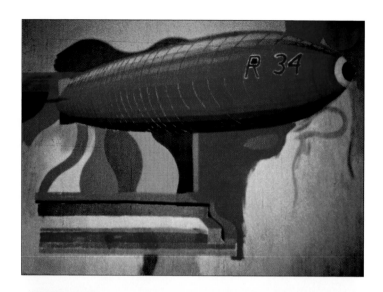

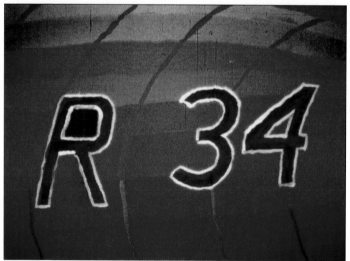

R34

Moreover, the art scene in his home town encouraged Chambers' bent toward realism. London artists were truly committed to the idea of local reality: the painter and novelist Selwyn Dewdney (who taught Chambers in 1944 and 1945 and became a lifelong friend) formed the nucleus of the group, which later attracted the poet and playwright James Reaney, Curnoe, Chambers and others. Reaney had gone west to Winnipeg in the 1950s, and returned confirmed in his ideas about the self's relation to an intimate personal space and continuity in time. His *Twelve Letters to a Small Town* (1962), like his earlier poetry and his later plays, celebrates the relation between personal, sacred spaces and civil spaces. This would become a theme of Chambers' art as well.

Yet, Canadian as his works are, Chambers' experiences in Spain had a profound and lasting effect on his art. He learned enough Spanish to read the writings of the extraordinary mystic St. Teresa of Avila; this was his introduction to the serious study of faith, and it led him to be baptized as a Roman Catholic in 1957. The influence of his conversion to Catholicism and his training in life drawing are matters that many commentators have noted. The Surrealist influence and its connection to his films has received less attention (though Ross Woodman has raised the topic).[10]

Surrealism seems to have been congenial to the character of Spanish artists. In the 1920s and 1930s Spain was the home of many Surrealists, including the playwright Federico Garcia Lorca, the poet and painter Rafael Alberti, the film director Luis Buñuel, the painter Salvador Dalí and (for a while) the painter Maruja Mallo, Alberti's lover. The Spaniard Pablo Picasso also made a number of Surrealist works that, as one would expect of that genius, were of the highest quality. If Spanish artists are disproportionately represented in Surrealism, in comparison to other European artistic movements of the twentieth century, the reason is not difficult to discern: in its search for the marvellous, Surrealism represents a continuation of both the metaphysics and the ethics of Roman Catholicism. Buñuel, for example, acknowledged that his aggressively atheistic stance was really a mirror image of the Catholic faith, and his films are deeply concerned with religion (and clericism); Lorca's New York poetry adopted a prophetic tone; and Alberti's poetry offers transcendental themes and even a derivative of mysticism (at least those written before Alberti was overtaken by political concerns during the Spanish Civil War).

The range of works that Spanish Surrealists produced is very broad, which makes it possible to cite counterexamples for any generalization offered about the movement. Still, I will hazard such a generalization and say that Spanish Surrealism leans toward what one might call veristic Surrealism, to distinguish it from the more automatist Surrealism. The theory and practice of Surrealist automatism grew out of a peculiar conjunction of interests on the part of the movement's founder, André Breton: first, Sigmund Freud's psychoanalysis, and second, Allen Kardec's

spiritisme. Breton maintained that rational thinking covers only a small portion of the spectrum of experience, which the rational mind mistakes for the whole of reality. Psychoanalysis and *spiritisme* encouraged alternative forms of experience—forms that a too rational civilization had dismissed. The product of the two interests was a set of techniques whose goal was to alter the subject's relation to the thinking process itself. It does so by inducing the surrender of rationality and the experience of self-alienation that Arthur Rimbaud, the great precursor of Surrealism, alluded to in his famous "Lettre du Voyant," when he wrote, "Je est un autre."

The form of Surrealistic expression that developed directly out of Breton's concerns treated the canvas (or the blank page) as a writing tablet on which messages from the unconscious are materialized in non-representational signs. The work of Joan Miró, André Masson and Jean Arp are well-known examples of this technique. The veristic Surrealists, on the other hand, were interested primarily in the intermingling of fantasy and objectivity in the mind as we form perceptions of the world which we normally inhabit—the world that Chambers, formulating similar ideas, called consensus reality. As Dalí's paranoiac-critical method makes clear, the veristic Surrealists believed that Freud had established that the world we experience as reality is a psychic construct shaped by our desires, and that each of us inhabits an individual—a *personal*—reality. They wanted to enlarge the space of freedom, to break out of the habit of forming the world we live in on the model of conventional reality. Their creative practices were intended to provide a model for the free construction of reality, and hence, the creating of hyper-real images became a key goal of their art: the strange and wondrous images of dreams and hallucinations composed with photographic realism. This method is exemplified by the work of Max Ernst, Salvador Dalí, René Magritte, Paul Delvaux, Remedios Varo, Leonora Carrington and Yves Tanguy. Because they often employed such academic conventions as Renaissance perspective, this version of Surrealism did not find the same welcome among the modernists as that afforded to automatist Surrealism.

Chambers could not have stayed around the Spanish art scene as long as he did without being exposed to Surrealist art, including some in the verist mode. Some of the canvases that he painted not too long after returning to London—*Sunday Morning No. 1* (1963), *Olga at the South Pole* (1963), *Olga near Arva* (1963), *Olga along the Thames* (1963), *All Things Fall* (1963), *Summer behind the House* (1963) *Olga Visiting Graham* (1964), and *Antonio and Miguel in the U.S.A.* (1965)—resemble paintings that belong to the verist tendency in Surrealism. They have the same magical "frozen moment" character that paintings by Magritte have. Furthermore, like many verist works, their representations of space have a hauntingly paradoxical quality: clearly, as representations, they allude to deep space, yet the painting surface remains resolutely flat. What is more important still, these paintings juxtapose elements in striking and incongruous ways. *Olga at the South Pole* can serve as an

example: we see an image of Olga Chambers sitting on a snowbank in Antarctica, as seals and an ermine play to her right and two polar bears and a snowy owl appear on her left side. The disposition of the figures—especially Olga's stiffness and the strange, mysterious inertness of the animals, who seem as a result indifferent to one another even though they exist in close proximity—lend an unreal quality to the total image. Balancing that unreality is the astonishing, meticulous detail of the rendering of the various figures (and of the overall scene) that makes the unrealistic space of the painting seem so concrete.[11] This unreal reality (or realistic unreality) illustrated exactly the point that Dalí insisted on in his statements about paranoiac criticism: that the artistic process rehearses the activity that produces what we know as reality—that the mind (imagination and perception working together) produces, by its extraordinary attention to detail, the reality within which we have our being.

Chambers frequently pointed out that a painting gets put together in pieces. The idea seems to have been with him from his first years as an artist. A series of illustrations, done in 1961, for a book of poems by James Reaney called *The Dance of Death at London, Ontario*, were done in a divisionist style, a style based on the optical fusion of numerous points of colours to give a luminous impression of form.[12] This later developed into another kind of "splatter" form, in which the objects gradually took shape within the globules of the surface effects. These works were the result of his first exposure (as late as 1961) to the work of de Kooning, Pollock, Klee and Kandinsky.[13]

There is a structural homology between the paintings Chambers made in the mid-sixties and films like *Mosaic* (1966), *Hybrid* (1967), *Circle* (1968–69) and *The Hart of London* (1968–70)—in the paintings, what Chambers called "molecules" of memory images coalesced into larger clusters, just as the individual frames accumulate to form individual shots, and individual shots accumulate to form "completed movements" and "completed scenes."

The composition of partial or fractured figures that retained properties of levitation, and, later, of "almost completed people-things" led Chambers to a new understanding of a painting's space, for he came to think of it not as a chaotic splattered surface from which he helped objects emerge, but as a space of order within which the object could be assigned its particular place.[14] Woodman spotted the connection of this with Surrealism, and asked Chambers about it in a 1967 interview. Chambers tried to distance himself from that artistic movement.

Surrealism, magic realism, dreamy, fantastic and so on, those labels are meaningless to me. Spatial experience is one thing I consider real in painting. This is rendered through tensions in different colours: some colours act as springboards, others as magnets. The importance of colour showed up more clearly in earlier works. Because I put objects into that space and didn't resolve it as a

purely abstract problem seemed to confuse people. I created the dynamics—patches of colour—then shaped the figures within them. Once I'd got an atmosphere creating itself the figures amalgamated with it. When the colour set-up became an experience, that is, when I "felt" a spherical density in the painting that allowed me to go around the work as well as through it, the painting was alive on its own.[15]

The conception of space as synthetic is a paradigmatically cinematic conception of space, as is the fragmentation of the human figure that occurs in these paintings.

Surrealist features persist in Chambers' paintings through the 1960s despite his denials, including the plexiglas paintings (e.g., *Music Box* [1968] and *Madrid Window No. 2* [1968–69]), graphite drawings coloured with oil paint glazes, and then covered with successive layers of acrylic. The plexiglas sheet gives the drawing a blurry, out-of-focus appearance. Thus, the bird in *Madrid Window No. 2* disappears and reappears with the slightest movement on the spectator's part. The title reveals the painter's intent: this is a remembered scene—the blurry, out-of-focus appearance alludes to the fading of memory and the disappearance and reappearance of the bird alludes to the transience of objects, in memory and in time itself. The subjective images in these works are rendered with the utmost of "photographic" fidelity and so become "objective."

Music Box No. 2 is based on Evaristo Baschenis' *Musical Instruments* at the Accademia Carrara in Bergamo and *Madrid Window No. 2* is based both on a work of the great religious painter of Spain's Golden Age, Francisco de Zubarán's *Lemons, Oranges and Rose* (1633) and on François Garnier's *Gooseberries and Cherries* (1644) at the Musée du Louvre. Avis Lang Rosenberg noticed that nine of the historical still lifes that Chambers used in paintings between 1966 and 1970 are reproduced in Charles Sterling's *Still Life Painting from Antiquity to the Present Day*. He used the book in fact rather like the library of "found photographs" and "found footage" he drew on for the films *Hybrid* and *The Hart of London*. These antique images contribute to creating the sense—which is also important for the film *Hybrid* (which includes still images)—that reality can be experienced as succession of moments: of stilled frames, or photographs, or "still lifes." Furthermore, an elegiac quality results from the use of these historical/dialectical images, which Chambers recognized as characteristic of painting itself.[16]

The plexiglas paintings suggest the fusion of memory and perception, or the convergence of the inner world and outer world, of self and object. André Breton's classic statement of the goal of Surrealism expresses a similar aspiration.

I believe in the future resolution of these two states, dream and reality, into a kind of absolute reality, which are so seemingly contradictory, a *surreality*, if one may so speak.[17]

Breton later expanded on this: there exists, he said, a certain "mental vantage-point (*point de l'esprit*) from which life and death, the real and the imaginary, past and future, communicable and incommunicable, high and low, will no longer be perceived as contradictories."[18]

Chambers' work, too, often seems to evoke a peculiar fusion of opposites—the amalgam of the ordinary and the extraordinary that so interested the Surrealists. *Sunday Morning No. 1* (1963), *Summer behind the House* (1963), *Olga Visiting Graham* (1964), and *Sunday Morning No. 2* (1968-70) are evidently amalgams of the ordinary and extraordinary. Chambers' ideas about the depiction of ordinary reality in his paintings could apply as well to such films as *Hybrid*, *Mosaic*, *Circle* and *The Hart of London*. *Hybrid* shows a man planting rosebushes, *Mosaic* shows a woman going to a doctor's office and travelling by streetcar, *Circle* shows Chambers' back yard and *The Hart of London* is composed of footage of Chambers' home town. About his interest in quotidian reality Chambers wrote:

> The *simply-being* of the world is perhaps best encountered in those things most familiar: the things around us. The unfamiliar and the strange demand our scrutiny and attention because the service they afford us is to offer themselves as signs and means by which we can navigate in the world. While the familiar habitually conceals its own *presence*, one can sometimes, by a thing always being there, discover it nameless for a moment on its own. And that is the threshold of *perception*. It is also the moment of miracle: the "hallowing" of the everyday.[19]

The ideal that Chambers expresses here is not far from the Surrealists' finding of the marvellous in ordinary reality. Furthermore, like the Surrealists, Chambers argued that the marvellous manifests itself only when rational thought is quieted and wilfulness in thinking abandoned (as it is in free association). In a published excerpt from *Red and Green*, Chambers remarked:

> *Perceptual* experience . . . brings the artist . . . back to the hidden place, at the single root of the powers of the soul, where the entire subjectivity is, as it were, gathered in a state of expectation and vital creativity. Into this place he enters, not by any effort of voluntary concentration, but by a recollection, fleeting as it may be, of all the senses—a primordial gift—to which he has to consent, and which he can cultivate, first of all by removing obstacles and silencing concepts.[20]

But the plexiglas paintings, too, with their multiple images (which encourage the viewer to synthesize the various images, engendering a flash of insight that reveals something unrepresentable) are also amalgams of the subjective and the objective, the real and the super-real. A fascination with the phenomenology of

the photographic image played a key role. It was during a trip back from Spain to Canada that he conceived a fascination with the photograph's seemingly magic capacity to bind time to eternity. On hearing that his mother was gravely ill, Chambers had returned for what he thought would be a brief visit:

> It was while riding a city bus uptown that its slow smooth ride spoke to me of opportunity and comforts I could not expect in Spain. It was feel for the place that produced my intention to stay on in London. It was also my home town, and there were spaces here along the river and in the landscape that had become mine years ago and continued to be so. The memory of such places multiplied the longer I remained so near them, and the images wedded to their presence surfaced in me like the faces of long lost friends. At this time I also discovered my own past, that of my parents, and of their parents in the likenesses preserved by photographic magic.[21]

Chambers' ideas about the photographic image are similar to those of Salvador Dalí. Even before he joined the Surrealist movement, Salvador Dalí was taken with the potential of the photographic reproduction. Photography and film represented for him a mechanical means of ensuring a connection between the poetic (i.e., lyrical or subjective) image and the world of brute, external (objective) fact—so strong was this conviction that he used Le Corbusier's assertion that "the strongest of all is the poetry of facts" as an epigraph to his "Poetry of Standardized Utility" (1928).

A year before that note, Dalí had written "*La fotografía, pura creació de l'esperit.*" I suspect that photography is the last art which most people would consider the pure creation of the spirit; but Dalí was convinced that reality, as conveyed by the camera, is created through subjective interpretation, and that belief lay behind his use of double images, and formed the kernel of his notion of paranoiac-criticism.

Dalí also related the virtues of the photographic lens to its ability to make us see objects anew: "Knowing how to look at an object, an animal, in a spiritual manner, is seeing it in its greatest objective reality. But people see only stereotyped images of things . . . and they find vulgar and normal all that they are in the habit of seeing on a daily basis, however miraculous and marvelous it might be."[22] Dalí did not mean by this the commonplace idea that works of art encourage us to adopt a new experiential relation to objects, from which vantage-point we can see them in a fresh way. For he contrasted stereotyped seeing not simply with seeing objects in a new way, but with seeing them as "miraculous and marvelous"—and one who experiences an object as marvellous, he proclaimed, understands the role that one's dispositions and obsessions—and freedom—play in constituting the object that one sees: "Knowing how to look is a new system of spiritual surveillance. Knowing how to look is a means of inventing. And no invention has ever been as pure as that created by the anesthetic look of the naked eye, without eyelashes, of Zeiss. . . ."[23]

Dalí emphasized the ability of photography and film to reveal the marvels that inhabit ordinary reality—to show that surreality is not distinguishable from reality nor reality from surreality. At this point, Dalí maintained that photography reveals the marvellous principally by changing the scale of the objects depicted. Such change "provokes strange resemblances, unimaginable (though existing) analogies."[24] Dalí waxed poetic on the capacity of enlargement to reveal the marvels that inhabit our world of everyday reality.

> The clear image of an orchid, lyrically unites with the photograph of the interior of the mouth of a tiger, in which the sun forms a thousand shadows with the architecture of the larynx. . . . In the large and limpid eye of a cow, a small white post-mechanical landscape is spherically deformed, but remains precise as far as the sky in which float small and luminous clouds.[25]

Dalí also was quite taken with the fact that not only could the photograph apprehend surreality (the marvellous), it could do so without imagination playing any role. The analogies that photographs reveal, even though they actually exist, are unimaginable. Fantasy in photography, he claimed, is "born of . . . simple objective transposition."[26] The idea that photography gains an advantage by bypassing the imagination is also implicit in his claim that scale itself can render an object marvellous: the camera lens can capture a cube of sugar in such a way that it bears comparison to the most gigantic structure, and it can then be experienced as marvellous.

But Dalí soon came to doubt that a change of scale was enough to transmute a photographic transcription of reality into a revelation of the marvellous. Photography's role became subsumed in a more general effort to gain "knowledge of reality" ("*conocimiento de la realidad*"). In an article "Reality and Surreality," Dalí offered a revised understanding of the potential of photography, asserting that reality is a product of spirit, and that as intellectual processes had usurped the role of the spirit in creating aesthetic systems, the modern age had allowed reality to slip away. Works of art created through intellectual processes are unable to move us poetically, he claimed, because lyricism requires that the givens ("*datos*") of reality be perceived through our consciousness (our mentality). These *datos* give evidence of a surreality inherent in reality, a surreality that can be probed through free association and through other means of investigating the subconscious. Dalí saw patterns of meaning uniting the phenomena of the objective world—phenomena that, absent the apprehension of these patterns, appear utterly diverse. He sought for a means to assist us in seeing that diverse phenomena belong together in one coherent system—a means, that is, for acquiring knowledge of the ontological truths that make ontic truths possible—and believed that he had discovered this means in documentary, which he understood essentially as an inventory. Dalí concluded

that photography is the best means for creating this documentary inventory; in "La data fotogràfica," he stated that "Photography is able to realize the most complete, scrupulous and stirring catalogue ever imagined. From the fine detail of aquariums to the quickest and most fugitive gestures of wild beasts, photography offers us a thousand fragmentary images resulting in a dramatized cognitive totalization."[27]

Dalí even proposed that his paintings could be viewed as photographs. He defined painting as "Hand-done colour 'photography' of 'concrete irrationality' and of the imaginative world in general" and insisted that these images were systematically elaborated—to which fact the precision of his images testifies.[28] He proposed that just as the elaboration of hallucinatory paranoiac images constitutes reality (as we know it), so the analogous elaboration of hand-done colour images results in a picture of reality—that is, they possess the essential character of a photograph.

The idea is not so different from that which motivated Chambers to adopt his method of producing his "perceptual realist" paintings, which involved approaching the object by rendering it in greater and greater detail. In his 1969 article, "Perceptual Realism," Chambers described how he squared off the "foto" (he used the Spanish spelling) to provide a template for the painting. The product of the method was a painting that could well be described as hand-done colour photography.

While Dalí celebrated the photograph as a means for bypassing the formulation of a subjective image, Chambers celebrated the impersonality of photography and perceptualist painting (which is based on the photograph).[29] The schooling that Chambers received in Spain had enabled him to understand the value of not imposing a personal style on one's experience—of opening oneself up to what is given in experience.

> Before the camera was invented, painters developed a painting style to compensate for the lack of visual information available to them. A constantly changing scene with no way of freezing the instant offered the painter little alternative but to find some intentional means of expressing the unity he felt for the thing he was painting. Style filled the gap as it were, where the artist had no more specific references to go on. The personality of the artist conceived stylistic innovations that became his hallmark . . .[30]

For Chambers the photograph can transcend time, and render the time-bound timeless, and so can afford knowledge of something that is beyond the self and higher than the self: it is almost a religious conception of the photograph, similar to that propounded by the young Salvador Dalí.

The various methods Chambers would employ over the years for incorporating the realism of photographs in his paintings are means for revealing the marvels that inhabit reality. Just as Dalí was quite taken with the fact that photography can not only allow us to apprehend surreality but do so without imagination playing

any role, so Chambers was fascinated with the way the styleless painting, based on the objectivity of the photograph and bypassing the lyrical ego, could evoke the mysterious. Just as Dalí understood that the documental character of photography and film could be pressed into serving Surrealist interests, Chambers, too, used "the thousand fragmentary images" of the real world to create forms that hold seemingly diverse elements in a resonant unity suggesting "a dramatized cognitive totalization."

To counteract the "slipping away" of the spirit from modern aesthetic systems, Dalí stressed the objectivity of the photograph, which (through an extraordinary linking of ideas) he saw as the product of a species of automatism. Chambers offered a similar view:

> The grey, dull scene may have impressed the sensibilities with an equivalent impact to the sunlit, contrasty one, but the short-circuit occurs where the mind interprets the impact as something it doesn't like or even something it does like *because*. . . . *Because* is the mental process of aesthetics, at whatever level of sophistication, where kinds of appearances trigger conditioned aesthetic responses to fade out an otherwise potential perceptual impact. The impact on the perceiver looking through the visible to a general vision-awareness of the whole will register impartially an experience because it is not intercepted by the mind. The aesthetic concern converts and manipulates its *own* energy according to its particular needs. The spontaneous and primary nature of perception cannot speculate in values.[31]

In tying Chambers' ideas so closely to those of the Surrealists, I run the risk of making it seem that Chambers derived his ideas about art-making from the Surrealists. I do not believe that he did. Mediocre artists copy; major artists assimilate a world-view, a spirit, and a philosophy. Superficially, Chambers' works do not resemble any Surrealist paintings (either of the automatist or the veristic variety), but they do embody a conception of reality very close to that of the Surrealists. Chambers' perceptualism also strove to present "the object" in its splendour, not as an external, independently existing being, but as a being that fuses objective and subjective attributes. What accounts for this similarity between the two conceptions of the object? The answer lies in the shared understanding of a quality of presence, and of its effects. The Surrealist "object," the marvellous object, is also apprehended as an irreducible particularity that surpasses representation as a general being;[32] and yet its being is equivocal. The object is a spatial object, but its presence, because it exceeds all concepts, is nowhere. It is both an object in space and an object whose being exceeds spatial location. In its latter aspect, its being resembles that of a representation: like a representation, its being is deferred—in order to apprehend it, a subject must refer the object to a concept or to a sign. This deferral

dislodges the object from its spatial immediacy and relocates it in another place, in a scene of "absence."

Thus the Surrealist image/text is enigmatic because it is characterized both by meaning (presence) and the lack of meaning (absence, because the key to the text is hidden away, absent). The relation of objects in early Chambers paintings is similarly inscrutable (as are *Mosaic, Hybrid* and *R34*). Like the Surrealist image/text, their presence is haunted by an absence, for it is a representation that substitutes for the "unrepresentable" lost object.

This dual existence has something of the character of the uncanny, inasmuch as it resembles the dual existence of those enigmatic productions, hallucinations and daydreams, whose "other scene" is the unconscious. The representation embodied in a Surrealist object (like representations in consciousness) are generated, much like hallucinations or daydreams, in a place and by an agency that is quite unknown (except through its effects).

The Surrealists were not alone in their interest in the paradoxical absent presence (and present absence) of objects that are invested with the lure of the unrepresentable. The distance that separates representations (and knowledge) from origins was an important theme of late-nineteenth- and early-twentieth-century thought. The Freudian unconscious, for example, is a hypothesized absent Other, which can never be made present. The practices of psychoanalysis (free association, dream analysis, the experience of transference) are practices that try to discover evidences of the operations of the unconscious in the traces that the unconscious leaves in conscious thought. Further, Freud's account of the formation of the ego (*das Ich*) depicts the ego as an absent presence. Freud claimed that ego constitutes itself by distinguishing itself as a unique and particular object, different from other egos. Thus, the self constitutes itself as and through *difference*, and so its very being relies on absence—on the lost object or the impossible "real"—as its foundation and support. A third piece of evidence of interest in the absent presence is Marcel Proust's *À la recherche du temps perdu* (1913–27), which is concerned with the process by which memory converts immediate experience into an alienated form characterized by absence. That novel's hero, recalling his past, turns "absence" into a represented—and re-presented—presence. The agency that represents—and re-presents—this new presence is the virtual reality of *logos*, of language and of "writing."

Language is central to the means by which the Surrealists produced the effect of an unreal reality (and a realistic unreality), of an absent presence (and a present absence). There is a parallel to this in Chambers' work: language has a forming role in his paintings. For if Chambers' idea of perceptualism is based on transcendence of consensus reality, and the experience of an enhanced reality in the "splendour of its essential namelessness," then we must equally recognize the converse: that his paintings, because they must depict the objects of consensus reality (even while they strive to provoke the experience of a higher realm), must render nameable objects—

indeed objects whose nameability is part of our experience of them. Chambers' paintings and films confirm this conjecture, for they make the force of language apparent: we see the woman with the daisies in *Mosaic* as "the spirit of feminine nature" and the old man as "death." We experience the individual images that compose the work as symbols belonging to a language for which no Rosetta Stone has been identified.[33] Surrealist art is likewise an art of an extremely *literal* character.

The Surrealist object had filiations to the unconscious—that is what gave it its power. But the realistic image in Chambers' art has similar filiations, and is equally troubling. Like the image in the works of veristic Surrealism, the realistic image in Chambers' work is that of the familiar, the domestic, the homely; nevertheless, it is invested with the power of something that disturbs by its unknowability. More than the "merely given," it occupies our inner recesses, and testifies to something we cannot know. Its temporal condition disturbs us with the power of the *unheimlich*: like a phantom pain, it testifies to the past—indeed can seem preternatural—even as it has a mysterious effectivity in the present.[34]

Chambers' Spanish training perfected his ability to make an accurate likeness of reality—but a simulacrum was not what he was after. He realized that, as he put it, he wanted a sense of participating in a "fellowship with essence." Ross Woodman, in an interview, asked Chambers if he considered himself to be a realistic painter. He replied,

> Yes, but I don't paint an exclusively visual reality. The visual is only one aspect of an experience. Each sensory organ records reality in its own way; a smell, a sound, temperature, texture, a landscape can reawaken their own image of an experience.[35]

The statement alludes to synaesthesia—a phenomenon that also interested the Surrealists. But ideas about synaesthesia are diverse, and we would do well to establish a more precise understanding of Chambers' conception of synaesthesia, the constructive notion of perception he relies on, and his explanation of how the "foto" illustrates the constructive character of perception.

Chambers treated perception as a form of *poesis*. The idea that sensation is an active, radically synthetic process had enormous ramifications for his perceptualist theories and practices. He remarked:

> A painting gets put together just like an experience—in particles. *Olga and Mary Visiting* [1964–65] isn't the description of a visual moment; it's the accumulation of experienced interiors brought into focus. . . . You are in a room, then in another room where you see an object being held this way, then you see it in motion, a week later a cup is tilting, the next day a finger curves in the air against a background, you hear a little clink, you swallow a cheese sandwich,

something fragile, a cup touches its saucer, you see white . . . a woman rests one leg over the other, pink . . . the thick rug is buff-orange. Sense combinations complement one another to enrich perception.[36]

These comments on *Olga and Mary Visiting* can be read as a statement of the homology between film form and perception. Chambers saw significance even in the fact that film is composed of particles—frames—that are put together to produce an encompassing experience of something that belongs to a higher, dynamic realm. Chambers' concerns with light, memory and the synthetic character of all perception fed his interest in photography. But the cinema offered an advantage that neither painting nor photography could convey so thoroughly: it could *show* a perception being put together in parts, synthesizing immediate *qualia* with information derived from memory and imagination. The structure of *Circle* reflects a similar idea, in which very short shots (that suggest frames) accumulate to produce the impression of flux, and of what holds that *fluxus* together and makes it a whole, just as the days accumulate into the pattern of a year.

Much of the art that Chambers produced from the time he returned home to London was imbued with Surrealist attributes. The film *The Hart of London* raises these Surrealist concerns to a new level. It exploits the capacity of photography that Dalí had recognized: "Photography is able to realize the most complete, scrupulous and stirring catalogue ever imagined. From the fine detail of aquariums to the quickest and most fugitive gestures of wild beasts, photography offers us a thousand fragmentary images resulting in a dramatized cognitive totalization."[37] Chambers' original idea for the film was as a Dalíesque compendium of "a thousand fragmentary images." To this end, he solicited home movies and snapshots from all Londoners.

The procession of spectral human forms that make up the extended sequence formed by these home movies and newsreels near the beginning of *The Hart of London* evokes a feeling similar to that often created by Surrealist art. They, too, seem to be ghostly forms, and one may well feel inclined to exclaim about them what a poet, observing the commuters in another London, remarked,

Unreal City,
Under the brown fog of a winter dawn,
A crowd flowed over London Bridge, so many,
I had not thought death had undone so many.
Sighs, short and infrequent, were exhaled,
And each man fixed his eyes before his feet.[38]

T. S. Eliot's image of a procession of Londoners all undone by death is virtually repeated in *The Hart of London*. Chambers' London, too, especially that depicted in

The Hart of London

the first third of the film, is an Unreal City, whose citizens are haunted by death. Altogether, Eliot's lines convey the awe, the dread, that Eliot's fellow Londoners inspired in the poet, as though he knew that all were not just doomed but, to all intents and purposes, were the living dead. This is how, in his illness (Chambers made the film while sick with leukemia), the residents of London seemed to him, too.

Eliot's lines, among the most famous in the twentieth century, offer an allusion to Dante Alighieri's *Inferno*.[39]

E dietro le venìa sì lunga tratta
di gente, ch'i' non averei creduto
che morte tanta n'avesse disfatta.

Poscia ch'io v'ebbi alcun riconosciuto,
vidi e conobbi l'ombra di colui
che fece per viltade il gran rifiuto.

(3:55–60)

As well as to Baudelaire's

Fourmillante cité, cité pleine de rêves,
Où le spectre en plein jour raccroche le passant [40]

Chambers' ideas on perception and what he called "perceptualism" are directly relevant to this film. The excerpt from *Red and Green* that Chambers selected for his autobiography begins:

> *Perception* in process is like watching a movie. Suddenly the spectacle freezes and loses focus. The sound dissolves. The defocusing spreads, brightens in a flash and becomes white light in the mind. All in an instant: Act one.
>
> This mute, imageless, invisible phenomenon then almost immediately is accompanied by a shadow, an emotion, a vital awakening whose intrusion heralds the shift from this creative centre to the process of conceptual knowing: Act two.
>
> Here the focus returns, the sound resumes and the film is moving normally again. The moment of "white light" is the moment of *perception*. Experience is the shadow or the emotion pointing outward. It is the frame returning to focus.[41]

The text outlines the structure of *The Hart of London*: it begins with the moment of "white light," proceeds to ghostly images—shadows that evoke an emotion, a "vital awakening"—and proceeds to the perceptual experience (which in the same text Chambers describes as "the flow into the 'simple' senses and into consciousness of

perceptual nourishment."). The film describes the way the past—memory, the interior realm, the subjective—gives way to the present, to the sensation of the objective realm. In *Red and Green* Chambers goes on to say that perception "is the gestalt 'sense' of the simple senses themselves—the 'spiritual unity' of these simple senses."

Chambers believed that what is disclosed through synaesthetic perception is a higher reality: what Breton called "a kind of absolute reality, a surreality." The Surrealists based this conception in part on spiritualism (in its French version, *spiritisme*). André Breton told André Parinaud, an interviewer for RDF, about the Surrealists' early experiments with induced hypnotic slumbers, and spoke admiringly of

> F. W. H. Myers's beautiful work, *Human Personality and Its Survival of Bodily Death*; or Théodore Flournoy's exciting accounts of the medium Hélène Smith in *From India to the Planet Mars* and . . . certain chapters of the *Traité de métapsychique* [Treatise on Metapsychics] by Charles Richet.[42]

Parinaud remarked: "I have trouble imagining you lapsing into spiritualism . . ." Breton's answer is telling.

> Of course not, far from it. We were deeply suspicious of everything that came under the heading of spiritualism, which since the nineteenth century had claimed a large portion of the marvelous for itself. More specifically, we flatly denied the tenets of spiritualism (no possible communication between the living and the dead), all the while maintaining a keen interest in some of the phenomena it had helped bring to light.[43]

Chambers, too, drew his ideas about this higher reality at least partly from the occult tradition. He stated that "[f]rom the time that I began to think *perceptualism*, I accumulated notes both of my writing and writings from other disciplines such as aesthetics, science, politics, the occult, philosophy and religion. . . . These disciplines speak in their own manner about intuition, which I consider to be the core of *perceptualism* as well."[44]

In *Red and Green* he offered an emanationist view of reality, according to which material reality descends from light:

> The ancient sages, ascending to the unknowable, made their starting-point from the first manifestation of the unseen, the unavoidable, and from a strict logical reasoning, the absolutely necessary creative Being, the Demiurgos of the universe. Evolution began with them from pure spirit, which descending lower and lower down, assumed at last a visible and comprehensible form, and became matter.

As the heterodox do, Chambers believed that evolution can reverse this descent: "A stone becomes a plant, a plant an animal, an animal a man, a man a spirit, a spirit a god."[45] Too, he conceived of the higher reality as flux, movement, dynamism, just as the heterodox do.

> The photo broadens the field of memorable events and isolates that moment of our emotion's response to that *something*, which, from among the chaos of the shifting lights and shapes, persistently escapes our concentration. It does away with memory and sketches. . . . For the artist, the photo participates in the present only by virtue of its ability to remember the look of the emotion that was quickened in him by something outside himself.[46]

"The chaos of the shifting lights and shapes"—that pretty much describes the content of *The Hart of London*.

In *Red and Green*, Chambers quoted from C. G. Jung; laid out the psychological basis of extrasensory sensory perception; proposed that humans are telepathic by nature, for nerve impulses travel outward from the body, along external nerve pathways, in much the same way that they travel inside the body; (at several points) quoted comments about the astral body and causal body; included a reference to the fourth dimension; described several séances; speculated on the possibility that souls could exist without bodies; and opined that along with the expansion of their physical vision, humans have experienced through their evolution outcrops of profound insight, extrasensory perception, direct apprehension of a supra-animal reality through a supra-physical, supra-temporal awareness. Chambers even cited the deeply Gnostic idea that the fundamental cosmic reality is a creative principle that has been called variously "astral light," "aether," "fire-mist," or the "principle of life," and that this creative principle formed the sun, the stars and satellites, determining their emplacement by the immutable law of harmony, and populated them with the various life forms.

He also quotes at length a passage in which the Russian painter Kasimir Malevich expounds on the ideas of Georgei Gurdjieff, the teacher of "the miraculous." This tradition holds that the central core of reality and experience is an unknowable, unrepresentable energy, and that its periphery is inhabited by more concrete, definite forms. Thought, too, for Chambers is energy, luminous at its core and more indefinite and spectral at its peripheries. The application of the metaphor of centre and periphery to both experience and reality suggests the identity of the two. Here are a pair of passages from *Red and Green* that testify to the central place these ideas had in Chambers' thought and practice:

> The painter, whatever he is, while painting practises a magical theory of vision. He is obliged to admit that the objects before him pass into him or else

that, . . . the mind goes out through the eyes to wander among objects; for the painter never ceases adjusting his clairvoyance to them. . . . He must affirm . . . that the same thing is both out there in the world and here in the heart of vision—the same or, if one prefers, a similar thing, but according to an efficacious similarity which is the parent, the genesis, the metamorphosis of Being in his vision. It is the mountain itself which from out there makes itself seen by the painter; it is the mountain that he interrogates with his gaze. What exactly does he ask of it? To unveil the means, visible and not otherwise, by which it makes itself a mountain before our eyes. . . . The painter's gaze asks them [light, shadows, reflections, colour] what they do to suddenly cause something to be and to be this thing, what they do to compose this worldly talisman and to make us see the visible.[47]

And more remarkably yet:

In a very real manner, events or objects are actually focal points where highly charged psychic impulses are transformed into something that can be physically perceived: a breakthrough into matter. When such highly charged impulses intersect or coincide, matter is formed. The reality behind such an explosion into matter is independent of the matter itself. An identical or nearly identical pattern may re-emerge "at any time" again and again, if the proper coordinates exist for activation.[48]

I do not want to leave the impression that the occult tradition was the source of all Chambers' metaphysical, religious and aesthetic ideas. Catholicism played an important role in his art, as it did in Surrealism, though unlike the Surrealists Chambers did not feel it was necessary to adapt his beliefs to suit a modern, secular age. Chambers' Catholicism was essentially traditional.

Many spectators have been quite baffled by the mode of experience that Chambers' work invokes—and especially that of his masterwork, *The Hart of London*. What the superimpositions in the film allude to, precisely, is that the objects we see are only a shadow of what is disclosed in true perception; as experience loses truth its object becomes more material. The experience that Chambers referred to as "perception" is a rare and profound mode of experience. This is a truth that the Surrealists also knew.

On November 15, 1971, Chambers wrote a letter to Father Ambrose McInnes, a childhood acquaintance who had become a member of the Order of Preachers (a Dominican) and (late in the artist's life) Jack Chambers' spiritual adviser. He described an experience of mysterious light that he had in 1969, in London's Victoria Hospital. It was just after he learned, while making the film *The Hart of London*, that he had leukemia.

The following night was Sunday, and I lay back about nine p.m. to prepare myself for another night. It was darkening fast and the trees had already become black shapes. I looked to the wall at the foot of my bed and felt myself begin to sink to the dread reality of dying. My consciousness which before had been flying desperately against the bars of its mind no longer struggled to get out. It was stilled by the approach of its imminent annihilation and braced itself as we sank. My only grasp at life was to repeat over and over: love Jesus, love . . . love Jesus, love. These were the last words of a dying man who nevertheless did not want the life he had known or the death to which his life had brought him. Suddenly but altogether gently there appeared in front of me "on the wall" a round glow of light that grew instantly to the size of a volleyball. The circumference was frayed and luminous and not sharply defined. At the bottom left of the glow were the capital letters LIFE and at the bottom right were the capital letters DEATH. When the glow increased the peripheral brightness obliterated both words. Its presence brought me upright in bed in a bolt of instant and all-pervading joy. It was fused with love. In fact there was no "I", only love. . . . I had been annihilated in the light of love along with LIFE and DEATH. Caught up and infused with that love I knew that this was *life* that never died; that I was now alive in a way that would never die. . . . Life was a temporary dream from which I had been suddenly and gently awakened into Reality. [49]

The sense of the loss, or estrangement, of the self—Rimbaud's sense that "Je est un autre"—and the belief in a higher reality, which reconciles the opposites of life and death in a marvellous realm that perdures, are fundamental to Surrealist theory and practice, as they were to Chambers' theory and practice. The vision of the fusion of life and death on a higher plane—this mental vantage-point from which life and death "are no longer to be perceived as contradictories"—is a very Spanish view. It is connected to the idea of sacrifice, of a death that guarantees life. Chambers deliberated on the idea of sacrifice and the role it played in transforming darkness into light, using a colour photograph that he had shot while visiting a slaughterhouse in Chinchon, Spain. It is very much like that image of the slaughtered lamb that appears in the film *The Hart of London*. The lamb lies on a table (we can think of it iconographically as an altar), blood flowing from a wound in the neck—considered iconographically, it represents the Lamb of God whose blood washes away the sins of the world.

Thus, the final words Chambers wrote in a letter to Father MacInnes were:

Perhaps even with the sickening failure of my life, and as I see how I fail each day, these failings in faith may become the seeds of humility disposing me more to God's love. I ask God through Jesus Christ to crush my will and mill it into the brightness of His love. [50]

The Surrealists would probably not have been too sympathetic to Chambers' working out his salvation within the Roman Catholic Church; but they surely would have recognized the desire to experience the abnegation of the will, so that brightness of a love from beyond might fill one's inner being.

Notes

1. Michael Riffaterre, *La Production du texte* (Paris: Seuil, 1979), 223.
2. If indeed there is a line: Michel Sanouillet and some art historians argue that "surréalisme" is simply the name a group of artists living in Paris took when they organized to create a French art movement based on German (Dada) ideas—that *surréalisme* is simply French Dada. The view has quite a lot to recommend it.
3. The example of the image of the African village that could also be perceived as an African mask is Dalí's favourite example of what he calls a double image. He writes
 The way in which it has been possible to obtain a double image is clearly paranoiac. By a double image is meant such a representation of an object that it is also, without the slightest physical or anatomical change, the representation of another entirely different object, the second representation being equally devoid of any deformation or abnormality betraying arrangement. (Salvador Dalí, "The Stinking Ass," Harrison and Wood, *Art in Theory 1900-1990*, 479).
4. The film is structured by a theme of assembly—one sees Curnoe and the Nihilist Spasm Band setting up for a performance and Curnoe working on a painting. As for the Surrealist affinities of these ideas, one might recall Wallace Stevens' reason for not liking Surrealism: poetry should step toward the unknown, he explained, while Surrealism is a collage, a shuffling of the familiar.
5. But film is the art that best exemplifies that—for the experience of a completed reality (a movement) in film is assembled from individual frames. The impressive flicker passages in the film also highlight this, as well as insisting on its character as an assemblage.
6. Curnoe himself raises a related point in the film with the colourist painting in schematized breast-shaped form with the word "tit" near the tip.
7. André Breton, "Manifesto of Surrealism" (1924) in André Breton, *Manifestoes of Surrealism* (Ann Arbor: University of Michigan Press, 1969), 14. It is exactly that sense of the marvellous that Chambers takes up in the masterful film *Circle*: that film concerns the mysteries of flux and endurance, and goes beyond "consensus reality." But it is the final section of that film that has especially strong affinities with the Surrealist tradition. Here again, as in *Hybrid* and *Mosaic*, Chambers offers a very enigmatic passage to demonstrate how experience gets put together in pieces. But I have dealt with that film at length in *Image and Identity: Reflections on Canadian Film and Culture*, and I do not wish to cover that same ground here.

8. Jack Chambers, *Jack Chambers* ([London, Ont.:] Nancy Poole, 1978), 44.

9. Chambers connects his own realist work with Peel's in his autobiography (*Jack Chambers*; see note 8 above). He notes that Paul Peel and George Reid, unlike the Group of Seven, were examples of the classic realist style (120–22). Reid was a very prominent painter in Canada in the late nineteenth and early twentieth century (president of the Royal Canadian Academy [1906–9] and principal of the Ontario College of Art [1912–29]). His paintings are of the genre type and often done in the grand manner, though they later become more impressionist. Chambers may have been interested in his use of colour and light.

10. Chambers did include a lengthy—and very disparaging—reference (culled from Jacques Maritain, I believe) to Surrealism in *Red and Green*, a collection of quotations culled from readings in aesthetics, philosophy, religion and psychology bearing on the issues he had identified as central to perceptualism, along with his own interpolated commentary; none of the quotations is identified, likely because Chambers wanted readers to accept what the passage said as reflecting his own view. Chambers submitted a selection from *Red and Green* to the Canada Council, to support an application for funds to finish the project. That selection included the following quotation:

> When man seeking for his own inner universe takes the wrong road; . . . he thus finds himself wandering in a false kind of self-interiority, where wilderness and automatism mimic freedom. Such was the adventure of the Surrealists. . . .
>
> [Surrealists] have presented the result of thought activity anterior to the work, without concerning themselves . . . with establishing in the work any means leading to a dynamism of analogous thought in the mind of the beholder. It is one of the points where theory in the hands of the Surrealists has wronged artistic practice. (From pages 68–69 of Chambers' supporting material, author not identified.)

The accusations against the Surrealists enunciated here are that automatism does not lead to true interiority and that Surrealist works do not provide a means of inducing spectators to engage in the same thought processes that the artist engaged in to make the work. It is difficult to know how to answer the first objection, since in their use of collage Surrealists foregrounded the construction of the work, and did so exactly to encourage the spectator to retrace the thought processes the artist used in making the work. The second claim demands to be contested: not all Surrealist art was produced using automatist means, and the veristic Surrealist art avoided automatism (in the sense implied here) altogether.

It would seem that neither Chambers nor Maritain (if indeed the passage is by him) had a profound understanding of Surrealism in all its varieties. Still, Chambers may have been intrigued by Surrealist works and Surrealist practices that did not fit his preconception of what Surrealism is. That conjecture finds support in the fact

that after quoting the passage above, Chambers went on to endorse comments made by the Surrealist painter Magritte and the *metafisico* painter de Chirico.

11. The peculiar disjunction between figure and ground is explained by the images' synthetic character. For example, for *Olga near Arva* Chambers used a bright yellow field from a landscape around London for the setting, but incorporated figures (Olga and children) transposed from photographs from Seville.

12. Chambers would draw on Reaney's work again, for a film. In 1965, Reaney presented three marionette plays in a tent at the Western Fair that the city of London mounted annually—Greg Curnoe designed the sets and made the marionettes for one of them, *Little Red Riding Hood*. Chambers filmed a performance for his film *Little Red Riding Hood*.

13. Chambers noted that he "had never seen their works before and that included whatever had happened in painting since Juan Gris and Picasso." (Jack Chambers, *Jack Chambers*, 93). The comment reveals just how extreme Chambers' alienation from the norms of advanced artistic practice was.

14. Chambers, *Jack Chambers*, 96.

15. Ross G. Woodman, *Chambers: John Chambers Interviewed by Ross G. Woodman*. (Toronto: Coach House, 1967), 9.

16. Avis Lang Rosenberg, "A Correspondence with Jack Chambers." Letter from Chambers to Avis Lang Rosenberg, 9 July 1972, *Vanguard* 11, no. 4 (May 1982); 19.

17. André Breton, "Surrealist Manifesto" (1924), in André Breton, *Manifestoes of Surrealism*, 14.

18. Cited in Maurice Nadeau, "Love and Laughter: Surrealism Reappraised," in *The History of Surrealism*, trans. Richard Howard, introduction Roger Shattuck (Harmondsworth, Middlesex: Penguin Books, 1964), 22.

19. Jack Chambers, "Proposal to the Canada Council for a Senior Artist's Grant," 4.

20. Jack Chambers, selections from *Red and Green* provided as support material for his application to the Canada Council, pages 7–8. Chambers does not identify the source of the passage quoted, which offers a more passive view of the higher activities of the mind than the Surrealists would have endorsed—but of course the montage which Chambers' paintings and films offer also suggests a more active view of these mental processes than this passage conveys.

21. Chambers, *Jack Chambers*, 88.

22. Salvador Dalí, "La fotografía, pura creació de l'esperit" in *L'Amic de les Arts*, Sept. 1927, 28. Cited in translation in Haim Finkelstein, *Salvador Dalí's Art and Writing 1927–1942* (Cambridge: Cambridge University Press, 1996), 71.

23. Originally in "La fotografía, pura creació de l'esperit"; cited in Finkelstein, 70–71.

24. Ibid., 71.

25. Ibid.

26. Ibid.

27. Ibid., 73.

28. Dalí's remark is quoted in André Breton, "What Is Surrealism?" (originally a lecture) published in André Breton, *Qu'est-ce-que le Surréalisme?* English translation by David Gascoyne, in André Breton, *What Is Surrealism?* (London: Faber and Faber, 1934). Reprinted in Herschel B. Chipp, *Theories of Modern Art: A Source Book by Artists and Critics* (Berkeley and Los Angeles: University of California Press, 1968); the passage quoted appears on page 416.

29. Note that Dalí, unlike Chambers, celebrated lyricism. But the gulf between their positions is not as wide as it might seem. For Dalí, a key aspect of lyricism is its stress on perception as *poesis*—and Chambers shared that conception of perception. Moreover, Dalí adopted—and advocated—the use of creative methods that bypassed the formulation of a subjective image; but Chambers also used methods that allow the painter to bypass the subjective image and thereby to avoid the distorting tendencies of the lyrical ego.

30. John [Jack] Chambers, "Perceptual Realism," *Artscanada* 26, no. 136-137 (Oct. 1969): 7.

31. Ibid., 13.

32. Cf. Chambers' remark that "the object appears in the splendour of its essential namelessness."

33. It is equally true, however, that the relations among them are multivalent and plurisemic—this contributes to their capacity to provoke a sense of mystery.

34. This explains its character as a dialectical image (to use that term from Walter Benjamin).

35. Woodman, *Chambers*, 9.

36. Ibid., 11-13. Of course, Chamber's remark also conveys why he believed, as he stated elsewhere, that perception is fundamentally supra-temporal.

37. Quoted in *Dalí's Art and Writing*, 73.

38. T. S. Eliot, "The Waste Land," *Collected Poems, 1909-1962* (London: Faber and Faber, 1963), lines 60-65, p. 65.

39. . . . behind their ensign came so long a train
 of people that I should never have believed death
 had undone so many.
 After I had recognized some amongst them, I saw
 and knew the shadow of him who from cowardice
 had made the great refusal.

40. The opening lines of Baudelaire's "Les Sept Vieillards" (dedicated to Victor Hugo) in *Les Fleurs du Mal.*

41. Chambers, *Jack Chambers* (from *Red and Green*), 157.

42. André Breton, with André Parinaud and others, *Conversations: The Autobiography of Surrealism*, translated and introduced by Mark Polizzotti (New York: Paragon House, 1993), 60.

43. Breton, *Conversations*, 64.

44. Chambers, *Jack Chambers*, 128.

45. This and the previous quotation are drawn from support material for a Canada Council grant application (selections from *Red and Green*), pages 25–26. Chambers does not identify the source of these quotations.

46. Chambers, *Jack Chambers* (from *Red and Green*), 159.

47. Jack Chambers, support material for a Canada Council grant application (selections from *Red and Green*), pages 19–20. Chambers does not identify the source of the quotation.

48. Ibid., 21–22. Chambers does not identify the source of the quotation.

49. Letter printed as Appendix 1 in Val Ambrose McInnes, *To Rise with the Light: The Spiritual Odyssey of Jack Chambers* (Toronto: Ontario College of Art, 1989); the excerpted passage appears on pages 49–50.

50. In McInnes, *To Rise with the Light*, 52.

The Hart of London

The Hart of London:
A Document of the City

Stan Brakhage spoke at The Jack Chambers Film Project,
London, Ontario, March 11, 2001. This is the text of his remarks.

I'M HONOURED to be asked to come to Jack Chambers' home town and to be
part of this celebration of his work. I have never seen so many Jack Chambers
paintings together in one place, things that I know only through reproduc-
tions, and that is as great an experience for me as it is always to see his films. He is a
major mentor of mine. He was kind enough to credit me with getting him started
in film, principally I think through *Window Water Baby Moving*, a childbirth film
I made that he saw and that encouraged him to photograph the birth of his own
children or at least one child. And the interesting thing is, as Peter Kubelka said to
me a long time ago, when one artist inspires another usually you wouldn't really
know it unless they told you, because they so transform whatever it is they've been
inspired by. Surely his childbirth, which you're going to see tonight embedded
within this great epic film of his, is utterly unique and distinct not only from any of
the five childbirth films I made but from any such notion of childbirth as has ever
been made. It is unique in ways that are intrinsic to his making, that is to say that
the birth is interwoven with death, the upsurging of life is interwoven with the
clipping of it back, the stunting of its growth. And yet none of this is a polemic. As
I put it into words, it sounds far more terrifying and shocking than it is within the
film, because—as was the case within his larger areas of thought—such contrast
was the normal condition of living, that birth and death were in some sense at one.
When you are born you have set yourself up to die, or you have been set up to die,
whichever way you want to look at it, and only time will separate birth and death.

Time has a lot to do with the film we are going to look at tonight. It's a long
film in one sense and in another sense. Because of the mastery of his making and

the intensity of his feeling in the subject, it can occur or reoccur to you later, if you give it that chance, as if it all happened in an instant. Sometimes I think, and it is one theory of dreams, that they occur in a burst of synapting in our sleep. And in the morning we torturously try to weave them into a story, boring our mate or roommate or whoever is living with us by the telling of it, trying to drag out this burst of occurrences, with all these associations building up, so that really only a poet might begin to tackle a dream in language. And that I must say is how I take Sigmund Freud. I take him as a philosophical poet or versifier, that he could take his own dreams, as he didn't want all the time to intrude on the dreams of others, and posit them in such ways that they became statements of truth. Well, the film we are going to see tonight, this statement of truth, can be taken in a sense as a long dream which occurs, in a way, in an instant.

Now, there is a tactic here: I don't want to get too technical but I think it may help people be more conscious of what's happening to them as they're watching the film to know the tactic. In one sense this is a two-shot film with a framing device. That is, the first half is one series of occurrences that are all interrelated. And then as everyone quite naturally feels there's a shift somewhere in the middle to another kind of tactic, of series of making. And these can be seen as two distinctly different shots. There's one splice, you could say, in the middle of this film—it's a one-shot montage—but that shot is softened for us across a number of cuts in the middle as we're gradually segued over from the clipping, the cutting back and the pruning of bushes, into the birthing of the child, which then leads to all that follows including the sacrifice of the lamb, of the many lambs one should say, and all of the nightmarish oddities of people's, how shall we say, playing-at-God behaviour across the last part of the film. But this material was found footage to which he added very little. What he did add is what made it, what wove his findings into something that was *wholly* his. And I mean that almost in both senses of the word, the entirety of it being his and the holiness of it. For it's not fashionable these days, in fact people are skittish about religion being discussed in public places, particularly in relationship to the arts. But all the same, you certainly cannot deal with Chambers without recognizing the deep importance to him, and the holiness, of his Catholicism. And so it's not enough just to say "spirit" over all of this as we do. One has to understand it in relationship to Catholic masses, to great Catholic Church music, the sacrifice of the lamb to Agnus Dei, rather than to think of it as brutal documentary footage—which it also is—of things that are almost impossible to watch.

There is a long beginning to this film, which is the root, which gives it its title. A hart, a deer, but also a heart, gets loose in London. That's also the Sacred Heart, that's also just a deer as the film presents it on the screen, loose in London, Ontario. And these two terms reverberate mightily because this loosing of the hart, of animal *spiritus*, into the nightmare of the city is the absolute centre from which this whole work spreads, which this man comes to be making when he knows that he

is dying of cancer. And he's fighting it in every way he can, all-vegetable diet, going back and forth across the United States to Mexico to get laetrile, struggling to see his way through to his children being grown, to stay with his beloved Olga as long as possible. But not fighting out of some clutching at life on earth. For always in his making, in his paintings and films, there is a loosening of the ties of the bond of material earth. There is a recognition of it which cannot be avoided as a human condition, which is essentially at the very least peculiar and at the worst absolutely nightmarish. But he presents it not as a diatribe, as if he had something to tell us, but within the forms of an art.

None of us are going to live long enough, nor has film been around long enough, to know whether film can be an art. But the desire that it be so, the wish to make an art of this medium was certainly his as it is mine, and as it is also the wish of a very small but very enthusiastic and insistent band of people who have loved all the other arts. The arts shake us mightily, particularly when they are new. They also are the greatest comfort that humans have. They permit that aesthetic distance so that one can see one's condition and the conditions of those around one and find it bearable, and enlightening and even beauteous. To stand at the lip of Hell, as Jack Chambers does again and again and in as many ways as he did as a cancer patient across all those years, and see the beauty, to stand looking at a commercial street in your city and see it as beautiful is no easy thing to do either. For you yourself know, and I'm not here to chastise you because my grounds are even worse than yours, we have cluttered the landscape with trash. And why have we done this? Look to the foolish faces. Look at the grins on these hunters in this film—that was found footage, mind you—as they stand beside the dead bodies of all these slaughtered deer. They're raked with some certain knowledge of what they've done but they do not have the slightest idea of why they've done it. So in some awful, awesome embarrassment which he found and rescued for us, we see something of the terrible human condition in our time.

But then there is also this. Where I most in my making think of him it is as the master of the superimposition. Now superimposition is where you take two pictures and you impose one over the other. In old cameras this was usually a mistake. It meant someone hadn't shifted the film forward so that you got two pictures, one superimposed over the other picture. And in film sometimes this happened when someone took a roll that they thought was unexposed and ran it through the camera again and got double imagery. When this happens it's usually a mess. It looks so exciting that people can't tell that it's a mess. So it flourished in the arts because it's just so busy, no one can tell whether there's anything sensible going on there or not, unless you're involved deeply in vision. You can get away with a lot of hanky-panky, but Jack Chambers never did.

When two things are superimposed and one is going this way and the other is going that way it's *contra naturum*, it's against nature as such. The eyes don't work

that way; not even if you're hit on the head do they work that way. They don't work, therefore the mind's eye doesn't work that way either. It's practically impossible to create such an imagery, with such disparity of movement, by closing the eyes. What does work is when there is enough relationship of shape, one shape to another in one scene and especially enough relationship in rhythm and direction, that it looks like what the eyes might see if they were seeing double. They wouldn't see things going like this [*hand gestures suggesting opposing movement*], they would see them going like this [*hand gestures suggesting parallel movement*]. His tactic for that was to superimpose the negative and the positive of the early scenes of London that he's showing. And when he does that he is also approaching what in still photography is called solarization, where you put a negative image over a positive of it and you print it. You get a kind of depth that's quite exciting. Like bas-relief, one image seems to stand out from the other. In most cases, that would be the negative image, through which the purest light from the projector comes. And in the other, the positive image, the light is being blocked by a horse, let's say, or a biscuit factory or a businessman or whatever. And the one image really begins to feel constantly spiritual and the other begins to feel, to me at least, weighted. But the two are intrinsically tied together here on earth and move in consonance with each other. And then there are superimpositions that are quite different from these. But when Chambers doesn't do this solarization or this negative/positive combining, if he puts two positive things together or two negative things together, or disparate scenes, you'll note that it acts according to the way the eye can actually see.

The reason for this spiritually is the statement that the spiritual and the physical represented by these things are integrally bound. Sometimes, it's totally a white, white world, where almost everything is wiped out by superimposing a lot of light shot again with another light shot. We approach at this point almost a break with the world, something that he must have been feeling again and again while he was undergoing chemotherapy and other therapies in his struggle to survive his cancer. So there's a push in the whole first half of the film to comprehend the animal life coming into the city and that being so horribly disruptive, leading to the slaughter of the animals. His way of recognizing it is the many images of human beings that reverberate over them. Even little children in the happiest of motions are seen to be made something de-animalized, dehumanized actually, in the clutches and the traps of the ugly architecture and the ugly endeavours and the ugliness of the slaughter of life.

I don't want you to think that I am coming here to chastise you for the ugliness of your architecture. In my country it's far worse, on average. But merely to say we've got to recognize the critique that was going on here. My words sound too harsh and heavy, but in the film, the critique is balanced, as in an art, so that it is said with love. It's the friend that can tell you the truth. And those who are sensitive and

The Hart of London

who listen and attend will know what's being done. And they can be, I believe, and Jack Chambers certainly believed, inspired enough to change it. And there's no other reason to make an art. Why would you make an art when during your life-time people are going to pay almost no attention to it and it's going to cost a lot of money if you're a filmmaker and even get you in trouble if it is shown publicly. The only reason is you wish to leave a trace that's balanced enough, integral enough, that it can last and actually effect human change. But at the same time, while Chambers would have changed things on earth, he could see things quite clearly and he did so with a sense that this is only a passage, a magnificent passage, and one into which he wanted to and did bring children.

He's moving always toward the spiritual delight after life and in the meantime, along the way, he shows every conceivable foolishness. And look, just to name a few things. People are trying to do a nice thing; they are taking birds around and giving them to people at Christmas. And they present this bird to this mentally disabled person who is terrified of it and the bird is terrified of the human and both the bird and the person recognize what's happening but everyone else in the room including the photographer seems to be oblivious. Only Jack Chambers wasn't and you have a chance not to be, though I've been where many audiences don't get it either. They think it's cute that they're inflicting this unwanted gift, or they think it's sweet that people have made these grotesque, huge, ugly flowers, that they're beautiful, and to protect them they've put umbrellas over them. Let's face it, you're entering a world wilder than Brueghel's. And it is not ordinarily seen as such because people are so used to reading this as if it were home movies—"Oh, look at that, he's swimming the river in ice-cold weather." He probably died of pneumonia the next week. And Jack Chambers has got the footage and is show-ing it to you. Such incredible madnesses, constantly. Physically harmed people doing Olympic-type games in sacks. It's just endless, just endless signs of despair. And in the midst of it, the most painful. This is no slaughter of the lamb, no sacri-fice that has the animal standing there looking like he just wanted to be sacrificed and smiling out from the great Jan van Eyck painting while a discreet little spurt of blood comes from his neck. This is a horrid, awful way to die. Bleeding these ani-mals to death, the others knowing what's coming to them. You cannot be a lordly human being and think animals don't feel things, and not see the terror on the faces of these creatures like Jack Chambers did when he photographed them. He doesn't rub our noses in it, he presents it. These are the stillest, the most straightforward images in the entire film.

Then there is the ending. He's out in the park with his beloved Olga, and Diego and John as little children. And it's in a park made for deer, where you can go up and touch the deer. You don't chase them down the streets any more, you just put them in a park and the little children can go and feed them things. Meanwhile they

have these big, prickly, dangerous horns. To entrust your child to this is . . . I know, I know. And I think Jack was fully aware of the risk to the children. He's the father, after all, and he loved these children so. And you have this incredible ending, that no one can ever forget once they've heard it: "You have to be very careful, you have to be very careful." That's the full verbal message of this great film. It's one of the greatest films ever made. If I named the five greatest films, this has got to be one of them. Thank you.

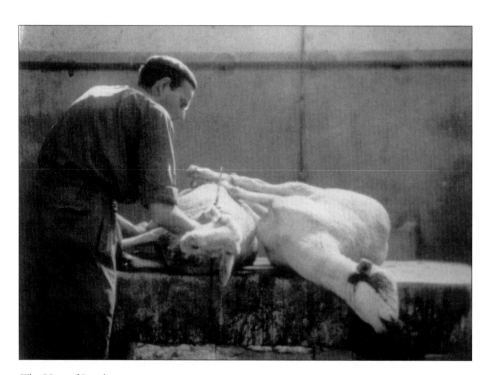

The Hart of London

AVIS LANG

The Hart of London:
A Film by Jack Chambers

T HE YEAR 1967 was the watershed of the first decade of Jack Chambers'
career. The severely flattened, handsome, icy and fastidious silver paintings
of 1966–67 had brought Chambers to an aesthetic cul-de-sac, a feeling that
his painting was no longer "surfacing by itself"[1] as it should. He began to feel the
need to reach back into the world and touch things, to start again, in a sense, at the
beginnings of experience. He even seriously contemplated apprenticing himself
to a Spanish woodcarver, a friend whom he had come to know while scraping
through life in Chinchon during 1959–61. He temporarily stopped painting (as he
has recently done again) and began instead to do graphite drawings of common
things such as the family chest of drawers. But Chambers also at this time deci-
sively turned to film, two films to be exact, both unequivocally rooted in human
life and born of human events: *R34*, a "creative documentary"[2] on his friend and
fellow London artist Greg Curnoe, and *Hybrid*, a discreetly horrifying document
on the mutilated children of Vietnam. This was the period during which Cham-
bers became not simply a painter, but an artist for whom different media could
travel different roads. Although he continues to be regarded as a painter—and
more specifically as the-man-who-did-a-picture-of-his-two-kids-watching-TV-
and-sold-it-for-the-highest-price-ever-in-Canada[3]—he has in fact built up a pat-
tern over the past half decade or so of expending significant and at times comparable
energy on drawing, writing and filmmaking, not to mention the organizational
demands of Canadian Artists' Representation (CAR).

Chambers' films have tended to be more structurally avant-garde than his other
works, and his friendship with Michael Snow (whose "radical, difficult" 1970–71
film *La Région centrale* was termed "the best film I ever saw" in a two-part article
devoted to it in *Artforum*, in the November and December issues of 1973[4]) must cer-
tainly have contributed its force to this fact. At times Chambers' conceptualizations

and ambitions in film have outrun his production. In December 1972 in the English periodical *Art and Artists*, he published a long article on his current work and ideas, "Perceptualism, Painting and Cinema";[5] the "cinema" referred to *C.C.C.I.*, which was not actually completed at the time and has since been set aside for rethinking. But Chambers has made one film that can stand with Brakhage's *Scenes from Unde Childhood* as an analogue for the most elemental levels of perceptual experience and learning, and with Frampton's *Zorns Lemma* as a carefully constructed, cosmic and poignant poem on life-as-a-whole. It is *The Hart of London*, composed during 1968–70, contemporaneously with *La Région centrale*.

The Hart of London is Chambers' major film to date, structured with the aim of effecting a profound emotional and perceptual transformation in the viewer and rendering him or her newly capable of participating in the mystery of totally ordinary life in a world where "[e]verything is being . . . everywhere there is being and nothing but being,"[6] a world where "there is not a human word, not a gesture, even one which is the outcome of habit or absent-mindedness, which has not some meaning."[7] It is a world of earth, air, fire and water, and there is so very much water. It swirls and envelops and covers and gives life and gives disaster and recedes and flows unceasingly, water inside us and water everywhere around us, the water-falls and the brooks and the deep pools and the vessels of tears and the lazy ponds and the slow quiet streams. Blood and water and spit and shit. The sense of life flows everywhere in fluids of all kinds. The leaking shit of a newborn child is inter-cut with the spurting blood of a dying lamb. Endless transformation, proliferation, evolution and flux. Clusters of maple keys in mid-season freshness, not ready to drop or generate, are juxtaposed with the very young Diego. At the beginning is the capture-by-killing of a wild hart that had entrapped itself in the back lanes of London; the initial sense is that the nature of man is against nature. But the film ends in a type of unambitious yet loving and respectful union with nature, in the personae of Chambers' young sons, Diego and John, hesitantly feeding nuts to the deer in a children's zoo. The last frames are given over to another kind of union, the continuity of the elements above and beyond the activity of humankind. The camera pans down the peaceful Thames again and again; each time, it arches into the high clouds, from earth to air through water. Between the beginning and the end are hundreds of human and natural events, sensations and images, reflecting the billions of experiences that living things undergo on their way through the world.

The Hart of London is a very difficult eighty minutes (others of its type are far longer); much of it is exhausting, disorienting and nerve-racking, verging at moments on the unbearable. There is extensive use of montage, of repeated cut-ting back and forth, of in-and-out focusing, and of two-stage superimposition of otherwise identical positive and negative footage, proceeding in opposite direc-tions and occasionally lapsed by a few moments.[8] Much of the footage is old news-reel film from the archives of CFPL in London, newsreels being an unparalleled

source of images of the human tragicomedy. One rapid-fire, almost indecipherable section in the first reel is simply scores of common snapshots that Chambers solicited through an ad in the *London Free Press*;[9] there are faces and faces, gestures and events. Most of the remainder of the film, perhaps half, was shot by Chambers himself, ranging from sheep heaving with death on the tables of the slaughterhouse in Chinchon to his two sons feeding the deer in the zoo. There is realism and autobiography in the parts, universality in the whole.

The film opens on the hart leaping through open fields, but soon images of hunters, guns, policemen, ropes and death take over. There is a loud and unpleasant periodic sound like the noise of distant shelling; actually it is the crash of breaking waves. Soon we are barraged with hundreds and hundreds of images that flash by so quickly and are so unreadable that they seem at times like momentary compositional arrangements of white and grey patches, lacking both intent and content and very nearly devoid of form. What can be identified is always rather ordinary yet important: a hotel, a wedding. Gradually things slow down, images get steadier and quite recognizable, there are more shades of grey. A new sound enters, water flowing with a reassuring gurgle; images become events, occupying time and space. Scenes of factory buildings and assembly lines pass before us, then give way to other images: a dormant maple whose keys lie in the surrounding snow, Olga and the children outdoors in the winter, horses ploughing flooded fields. Again the film changes pace, and we are jarred out of our easy perceptions by a painfully swift passage through trees. The reel ends in the pruning of branches, with tight close-ups on their lopped and vulnerable ends.

The overall character of the first reel is one of fragmentation, disorientation and vacillation. A large part of it is intentionally an onslaught of visual chaos, because there is nothing else that can bring a sophisticated eye to the point of desperately craving to see something, anything, a perfectly ordinary bit of the world, just one simple, recognizable, lasting, perfectly focused entity—which in this case is a timeless, placeless image of life's renewal: a man sowing seeds as he walks barefoot through a muddy furrow behind his two ploughhorses. This is the way Chambers describes his motivation for the structure:

In a way there's almost two kinds of consciousness, isn't there? When you're looking at the first part of the film, I remember when I was looking at it I was feeling that this was dragging on and I became very conscious of the time that I was in while I was sitting here looking up there. And later on when the images became concrete and started to awake another sense, let's say with the help of what I was seeing I began to experience things of my own through what I was seeing, so that you get another time sense that you're in—your mental time sense, your whole machinery time sense—as well as the time sense of just watching the thing for an hour and twenty minutes. . . . When the images start

Grass Box No. 2 1968–70
oil/graphite/plexiglas
originally 94 x 124.5 cm; now 82.6 x 89.5 cm
Nancy Poole's Studio, Toronto

to congeal, like pulling the cart, then you're prepared for something. You're prepared to really see things. And all that latticework in the front was a preparation to do that, to make the eye think, For God's sake let me look at something. And then you give them something to look at. And that's when you have the best opportunity of really penetrating because the eye will open for you, of course the eye of the mind. . . .[10]

The second reel begins with a flood of sensory input, barely processed. An eye flutters open, and then there are feet, hands, mouths and bodies, exploring and experiencing. A crashing sound underscores the confusion. The next major segment is pivotal: a birth set against a death. These are thresholds comparable only to each other, and it is the one that makes the other real.[11] If generation is a central theme,[12] it is nowhere more unmistakably embodied than in the forceps birth of a baby boy that is intercut with vivid colour footage of a bloody, expiring sheep. The child emerges with bloated, engorged testicles and an erect penis, and the camera that is held by the man with two sons of his own pans over the remarkable sight again and again, filled with confidence in the endless and ubiquitous perpetuation of life. The Christian links between lamb and infant are unavoidable; soon after the birth/death, there is also a sort of ontogenetic link established at the level of the foetus.

Having been born, all things live in the world, and the world is what Chambers now gives us, just as he did in the first reel, but then perception was hardly possible because we saw through a glass darkly and knew but in part. To say simply that the film is about generation and gestation, or about birth, growth and death, or about perception, or about the cycles of nature and the human condition, is somehow to negate the next section's extremely pointed quality—the utter specificity, the utter particularity of the events that roots the structuralist complexity in a completely non-elitist universe. A teenage boy goes for a swim in the Thames in the dead of winter, while a policeman who was notified beforehand stands by with a life-preserver and a paddy wagon. A woman rummages around her still-cold early spring garden for a barely formed violet to tuck into a buttonhole of her styleless coat. A man with confused and frightened brown eyes climbs out of a mine cave-in while many arms embrace him back into the world of the living. A complacently charitable businessman presents a lively little bird in a cage to a sadly retarded young boy as part of a Christmas-gifts-for-unfortunates campaign. And so on and on.

Just preceding the final two sequences—the puzzled little boys feeding the zoo's rather oblivious deer, and the view down the Thames and up the sky—we watch Chambers mow his front lawn. There could hardly be a clearer way for the filmmaker to let it be known that what follows is virtually a manifesto of his values and philosophical stance. Furthermore, the "home-movie" technical quality of the filming of the final two episodes, plus the fact that they are in fairly crude colour and have an accompanying soundtrack of cautionary parental whisperings, sets

them off even more from the rest of the film. Almost everything else is black-and-white, except most of the sheep footage, and there are no human voices. Chambers is summing up by saying what untold numbers of less visibly gifted people have been saying in small voices and without fanfare for centuries: that he is just a man, that his children are the most important thing in his life, and that the world is a miracle. His own comments on the effect of the film as a whole, made several hours after he'd seen it for only the second time, make a similar although more general point:

> If you take a thing in a progression, you know, and sort of intuitively work your way through it, mould the thing and have it happen again and again in various ways, it means a lot more at the end of it than if it was shortened up and said in two sequences, as this compared to this. Meanwhile you've gone through an experience of your own self, and you've gone through the experience of something being resolved *in you* because of what you're looking at, as well as what you're looking at seems to be resolving itself too. What I felt today is that there are certain resolutions that take place in you that you're not altogether conscious of, but certain resolutions about life and about things. I found that I was almost saying to myself, Yeah, things really are good and things really are unique, things really are full of wonder the way they are.[13]

Altogether, *The Hart of London* is one of Chambers' masterpieces; it is not a narrative unfolding at a suitable aesthetic distance but a metamorphic process that one undergoes, that even the artist finds himself undergoing in the presence of what he has made.

Notes

1. Taped conversation between Jack Chambers and Avis Lang, 17 October 1972. "I'd sort of painted myself out. I think."
2. Ross Woodman, "Artists as Filmmakers," *Artscanada* 25, no. 118–119 (June 1968): 35.
3. *Sunday Morning No. 2*, 1968–70. Sold in 1970 to Mr. and Mrs. Eric Schwendau for $25,000. Has since been resold.
4. John W. Locke, "Michael Snow's *La Région Centrale*," *Artforum* (Nov. 1973): 66–71 (subtitled: How You Should Watch the Best Film I Ever Saw) and *Artforum* (Dec. 1973): 66–72.
5. Jack Chambers, "Perceptualism, Painting and Cinema," *Art and Artists* 7, no. 9 (Dec. 1972): 28–33.

6. Pierre Teilhard de Chardin, "The Mass on the World," *Hymn of the Universe* (London: Collins, 1965): 22. See next note.

7. Maurice Merleau-Ponty, "What Is Phenomenology?" in Alden L. Fisher, ed., *The Essential Writings of Merleau-Ponty* (New York: Harcourt, Brace & World, 1969): 39–40. I purposely cite Merleau-Ponty and Chardin, because in my first meetings with Chambers in the fall of 1972, he mentioned them again and again as recommended reading for understanding his point of view.

8. Taped conversation between Jack Chambers and Avis Lang, 19 October 1972. "That's why you would never see anything . . . nothing would catch up to itself."

9. I would like to thank Goldie Rans for initially mentioning this to me. Chambers responds to a question about this in a letter to me of 27 July 1973: "Yes, I solicited fotos from Londoners of anything and received a couple of thousand, all of which I filmed and used in the rapid-fire section of images in Reel No. 1." There are marvellous implications here of the acceptance of randomness and chance, of the equivalence of all information and of the usable meaningfulness of all fragments of experience.

10. Lang-Chambers interview, taped 19 October 1972.

11. Ibid. "The baby's born and . . . you stay with the birth. The only other thing you can go to is the death, because it's the only other thing you can compare it with . . . You see, they're both on the threshold of a new experience or a new life. Because it seems to me that just because we die here, nothing's gonna stop . . . It's a perpetual thing, just like energy." And elsewhere in the same tape: ". . . When the kid is born, you know . . . You've got the lamb dying in colour. Well, it's almost like the colour takes the time position forward to another dimension. Like you go forward to you might almost call it a dimension of having lived, as opposed to having just been born, and this again is the preparation for another gestation. And this is a look at the passage into that other sleep, you know."

12. Ibid. Chambers' own one-word summary: "It's generation, that's the whole thing."

13. Ibid.

The Hart of London

FRED CAMPER

The Hart of London:
Jack Chambers' Absolute Film

I N P. ADAMS SITNEY'S *Visionary Film*, the first and still the principal history of North American avant-garde filmmaking, a brief passage alludes to the idea of the "absolute film." This sub-tradition extends from Stan Brakhage's *The Art of Vision* (1964) to Bruce Baillie's *Quick Billy* (1970), Michael Snow's *Rameau's Nephew . . .* (1974) and Hollis Frampton's unfinished *Magellan*; the idea is to try to make the one complete film that would encompass all of cinema—and the entire cosmos. Thus *The Art of Vision* includes images of tiny cells, a childbirth, a forest and a mountain, and the sun and the stars. It's also a kind of inventory of Brakhage's most advanced techniques, and is over four hours long. *Magellan* (1972–84) was originally to consist of one film for each day of the year; later, presumably feeling he couldn't show all he wished to in "only" 366 parts, Frampton planned two films for each day, but unfortunately died young, well before completing the series. *Quick Billy*, more "normal" in length, progresses from abstracted images of the sun and the moon to sex and to a mock-heroic *faux* Western. Then it continues on with a series of unedited camera rolls.

Though to my knowledge no one has proposed including Jack Chambers' astounding eighty-minute film, *The Hart of London* (1970), in this category, I think it fits. Its themes include the alienated relationship between civilization and nature, objective versus subjective perception, and the cycles of life and death among humans and animals. Made in part out of newsreel footage, it enjambs the slaughter of lambs (Christian symbolism probably intended) with the birth of a baby, and includes a field being ploughed and disaster victims emerging from underground, apparently somewhere in the Middle East. Chambers' original plans for it included images of Jesus descending, which are not in the finished version—but the finished version does set up a dialogue between two Gnostic notions: the view that

objects in the material world are prisons for light and the idea that light, in its freed form, represents a purer, divine energy that underlies all things.

The film is rarely screened—I know of only one public screening in Chicago, and that was in a class taught by Brakhage in the late 1970s, attended mostly by School of the Art Institute students. An informal poll in 2000 of ten Chicagoans with a special interest in and knowledge of avant-garde cinema—film historians, filmmakers, professors, critics, curators—revealed that only three had seen Chambers' film. While written about sporadically, it shows up in few of the synoptic studies of the movement, and it also seems to have divided even its most knowledgeable viewers—some love it (Brakhage, an early advocate who helped arrange distribution in the United States, has written of it as "one of the few GREAT films of all cinema"), but many give it mixed reviews, and one distinguished historian of avant-garde film told me he still isn't sure what to make of it. I myself didn't like it on my first viewing two decades ago, yet loved it on my second—and third, fourth and fifth. Part of its difficulty is its originality. At times superficially resembling Brakhage's work, and at other times Bruce Conner's, it's not really like either. It straddles the boundaries between the poetic film and the found-footage collage, but the usual terms on which both are discussed prove to be only marginally useful in understanding it. For one thing, Chambers' mix of styles give his film a raw, unfinished look that separates it from the more "refined" aesthetic tradition of Brakhage, Baillie and others.

The "London" of the film is in Canada: Jack Chambers was born in 1931 in London, Ontario. He studied art there, worked in construction, travelled to Mexico and spent eight years in Europe, living mostly in Spain. There, he studied art in Madrid and converted to Roman Catholicism, returning to London in 1961 when he learned that his mother was dying of cancer. He became well known as a painter (examples are in major Canadian museums) while also writing poetry, and in 1966 began making films. There are five completed films in all, all extraordinary in different ways; *The Hart of London* is generally agreed to be his masterpiece.

Part of what confused me about it on first viewing is that the first half has some resemblance to Brakhage's work; indeed, Brakhage says that seeing his own *Window Water Baby Moving* (1959), which shows the birth of Brakhage's first child, is one of the things that inspired Chambers to make films. Images of London appear in multiple superimposition, often bleaching out to white or near-white, creating a subjective flow that suggests the interiorized vision common in Brakhage's work. Then, as the film gradually shifts to longer takes of various newsreels and home-movie-like footage, seen without superimposition, it's hard to know how to take the many breaks in tone along the way, each of which registers as a rather rude shock.

Chambers' own writings offer some help, although they are also quite dense and theoretical. In two manifestos published in *Artscanada* in October 1969 and *Art and Artists* in December 1972, he gave names to his art-making practice, calling

it "perceptual realism" and later "perceptualism." Chambers' aesthetic is in some ways more realist than that of most avant-gardists. He argues that style in painting, while reflecting an artist's personality, is largely the result of a pre–photography era attempt to "compensate for the lack of visual information." But an excess of style, "painting derived from the lyrical ego and the mind-aesthetic," should be avoided. The solution is images that retain their realist connection to the original scene.

Chambers filmed his back yard for his earlier film *Circle* (1969), and he argues that because it provides only "the objects out-there to look at," the viewer "is led out of himself towards nature rather than inwards to the invented, symbolic or memory meanings." But Chambers' goal is not simple verisimilitude. "Those who see appearances as the only reality," he wrote, "have not experienced . . . wonder." Chambers hopes to address the moment of perception, before the mind is able to interpret a scene, thus placing the viewer in "a state of receptive passivity that somehow releases a higher . . . sense." The final goal is to allow the viewer to "perceive the Invisible Body 'behind' the world." In his distrust of accepted interpretations of objects, his writing and filmmaking do resemble Brakhage's.

Some form of Gnostic mysticism seems to be at work here; for the Gnostics the created world, trapping energy in concrete forms, kept us from experiencing the original "spark." Chambers' use of superimpositions, almost bleaching to white in the first section—a chaos of images becoming light—and his pans from river to sky, at the film's end, suggest a belief in light as a conveyer of that "Invisible Body." Chambers' sometimes surprising, even stupefying cuts, linking material one might not expect to see linked, further seem to be a way of denying the mind simple, and single, interpretations. Intercutting a birth and the slaughter of lambs is so overdetermined with meaning as to render any single response impossible. The viewer is further startled when Chambers cuts between black-and-white and colour. Chambers told an early writer on the film, Avis Lang (whose article is reprinted in this volume), that the whole theme of the film is "generation," and that's certainly present here; the sense of the life cycles of plants and animals that the film conveys loosens any specific connection by envisioning each being within an overall flow.

The Hart of London begins with television news footage from 1954, of a hart that wanders into a suburban-looking portion of London. We see it first in woods, then streaking through backyards and leaping a fence. There is a powerful tension between the subdivided yards and the deer's graceful movements: it's immediately apparent that this animal was not made for quarter-acre lots. There's also some puzzlement, on the part of the viewer, over how to react to this interloper. Townspeople point to it, and the footage seems to be presenting the deer as some sort of spectacle, offered to us for our viewing pleasure, like an animal in a zoo. Officials chase, capture and finally kill it, and its corpse is laid out before the camera.

The imagery seems inviting, but as one realizes it is created as a kind of display of the hart, alive and dead, intended for television viewers, one is also repulsed.

One of the great sub-themes of the film is its analysis of the way news footage has less to do with finding the truth of a scene than creating an engaging spectacle, compelling the viewer's attention with the same Pavlovian manipulativeness as those shiny bright objects used by hypnotists. Most important—and most chilling—is that every other major scene of the film is a recapitulation, thematically and formally, of this opening.

Chambers tells a very Canadian tale. Canada, which has perhaps the vastest area of surviving wilderness on the planet, tends, particularly in its most populous and industrialized province, Ontario, to turn its back on nature. Toronto, Canada's most populous city, features an ornate, Victorian architecture that has absolutely nothing to do with its surrounding locale, making the tackiest Chicago Prairie School knockoff look magnificently eco-centric. Toronto itself is mostly cut off from Lake Ontario, on the shore of which it sits, by high-rise buildings. London, which seemed merely bland to me as I passed through twice, is in Brakhage's view "one of the grungiest, most uninteresting industrial towns imaginable." Brakhage says he thinks Chambers would not have disagreed with his assessment of the town; is the "Come to London" banner we see early in the film ironic? But by intercutting London with news footage from other locales, and by locating the largest themes in mundane images from London itself, Chambers also finds the whole world there.

Following the killing of the hart, we see dense superimpositions of London images, some of them old snapshots that Chambers obtained by advertising for them. One becomes lost in an almost engulfing flow, but even here a kind of attraction-repulsion push-pull is present: superimpositions are typically tactile and multilayered, creating depth, but for every moment when the imagery seems invitingly seductive, there is another when the layers clash, or create not a supple surface but an almost impenetrably solid one, pushing the viewer away. That some of Chambers' layers are in negative, with harsh and pervasive blacks, contributes to the rebuff effect.

Appearing within this flow are a man with a rifle, a businessman's face, and a tall and wide downtown building whose windows form an imposing grid. Interwoven, they suggest the aggression inherent in culture: the building cuts off the light of the sky, replacing it; the rifleman echoes the killing of the deer. The building contrasts with those moments when the screen goes white, or with the colour image of the sky that ends the film. For Chambers (as he wrote about another of his films), "Reality . . . is an invisible pattern of energy which in its attenuated, material form becomes trees, river, people, sky." But if even trees "attenuate" reality, *The Hart of London* seems to argue that human constructions do so more severely.

Early in the transition between the two sections there is an overhead shot of a body of water with swimmers dispersed in various coves and bays. The imagery is

The Hart of London

crisp, high-contrast and summery. Then we cut to a newsreel shot of a catastrophic flood, homes isolated by floodwaters in lower-contrast grey. Water is seen as both benign and deadly, and this divided attitude toward the substances of the world is pervasive throughout, reinforcing the film's overall dualism.

Soon we see extremely lush and soft close-ups of leaves, and feel as if we're lost in wild nature, however small the scale. Suddenly, in a focus-change, a pair of metal clippers is revealed, and we realize these plants are being trimmed. They seem to emerge so gently, as if an expected part of the scene, that it would seem that being neatly reshaped for display is a natural fate of these plants, as if our very conception of nature includes our alterations of it. Here the viewer may also reflect on the nature of filmmaking, which parses reality into its own rectangles in order to better show it. Indeed, there are metaphors for the filmmaking process throughout the film, originating with the images of the hart trapped in rectilinear backyards. Later, the birth is preceded by close-ups of eyes looking out at us, stopping our customary imagined passage into the image with a confrontation that also refers to it.

The birth itself appears difficult: forceps are needed, an episiotomy is performed. The baby has to be slapped into life, it seems, and its writhings are not unlike those of the dying sheep we see in the Spanish slaughterhouse that so impressed Chambers in his youth that he returned there to film it. In his writing, Chambers compares the art-making process to the products of nature, to "fruit growing on trees." The pairing of birth and slaughter make another metaphor for filmmaking, the cutting and other rearranging inherent in both suggesting the acts of framing and editing.

The "display" theme continues: we see a young man in shorts swim across an icy river in winter. Almost from the start, the police are there, and an officer stands by holding a rope. Soon the youth is hustled into a van. He presumably encouraged the filming of his stunt by local news, and his "capture" echoes the hart's, suggesting a continued clash between nature and town. Soon we see footage of disaster survivors being led out of a hole in the ground. Now the swimmer's dangerous stunt, which was arguably valorized by his arrest if not before, seems glib, an almost trivially safe bit of play compared to what befalls others.

Near the film's end, there is a single shot of Chambers himself cutting his lawn with a power mower. A row of rectangular lawns in the background not only echoes the opening but also reminds us that the filmmaker is implicated along with the rest of us in the human subdivision of nature. Chambers follows this image with an overhead shot of the stone ruins of a very ancient city, returning to his theme of "generation" by pairing creation and destruction (rendered further multivalent by the fact that lawn-mowing is itself arguably destructive) but also suggesting that our efforts are useless, that time and decay always win in the end.

Avis Lang takes the penultimate scene and the pans up to the sky that follow it as optimistic assertions that "the world is a miracle," echoing Chambers' own

response to seeing his own film for the first time: "Things really are full of wonder the way they are." But once again the film points in an opposite direction as well. In home-movie-like colour footage, Chambers' two young sons approach some deer, first seen by a fence; they are in the town's open-air zoo. They approach cautiously as their mother's voice whispers on the soundtrack, "You have to be very careful." Eventually they succeed in feeding the deer. Though we only see the fence initially, we are aware that these are not wild deer. Yet the mother's warning, repeated almost to excess, implies that they have the potential to harm. Swimming has turned to disaster in the film's editing twice before. The world, full of wonder, also has the potential to kill us.

Chambers himself was diagnosed with leukemia in 1969, while he was working on *The Hart of London*. He was not expected to live long, a knowledge that likely affected the structure of the work. However, perhaps by aggressively managing his own care, he outfoxed the doctors and lived until 1978. It was, as so often seems to happen with artists, only around the time of his death that his films started to receive more attention. Now, twenty-five years later, perhaps *The Hart of London* will finally be recognized for its miraculous interweaving of mystical light poetry, bitter commentary on the way our culture reduces reality to mummified images rendered trivial by media, and impassioned vision of our civilization's alienation from the nature that gave us life.

The Hart of London

Chambers' Epic:
The Hart of London,
History's Protagonist

1

I N MARCH 2001 Stan Brakhage was in Canada for a weekend at the London
Regional Art and Historical Museums devoted to the work of Jack Cham-
bers. En route, he stopped at Toronto's Cinematheque Ontario for a showing
of his newest films, and what might have been a brief ceremonial round of ques-
tions and answers ballooned into an hour of Brakhage speaking on many topics.
At one point, he launched into an impromptu lecture on Chambers, insisting that
The Hart of London (1968–70) was an "epic" film. This was not the first time he had
made the assertion. In a letter written in 1977, Brakhage called *The Hart of London*

> [a]n epic in consideration of city, and I find it a good kin to Vertov's "Man with
> a Movie Camera", Rutmann's "Berlin", and especially Cavalcanti's "Nothing
> But the Hours" in that it makes an absolutely unique (and contemporarily ter-
> rifying) contribution to the field of dreams of the City, holy or otherwise,
> which have haunted humans since the earliest writ. Perhaps only a writer-of-
> movement COULD extend full consideration, as I believe Chambers has done,
> to Charles Olson's "polis is eyes."[1]

Twenty-five years ago, Americans who knew avant-garde cinema might have
been expected to know Canadian experimental films. Joyce Wieland and Michael
Snow had been working in New York through the 1960s, and had firmly reshaped

the American avant-garde cinema, making their own reputations and stirring debate. However, it was not in the context of these two Canadians' films that Brakhage formed his high regard for Chambers, the Canadian artist who had stayed home, in London, Ontario. Chambers' impact on American avant-garde films then, as now, was nil, and Brakhage's appreciation for *The Hart of London* was and is still unique in the United States. And so, in his preview article for a screening of Chambers' film (in 2000), the Chicago film critic Fred Camper started by informing his readers of some basic facts: that the film has gone unseen, that Brakhage is its sole champion, and that it is a Canadian film.[2]

Camper writes that *The Hart of London* "is one of those rare films that succeeds precisely because of its sprawl; raw and open-ended almost to the point of anticipating the postmodern rejection of 'master narratives.'"[3] Camper admires this strange Canadian film; he regards it as an aesthetic success, but his tone is never exalted, like Brakhage's; for him the key word is "sprawl." My attitude is similar. *The Hart of London* is not just "raw" but rawboned, in the sense that it has a weathered, rusticated face. Frequently graceless and openly sentimental, it is also masterful—lucidly composed in many passages, rhythmically imposing—and gruelling in its pathos. The film is a peculiar amalgam, a formalist-but-folkloric film, regional and naïve, modernist and sophisticated all at once.

These impressions, however, offer no access into the larger problem *The Hart of London* presents. Its size and sprawl are matters that badly need to be addressed before the film is irretrievably entombed as an oddball monument of Canadian cinema, assuming that has not happened already. I want to get at the problem by taking up Brakhage's suggestion, to think about the film as *epic*—in its formal articulation, its treatment of found materials and even its possession of a protagonist—and to argue that it arrives (as epics often do) at another genre: the romance.

2

The Hart of London was Chambers' last film. The previous one, *Circle* (1968–69), differs from it in several respects. It is tightly ordered, coolly and steadily instructing the viewer on how its implications are to be understood. The critic who seeks to frame *Circle* in an analysis encounters little resistance. Its tripartite symmetry and economy of means shape the viewer's response and promote a ready distillation of its meanings. *Circle*'s place in the lineage of Canadian image-making is clear.[4] Although regarded as a greater Canadian film classic, *The Hart of London* does not offer the viewer the same guidance. The viewer attempting to construe its project has, at first, little to go on beyond its most sentimental imagery—a dying deer, a slaughtered lamb, a baby, snow and water—all elements that accentuate how

raw, rustic and naïve it is, not why it is also a strong and sophisticated masterwork.

The Hart of London, finally, has not received the sustained critical attention commensurate with its canonical status. Imposed on Canadian film students by teachers who never write about it, it has settled in as a classic, but in the most inert sense.

3

That said, and it is hardly a promising start for what a reader might expect of this essay, it must also be stated that The Hart of London deeply influenced the Canadian avant-garde cinema: specifically, Chambers articulated the responsibility that a community's public and private record imposes on the Canadian film artist's imagination. This sense of the film lies on the surface of The Hart of London and has made it seminal for Canadian experimental filmmakers. Unlike their American counterparts, inclined for their own excellent reasons toward an imperially subjectivist cinema, Canadian avant-garde filmmakers have felt compelled to construct a public art, an experimental cinema of and for a Canadian sociality. The success of their endeavour has been, to say the least, uneven, but that is not really the point. To illustrate the matter in simple terms first: Chambers made found visual documents, photographs and newsreel footage crucial to the fabric of his film's textuality—and to any reading, interpretation or sense one might take from it. He reworked these materials with the full aggression of an experimental stylist and did dramatically alter their character as visual documents, but it does not mean that he transformed them into something private and subjective. On the contrary, Chambers insisted that these materials belong to the community. That insistence owed nothing to the mainstream Canadian social-style tradition of the National Film Board, the tradition of the didactic documentary. In fact, The Hart of London is powerfully estranged from almost everything that didactic style stands for. Yet, and contrarily, the crucial role image-documents play in The Hart of London placed the film in a direct relationship with that tradition—as both its aesthetic challenger and ethical companion.

In other words, The Hart of London stands as an alternative cinematic monument, and "alternative" is meant here in the strong, common sense of the word.[5] Many experimental films that were made after it, whether avant-garde in the most academic sense (e.g., Gary Popovich's Self-Portrait: Taking Stock series [1992]), "experimental documentaries" (that oxymoron so beloved of Canadian arts councils) or avant-garde in the most ambitious sense (e.g., Bruce Elder's Illuminated Texts [1982]), must be placed in the powerful contrail of Chambers' film.

Along with the responsibility Chambers also articulated a certain permission—permission to "sprawl"—for the Canadian avant-garde. Among the filmmakers

who took up the challenge of these ideas, none had a fuller awareness of their implications than Bruce Elder, who as a critic provided the most complete analysis of Chambers' films, and then as a creative artist developed the extended-form montage cinema of the heterogeneous type that *The Hart of London* pioneered. Elder's forty-two-hour cycle, *The Book of All the Dead* (1974–94), must now be regarded as the very definition of the "sprawl" that Chambers' film inaugurated in the Canadian avant-garde.

What kind of length are we talking about here? Chambers' film clocks in at eighty minutes. This is almost standard feature length. Two other crucial Canadian films at the turn of the decade were likewise lengthy. Together they signalled the moment that Canadian avant-garde filmmakers engaged with long forms.[6] In contrast, American avant-garde films of the 1960s were characteristically compressed works that rarely ran over twenty minutes. There were practical reasons for this but also reasons of form and genre, and I will come to them soon. The point is that around 1970, Canadian experimental films were suddenly different. They were longer. Bookending *The Hart of London* at the time of its release in 1970 were Joyce Wieland's feature-length *Reason Over Passion*, in 1969, and Michael Snow's 180-minute *La Région centrale / The Central Region*, a gigantic work for avant-garde cinema, in 1971. Three films directly about Canada, they were confident, ambitious and intense—a remarkable contemporary florescence of cultural nationalism. English-Canadian feature films were then negligible, so these films stood as resonant monuments of the country's cinema. This was the moment when avant-garde cinema in Canada actively became a public art, perhaps the first and only instance of avant-garde cinema playing such a role in any national cinema since the 1920s. A reason these films had the resonance they did was in part because they were big films, generously scaled as well as long, about a big country just then becoming aware of, and proud of, its size. All three are films of grand landscapes and heroic traversals, but none of them are at all like Griffith's *The Birth of a Nation* or Gance's *Napoleon*, grasping at dramatic statements of national destiny. These Canadian films were reflective, even philosophical. *The Hart of London* was a deep-time drama of Canadian origins, while Snow's film was such a totalizing gesture that it seemed like the first Canadian film. Completing that symmetry, *Reason Over Passion* seemed like the last Canadian film—which was probably Wieland's intent. Given the sorry devolution that English-Canadian cinema experienced within a decade of *Reason Over Passion*, she may have been right.

Formal and tonal differences among them are revealing. When he made *The Central Region*, Snow retooled the axiomatic-systematic mode he had already devised in *Wavelength* (1967) and <——> (1969), expanding it into an exhaustive permutation of possibilities of camera movement. Snow projected a grand (even

cosmic) scale of spatial conceit, and sustained an astringent tonal solemnity unique in his cinema. Expanding her range of lyrically political ironies, Wieland made *Reason Over Passion* the eulogy of a trans-Canadian geographical trajectory, but the film also represents the extension of spatial motifs her previous films had developed (and, one recalls, the title was shared by a Wieland quilt). Neither Snow's film nor Wieland's film, in other words, changed the artist's basic procedures, but proved these could be scaled larger, much larger. *The Hart of London* was, and remains, different. Not just a long film, it sprawls, breaking into parts, and parts of parts. It is heterogeneous, its overall shape is uncertain, and unlike the works of his colleagues, Chambers' previous films do not hold the key to his large work. Given that he would make no further films, *The Hart of London* becomes at once apodictic and ambiguous: an undeniable statement whose nature and meaning are unsure—a problematic classic and difficult to organize into a textual whole without shutting the film down into outright mystification.

All these features of *The Hart of London* also constitute an important promise to Canadian filmmakers: that long, multi-part, heterogeneous, uncertain cinema could be theirs to be made. However, Chambers made the promise without also projecting a comprehensible form. This is what Snow and Wieland accomplished with such great lucidity that no one could dare to follow them. Chambers risked fragmentation, made an imperfect and even wounded great film and created a problem Canadian filmmakers could develop (and some did). *The Hart of London* is that earnest long film that will not readily give up the secret of its power. Finding it too problematic, critics tended to ignore the problem, which is why such an entombing silence has fallen around this Canadian classic.

4

It is not that spirited appreciation initially failed to greet *The Hart of London*. Rather, in the rush to praise and communicate enthusiasm for it, critics barely got past describing the opening segment. They reduced even that to its anecdotal stratum. The familiar account goes like this: using found newsreel footage shot locally in London, Ontario, Chambers arranges shots of a deer's advance from the snowy woods into the back yards of a city while men are closing in with guns and ropes. The deer is captured and then killed.

This description does provide an adequate anecdotal account, in the sense that all the images are devoted to conveying the deer episode. You can see where the interpretation might take off. Chambers has made a poetic depiction of the tragic encounter between nature and culture, staged at that familiar edge of the Canadian

experience, the threshold where the alien landscape and the anxiously patrolled human habitat-enclosure meet. Chambers does not introduce complex symbols or metaphors. That leaves the deer, the guns and the ropes. The footage is heavily processed, but the film's sentimentality is as transparent as the artist's statement.

There is nonetheless a peculiarity that such paraphrase neglects. Chambers actually expends more than twenty shots, four of them very long takes, and ten (at least) involving superimpositions, *before* the deer even gets near the town. Under a soundtrack that some describe as white noise (I think it sounds like a processed and evenly looped recording of winter wind), the film begins with an extreme long shot of the deer in snow, then a closer long shot of the deer in landscape. Both shots are so whitened in Chambers' printing and superimposition that they almost seem like a void.[7] Seven further long takes (though of diminishing length) closely resemble the two initial shots; the camera position changes but not the white atmospherics (and these reduce spatial cues to a minimum). Next, a new series begins: men with binoculars in superimpositions, another take virtually a void, and then suddenly a more readably printed close-up of a rifle being loaded. (Everything happens under superimpositions, but Chambers printed the rifle shot in higher contrast and introduces it quite percussively.) After that, another measured, whitened shot of the deer, followed by a kind of cross-cutting between the deer and the men, in which the shots slip into and out of superimposition, so that sometimes the deer and the men are seen simultaneously. Then there is an extremely long take that is almost blank—white and yet faintly readable as a landscape.

This is just the beginning of the film's first segment. The patterning set up here will persist: Chambers expends many shots on a single action, distending its representative function and rendering the images almost unreadable through printing and superimposition, then abruptly administers a shock: a brief series of graphically and spatially defined shots (with sharper grades of printing, depth cues, etc.). These clear images are extended into an intermittent close-ordered series, then withdrawn back again into a super-low-contrast, whitened superimposition. These are the components of the style of the first section of the film, the *deer section*, I will call it here.

While an anecdotal paraphrase catches the drift of the passage well enough, it does so at the cost of ignoring the larger-scaled oddities. Chambers' long delays, an effect of his prolix cutting style, both advance events and hold them suspended. The suspense, in the familiar meaning of the word, is kept going by the sudden appearance of shots that threaten the segment with decisive, violent action; another kind of suspense is prolonged when Chambers withdraws his shot series from the action for long, postponing passages. All this entails the tremendous excess that is the norm for this film, and results in a vast disproportion between the economy of the episode and its elaboration—so much disproportion that "narration" hardly seems the right term. Nonetheless, narration is exactly what

Chambers is developing with this opening segment. The deer episode, made of found footage and nothing else, is just that, a narrated episode.[8]

After the very long whitened landscape take, events begin to speed up. The montage rhythm does not, however. The whole deer section is set to an indomitably constant metre. What changes is the ratio of shots to anecdote. Soon it shifts into the opposite direction, toward ellipsis. The deer comes into town, or its outskirts (there are only small houses). Men appear clearly now, walking between buildings, carrying ropes and guns. Then two men together, then fences and back yards; next, three men, one with a rifle, then two women who point. A new series: panning shots of the deer trying to leap over back yard fences. In a fairly subtle style shift, Chambers is now clustering readable shots into tight sub-sequences, though largely still under a canopy of superimpositions. Screen direction is confusing; there are missing intervals of screen space. This impedes an ordinary sense of visual contiguity while temporal continuity is, at best, conjectural. Nonetheless, the episode, elliptically or not, proceeds inexorably toward the confrontation.

I would like to isolate two aspects of this segment for further comment.

First, the found footage: I want to emphasize, yet again, that Chambers did not make these shots in the deer segment. However much he remade them by printing, superimposition and montage, their order and readable sense still conform to their source. Chambers does not (as for example Bruce Conner does in *A Movie* [1959]) transmute the images through an associative montage. Nor does he add anything to shots in the next section, which I will call the *city montage section*. Only in the third large segment of *The Hart of London*—approximately forty minutes in—will Chambers begin to deploy his own footage, which then predominates until the fourth and last section, where found footage comes back in a mixture with original shots.[9] This feature of the film is one that critics rarely discuss, but that Chambers insists on: the found footage is *public-social* in character.[10] These are pictures and film shots made and kept anonymously. They are a community chronicle, an archive of memories, and as authorless as they are artless. When the artist uses them to make this film, he makes them speak to us, in a sense, for the first time; here they become conscious of their own implications. This is different from the artist transforming the images into a symbolic projection of *his* implied meaning. Chambers' usage of these images plants *The Hart of London* firmly in history. But what kind of history or, to put it another way, what *form* has this historical material now assumed?

To start with, the images of the deer episode have the character of an evidential legend: the emblematic "first" and therefore legendary encounter between nature and men. This is arguably the legend we see here, or that Chambers makes us see here. Just the same, this is a local TV news clip, "evidence" of a minor event in a city that probably happened more than once over the years[11]—long after human settlement was achieved. The paradox of this material, which is illuminated by Chambers'

extravagant treatment of the footage, is its double resonance, as legend (at once folk-loric and re-fabricated) and as evidence—it happened in time and space.

The *city montage section* that follows is image-processed in very much the same way as the deer episode, and with the same progression from whitened void to a readable montage of images. However, it is much longer and it is a story-less shot series redolent of open historiography, not a closed anecdote or episode. A cata-logue of photographs is followed by heavily re-cut found film clips. The section depicts the founding human settlement, the montage is a progression of country town, industrial town and, eventually, urban development. By putting the two ex-tended sections—the deer and the city—beside one another, Chambers makes the tragic encounter with nature serve as strong prelude to, almost the condition of, the city's film historiography. In another sense, though, the deer episode appears *in medias res* and the city section peels back time to the beginning, to the city's found-ing. Then, in the third section, Chambers veers sharply away from these obviously juxtaposed extended units, into a different mode whose description I will delay. Together, the first two sections set what we should regard as the *diegesis* of Cham-bers' film—the deep time and spatial compass of the whole work. By engaging in acts of narration, even so eccentric a narration as this, Chambers insists that his avant-garde film have a firm diegetic stratum: a time and a place in which events transpire. I take it that everything after this which appears in the film takes place "there," a point that Chambers confirms in the fourth section, when he answers the city montage with a section I term *social life*.

The second aspect of the deer section that I want to isolate is the deployment of the human figures. The long shot of the whitened void, where I halted my preliminary description, and Chambers halted the deer's advance toward town, is followed by a clear shot (under just a wispy superimposition) of a man with a rope. It is the first depiction of human presence lasting more than two successive shots. Ten shots, in fact, are given to this man. They are clearly visible and nearly in continuity, though the filmmaker uses overlapped cutting. These ten shots are followed by a brief shot of a man with a gun and then a shot of the two pointing women. Chambers then counterpoints this clustered series with a sequence of long panning shots showing the deer in clear focus and (relatively) high contrast, leaping around back yards trying to escape over fences. It is a pathetic sight. It is not, however, a tragic climax. Here Chambers decelerates the cutting, conform-ing his trims to the original footage's pans (the passage is, incidentally, one of Chambers' rare triumphs as a film editor).

The final confrontation, which appears after these two passages, is both swift and slow simultaneously. Mostly it is elliptical. The same kind of disproportionate expenditure of shots we saw before intervenes again. Chambers uses long takes now, even introducing a long veil of black leader, cut into the crucial narrative point—the confrontation of men and deer—but otherwise the footage is whitened

by using negative footage in superimpositions. We are allowed just glimpses of what happens, a technique that distends and slows the passage. We wait and struggle to see clear images. Yet the event itself, the deer's capture and killing, is so elliptically edited that we must look quickly to grasp the key images. A long take of void-like whiteness intervenes again, and then we see the deer's capture in a slow flurry of superimposed images taken at various distances: men tying the deer, a man with a rifle, an interval of whiteness, men in negative, and then a very long series of shots that become, again, almost unreadable and blank.

The deer segment is winding down now. This does not happen all at once.

There is in *The Hart of London* a recurring tendency toward ceremonial segueing. Here it leads into the next longer sequence, the city section, a protracted montage divided (as I suggested above in the discussion of found footage) into two subsections. The first uses still photographs, abundant negative printing, multiple layers of superimposition, repetition and more whitened, blurred intervals. The images at first conform in style and readability to the deer section, but then the montage becomes accelerated and more difficult to comprehend. After a sustained passage of confused opacity we get to see enough of these photographs to realize that they are archival images of the city of London, Ontario. When the film footage eventually takes over again, in relay and not abruptly, the images gradually clarify. Contrast, contour and other spatial cues appear, and Chambers helps by repeating many of them. Together, these are the wordless chronicles of a place and its people, gathered and reworked by the filmmaker. Their progression, while not linear, moves toward larger buildings and structures, like bridges, train yards and warehouses, indicating the industrialization of town life and then its urbanization. While we can see all this in general, plus some names on buildings, it is not easy to distinguish what is under all the superimpositions and rapid-repetition-variation of the montage flow. Yet for all the impediments to ready visual comprehension, an impression of progress from small town to medium-sized city is discernible. The people we eventually see are at work, operating a pile driver, guiding vehicles, etc. We also see men piling dead animals (wolves) in scenes that rhyme with the deer's death footage. Death continues, then, and multiplies suggestively through this urban history. It is part of the city's routine.

There is nothing obscure, in the sense of mysterious or symbolic, about *The Hart of London* so far. If anything, the passage just described, like the deer section before it, is tremendously obvious, repetitious and sentimentally forceful. It is distended and elliptical, but never other than literal. Rarely has an avant-garde filmmaker done so much to his footage, extended passages to such lengths, and yet sought so little apparent superadded signification. The ruling symbol, the deer, is the only likely metaphor. By piling up motifs and distributing redundancies around the assembled core figures (or at least we can say, the most repeated ones), Chambers creates masses of images that through his use of superimposition, constantly

vary in tone and rhythm but rarely in meaning. The layered juxtapositions are never identical and the rhythmic relations among the layers are uneven and often jittery, but the montage metre remains indomitably constant. Chambers also breaks shots into pieces, using partial clips first and other portions later, not to continue actions but to excerpt them at a different point. There is no single episode in the city section, as there was with the deer, but there is an enlarging scope of significance. When the film encompasses the deer event with various photos and film clips we come out of legend into something that could be named as "history" without much hesitation.

The city section now devolves (or perhaps continues) into a new series that includes a tree, plant forms on ice (in close-up), a child climbing through a snow-bank in long shot, then two children and a woman walking through the snow in a very similar framing. The three of them are next framed as if in a home-movie portrait outside a house. These shots, which definitely abandon the previous superimpositions, serve perhaps as image recapitulation: snowy landscape, the town and the mother and children, taken as figures of settlement, condense the patterning that precedes them. Chambers recaps this passage further with super-impositions and shots of water, in close-up and moving, followed by a short sub-section marked off by an internal unity of its own. Finally a new element appears: documentary-clear shots of farmers on their tractors ploughing fields, cows stand-ing in spring floodwaters, flooded homes, vegetation. The sound has changed, with the white noise/wind switching over to evenly timed whooshes of water sound. Another segment is forming, folded under its predecessor. The transition is a long series of close-ups of a man with a large pair of pruning shears, violently cutting a hedge; then a passage showing the cruelly cut ends of branches. When this pas-sage emerges as the film's third section—which happens now through a complex but short montage—the new section will be different in scale and style both. It will be an extremely intimate encounter with an infant boy, cross-cut with the killing of lambs, and cross-cut again with a human birth seen in extreme close-up.

5

In the two sections just described, Chambers maintains the level of high excess in his number of shots and his extending of passages greatly beyond their anecdotal function. But the excess does not, I repeat, yield associative functions, at least, not such obvious associations as metaphors. The deer and city sections are instead given over to metonymy, to use Jakobson's differentiation. The exceptions that are significant are global or general exceptions, like the symbolic deer. *The Hart of Lon-don* firmly establishes certain stylistic norms with the first two protracted sections.

The third sector will veer sharply away from those norms. If in the first two segments we seem to overcome the difficulty, learning to piece images together into a formal whole at the local level, when we come to the next forty minutes of the film's span the situation will recur in a worse way.

6

Have my descriptions of those first long passages corrected any previous interpretation of the film? Not really. *The Hart of London* does not resist paraphrase in the service of a thematic reading, as I have suggested. But its prolixity creates serious problems for anyone attempting a sustained account of the film, even before attempts at paraphrase and interpretation start, or should start. The film has scarcely begun when it overruns most critical accounts. This problem can be ignored, and it usually is. The critical compensation is to square the film off tidily, using paraphrase and explanation. Neither move is mistaken. Chambers' open sincerity makes his intentions obvious enough. Nevertheless, the reason I feel close to Fred Camper, who is less settled in his response than other critics, is that the film poses a formal challenge to the habits of poetic compression traditionally strong in the avant-garde. What is all this extravagance for? Ignoring the problem does not make it go away. Instead, it seals up the film in monumentality that a response like Camper's (he marvels at how strange this wild and raw and sprawling film is) cracks open. Another way of saying that critics ignore the problem is that the kind of critical interpretation they practise on *The Hart of London* regards it implicitly as just another short avant-garde film, only much longer. I want instead to follow Brakhage's lead, to see the film's expansiveness as the issue and to see the film as epic.

Brakhage can be generous and eloquent when speaking about avant-garde filmmakers with whom he feels a personal affinity, as is certainly the case with Chambers, and maybe he just meant that the film is large in conception.[12] Yet I am more impressed by the exact and pointed language he used a quarter of a century ago and then recalled exactly, without prompting, in 2001. In his letter, Brakhage also provided a cinematic genealogy for *The Hart of London*—within documentary film, no less—and he put a name to Chambers' accomplishment that, in Brakhage's scale of critical assessment, has no higher avatar, the poet Charles Olson. He named the film's genre in the spirit of Olson when he called it an epic. Experimental films are only rarely associated with genres this way and almost never by filmmakers. The avant-garde cult of originality and uniqueness militates against it. So when the most famous champion of that cult, Brakhage himself, places *The Hart of London* among epics, the event is extraordinary: the definition falls well outside the categories that Chambers, or critics who stick close to his commentary, would use.

My venture, then, travels onto thin ice here. In what follows I would like to pursue Brakhage's suggestion, admitting in advance that I will wander off from his compact assessment of *The Hart of London*.[13]

To repeat and vary slightly what I said above: critics have offered spirited commentary on Chambers and *The Hart of London*. Avis Lang (then Lang Rosenberg) published an evocative interpretation of the film in 1974. Ross Woodman's work on Chambers was enriched by his lengthy interviews with the artist.[14] Bruce Elder's discussion in *Image and Identity: Reflections on Canadian Film and Culture*[15] also added depth and detail to Chambers studies. My remarks here do not seek to supersede these critics' interpretations; instead, what interests me in Brakhage's classing of *The Hart of London* with epic is that on rereading Lang and, especially, Woodman, I find that there is some implied sense of genre in their texts. They take the film in what are essentially Symbolist terms, and their accounts match closely with the interpretive protocols P. Adams Sitney used with what he called "the lyrical film." The genre implication of lyrical film is readily, if variously, understood. If the narrative feature film is prose, the lyrical film is poetry, in terms of its compression, complexity, expression of direct subjective feeling and tight formal unity. So many exceptional experimental films made between Brakhage's *Anticipation of the Night* and *Window Water Baby Moving* (both 1959) and Bruce Baillie's *Castro Street* (1966)—including Chambers' own *Mosaic* (1966) and *Hybrid* (1967)—have been lyrical films that the mode seemed to define the very aesthetic of avant-garde film.[16] The lyrical film was not seriously challenged, or even made to appear as a genre *per se*, until Snow's *Wavelength* opened the critical issue by exemplifying a different basic avant-garde form, the structural film. In what genre then do Chambers' *Circle* (1968–69), and more directly *The Hart of London* (1968–70), belong? I am not suggesting they are, in any sense, structural films; I don't think that they are lyrical films. However, Brakhage's use of the term "epic" opens the question of genre from a new angle, one that leads into the problem of *The Hart of London*.

7

In the debates about experimental cinema in the 1960s, the matter of genre hardly clamoured for attention. Then, in 1972, P. Adams Sitney published "The Idea of Morphology"[17] and followed it with *Visionary Film: The American Avant-Garde* in 1974. Sitney did not intend to develop a scheme of experimental genres *per se*. However, Marjorie Keller makes the correct inference when she calls Sitney's categories "form genres."[18] Sitney sets them out as a succession: the trance film (or psychodrama), succeeded by lyrical film, mythopoeia, a set of "apocalypses and

picaresques" and then the structural film. He argues that these types of film flow from one another developmentally. These are not what we usually think of as film genres (i.e., story-types). Nor are they conventional literary genres; for instance, they are not consistently dependent on the kind of literary archetypes Northrop Frye takes to be foundational. Sitney defines his genres in terms of formal parameters, stylistic practices that arise from ways of seeing and making; they lie closer to what Todorov called, in a completely different connection, "theoretical genres." They are constructs of the critic, segmentations of the flow of experimental filmmaking differentiations based on the critic's interpretive and analytic insights. Sitney's analysis is based on his belief that avant-garde cinema recapitulates features of Romantic poetry. Although controversial, Sitney's morphology is a heuristic device and an immensely productive one.

Sitney mentions epic in connection with Brakhage's *Dog Star Man* (1964) (mythopoeia roughly corresponds to epic), perhaps the most "archetypal" film ever made. But in his view, despite the successive stages of development of the form-genre, in which the lyrical film precedes epic, the lyric form can also continue right through it and go on after it. His example is Brakhage's *Songs* (1964–69). Moreover, Sitney never develops epic *per se* in his typology. But Annette Michelson does. In the course of "Camera Lucida/Camera Obscura," an article prefacing a special edition of *Artforum* devoted to Eisenstein and Brakhage that she edited in 1973, Michelson draws a contrast between Eisenstein's epic cinema and Brakhage's lyrical cinema. Forms of montage serve as the analytical crux. She discusses how the two filmmakers treat cinematic temporality through montage and develops a contrastive interpretation implied by the genres she names. It is striking to hear and read Brakhage four years later, without any doubt aware of Michelson's discussion of himself, refer to *The Hart of London* as an epic and claim a kinship between it and Vertov's *Man with a Movie Camera* (1929), whose montage style is akin to Eisenstein's epic mode, particularly when a contrast is being drawn with Brakhage's own.

Drawing upon a portion of the first chapter of Erich Auerbach's *Mimesis*, in which he discusses Homer's device of "epic retardation" in *The Odyssey*, Michelson makes comparison with Eisenstein's montage device of "temporal distension," prominent in *October* (a.k.a. *Ten Days That Shook the World*, 1929). Her focus falls on passages like the "raising of the bridges," where the Soviet director uses overlapping editing to render an event from multiple viewpoints while suspending— or rather staggering—the event's temporal advance. The resulting disjunctive imbrication of shots—which goes against the norm of continuity editing's usual cutting-point elisions—opens a perceptual space where the synthesis of the constituent elements of the sequence is elaborated with analytical insistence and heightened clarity. The purpose, and the effect, of Homer's epic excursus, says Auerbach, is to bring everything into visibility and into the foreground, and to

leave nothing in shadow, nothing unknown. So too, Eisenstein's montage is a device to lay out events in all their components, says Michelson, "experienced as unfolding, as a laying out before one, fold by fold, of a fabric that is the event."[19]

Brakhage knows Eisenstein, Michelson reminds us, but knows him through the lens of Maya Deren's films and her film theory of the 1940s and 1950s, the first important and sustained productions of the American avant-garde. Deren's critical and formative reflections would, in fact, underwrite the movement's first long decade. Deren's example instructed Brakhage and he then discovered his own cinematic temporality, which like Chambers' is manifest in his montage, a technique that is, in Brakhage's case, diametrically different from Eisenstein's "unfolding." Michelson explains "[r]ather than splice a moment of time into which [Deren] could insert the integrality of a film, she attempted to work with the single moment, distending it into a filmic structure . . ."[20] The renewal of the energies of avant-garde cinema Deren set in motion through this cinematic equivalent of modern American poetic imagism would engender the avant-garde's American aesthetic, weaving and then stretching the fabric of the trance film, itself her break with the Surrealists' psychodramatic cinema. After his lengthy apprenticeship through the 1950s, Brakhage unbound that trance fabric and the imaginative force that the consequent lyrical film released, a force that would propel avant-garde filmmaking through the next decade, the 1960s. "It was left for Stan Brakhage," writes Michelson, "to radicalize this [Deren's] revision of filmic temporality in positing the sense of continuous present, of a filmic time which devours memory and expectation in the presentation of presentness." That presentness serves to incarnate the "I" as eye, positing a "hypnogogic consciousness of the image inaccessible to analysis."[21] The consequent distinctions Michelson makes between Eisenstein's epic cinema and Brakhage's lyrical cinema are diametrical and they are far-reaching. Her summary of the consequences is trenchant. She writes,

> If Eisenstein's cinema of intellection depends upon the unity of the disjunct, sensed as disjunct, the cinema of sight will be, from this point on [i.e., from the films of Brakhage on], incomparably fluid . . . aspiring to a rendering of a totally unmediated vision, eluding analytical grasp.[22]

8

The Hart of London appeared at the end of this development, and Brakhage, who more than anyone else in the American cinema was in a position to know, recognized it as an epic not long after the film first circulated. But how to situate *The*

Hart of London within the set of analytical distinctions reviewed here? This question comes in phases, because Chambers' film is inconsistent in important respects with regard to its form and stylistics. The first phase in this essay is retrospective, an analytical appendix to the descriptions of the opening two sections offered above.

I understand that Chambers' prolixity of shots, used in the deer episode, and the cavalcade of photographs and film clips in the city section, are an "unfolding" of episode/history roughly similar to the type that Michelson attributes to Eisenstein's epic style. We can isolate short passages—the man with the rope, the deer in the back yards, and I would add the figure of the horse-carriage driver in the city section, and some others[23]—where Chambers' overlapped cutting patterns are of the same staggered and elaborated type as Eisenstein's. The deer seen in the back yards is, for instance, cut to accentuate, through retardation, the pathos (as Eisenstein uses that word) of the event. But this observation is not all that illuminating since these passages are accentuated exceptions and not typical of the whole of either section of *The Hart of London.*

Eisenstein, Michelson says, seeks to unfold everything with a maximum of visibility and clarity before a spectator whose analytical gaze the montage solicits. Chambers also insists on a complete unfolding. His distension covers every part of the depicted event, also as in Eisenstein. Even Chambers' ellipses paradoxically serve this end of deferral.[24] He deploys that indomitable metre against which the viewer measures every shot's (and every superimposition's) presence, slippage and passage into and out of view. The result is that when we see something, for example a rifle being loaded in close-up, it is a strong synecdoche of a complex action, condensed into a threat of the gun. Just as often, however, we cannot read Chambers' image. We scan and miss what's there in the fuzzy whites that soften space and blur contour. Then the blasts of higher-contrast shots, in positive and negative, with space cues and graphic definition, compel us to recognition. This is a process of reception akin to but different from Eisenstein's montage, or for that matter Vertov's.

To be blunt, Chambers elicits something less certain (and less processual) than an "analytical" gaze. It is only a glance—when he allows it.[25] What we do see oscillates wildly between "presence" and ghostly semi-absence, between clarity and fuzzy indistinction. Visibility is occasional at best during *The Hart of London's* first two sections. The stylistic arsenal imitates the pacing and flaring of memory imagery. The photographic-film image becomes time's ghost trace, a sliver, a fracture of witnessing. The struggle to see generates an anxious and intent looking. Paradoxically, this is what Chambers' stately cinematic metre insists upon. The montage offers us sharp looks and rapid repetitions, then longer looks, then almost nothing to see at all within a constant and measured montage. The economy of our attention assumes a beat of loss and recovery of vision, a mutual folding of

The Hart of London

the invisible and the visible, a shifting threshold of signification. But it has a beat. It is insistent, savage, raw and a bit cruel. There is, moreover, a countering, epic process in Auerbach's sense, in the proliferation of shots that open out to redundancy, refracted representation, etc. In the end, nothing at all is hidden from our eye's grasp, nothing left in shadow. What we have gained has not come easily or directly. It has been unfolded, but elliptically and never in surrender to a masterful, or analytic, gaze. I am speaking of the first two sections only now: the visual, the chance to see, is frail and manifested abruptly, mercurially, but it is finally present and unfolded—everything there is to see.

The form is arguably epic in Michelson's sense of montage style. But the problematic of the film's visual style only returns at the level of the shot. Chambers' printing, his negative passages and, especially, his superimpositions are close to Brakhage's image patterning, and far from Eisenstein's. Brakhage's mode of cinema, finally, always sets up a protagonist. It is Michelson's Brakhagian "I," a hypnogogic self, a self in an extraordinary state of reverie that she (and just about everyone else) counterpoises to a state of analytical attention and self-possession. Whether or not *The Hart of London* is an epic overall, in a proper sense—and this is as far as my argument will carry that claim—the new problem of that "I" arises: just who is the film's protagonist?

Before attempting to answer that question, let us look at the two first sections' proper relation to epic. The filmic material Chambers deploys is, as I have mentioned, public and historical, anonymously made, without knowable intention. His use of it is an unfolding of what is there to unfold in what was found. The imagery gathered in the first two sections—and the same kind of material will appear again in the fourth section—is first of all, to repeat again, social chronicle. The images are a mixture of local legend (the deer episode), public and private photographic records, and filmed footage documenting a town's life from settlement to city; all are archival, of the times of their making, and were inert for years. Their placement here in sequence, set to an aggressive visual style, and especially to a steady montage metre, heightens their gravity, suggests that what has happened to them in Chambers' hands is analogous to what happens when the literary epic assimilates oral tales, fragmentary writings, or stories of the gods and heroes and monsters that a people regards as in some way foundational. This is also what happens, analogously, in Eisenstein's *October* and Vertov's *Man with a Movie Camera*: chronicles of revolution are heightened and given epic form. It is not everything an epic might be, but it is richly implicatory. Such works elevate their materials from the blind and dumb (but rooted) sources that feed them. This upward movement—this intensification—is a cinematic process resembling the transmutation of oral traditions that a later poet deforms, and in a sense finalizes, to compose an epic. As photographic material, the archive Chambers draws out and into his film

is "evidential" (and synecdochic), but, however "legendary," is also inarticulate. The materials must be made to speak, which is what Chambers' montage achieves. It is a measure of the exactness of Chambers' intention that he does not make it speak for him, but for itself. There is a superbly hesitant "I" here. The hesitation implies that the glance is not only his but ours, and that finally transforms these rawboned, rustic, stupid and sentimental images into ghostly, jittery, uncertain, grand, pathetic, richly implicatory witnesses to time lived in depth.

In Chambers' case the material is modern and historical, like Eisenstein's and Vertov's, but—and this is crucial to its Canadian cultural resonance—it is the deep-time story of a prosaic place and a prosaic people set against a huge and mute landscape. In the glamorous (sometimes grotesquely glamorous) revolutionary Russia of Eisenstein and Vertov, film epics come to their forms (as we are told so often) because their creators know the truth of the scaffolding they construct, and they judge the images they shoot against the eschatological assumption that every fragment ascends to the leitmotifs of the dialectic. In a wholly different spirit, Chambers submits London's archival materials to a style of aggression that likewise gravely distends their scope and significance on screen—he *is* that kind of epic filmmaker—but the truth here is less certain, and certainly not of the same eschatological type. When Chambers lends high drama to the legend of the deer, he starts as classical epics do, *in medias res*, and then follows the deer event with an account of a city's founding. But London, Ontario, is no Troy. The pathos of the deer episode *is* comparable in form to the fallen woman on Eisenstein's bridge in *October*. But the montage of London's history, with its recurring images of dead animals lying on the snow and the good burghers in their hats and coats, has no equivalent to the knowing cosmogony of *October's* "For God and Country" sequence. Chambers' equivalent will perhaps come in the third section of his film. But even there *The Hart of London* is an uncertain epic, although it seems a bit more certainly to be an epic.

9

The distinctions reviewed here, and the conclusions about *The Hart of London* they have led me to, hold little immediate relevance for Ross Woodman. His critical task, in his interviews with Jack Chambers and his essays on the films, was to provide an account of the artist in a setting, that of Canadian culture, where he was a well-regarded painter. Woodman's approach is biographical. In his hands, a painter would become a film artist. And so Woodman's portrait of Chambers as an amateur theorist of "perception" arises from the critic's trust in Chambers' theoretical reflections. The resulting portrait happens naturally. Whenever Woodman

offers evidence for his interpretations by drawing on Chambers, he shows how his ideas apply; and they do apply. However, there is a certain slippage between *Mosaic* and *The Hart of London*, at the point where *Circle* appears.

Chambers speaks of the "temporal insistence" of cinema as its great lesson to him and this is the notion upon which Woodman bases his substantive discussion of the artist's films. Yet when, in *Circle*, Chambers allows temporality to exert a direct effect on the film's form, Woodman shrinks his reading to say the film is an illustration of Chambers' then recently framed theory of "perceptualism."[26] It is an account made without much sympathy for *Circle*. The central and longest segment of that film differs notably in form from Chambers' earlier *Mosaic* and *Hybrid*, where he constructed his montage around a pivot, allowing these films more or less to spin out their form imagistically. In *Circle*, form becomes firmly successive. It falls into three parts. The central suite of images consists of 365 shots, each around four seconds long. Chambers took them, one every day for a year, with a camera mounted in the same spot looking out into his back yard through an opening he made in the wall of his house. He did not adjust the camera or add filters to compensate for changes in light and atmosphere, so while the camera takes the same "view" in every shot, the image variety is large, changing in visible depth, detail, light and atmosphere. The space, a back yard that we come to know well, mutates subtly as events—the hanging of wash, the movement of a child, the appearance, then disappearance, of a fallen tree branch—come and go in seconds. The difference between shots serves as an index of screen time measured against the radical similitude of diegetic space. It is a film that combines the gaze and the glimpse. To watch this longest segment of the film is, in sharp contrast with *Mosaic*, to feel an image being firmly acquired, and then lost and just as firmly replaced by another. Offering the first of Chambers' indomitable montage metres, here set by the clock of a frame count, *Circle* breaks with the compressed organization of lyrical form. Chambers admits time *difference* itself as a *compositional substance*.[27]

Because Woodman's tendency is to see Chambers' art as a unified project, he misses some things about *Circle*. Yet he understands better than other critics precisely how *Mosaic*, for example, is a lyrical film. Woodman persuades us that the artist moved to filmmaking from painting in the first place because the film medium offered a different sense of time. At some point in his thinking and artmaking, Woodman reports, Chambers found himself bound to temporal arrest in his painting and to a limited objecthood from which he sought to free himself. Temporality, then, becomes the problematic in Chambers' art after the mid-1960s, the issue that produces a succession of new styles. Woodman proposes that Chambers' cinematic imagination, which was growing before he ever made a film, provides an opening into his meditations on time as the unifying issue.[28] The anticipation of cinema in the following comment, which Chambers made on a

painting, has become the canonical point of connection between the artist's painting and filmmaking:

> *Olga and Mary Visiting* isn't the description of a visual moment; it's the accumulation of experienced interiors brought into focus.

Chambers then continued, describing the way a painting gets put together as if it were very much like a film:

> You are in a room, then in another room where you see an object being held this way, then you see it in motion, a week later a cup is tilting, the next day a finger curves in air against a background, you hear a little clink . . . Sense combinations complement one another to enrich perception.[29]

To a reader of Eisenstein, who penned innumerable passages illustrating the montage principle by breaking down every conceivable art form, from Dickens novels to Kabuki theatre, into shot lists just like this one, Chambers' description seems uncannily familiar. The resemblance even extends to the sound-image juxtapositions Chambers finds in his painting! The work in question, *Olga and Mary Visiting*, was made while *Mosaic* was under way. For Woodman, the painting distils the act of filmmaking, rather than acting as a prompt to the film. His argument is that film contrasts with painting, which is a collage organized in space, while the film is collage spread out "in a time sequence." This persuasive comparison operates well when the montage in question is that of *Mosaic* and of *Hybrid* (and of *R34* [1967] as well). These films are arguably collage-based in the sense Woodman means, namely that cinematic time is rendered into a synchronic platform under the progressive repetitions of montage, as in *Mosaic*.

There is, however, a missing step in this account. While a film does materially unfold "in a time sequence," what is basic to Michelson's distinction between the unfolding, epic "cinema of intellection" and the "fluid" (lyrical) "cinema of sight" is that film artists develop radically different temporal strategies to deal with that cinematic materiality. "Sequence" does not quite cover these strategies or, at least, the lonely word becomes unhelpfully ambiguous when we try to use it as an analytical tool for close work. Indeed, the temporal strategies of the pioneers of experimental filmmaking were so idiosyncratic and so influential in the visual arts of the last century that no question of cinematic form and stylistics within the avant-garde has failed to become saturated with them. There is no one defined temporality, no single "time sequence" in the film medium, which is why structural film had such an impact in American experimental cinema following a decade of lyrical films. *Wavelength* shifted cinematic time signatures. The critical epistemologies of the American avant-garde accordingly trembled. Cinematic temporality also

pertains to theoretically suggestive genre-related distinctions, to take the three at hand: between lyrical films' extreme present-moment compression, structural films' temporal elaboration and epic films' analytic distensions and ellipses.[30]

That Chambers' sensitivity to these issues and to the different temporal structures of film was gained from painting is an important truth that Woodman draws from the artist's commentary. He reports that Chambers especially detested what he called "descriptive time," the kind of stair-step temporal construct used in conventional narrative films. The lyrical film shows how cinema can achieve a different temporal shape—presentness. For Woodman, this is the meaning of a "collage effect," despite some shaky preliminary definitions he tries out. Collage, for instance, is not spread out in time, but condenses imagery into a synchronic image-paradigm of relations; film articulates those same relations through an advance-recursion type of composition. The motion, or mobility, of perception is what Chambers seeks in film, in order to escape the temporal arrest of painting. *Mosaic* and *Hybrid* show scant interest in temporal "sequence" *per se*. So Woodman's analysis of *Mosaic* is a description of a film whose highly interruptive and associative editing pattern finds its unities not "in sequence" but in an internal web of relations in which the images are associated rather than successive. It would not be going too far to suggest that *Mosaic* and *Hybrid*, like other lyrical films, seek a time-form one might call an "eternal now"—whether that time be lost or regained.

Woodman further brings out of Chambers' own reflections the claim that film allowed the artist to get at a "forgotten" awareness. This leads him to a fine Symbolist interpretation of *Mosaic*. He shows how that film manifests a struggle against what the artist took to be suppressive forms, in painting and narrative cinema alike, by recovering a time-in-depth (through what Deren termed "vertical montage"). However, around 1967–69, and this is the point when the making of *Circle* comes to him out of his painting, Chambers' reflections led him toward a more material and successive, less lyrical sense of film time. Here Woodman implicitly disagrees. His indifference toward *Circle* reduces it to an interval, a theoretic side trip on the way to *The Hart of London*, where Chambers again reintegrates his filmmaking and his thinking in an expanded lyrical form. Woodman resumes interpreting in Symbolist terms, this time explicitly, using the eighth of Rilke's *Duino Elegies* to provide an intertext to *The Hart of London*. But it is not, for all that, a film Woodman analyses in an extended way, though he does offer an interpretation of the whole.

My review of Woodman may seem like a further methodological interruption, pointless and even hostile, but my intention is quite different. Woodman's analysis guides us to the third and most difficult section of the film, the section rendering uncomfortable my attempt to understand *The Hart of London* as an epic. Were this third section a separate work, it would be fully and purely a lyrical film.

10

Focusing on Snow and Chambers as its principal strong artists, Bruce Elder's critical account of Canadian avant-garde cinema, to which I have referred several times, rests upon a third distinction in addition to those made by Michelson. Elder discerns the critical differences not in montage but in the way Canadian artists wrestle with the film image. Their films play as defining a role for Elder as those of Eisenstein and Brakhage for Michelson, this time with Brakhage and Snow providing the crucial contrast.[31]

Elder sees Canadian cinema sharing a unified project, dually rooted in representation and in a philosophy of consciousness. In *Image and Identity*, Elder proceeds in several analytic registers at once. The most important applies his analysis of Canadian thought and visual culture to the aesthetics of photography. His central claim is that historically photography has met Canadians' cognitive and philosophical needs for understanding and mediation between the country's imposing natural landscape, which was alien to the Europeans who encountered it, and human consciousness, which their tradition obliged them to see as connected to nature. What differentiates the American avant-garde film is that it committed itself to unitary enclosed forms and, in a sense, a unity of material effect, whereas the Canadian project always looks outward to the exterior world and remains bound to representation. The film image in the lyrical mode is always, in a sense, expressionist, always about the "I" that the image projects inward. Lyrical films are an adventure of the subject's interiority. American filmmakers struggle against certain photographic features of film, especially the duality and the paradoxical temporality the photograph entails. Elder takes it to be of critical importance to Canadian cinema that its engagement with the image differs. Because the film image provides a kind of temporal presence-absence, and because the physical photograph is bound to something that the image it fixes is not, namely the real that gave rise to it, its very nature imposes a plurality on the artwork. There are at least two *times* in a photographic representation: what is seen and what was. In the Canadian avant-garde, represented with particular intensity by Snow and Chambers, the plural characteristics of photography come to be unfolded into new meditative modes. The clarity of this meditation is supreme in Snow's films between 1967 and 1971 where the epistemic dimensions of the image are manifest at the same time as the film enacts a representation.[32]

Elder extends this interpretation to Chambers a bit differently. The striving to reconcile with nature, which has always appeared to the Canadian consciousness as radically other, is Chambers' moral purpose. Elder does not say this specifically, but the time a photograph can carry within it is a historical time. It can also be fetishistic-private (making synecdoches of desire), object-based (a photo of a tree),

or artifact-based (as often in Snow's art; he frequently builds the things he shoots); or the picture can show another subject's drama of presence to us. I argued above that in *The Hart of London* Chambers chooses the historical engagement, the quality of the chronicle or witness in the found footage he incorporates. Chambers carries a powerful historical and social sense into the second section of *The Hart of London*. And the deer section injects another kind of legendary or deep time into the film. In the third section, Chambers chooses differently again, for the unconscious time, the "forgotten awareness" that produces the film's protagonist, embodied consciousness.

The unconscious, for Elder (as for Woodman), is Chambers' centre in *The Hart of London*. This is not the familiar Freudian sexual unconscious. It is the equally psychoanalytical event of the conscious appearing at the edge of the acquisition of perception of the outer world, accompanied by a stabilized subjectivity and by language acquisition.[33] In making his interpretation of the film, Elder provides a portrait of what I take to be the protagonist of Chambers' film. Therefore, in my reading of this section of the film, when Elder proposes the "I" as the unconscious of one born into history, the epic mode opens out, as signified by Chambers' powerful shift to a symbolizing associative montage.

Elder agrees that Chambers insists that the historical and anonymous archival material that he uses belongs to a community, a sociality, and he gives the film's first two sections a unifying purpose in expressing the truth that consciousness cannot arise without a community. The formed and embodied self belongs to language and history. The first section manifests the image as a ghostly and uncertain witness, which is why the stylistic aggression Chambers visits on the footage preserves its representational substance and yet, at the same time, accentuates the difficulty of seeing and reading the images. They are ghostly not because something is haunting the film's world in a supernatural way; they are ghostly in the sense of faintness. Visual uncertainty and technical instability are spectral when we compare a discursive and sure knowledge of the world to these faint witnessing pieces of it. Elder's analysis of the film as an allegory of unconscious or forgotten experiences of seeing grounds his discussion of *The Hart of London* in the adventure of a consciousness coming to awareness of the outer world. It is, for Elder, the story of the Canadian avant-garde's subject-protagonist that Chambers draws into a heroic and yet intimate large scale.

For Elder, writing through the 1970s and 1980s, an experimental film of any ambition doubles the aesthetic agents involved. The artist's process and the viewer's process are symmetrical around a model of consciousness. Elder argues that these agents are epistemological fictions correlated with the formal operations of a film. In a way they are characters joined in mutual exchange across the meditation that film work engenders. But, in a more forceful way, they are fictions (or allegories) produced by formal effects worked on images. Every exchange in the films he regards as well made is, then, deeply subjective but not, for all that, concerned

with personality.[34] Elder's subjects are philosophical subjects and the subject matter, finally, is consciousness.[35]

11

To resume the long-interrupted description of *The Hart of London*, we turn now to what Chambers shot himself, in section three, which I awkwardly call the *infant-boy/lambs/birth* montage. This footage is intimate, coherent and deliberative. It is as steady as the footage of the first two sections was faint and shaky. The long transition into the third section is a proper "intellectual montage" of fluid associations. Associational montage has not previously appeared in the film and when it does here, Chambers makes the strangest and most elliptically elegant association of all his film work: he is introducing the eyes of a child. The third section eventually accumulates a manner fully within the high-lyrical style, in which soft-focus, assertive camera movements, plastic cutting and the extended use of extreme close-ups predominate. These many black-and-white shots, running to a pale grey scale, receding to whitened shots, then using close-up pans over an infant boy, are intercut with dark grey images centred on a birth taken in extreme close-up. The images then begin to be juxtaposed with long takes that use the strategic shock of high-saturation colour. These medium long shots, centred and in clear-focus framing, are of the slaughter of lambs.

Not only the raw and gruelling emotionalism reaches an apex here; so too does the diversity of film materials in *The Hart of London*. Varied but carefully chosen, the material falls into three streams. Chambers breaks apart the stylistic norms established in the first two sections and, changing subject matter completely, he moves from the chronicle of a city to a birth, the growth of an infant and the slaughter of lambs. The montage in this section quickly sets up new norms and associations, however, then settles in for a long steady cycle of cross-cutting.

In discussing the mythic-epic prototypes of literature, Frye speaks of epic as "a world of total metaphor in which everything is potentially identical with everything else, as though it were all inside a single infinite body."[36] Is *The Hart of London* an epic work of this ingathering type? An affirmative reply probably would have pleased Chambers, who did seem to take the film, intentionally, as a totality within the finite "body." It is a process, and in the Woodman interview he names it: "generation." If this name sufficed, lyrical unity could be realized by winding the whole around it. But the term is itself displaced, since "generation" in the third section is so indelibly linked to sacrifice and death. As we have seen, *actions* were depicted earlier in *The Hart of London*, rather than symbols—violent, forceful, death-dealing actions, as well as constructive ones. In this lyrical third section,

action gives way to association and the lambs' slaughter gathers the earlier depicted actions together as symbolic of mortal sacrifice.

Now to ask the question again: who is the protagonist of *The Hart of London*? Determining the answer to that requires another plausible principle of gathering. The protagonist is not a usual kind of epic character, like Ulysses or Beowulf, that much is certain. And it is not the deer. Elder's interpretation, although he does not deal specifically with the question, may allow us to locate another kind of protagonist: consciousness itself. He reads the whitened void-like shots of the first section as a sign that Chambers does not sentimentalize nature but rather associates it "with the annihilating emptiness." Elder believes that the film is organized along thematic lines that oscillate between the nurturing and lively and the dangerous and deathly threatening. In these matters Elder is extending Woodman, deepening his Symbolist analysis. However, Elder's criticism treats the whole of *The Hart of London*, trying to isolate the principle of its image-process and program. As so often in *Image and Identity*, he finds it in a formal oscillation that correlates with the symbolic imagery. If the figure of the protagonist is the infant boy, then the birth of the hero's consciousness, his discovery of his place between birth and death, Elder suggests, is pivotal to the film as a whole.

In the prelude to his analysis he offers an account of the growth of consciousness to the stage where language begins to be acquired and where image recognition shakily emerges.

> In the first few months of life the mental representations of very tiny children are constantly changing; these are synesthetic sensations/perceptions. Apperceptions are rather like continuously altering hallucinations. They later become somewhat more specific and less synaesthetic, and increasingly they become sorted into representations of the internal world and representations of the external world. Even so, in the early stages of this process, these representations (at this stage mental imagery) are quite unstable and somewhat unfocused. Perhaps the most accurate way of characterizing these images is, to appropriate J. M. Davie's term, "wobbly images." These wobbly, unstable images are correlated with, literally, a shaky sense of the self.[37]

The "wobbly image" is channelled through language, which becomes the analytic tool the emerging subject uses to process sensations into perceptions and the categories of a cognitive consciousness. "Involved in the formation of every perception is a process which results in the raw material of sensation being assigned to a familiar category, a process that is intimately involved with the abstracting and generalizing functions of language."[38] However, the unstable image can return and form a threat to the self. "[T]he wobbly image sometimes reappears in consciousness even after the acquisition of language, and with it comes a sense of the uncertainty of reality,

a sense that the being of both the self and the external world is in jeopardy."[39] In a sense, the wobbly image is that sign of the regression of the subject and this regression entails the loss of clear vision of the outside world and that threatens death.[40]

Elder proceeds to interpret the film, initially emphasizing the first and second sections as unstable, rapidly changing and achronological memory images, and hence as manifestations of the unstable protagonist in the sense of consciousness. The images of a void-like landscape—an "annihilating emptiness"—correlate with the unstable technical character of the image discussed above. He argues that the first section suggests consciousness emerging, the self needing to be placed in a community in order to achieve the state of full consciousness. The movement of these sections is toward the emergence of perception, the sorting-out of interior from exterior images, the acquisition of language and the achievement of abstraction. And yet the threat of non-being and the loss of reality, negative hallucinations and intimations of death keep coming back. The aggressive oscillation of the images, the recurring whiteouts for example, is a formal correlative of the usually unconscious oscillation between firm and "wobbly" images. Elder adds another element specific to Chambers: these psychic phenomena are identified for him with a mystical sense. Visual instability is to be associated as well with the mystical void. Chambers, then, forges the structure of *The Hart of London* through a triangulation: the unstable image as an unconscious memory of an early stage of consciousness, the intimation of death that the memory can set off when the "wobbly image" comes back, and, religiously, the mystical void.

There are some problems with description. Elder takes it that the city section is achronological (he labels it, after Christian Metz, a "bracket syntagma"). In fact, the sequence represents a temporal (though not linear) progression and does so as the imagery becomes more readable. However, this hardly obviates his main point—on the contrary. Here is Elder's account of the development of the film:

> Throughout the rest of its length, the film follows along this course of development; the imagery changes from black and white to colour, becomes more stable, more conventionally realistic, and takes on greater depth. The general development from less stable, early internal imagery to conventional imagery represents the world external to consciousness. It represents a move from within to without. . . . It shows how imagery that is the ground of our being and that at first seems to be purely internal achieves a locus in the real world, thus bringing self and other into a fundamental ontological relationship.[41]

If Chambers clearly allows the "wobbly image" to return, as it were "later," after the accomplishment of the city, we should ask where, or to whom, are we to attribute such unconscious features? The baby boy passage Elder analyses is a condensation of themes seen earlier in the film. "Even the seemingly innocent baby

possesses aggressive instincts and that is that innocence and aggression can be associated with one another,"[42] he writes, after explaining that neither nature nor the human is all gentle; both are also violent. There are deer in nature but there are also wolves. Around the baby are the two other streams of images, the birth passage and the lamb slaughter. Elder takes the structure to be a triangular parallel: birth, death, the child.

The child is seen only in elliptical moving-camera close-ups, in a kind of portrait taken from inside the child's perception. The fragmentary montage and camera movements—all of them extreme close-ups—suggest a different kind of uncertainty, the subject's inability to form a cogent visual whole, to differentiate the self from the exterior. This is the protagonist—the hero—of the epic. We encounter him here in a state corresponding to the perceptual world-in-flux we encounter *in medias res* in the deer episode. His birth to consciousness recapitulates the historical process. Chambers places the protagonist here in the middle at the moment when consciousness is just being achieved. It is a sort of macro-micro correspondence between the hero and the epic world that gathers in the whole, folding the large-scale action under the infant's groping.

The intercut passages—first, the infant boy is paralleled with a birth, shot so close that we see only the birth aperture, blood and a head. It is a rather gruesome birth of flesh itself. The infant is also soon flanked by the high-saturated colour footage of the dying lambs. Elder takes this imagery to be Christian.[43] However, despite Chambers' Roman Catholicism (and he was a convert), I read it less iconographically and take it to be more "primitive," not a symbolic sacrifice but sacrifice *per se*. One reason that *The Hart of London* is so raw a film is that Chambers cannot help but heave ever closer to the bloody birth and gruesome death imagery, to distend (again) his prolix shot series vastly beyond their symbolic function. In a paraphrase, this section does say: birth, consciousness, Christological symbol. But, as the blood flows from the distended vagina and drips from the prone neck of the trembling lamb in protracted takes, Chambers is closing on René Girard rather than on some likely symbolic Christology.[44] Not that this is so much a contradiction as it may seem—Girard's sacrifice enfolds Christianity—but Chambers has forged a brutal kind of monstrosity with this passage. Its direct pathos I take to be as primitive, a raw epicality itself.

This forging is not accidental but the result of the film's gravest intensity. Of course, the sustained shots of the lamb's slow death answer and link up, through contrast, in their clarity and the garish vividness of their colour footage, with the glimpsed death of the deer and the corpses of wolves. The bloodletting, like the birth and the rise of consciousness, is a founding gesture—told once and endlessly recurring—of *The Hart of London*'s cosmogony. The appearance of death and dissolution, which Elder takes as the counterpoint to the emergence of consciousness, has now become incorporated into the symbolic stratum of *The Hart of*

London. The passage is involved, in its associative difference, in securing language but also, just like the other sections, it is repetitive, an unfolding. Not a progression but a meditation. The section is a large *caesura*, the emphatic resting point where the birth of the epic protagonist into the "economy" (in Girard's sense) of birth, death and consciousness occurs. The imagery at this point, as Elder observes, solidifies, especially on the picture of the dying lamb. The weave of the whole—a world of "total metaphor" (Frye)—establishes itself in a textual unity. We can, from here, grasp *The Hart of London*, and all its excesses, from this centre forward and backward.

12

Epics do not last as depictions of human circumstance. They are but a moment in a cycle of depictions. And as epics sometimes do, the last section of the film decants *The Hart of London* into romance.[45] In the fourth section, which I term the *social life section*, the hero reappears as a young boy (various boys, in fact). He is glimpsed in a long series of sub-sequences that depict the social life of the city, beginning with a community bonfire to which Chambers devotes a long passage. Language returns to the film, along with found footage. The fire is a civic event, watched over by the London fire department and attended by families and children. Chambers cuts the newsreel footage in a way that generates a duality: from one angle we see the people front-lighted by the fire, clear and looking toward the camera. From the reverse angle, we see them as vague shapes silhouetted against large conflagrations filling the frame. The void, fire this time, and the discernible image, people, are being modulated now into alternation. It is the last reprise of the motif, for now Chambers offers us a series of episodes, as he did in the beginning of the film. These, however, are the small events of town life, seen in clear focus. One is a winter swim taken by a young man—in cold countries apparently a ritual, usually reported as a humorous human-interest story. It is a ritual with some semi-remembered element of sacrifice—a token offered to the winter gods no one believes in, a heroic coded labour reduced to a guy-thing stunt. But it is also suggestive of an action, one now tamed and inconsequential. The epic actions of killing and founding cities have been scaled down to a species of play, like jousting in European culture, which shrank the epic combats at the walls of Troy to ceremonial contest sports. The winter swimmer is rhymed with the reappearance of the protagonist in a summer swimming pool seen in a short colour passage (the colour, in turn, recalls the lamb).

The fourth part of the film marks a sharp falling-off of Chambers' stylistic energy and intensity. Elder takes the images' program to suggest the destruction of

nature by human hands, and his catalogue of specific passages is persuasive.[46] However, what strikes me in this section is not destruction but domestication typical of romance; the exchange between "generation" and destruction has been settled decorously compared with the first three sections. Instead of the oddly violent hedge-clipping by the man with the huge shears that we saw in the long segue out of the city section, here decorous ladies pick flowers for boutonnières and the filmmaker himself appears, casually cutting grass with a lawnmower in front of his house. Chambers' stylistic relaxation seems to indicate that the epic is spent and we are in the romance. This is the genre that knows the epic has come before. Romance stories assume a settled culture and a stable social world. The crucial life events, birth, consciousness, death, are now secured by a social order. The catalogue of virtues, joys and destructiveness no longer makes a world, and no void any longer threatens it with dissolution. Moreover, the import of fundamental things has become unreadable in crucial ways. Domesticated as part of social life, the raw stuff has been covered over. The unconscious has appeared; "awareness" has been forgotten. And so the film ends with a passage that Chambers shot showing his sons—stand-ins for the epic protagonist—as they tour a petting zoo where they encounter some protected deer. Heard as a voice-off, a woman's voice intones again and again, "You have to be very careful." These are the only spoken words in the film. Elder provides a careful analysis of the passage, concluding that the woman is "exhorting them to take care of the hart," who is no longer hunted and killed but placed in a quasi-domestic enclosure. Here, as so often in romances, the encounter between nature and the human, even very young children, is no longer a pathetic and violent epic action, but a moment of tender, civilized, even pastoral exchange.

Notes

1. Stan Brakhage, "Letter, September 16, 1977," *Capilano Review* 33 (1984): 43. Charles Olson was a major American poet and poetry theorist of the postwar period. His influence on Brakhage, and a number of other visual artists (notably Robert Rauschenberg), in the 1950s and 1960s was profound.
2. Fred Camper, "*The Hart of London,* a Film by Jack Chambers," *Chicago Reader* (2000): 1. Noting it is Canadian stands out a bit, as if it were explanation for an artist's obscurity. Americans rarely mention the nationality of Snow, Wieland or other Canadians who become well known there.
3. Ibid.
4. See, for example, Bart Testa, *Spirit in the Landscape* (Toronto: Art Gallery of Ontario, 1989), 23–28.
5. I take this sense of the film's historical position indirectly from Bruce Elder, *Image and Identity* (Waterloo, Ontario: Wilfrid Laurier University, 1989), passim. Elder

makes a crucial point in placing Canadian avant-garde cinema adjacent to Canadian documentaries, believing that they share a common root in Canadian culture. The expressed commitment to the representational armature of photography and film distinguishes Canadian visual culture as whole from the mainstream of modernist art. Elder argues that the avant-garde differentiates itself within the Canadian familial compact of visual and intellectual culture but does not effect a radical break with it. Elder's account of the Canadian avant-garde film, then, describes it as the self-consciously philosophical wing of a national cinema generally given to over to didactic documentary impulses and realist fictions. These, too, are philosophically rooted, but they are less self-aware of what is fundamental to their preoccupations and ambitions. The distillation of a reflective consciousness in Canadian film is a task that falls to its avant-garde filmmakers. This important cultural difference of Elder's account of Canadian experimental film can be clarified by making a comparison with the American avant-garde, which has been inclined to insist on its radical distinction from feature fiction filmmaking and documentaries alike, seeing itself and insisting on being seen this way, as the subjectivist-poetic other to a national filmmaking that is industrial, collectivist and prosaic in all its dominant tendencies. In its historical placement, after the serious decline of the Canadian documentary and before the rise of Canadian fiction feature filmmaking, *The Hart of London* can be placed as an alternative site-holder—as a monument, in short, in the tangled history of Canadian visual culture.

6. It should be noted that just previous to this period in which *The Hart of London* appeared, Canadian filmmakers had done innovative work on a very large scale, especially around Expo 67. This is the period that gave rise to the Imax format as well as *La Région centrale / The Central Region* (1971), which is not so incongruous as it might seem, if we regard that work retrospectively, in the setting of the cultural moment and its impact on Canadian national culture.

7. This is the word that Elder uses in *Image and Identity*, on page 384.

8. If we were to compare *The Hart of London* to, say, Brakhage's *Dog Star Man* (1964), a comparably long elaborate avant-garde film, we would immediately note that Brakhage is constantly filling in the long delays of his film's action with metaphors and symbols. In contrast, Chambers keeps his film at the level of the narration of the found footage's actualities.

9. The segmentation of almost any film such as the four-section breakdown of *The Hart of London* I offer here is somewhat arbitrary. It is especially so in the case of an experimental film where segmentation does not correspond to a plot breakdown. Moreover, Chambers does not indicate sections with notable breaks. Instead, every section segues into the next, gradually introducing what will become the predominant imagery of the next segment. Because he uses a high degree of repetition of shots throughout the film, segues between sections are themselves intervening sequences, several of them quite lengthy, such as that between the second and the

third. I have not separated these transitional passages out or labelled them. My seg-
mentation, then, separates the film into four large parts: deer episode, city montage,
infant-boy/lambs/birth montage, and social life. The grounds of my segmentation
are (1) the dominant imagery of the footage, (2) the stylistic shifts, which will be
analysed here in steps; (3) the structure of the film as a whole. Of these three factors
number 3 is the least certain; the structure of the film being precisely what this
analysis seeks (in part) to discern.

10. Elder is an exception; see *Image and Identity*, 384.

11. Canadian television stations have always seemed fascinated with the appearance of
wild rural animals in urban or suburban settings, an event that occurs often and
seasonally enough to form a minor motif of the country's television newscasting.

12. At the Chambers symposium in London, Brakhage had less to say about the
specifics of Chambers' art and more about his personal feelings about him than he
had in Toronto. Then again, this was the flavour of the home-town event overall,
and Brakhage obviously tuned in to that. At a afternoon panel, presided by Ross
Woodman, and coincidentally anchored by Elder and Brakhage, Jim Shedden
showed an excerpt from his portrait film, *Brakhage* (1999), in which the filmmaker
delivers a long, touching and hilarious anecdote about London, Chambers, his
own long film, *The Text of Light*, and a University of Western Ontario engineering
student. The passage delighted the audience with its sentiment and spirit. This was
what the symposium was like overall.

13. I will not, moreover, be pursuing the connection between Olson and Chambers to
which Brakhage alludes.

14. These authors' main articles on Chambers' films are gathered in *The Capilano Review*,
33 (1984): 47–70.

15. See 214–42, 379–89, and passim.

16. See P. Adams Sitney, *Visionary Film: The American Avant-Garde 1943–1974* (New York:
Oxford University Press, 1974, revised edition, 1979), 136: "The pervasiveness of
the lyric voice in cinema among the works of neophytes in the late 1960s, a decade
after Brakhage's formative works in that mode, was so great that it seemed that that
way of film-making was completely natural and must have existed *ab origine*."

17. *Film Culture* 53, 54, 55 (Spring 1972): 1–24.

18. Marjorie Keller, *The Untutored Eye: Childhood in the Films of Cocteau, Cornell and
Brakhage* (Cranbury, N. J.: Associated University Press, 1986).

19. Annette Michelson, "Camera Lucida/Camera Obscura," *Artforum* 6, no. 5 (Jan.
1973): 35.

20. Ibid., 37.

21. Ibid.

22. Ibid.

23. This figure appears later in the city segment—the portion that uses film footage—
and Chambers repeats him in various printing registers (from faint and ghostly to

dark and "present") passing across the frame. As one of the very few moving and directional figures in the whole montage, he performs (I think) a triple function: he is a temporal indexer that contrasts the later-modern from the early-modern moments of the montage; the figure of the horse suggests nature itself harnessed; the figure is more than a bit ghostly or spectral, the figure of a past that still lingers.

24. Ellipsis and Soviet montage has been specifically analysed by Michelson herself in "The Wings of Hypothesis: On Montage and the Theory of the Interval," in Matthew Teitelbaum, ed., *Montage and Modern Life, 1919–1942* (Cambridge: MIT Press and Institute of Contemporary Art, 1992), 60–81.

25. I take this gaze-glance distinction, rather roughly approximated, from Norman Bryson, *Vision and Painting: The Logic of the Gaze* (New Haven: Yale University Press, 1983), 87–131, especially 87–96.

26. Ross Woodman, "Jack Chambers as Film-maker," *Jack Chambers Films, Capilano Review* 33 (1984): 60.

27. See Elder, *Image and Identity*, especially 239, where he discusses time and *Circle*.

28. Elder, I think convincingly, extends this discussion when he sees Chambers wrestling with temporality through his engagement with photography specifically and this leading him to filmmaking. The silver paintings figure more importantly in Elder's discussion than in Woodman's but this is a matter of emphasis and not dispute. *Image and Identity*, 214–42.

29. Woodman, "Jack Chambers as Film-maker," 51.

30. See Sitney, *Visionary Film*, 369–97; Michelson, "Toward Snow, Part I," *Artforum* 9, no. 10 (June 1971) and Elder, *Image and Identity*, 188–213.

31. Except for the Canadian nationalism that figures in Elder's book, this is a point on which Michelson concurs, and in fact she closely anticipates it in her discussion of Snow's *Wavelength* and his non-film art. See her "Toward Snow," published two years before "Camera Lucida/Camera Obscura" in *Artforum* 9, no. 10 (June 1971): 30–37.

32. Elder lays out his theoretical program in this respect in chapter 11 of *Image and Identity*, 263–95.

33. This developmental psychoanalysis is the main concern of the "objects relations" school and especially figures in the work of J. M. Davie and Donald Winnicott. See *Image and Identity*, 375–79 and 390.

34. The weak Canadian films discussed in *Image and Identity*, for example *Goin' down the Road* and *Not a Love Story (A Film about Pornography)*, push the viewer away from such collaboration by generating coy textual elisions and deceptions and putting them where honesty and doubt ought to be. Chambers and Snow are, in this respect, completely open in their solicitation of the viewer's collaboration.

35. The 1970s saw a psychoanalysis of film spectatorship pervade film theory. Portions of *Image and Identity* sidestep some of these models and propose alternatives applied to various experimental filmmakers. "Forms of Cinema and Models of the Self" is the title of the fourteenth chapter and it is here that he discusses *The Hart of London*

(and *The Central Region*). The "protagonist" of an avant-garde film is its form (and other matters, like its metaphors) first of all, and finally consciousness itself, which is, for Elder, the primal subject matter of the strong films he interprets.

36. Northrop Frye, *Anatomy of Criticism* (Princeton: Princeton University Press, 1971 [1957]), 136.
37. Elder, *Image and Identity*, 377.
38. Ibid., 378.
39. Ibid.
40. In the American avant-garde, such partial obliterations of images' representational contours suggest something quite different, namely the discovery of inner vision, and not a threat to consciousness.
41. *Image and Identity*, 382.
42. Ibid., 385.
43. Ibid., 386.
44. See René Girard, *Violence and the Sacred* (Baltimore: Johns Hopkins University Press, 1977).
45. See Frye, *Anatomy of Criticism*, 186–205. Also see Frank McConnell, *Storytelling and Mythmaking: Images from Film and Literature* (New York: Oxford, 1979), 83–94.
46. Elder, *Image and Identity*, 388.

The Hart of London

PETER TSCHERKASSKY

At the Heart of London:
Jack Chambers'
The Hart of London

I F FOR AN INSTANT we could cast a voluntary unfocused eye over the entire range of current avant-garde film production, one marked difference between North America and Europe would immediately stand out. This difference would best be noticeable in an ideal representative sample or "cross-section" (if such a thing were possible). Very roughly stated, it would be this: in contemporary North American independent film production, a significant number of works are tied to a story, in the widest sense. These are often autobiographically inspired films, especially those works made at art colleges. In Europe, on the other hand, such films are practically nonexistent. What we find in their place are works oriented toward questions of fundamental aesthetics or formal artistic structure.

Of course, this status quo has historical roots. To make that point a little bit clearer, let me name four important artists of classic North American avant-garde film who still exert a far-reaching influence: the four are Maya Deren, Stan Brakhage, Andy Warhol and Kenneth Anger. The most important sources of inspiration in European art film today are in the abstract films produced in Germany between 1919 and 1925 by Walther Ruttmann, Viking Eggeling, Hans Richter and Oskar Fischinger, together with the French *cinéma pur* of the 1920s (Fernand Léger, Man Ray, René Clair, Henri Chomette and others). Following World War II, the Austrian Peter Kubelka was the dominant figure, together with his compatriot Kurt Kren, who gained much influence through the attention received through British structural film artists and theorists.

These contrasting influences show us very clearly how the historical differences came about. In Europe, the short form ruled: concise but meaningful formulations of aesthetic questions, the works are either highly abstract, or tend

to use images that have a certain interchangeable quality (consider, for instance, the beer-drinking mannequins of Peter Kubelka's most influential metric film *Schwechater* ([1958]).

In North America longer productions are the rule, and they are often semantically loaded; for example, think of Deren's early psychodramas (*Meshes of the Afternoon*, *At Land*), Brakhage's lyric meditations, Anger's ritual conjurations and the voluptuous self-revelations of Warhol's Superstars before his staring camera.

This comparison is not intended to be a value judgement in any sense, but simply a statement of the historical roots of much of today's art film production. However, the European contemporaries of the New American Cinema were certainly aware of these aesthetic differences—and they had very definite opinions about their American counterparts. The standard German reference work on art film, the *Lexikon des Avantgarde-, Experimental- und Undergroundfilms* (Encyclopedia of Avantgarde, Experimental and Underground Films) (1974),[1] describes Stan Brakhage as an "irrational" artist in whose works "form becomes an extension of content. Form here takes on the role that visual symbols had played in earlier films. Form becomes the servant of the emotional content. . . . Advanced formal filmic means are not understood as the dialectical inversion of reality; but instead, degenerate into nineteenth-century paintings."[2] Brakhage's aesthetic, which is rooted in the Romantic age, undergoes a radical critique.

In 1970, the year it was completed, *The Hart of London* would probably have been similarly received by Chambers' European contemporaries. Jack Chambers knew and appreciated Brakhage.[3] Thematically, too, *The Hart of London* demonstrates its indebtedness to what many Europeans saw as a Brakhagian "reactionary nature mysticism." The film's lengthy introductory sequence explicitly declares its fidelity to the North American aesthetic tradition I have just briefly described: the long archival footage from a local television station in 1954, showing a deer in the London suburbs, establishes the animal—or rather its sad fate—as an overarching leitmotif or metaphor for the entire eighty minutes of the film. Nevertheless, Chambers' art is conceived on a level that precludes cheap polemics. Particularly fascinating from today's perspective—an ideologically less agitated era than the early seventies—is Chambers' conception of the filmic image *as filmic* image, his treatment of the found film material as well as his delicate way of intertwining it with autobiographical material. In this respect both Europeans and Americans can still draw creative inspiration for their respective traditions from Jack Chambers.

The deer of the opening sequence has lost its way in the wintry, snowy suburbs of London. It is captured and finally shot (the killing is not shown). However, Chambers avoids the trap of developing a cheap dialectic of "good nature versus bad civilization." On the contrary, this introduction serves as a reflection on the nature of film itself. Chambers manipulates the images of the deer and its pursuit in a multiplicity of ways, mirroring them, turning them upside down, changing

from positive to negative and back again. At first all this seems unmotivated, almost like a technical game. But soon it becomes clear that by means of these artful moves the filmic image is established *as image*, as an optical body that seizes and detains its object.[4] With the mirror images and inversions Chambers questions the idea that there could be a world outside the picture. In place of a spatial grammar that leads beyond the frame, he uses a repetitive movement that always leads back into the picture and thus captures the visual subject—in this sequence, the deer— and never lets it go.

This prologue of the deer's dual capture (by the police and equally by Chambers' manipulations) is followed by a longer sequence, a re-examination of London's history, represented by an impressively large collection of early photographic records and moving pictures. It should be noted that at the moment of transition, all of the film's sequences—however heterogeneous their various subjects appear at first view—always make metonymical or metaphorical reference to each other. Here, at the cut between the prologue and the first long sequence, Chambers presents himself as a hunter and collector, who has set out to "capture" and display as many images of his birthplace and home town of London as possible, as the hunters, earlier, displayed the body of the deer. And just as the deer was ultimately dead, so Chambers' prizes, namely the old photos testifying to a past that no longer exists in *this* way, are also *dead*.

A great many authors have been preoccupied with the embalming aspect of photography.[5] Although the techniques used to create film and photography are comparable, they nevertheless do not stand in the same relation to death. Whereas in static and silent photographs the dead are respected as dead, film, by virtue of the specific qualities of its signifier, gives the dead back a form of lifelikeness. Movement is the primary reason for this: an important characteristic of still photography is the connection between someone physically present and someone who no longer exists in time. This disappears when the viewer is watching a film, since movement is always perceived as taking place in the present. The film image refers to its object by the laws of resemblance, appearing to imbue it with renewed life. However, Chambers resists this illusionistic re-animation. For although the deer and its pursuers remain (mostly) recognizable in spite of all the layering, the sequence that comes next is pushed by means of countless multiple exposures almost to the point of being unrecognizable, indeed in numerous places even beyond that point, dissolving into a diffuse grey. Chambers often uses a technique of copying the positive and negative of the same image on top of each other, which tends to make the subject disappear. In this sequence Chambers powerfully assaults the iconic claims of the film image, and radically questions the denotative, symbolic function of film as a whole. We should remember the medieval palimpsest here. For reasons of frugality a great many written documents of antiquity and the Middle Ages were effaced and reused to inscribe new texts. However, some traces

of the older inscriptions can still be discerned. Thus a palimpsest represents the simultaneity of various eras of time, a co-presence in which the old is covered over and obscured by the new, yet can never really be obliterated. The palimpsest—and this sequence of the film is nothing less than a film version of a palimpsest—can be understood as a metaphor for history. Chambers now penetrates this history by entrusting himself to a pulsating flow of images (acoustically further emphasized by the soundtrack, with its rising and then dying-away noise of a large, fast-flowing river) that will carry him into the heart of London.

By the radical layering of images, which leads to their obliteration and replacement by a diffuse grey light, Chambers establishes the major theme of his film, that of the natural cycle of being born in order to be extinguished by dying. The heart at a standstill is the point at which the film emulsion is obliterated under the accumulated weight of too many remembered images.

Death is most immediately visible in the images of rows of many dead deer killed during a hunt. And it is precisely these cruel found images that lead—almost imperceptibly at first—into Chambers' own filmed footage. This transition into the private is marked acoustically by a change from the sound of the great river to that of a babbling brook, a subtle metaphor for the very different, comprehensible dimension of family compared with the larger sweep of the city and its history. Even the scale of the images underlines this transition. The many long shots in the found footage are replaced by intimate close-ups, often of plants, of water, or of parts of the body of Chambers' wife and their two small sons. Little by little the layering is decreased and Chambers reveals an almost unobscured view of his own private landscape. This is the frame he chooses for a closer focus on his subject of dying and death. This theme is broached very explicitly in images of the ritual slaughter of the lambs woven together with shots of his son's birth; finally the image of the helpless body of the newborn is interspersed with oppressive pictures of dead human and animal fetuses. Only in the final sequence does Chambers make a kind of peace offering. His wife whispers, again and again, "You have to be very careful," while his sons slowly approach some tame deer with food. This end does not truly reconcile, but seems to offer something like a fundamental strategy for the conduct of a life.

The Hart of London is one of the great fugues in the history of film art on the subject of the physical life, its emergence and its end.[6] Yet Chambers entirely eschews "argumentative" sequences that would position humans as the "others" of nature, since everything that is presented here is subject to the laws of birth and death.

To himself, the artist, Chambers assigns the role of an observer, a collector of evidence who registers but does not stage events. This nearly documentary, non-judgmental posture might have spared him a European verdict of "nature mysticism" at the time when the film was made. Chambers adds to this an ability to

marry specific material aspects of his medium to the content of the images, as, for instance, when he allows the typical orange frames of exposed roll-ends to extinguish the image of a dying lamb, and the subsequent cut is introduced by the equally recognizable beginning of a film roll leading into pictures of his newborn son. This unspectacular, subtle use of material strategies to produce meaning permeates *The Hart of London*, and hence, the film's power to overwhelm viewers, even today, is undiminished.

Translated from the German by Judith Orban

Notes

1. Hans Scheugl & Ernst Schmidt jr., *Eine Subgeschichte des Films. Lexikon des Avantgarde-, Experimental- und Undergroundfilms* (A Subhistory of Film: Encyclopedia of Avantgarde, Experimental and Underground Films) (Frankfurt/Main, 1974).

2. Ibid., 105.

3. ". . . [the film] resembles the work of American avant-garde filmmaker Stan Brakhage, whom Chambers much admired": Bruce Elder, *Image and Identity: Reflections on Canadian Film and Culture,* chapter 13, "Idealism, Photography and the Canadian Avant-garde Cinema," 355. Elder's analysis of Chambers' art (and the entire book) is nothing less than brilliant.

4. This dialectic, between the body of the image and one's own actual body as a cage, permeates the whole film. It is clearest in a sequence in which a bird in a cage is given as a present to a completely paralysed boy, as well as in the scenes in which bound sheep are ritually slaughtered. A birth scene is also to be viewed in this context, as almost a breaking-out-of-the-body-cage—though merely into its own still entirely unco-ordinated (in terms of motor skills) baby's body.

5. See Roland Barthes, *Camera Lucida: Reflections on Photography*, trans. R. Howard (New York, Hill & Wang, 1981); Philippe Dubois, *L'Acte photographique* (Paris, Brussels, 1983); Gabriele Jutz, *Gedächtnis und Material: Strategien des Erinnerns in der zeitgenössischen Filmkunst* (Memory and Material: Strategies for Memory in Contemporary Film) in Moritz Csáky & Peter Stachel, eds., *Die Verortung von Gedächtnis* (Making Memory a Place) (Wien, 2001).

6. I would like to draw attention to another masterpiece of film, made barely twenty years later and amazingly reminiscent of Chambers' film—I'm referring to *Aus der Ferne: The Memo Book* (From Far Away: The Memo Book), made by Matthias Müller (Germany 1989).

Jack Chambers in his Dundas Street Studio, London, Ontario, May 16, 1964

Personal Statements

Greg Curnoe

On May 28, 1989, the Toronto International Experimental Film Congress paid tribute to Jack Chambers with a retrospective of his films. The program, the first complete presentation of the films in many years, was curated by Tom Graff, who edited the 1984 issue of The Capilano Review *on Chambers. Joining him to introduce the films were Stan Brakhage, Bruce Elder and Greg Curnoe. Curnoe had been asked to speak about* R34, *Chambers' award-winning documentary on Curnoe's art and its making, but his remarks encompassed much more than that. (The complete audio record of the panel's remarks is housed in the Art Gallery of Ontario's Edward P. Taylor Research Library and Archives.) – Ed.*

Jack Chambers was one of my best friends for a period of about fifteen years. He was a complex person, perhaps the most complex person I knew. His complexity took the form of great personal privacy. His closest friends didn't know what he was doing and important personal decisions and actions would be taken without their knowledge. To some extent his work in film and painting reflects this complexity. Perhaps that is why it is difficult to take in all the elements that are combined in his work.

He was a good actor, and this, combined with his sense of humour and his willingness to use his sense of humour anywhere, added to the complexity of his personality and to the varied reactions and perceptions people had to him and about him. And I was no exception. It was hard to know when he wasn't serious. I will try to tell you a few things about Jack, but it would be wise to keep in mind Oscar Wilde's remark that "the true artist is known by the use he makes of what he annexes and he annexes everything."

When Jack moved back to London in the early sixties, he went to a lot of movies. A friend of his who went to the show with him a lot at the time recalled

that Resnais's *Night and Fog* moved Jack and that he wept during the film. He was very impressed with Dreyer's *Joan of Arc*, particularly with Falconetti's portrait of Joan, who, of course, had tremendous religious influence or significance for him, since he had recently converted to Roman Catholicism. He was also impressed with *El Cid*, starring Charlton Heston, because of its portrayal of Spanish history—which puzzled his friend, who thought it was awful. I remember him talking knowledgeably about the Nouvelle Vague and Godard, etc. We also talked about *Last Year at Marienbad* a lot, and he enjoyed David Lean's *Lawrence of Arabia*. To my knowledge he had no interest in underground film as late as 1963. His interest was in movies, commercial releases.

On Christmas Day 1963, Jack exchanged gifts with his filmgoing companion. He gave her two record albums. The first contained the Debussy and Ravel string quartets and the second contained Spanish Renaissance music. She gave him a used 135mm still camera. Until that time he had no radio, record player or TV and, until that Christmas, no camera. With it he began to take all kinds of photos including several of a rather classy cemetery called Forest Lawn Memorial Gardens. These photos were later used in a painting, and the cemetery also appears in *Mosaic*. You've just seen the cemetery in this last film. At this time he was also writing constantly: poetry, prose, journals. His friend felt that much of this writing resembled Kafka in that it came to no conclusions. Some of his letters used tiny crosses in place of periods.

One of the consequences of Jack's classical art training was that he lived in Spain under the dictator Franco for almost ten years. When he returned to Canada in 1960, Hugh Thomas's *The Spanish Civil War* had just been published in paperback by Penguin and George Orwell's *Homage to Catalonia* had just come out in paperback. I was reading both of those books, and had no sympathy for Franco. I don't think I knew anyone who did. Seeing my interest, Jack gave me an anthology of the writings of José Antonio Primo de Rivera. He was the founder poet of the Spanish Falange. At the same time, Jack was an admirer of García Lorca. When he visited my studio the first time, the first thing he wanted to hear was some rock 'n' roll. He loved Fats Domino. He knew a lot about flamenco music, of course, in particular flamenco singing, at a time when most Canadians thought that flamenco music was Carlos Montoya. I have a great album of José Menese that he brought me back from Spain on one of his trips there. I recall that he admired strong leaders and approved of Pierre Trudeau's imposition of the War Measures Act. Yet some of his closest friends were left-wingers and trade unionists.

I remember that over the years we talked about writing a lot: about Robbe-Grillet, Charles Olson, William Carlos Williams and Edward Dahlberg. We also talked a lot about the importance of the initial impact of things seen, of how that initial impact was vital and contained a lot of information.

In the early 1960s the head of the art department at the H. B. Beal Technical School in London was seriously hurt in a car accident, and Jack Chambers was hired as a substitute teacher. On his first day, another teacher introduced him to the class by saying, "This is Mr. Chambers. He is teaching in place of Mr. Ariss. Behave yourselves and let's not have any problems." When the other teacher left, Jack said, "My name is Jack, and that guy's a bit of a prick, isn't he." He and the class got along very well, but the other teacher was not amused.

Jack was very generous. He was always able to laugh at himself. He did not suffer fools gladly and was impatient with social events unless they were of some use to him. He was an excellent snooker player, very deliberate and precise. He had done some pool hustling, I think. He had the moves of natural athlete. He was always sniffling and had a lot of allergies.

He had acquired some Spanish figures of speech and always inserted "no" as an Ontarian would use "eh." He spoke with surprising metaphors, like the ones he used in his writing, in elaborate and sometimes startling phrases. His handwriting was small and precise. He had dark hair and a rather pale skin. His hair was curly and he seemed to have a perpetual cowlick at the back, which made his head seem square.

In the 1960s he got a few portrait commissions, which helped him to earn a living. Nobody sold many paintings in those days. One commission I remember was for a retiring dean at the University of Western Ontario. Jack worked from a photograph in which the dean looked slightly ridiculous with a lopsided grin and a noticeably crooked tie, a striped tie. The portrait was very faithful to the photograph, and some of us wondered how he would ever get the university to accept it. Tony Urquhart, the resident artist at the university, was with him when he went to the meeting that was to examine the portrait. And to this day, he doesn't know how Jack managed to sell them the painting. It was hung in a closet until Jack became better known, at which time it was taken out and displayed more prominently.

When Jack returned from Spain, he first worked in a space at the Artists' Workshop on Dundas Street between Wellington and Waterloo. He then moved to a studio above Vaisler's clothing store on Dundas Street near Richmond (these are all London street and place names) on the north side. Later I found him a studio space on Dundas Street, east of Clarence, since demolished. Later still he moved to the Dixon Building on Talbot Street, a building also occupied by James Reaney's Alphabet Press and by the sculptor Royden Rabinowitch. His last rented space was my old studio on King Street. It had previously been occupied by his good friend Brian Dibb, and it appears in the film *R34*. After that he built a studio beside his house on Sherwood Avenue.

He edited his films in a front room there. It was a small room on the left off the centre hall. There were always loops of film hanging from the wall over the editor.

Against the front wall were cupboards containing cans of films, including the films of the London Film Co-op, which he founded. There was a wall phone hanging on that same wall as well.

Jack and I watched a lot of hockey games together, and we attended a lot of closed-circuit boxing telecasts of heavyweight matches at the London Arena and London Gardens. We both followed George Chuvalo's career with anguish. During those bouts, Jack would pound me on the shoulder as things got exciting.

In 1964, Jack began to shoot 16mm film using a borrowed Cine Kodak silent camera. Don Vincent, an experienced photographer, had been helping him with exposure settings and shooting. Later that year, Don located a good used Bolex for Jack. He bought it, and with it he continued shooting much as he had with the still camera the year before. The deserted farmhouse with the dead raccoon in *Mosaic* was found by Jack and Don as they were driving around shooting various scenes north of Fanshawe Park, near London. Flowers were picked nearby, and Olga Chambers changed into a white robe and the sequence was shot.

A couple of years later, Jack approached CFPL-TV, the local television station, about getting some old film stock and stripping it to do some experiments with painting on film. He was very interested in Norman McLaren's work in that area. At some point, he got interested in the images on the old stock. He then asked for permission to use some of their old news film footage. He was given permission by the station manager over the objections of the news director, who felt the film files of the station were a historical archive.

CFPL used reversal film exclusively at that time, and copies from reversal film lose a lot of quality, so Jack was allowed to go into the original rolls of film in the files, which were organized chronologically. He took out sections which he edited together at the station. He would give the edited clips to the lab man, Hank Lane, who would print them. Jack would edit more original film into the second-generation print and it would be reprinted again. He would do this through several generations of prints. The quality gradually became more and more degraded. He was using specific material in this manner—for example, car accidents involving particular models, specific London street scenes, a deer running up a city driveway, etc. Because he took the film out of various cans, cut it up, removed sections and rolled the film up again unspliced he badly damaged about five years of original news footage from the early days of CFPL-TV. Whether the film that resulted from this work [*The Hart of London*] is of more significance than the local history contained in a TV station's files is another question, one that will have a different answer for you or for the local historian.

I don't remember much about the shooting of *R34* except that I realized that Jack was taking moving images of me and my wife, Sheila, and editing them into something of his own. The process was not intrusive, as is usually the case. *R34* was taken from the name of the first aircraft to fly the Atlantic nonstop. I was putting it

in the painting [part of a mural commissioned for Dorval Airport, Montreal] in the film. *The Hart of London* was a play on my painting *The Heart of London*, Chambers' hart being the deer that ran up the driveway.

I have been overcome with sadness as I write much of these things. I remember how close we were and how his becoming ill changed everything. I still can't believe that he had such bad luck. It is very good to see this event taking place because I am afraid we have been losing track of Jack Chambers and his work. His paintings are rarely seen and his films almost never. And, of course, he made all these things to be looked at.

Laurence Kardish

Had I known in the late sixties what energy and ecstasy were illuminating London, I might never have left Ontario for New York City. It was with the American "underground" that I found work to support my studies and an aesthetic that transformed my thinking about art. That film was an art equal to the other plastic and/or visual arts, there was no doubt; that this art could not only sustain itself but even be refreshed without reference to either narrative or abstraction was a healthy lesson I quickly learned from the films of Stan Brakhage, Ken Jacobs and Bruce Conner. Concrete and real as the images of cinema were, their expressiveness in the hands of the right manipulator could be strong, dangerous and exhilarating.

In New York I found an ever-fluid community of artists who practised cinema as gesture, and I had believed that this mode of making somehow emerged from the vivacity of Manhattan, a city then compromised by racial tensions, drugs and war. It was the work of Jack Chambers that suggested another explanation, simpler and surely more obvious. This singular, modern practice of cinema—in which perspective becomes untied, images follow one another apparently at random but with an interior intensity, and meanings reveal themselves in the rhythms and synaptic connections between shots—was not inflected by life in the city but emerged from the spirit of the maker. That this spirit was alive and well in London I found miraculous.

Chambers' *R34* (1967), which I saw in 1969, I thought a revelation—a virtual riff on one artist by another. By using scatter, Chambers reinvents the notion of documentary; I was as fascinated by Chambers' dynamic vision and his understanding of the creative process as I was by the assemblages of Greg Curnoe. When I read that Chambers and Curnoe were but two of a community of artists encouraging, supporting and defending each other in London (not without some rivalry) I was gobsmacked. (Having grown up in Ottawa, I came to believe that life all across the province was indeed good and constrained—safe, secure and

sanitary.) Chambers allowed me to imagine the unimaginable, a small Ontario city enlivened by the rude passions of unbridled stars.

R34 was the first Chambers film I saw, and *The Hart of London* (1970), with its haunting intimations of mortality, I think his most poignant; but *Circle* (1968–69) is a masterwork. At once mysterious and elegiac, it is a carousing mix of footage. Some of *Circle* is shot through a wall hole Chambers bored to the outside of his house, some of the film is composed of what appears to be home movies and some may be found footage. Cut together, roughly, swiftly and incisively, the film—with its fractured perspective of a back yard where overturned furniture seems ominous and the tree shadows threatening—seems about the terror of domesticity and the anxiety engendered by the familiar. As the critic Parker Tyler once observed, "The void itself is a ground." Chambers makes the void palpable.

Steve Anker

One of the pivotal moments of my three years as exhibition director for the Boston Film/Video Foundation was the local premiere of Chambers' *The Hart of London* in 1978. I had heard that Stan Brakhage had unearthed a remarkable major work by a mature, little-known (to us) Canadian filmmaker and painter, and that it was being made available to American audiences for the first time. Since my past experiences with Stan's recommendations had usually proven to be positive, I looked forward to sharing in this new discovery. I was little prepared for the profound experience that awaited me; as soon as the first images hit the screen I realized that this was an astonishingly original and knowing sensibility; it felt as though the powerful potential of cinema was being discovered for the very first time. The impact of Chambers' haunting use of overlapping positive and negative archival imagery, coupled with the throbbing soundtrack, was palpable; everyone in the room was affected. Ordinary, unassuming street activities from long-past times became spectral evidence of mortality, and, as the film progressed, of human hubris and myopia. The directness with which Chambers was able to address the sadness, and finally the tragedy, built into human social organization—in marked contrast to the innocence and vulnerability of "lower" animals, was no doubt largely due to his complex use of an array of sound and image techniques. It was stunning to me at the time how this man had taken his training as a painter and transferred it with such accuracy to a totally dissimilar medium—cinema. But in hindsight, it was the unfailing compassion and anger behind each of Chambers' stylistic gestures—the use of colour in contrast with black and white, the positive-negative imagery, the highly subjective camerawork in contrast with the objectified archival material—that made *Hart* such a unique and exciting experience. Indeed, the BF/VF screening

room had a hushed focus of mind that suggested a time-worn ritual was being enacted, not just another "avant-garde" movie being routinely shown.

Two of the cinematic techniques fundamental to the film have been employed in numerous other films, before and after *Hart*, but Chambers makes them uniquely his own by creating a fabric that becomes more profoundly metaphorical as well as experiential as the film develops. One is his complex use of multiple repetitions through different sounds and images that return inexorably, with haunting regularity, within each of the film's sections. Echoing life's cycles and at the same time conveying a potential sense of its maddening entrapments, these mesmerizing elements become an almost unconsciously perceived backdrop to the action and differing kinds of material in the film. The second technique is Chambers' brilliant use of composite negative-over-positive versions of the same archival images during the first part of the film. The positive-negative combinations struggle to attain unity but remain unstable and only fleetingly remind us of wholeness. This device had been well used in earlier films such as Brakhage's *The Dead* (1960) and was employed later in Nina Fonoroff's *Department of the Interior* (1986); Chambers reserves it here for old street images of London, Ontario. The overlays further flatten already distant evidence of forgotten times, creating a perfect expression of the inevitable connection between life and death. This understanding deepens as the film progresses.

I've shown *The Hart of London* three times publicly in the years since and have also included it in a number of film history courses. Even though its particular spell has become somewhat familiar to me, I am always struck by the freshness of the film's impact. I remember having traversed the territory before, but each screening brings the multiple figures to life (and death) with a renewed sense of irony, sadness and wonder. I can think of few other films that so powerfully combine sensory experience, a pure use of cinema, with philosophical and spiritual implications of such profundity.

Tom Sherman

When I emigrated from Michigan to Toronto in 1971, I was told a lot of my ideas were similar to those of Glenn Gould. I too had abandoned traditional media for electronic recording technology. Being young and convinced of my originality, I didn't get around to finding out who Glenn Gould was until years later. What a gift it would have been to know Gould's work back then—to have met him and talked with him about the future.

Years later, in 1978, having established my work as an artist in Toronto, I was showing some of my videotapes at the Ontario College of Art. One of the tapes

was *East on the 401*. It was a twenty-eight-minute assemblage of video shot through the window of a Dodge Aspen speeding east on the Trans-Canada Highway toward Kingston. I was aware that scores of young artists were "going down the road" to Toronto from the Maritimes, and I wanted to reverse that, flying in the face of the trend toward urbanization. The tape was intentionally banal, emphasizing the explicitness of video captured in and depicting real time. After I presented the tape, a student asked me if I was aware of Jack Chambers' highway paintings. I knew Chambers did photo-realist paintings, and that he was good, but wondered why someone would ask me, a video artist, to look at paintings. Again, as a young artist, I declined to accept this gift of reference.

Sometime around 1983, I was in London, Ontario, and went to check out the then brand-new building housing the London Regional Art Gallery. There was a retrospective of Jack Chambers' work. In a large gallery crowded with Chambers' paintings, I encountered his two large highway paintings. I was floored. I had never seen these paintings, and they were absolutely stunning. His vanishing-point perspectives of the Trans-Canada Highway had preceded my highway tape by nearly a decade. His highway images were deliciously artificial, composed of rich pool-table greens—in both cases the landscape was flattened and tipped up to slap the viewer in the face. One of these paintings, *401 Towards London No. 1* (1968–69), was one of the most beautiful things I had ever seen.

I had been aware of and impressed with the photo-realist trends during the Pop, Conceptual and Post-conceptual periods. There was a lot of interesting "road-work" coming out of California in the early 1960s. The photographer/painter Ed Ruscha comes to mind. His book, *Twentysix Gasoline Stations* (1962), was very influential. But Chambers' 401 paintings knocked me out because not only were they masterfully drawn and painted, they highlighted the banal architecture of the modern highway, celebrating the utility of contemporary transportation (speed, uni-directional divided traffic, controlled access . . .), and immersing viewers in the surplus of space so common in Canada, evident even in a busy trucking corridor of southern Ontario. And then there is the mythic substance of the road—the road either permits one to escape the stifling familiarity of one's home or is the means for one to return. Chambers, in his highway paintings, is pointing back to London.

Paintings about highways are images embodying time. The architecture of transportation represents speed and modernity, the compression of space by time saved. Photo-realist painting begins with photography. The camera reduces the time (and space) between perception, experience and description. Chambers was making his transition from painting to camera, transforming the discipline of painting into an ability to reconcile the frozen split-second exposure of photography with the languid, luxuriously contemplative, hyper-extenuated time of making a painting.

Cinematography and video, with their combined, complementary capacities to record light and motion marking the passage of time through space, and the potential

Mosaic

to construct completely synthetic timescapes through repeated screening and re-play, loomed around the next bend. Chambers slammed into time-based media with his eyes wide open. His highway paintings represent an unavoidable collision with post-modernity, an impact he survived nicely, given the evidence of his films.

Gustav Ciamaga

Though I had known Jack and admired his talents since our common high school days in London, Ontario, our paths rarely crossed. We sometimes had a coffee or a beer together, but the occasions could be years apart. For some reason the conver-sation rarely delved into artistic matters. I do remember we once talked about his first exhibition—I think it was his first—at the London Public Library; this was after he returned from Spain. Though he was proud of these early efforts he was sure he couldn't go back to this form of expression. Then in the mid-sixties I received a call from Jack in London, asking if I could provide him with an electronic music score for his new film, *Mosaic*. Although he had spent considerable time on this

film, he required the music immediately ("tomorrow"), as he was showing it in a festival that weekend. I agreed to provide him with a temporary soundtrack, if he would return the film to me at a later date for a proper score. The next day, we met at the University of Toronto studio and, during the afternoon, assembled a rough soundtrack using concrete sounds. The sound of typing on an ancient typewriter was recorded and then, using the processes of the time, multiplied. I found the film quite astonishing. Even on first viewing, even though it was his first film, it impressed me as pure Chambers.

When I called him at the conclusion of the festival, he informed me that the film had been received favourably. Consequently it was being shown in various venues throughout the United States, and upon its return he would allow me to create a soundtrack more worthy of the beautiful imagery. For whatever reason, I never got to see the film again, and regrettably the proposed collaboration with my esteemed colleague never took place.

Paul Arthur

Retinal Skin

Jack Chambers completed *R34* in 1967, a significant year in the development of North American experimental cinema and a watershed in the political upheavals of the time. Both trajectories, cultural and social, have a bearing on how we perceive this film today. Its method is less descriptive than processual, mediating a position as time-bound record, with heightened awareness of its own act of construction—an approach redolent of broader innovations wrought by sixties culture in the promulgation of new historical subjects. It is in its bald particularities an "artist's film," an image-and-sound sketch of the London collagist-painter-musician Greg Curnoe at work on various projects, performing domestic chores and voicing scraps of biographical information ("I started off by drawing cartoons") and political musings ("I am not in sympathy with our society"). Chambers was quick to insist that *R34* is "not a documentary," but while it defies conventional portrayals of the studio artist and his work, it functions nonetheless as a kind of intimate double portrait in which filmmaker and subject are joined, or mutually refracted, through analogies—as well as dis-analogies—between graphic and cinematic compositional practices. The master trope adopted for both media is music, in particular an unspoken fealty to the jagged byplay of modern jazz. A duet to the tune of reflexive portraiture.

Chambers mobilizes a range of visual and sound/image strategies in drawing attention to compatible aesthetic options: editing as a form of collage; camera

movement and the rhythmic insertion of black leader as filmic equivalents of brush strokes; a shared ability to slide between full iconographic presence and abstracted shape or colour. Building slowly out of isolated, decontextualized shots of collage-making, Curnoe's physical gestures and shards of voice or concrete sound, the pace accelerates toward the middle in a flurry of montage articulations. Having demonstrated, as tribute, the dexterity and sensual impact of filmic chops, Chambers returns to a realm of mediated pop experience—TV clips and news photos of boxers; stills of the Rolling Stones—from which filmmaker and painter alike take their creative cues, a reality in which their work, however critical, remains enmeshed.

According to Chambers, *R34* is ultimately about the relationship between perception and sensation, with the latter understood as that which "goes through the skin to the core and back through the skin into the exterior world." He called what he did "perceptual realism," and I take this term to mean an embodied ideal of vision wherein sight is an adjunct of touch, a means of making phenomenal contact with the world. Or to put it another way, the eye as assisted-eye, *kino-eye*, becomes a latent skin—at once drum skin and skin of painted canvas—registering through the manipulation of formal codes not only an optical presence in front of it but myriad tactile vibrations traversing the space between object and receiver, between screen and film viewer.

Michael Snow

Of Jack Chambers

Even before he knew he had leukemia, Jack Chambers' work involved a dalliance with death.

The moving beauty of his paintings is in their expression of art as death-in-life. The "quick" become stopped, fixed, "dead," when they become "art." His compassionate preservation of the sights, sighs and sizes of life is not "life" but is in life.

Despite their Apparent Motion the above applies to his films as well.

Circle is an elegy of departed moments, re-experienced as photo-chemical ghosts. *The Hart of London* has fled but beats on at twenty-four frames per second.

<div align="right">

— MICHAEL SNOW
alive May 9, 2002

</div>

Yann Beauvais

When I discovered *The Hart of London* at the Collective for Living Cinema in New York one day in December 1983, it was a major event in my life. Before that I had never felt so sure that experimental film could be a necessity for others. I had just shown my work in New York for the first time, and thought I had a clear idea of what experimental cinema was and represented. And then, suddenly, here was this city symphony, this symphony about London. In the film, the city appears as the tomb of a stag that has wandered into a territory no longer its own, where it is seized by humans, and by their civilization that makes temples of slaughterhouses. The capture of the animal, in an image of birth, of mastery, prefigures and evokes death.

Whiteness enshrouds everything. Figures emerge and disappear—we can never be sure we have seen them at all, but in the beginning they are central to our experience of the film. Everything works together to awaken our perceptions. Suddenly our eyes are open, our senses alert, and we become the prey, as though we are in danger. And when, later, we witness the slaughter of sheep (memory fails here; it's hard to say if one animal is killed, or more), we become conscious of the fact that, in some way or another, these deaths are expected.

The experience of the film is new every time we see it. In fact, in the eighties, the perception of this film privileged its biographical, personal quality, while a few years later the focus was on the importance of the sequences of found footage, newsreels and clips of TV news programs. Today, the way these disparate elements are articulated remains fresh and relevant. Fragmentation, dispersal, vertigo are recurrent motifs; the film plays on the irresistible movement of life, the juxtaposition of birth and death, the passage from one to the other: their co-presence. This being-in-the-world can only affirm itself because it is in the process of disappearing. The singularity of the statement reveals itself in the structure of the film, which carries us through vertigo and violence to the calm of a life constructed from dailiness, a life that is neither reified nor devalued. The film, like a life, inscribes passages, placing colour photography against black and white, revealing the fragility of the latter. The regenerscence of vision effected by the fading of sight into dimness is disconcerting, in the sense that it plunges us into a state that resembles abandonment at the moment of its disappearance, but at the same time reassuring in its presence and reality. The vision is endlessly renewed, regenerated as much by what is filmed as by the filmmaker's treatment of the subject matter. What is remarkable in *The Hart of London* is Jack Chambers' ability to blend sources, placing the standardized professional-quality newsreels beside shaky, underexposed home-movie sequences with their awkward rhythms and unique framing. The masterful, intricate way these are intercut is typical of Jack Chambers' work, his quest to know

himself as human, not less, not more; not a god, and thus only a moment in a cycle. His acceptance of this fact shapes his perception of the different elements of the film, and enables it to move beyond the status of a simple filmed diary into the realm of reconciliation.

Translated from the French by Jo-Anne Elder-Gomes

Carolee Schneemann

Perhaps it was ten years ago that the artists Arakawa and Madeline Gins told me of a scientist researching optical physiology. He had determined that cats would be his living subjects. To this end he had constructed a three-storey-high narrow cylinder. Along its interior vivid images were pasted, illuminated. Photographs within these cylinder walls depicted elements interesting to cats: brightly coloured birds, bowls of food, shimmering fishes, wild animals, human faces. The experiment was contrived to photograph the last retinal image mirrored on the pupils of the cats immediately after their death—killed from the impact of being thrown down the narrow cylinder.

If there could be a retinal analysis of imprinted filmic imagery, expanded in time by description, compressed as memory, as an intensity of linked recognitions —this optical imprint on my inner vision would be inscribed with fragments from the films of Jack Chambers.

Perhaps, my first viewing of Jack Chambers' films occurred shortly after being told of the sadistic cat experiment. A few years later, I was able to teach his indelible works during a year as film faculty at the San Francisco Art Institute. Associations with the brutal cat experiment recurred, when I realized I would have to lock my students in the film viewing room if they were to see the complete projection of *The Hart of London*. Unlike the cats, whose volition was stolen from them, my students stood scratching at the locked door insisting, "We're not watching this!"

They could close their eyes, but could I shift their resistance to the gestural flinch and muscular reciprocity of Chambers' images: moist animal eyes, spurt of blood, birthing of a human infant, fire, shadow—this threshold of spectral literalization that the mad scientist had intended to capture on the retina of the just-dead cats. Could I brand the students' vision with Chambers' fleeting forms, their flash and tumble, an energy which tosses us into an unconscious ecstatic terror? Because Chambers' images emerge as if structure in time is propelled, an eddying, oceanic force; edited so that we viewers are engulfed by the rhythms of an inspiration as challenging and unstable as the invisible sources of imagination itself.

So that suddenly we inhabit a ghost city constructed before our very eyes, a hundred years ago. Blackened swirl of smoke. Muscular gestures, men labouring. Darkening clouds. Rail tracks' horizontal spin into receding horizon, parried dissolve of vertical smokestacks ascending. Ascending. Incandescent shapes emerge, dissolved into grains, celluloid falling snow. Dissolve. Intercut to black.

Dissolve to whitened/greyed curly fur. Close-up sheep's eyes glistening terror: sacrificial ballerinas balanced on planks, facing the camera eye. Slaughterhouse blades gash. Lens eye splattered. Exploding blood. Indelible chaos. (Domestic food chain.) Intercut to black.

Circle: Or the time-lapse seasons circle. Camera fixed long lens from a field facing toward a familiar back porch. Home. Step printing the optical delay/relay. Humble detritus, seasonal fugue. Appearances. Disappearances. Bowl, shoe, dog, bicycle. Child, woman, man appear, disappear. Snow, wind, leaves, grass, leaves, snow, branches. Appear. Disappear. Clarity. Rupture. The unreeling. Indelible. Gone.

Tony Pipolo

I have seen Jack Chambers' *The Hart of London* only twice, and both times came away moved but uncertain what kind of film it was. At times its images evoked such powerful associations that their ultimate "meaning" seemed apparent. But days later, any such clarity evaporated, to be replaced by the film's resistance to reduction. This, I now believe, is both its fascination and its strength.

For most viewers, the most startling and memorable images in the film are probably the prolonged shots of the bloodied lamb draped over the wooden block of a slaughterhouse. The undeniable power of these images derives in part from their graphic and temporal assertiveness in a film largely composed of fleeting black-and-white images, many of them negative superimposed on positive, creating a ghost-like impression. Like the soundtrack of the film's first half—the surf beating on the shore—they advance and recede in endless patterns.

By contrast, the images of the lamb, drenched in red, are given such extended screen time that they are bound to imprint themselves on the viewer's memory. They have the quality of certain still-life paintings of dead animals, except that here they create a most unsettling effect as they measure the time it takes for the body to be emptied of enough blood to finally give up its deceptive signs of life, those intermittent stuttering spasms that hold us captive to the spectacle of a most un-still life.

These images are preceded and followed by shots of a baby. Extreme blurred close-ups of the baby lead us to a huge close-up of the eye of the first dead lamb, whose body the camera pans down as it lies on the block. The juxtaposition

continues as footage of the birth of a baby cuts back to the bleeding lamb. Coming into the world seems as bloody a process as leaving it. While the analogy is obvious, it seems less relevant than the way the film in general allows disparate images to become infected by those near it. Thus a flower in a garden trembles with hidden, unknown links to the bloody images on the same reel.

Men with guns haunt the entire film, embodiments perhaps of the primeval aggressive instinct of the race, while the opening shots of a deer running free prefigure the birds, wolves and lambs throughout—both men and animals engaged in the endless dance of hunter and prey. The film's extended contemplation of these scenes precludes any trite metaphorical readings in the same way that the found footage in Bruce Conner's *A Movie* both engenders and disperses associations, placing them within reach only in the deepest recesses of the collective unconscious.

This minimal cataloguing is misleading. The film is rife with innumerable images that seem to resist recuperation by any one theme. Trains, paratroopers, gardens, umbrellas, horses and wagons, construction workers, children and bicycles, snow, fire trucks, beaches. Yet the return of more graphic imagery—the undifferentiated embryos of unborn lambs and children—suggests a certain insistent refrain. In its final moments, children slowly approach a deer near a fence, warned quietly by adult voices on the soundtrack that say, "You have to be very careful." A cautionary phrase, heard three times, it resonates with both fear and hope, replaying the drama of attempted communication among life forms, ever hesitant and unpredictable. It is one of the achievements of Chambers' film that it instils the same transfixing ambiguity among images that seem eminently decipherable.

Nina Fonoroff

I first saw Jack Chambers' *The Hart of London* in a filmmaking class at Massachusetts College of Art in the late 1970s. Given my ignorance of both zoology and geography, the double meaning I heard in the film's title in no way prepared me to be mauled by a pack of human wolves.

The film provided no easy point of entry, and as it wore on it continued to thwart my desire for description and explanation. Its web of disparate human motives and actions and their range of (possible) consequences were not even loosely interwoven, but were instead laid out adjacent to each other, in anxious coexistence. I was perplexed by the large sections of black-and-white footage jarred by colour film; negative and positive images soldered together and then pulled apart; images of the public record (mug shots, billboards, public buildings) abutting intimate portraits of the private sphere (family pictures), an archive of

ghostly faces and streets, each with its own private history but together mapping the skeleton of what felt like a municipality, if not a community.

My recent viewing of the film's tumultuous play around the boundaries of intention and execution (in several senses of the word), makes me aware of my own uneasy pleasure in the film's structure, and even its moments of humour. A deer appears incongruously in the midst of a residential neighbourhood; hunters (less startlingly) show up in the wild, armed for the sport of killing. We are made to ponder the differences (and similarities) between these two phenomena. The film seems at times to court overt misrecognition, as one sometimes mishears song lyrics. Thus, a group of boys hauling sleds through the snow is revealed, through repetition, to be a group of men hauling the carcasses of animals they have killed. We all misinterpret. We are all captives; we are all scavengers.

My classmates and I didn't know what to make of the bold juxtapositions of animals lying on a slab waiting for slaughter, an aborted sheep fetus and a live human birth. The sound of rushing water continually ruptured the images' containment field, changing pitch and density from one section (season) of the film to the next. All of the excesses of tenderness, curiosity and brutality were deliriously conflated: a mass of permeable boundaries. At length, I could only view the delicate pruning of a shrub as a violent amputation. The butcher knife that mercilessly cut the sheep's throat, the forceps that extracted the newborn's head from its mother's vagina, the gardener's pruning shears: all were emblems of an assault upon the delicate net that binds the living. All were instruments of torture.

In class, the film provoked some controversy about the seemliness or the wisdom of using such broad strokes to deal with issues like the sanctity of life, or the inevitable, shared suffering of human and nonhuman animals. Some even felt that they had been manipulated by this herd of "sensational" loaded images. What if these images had induced in us emotions that the filmmaker himself had not felt, or meant?

We wanted to know what state of duress or urgency had prompted this disturbing onslaught of blood, fire and amniotic fluid. Had we just seen an "autobiographical" film? We speculated that the work must have grown out of a life lived under the terrible misfortune of illness, madness, the fear of death or (in a less spectacular vein) simply a hypersensitivity to the "normal." We sought to ferret out Chambers' life history, the story *behind* the film that would elucidate or authenticate its disturbing contents and their juxtaposition.

Memory lies, and the historical record often suffers a peculiar fate. The facts of Chambers' life remain as elusive to me today as they were years ago. What I learned from *The Hart of London*, however, was the paramount importance of craft in the face of both personal and public tragedy. The malleability of film's raw materials, and the power of the tools we use to shape it was its great lesson for me. Our filmmakers' forceps, gardening shears, butcher knives, rifles, hammers and soldering

irons are capable of decomposing and puncturing the delicate membrane we call "reality." There can be a giddy delight in all this, as I was to discover. Yet in this context, the injunction "You have to be very careful," poignantly repeated in the last few minutes of the film, as if spoken by a mother to her child, applies also to the images we capture, scavenge, distort, assemble and release in our work. In the end, *The Hart of London*'s steadfast refusal to yield up its own secrets renews its energy for me, reminding me of a paradoxical movement: the more one is drawn to a centre, the more one is pushed toward a periphery. This is a movement that I continue to follow and inhabit.

Jack Chambers

When I finished *The Hart of London* in 1970, I began work on a new film titled *C.C.C.I.* The three *C*'s stand for *centre, curve* and *circumference*. The *I* stands for *insert*. The film was shot over the space of a year. The *centre* and *circumference* shots were done every time from the exact same spot in the landscape. The camera came there every four days and took eight shots at 45° each. At each visit it repeated the same shots in the same circular fashion. Again, as in *Circle*, the aperture was the same every time all year round. I began shooting on a winter morning about ten a.m. A time sequence was established, so that come summer I was shooting around noon, in autumn in late afternoon, and in winter, early evening or darkness. Then follow some dream images and the landscape shots begin again coming out of dawn darkness into the brightness of winter moon and into an imageless light. The *curve* and *insert* shots are merely curving motions of the camera over different objects, and the *insert* is either a stationary or a moving object in front of a stilled camera. The *circumference*, while done laterally, was completed vertically by four circular pans starting at the ground at my feet, going up the landscape over the sky and down the opposite landscape to my feet again. These are filmed at different times of the year. The film is about twenty minutes long and still unfinished though not abandoned.

Mosaic

Anne Michaels

The Day of Jack Chambers

The day of Jack Chambers
we are black smudges on the frozen river.
You're walking ahead—in summer I would've said "upstream"—
sky, blue of veins, air the palest skin.
Old February light, weakest of the year,
casting its tinge like light in paintings
when the varnish has aged.
You're halfway up the river,
it's five o'clock and I can tell
by the way your back's to me, you're measuring pigments,
stealing the contents of this light, and sure enough
it begins to get dark.

We spent the day looking at Chambers' paintings.
Even the earliest have the magnification of dying.
Ten years of leukemia, you have to think what you fear,
not just be afraid.
When he worked from photos
he added what happened before the shutter was pressed—
and what happened after.
Objects hang in the air where they'd been the moment before,
floating like dust in sunlight.
Always the same light—captive, gasping to get out
from Sunday place settings, his wife's hair,
from chrome trim and roofs of cars on the highway.

You explained visual time,
how there's no weight without shadow.
Nothing falls, every figure has a ghostly buoyancy.
You explained how Chambers grounded things with his light,
leaving the ghost inside.
I understood this by thinking "language" instead of "light,"
how everything suspended stays temporal.
I understood it as a grammar of beauty
with its apex of loss,
dishevelled burning trees half leafless.

As a room full of rain and the raft of our bed.
The way we fall from each other like halves of an orange,
skin dark as pottery in lamplight.
I know it, naked in the light of the fridge,
cold plummy resins in our mouths, warm sticky resins
of our bodies. By nights
we drain the pictures from your head and words
from my throat until I find nothing but sounds there.
And today, by way of light closing around itself
until the river is dark and all I see is your white breath.
By way of a young woman's hunger
to taste every part of her lover, even his words.

Chambers' painting of a girl: if the light were stronger
you'd see her bones, the green-blue tributaries
beginning and returning at the heart.
And the sky that's "wrong,"
cloud-mottled, above the horizon,
yet painted as if we're looking straight up.
Your brain tricks you,
like losing your balance in a dream,
being woken by the feeling of falling.

What you paint
are the parts left behind
when two people join.
Your figures look calm,
but their throats are closed
with cries that can't get out.
They are in mourning.
Your canvas finds a weakness in the air's tension,
someone's past steps out.
We arrive by accumulation.
Time twists us by the shoulders until we're positioned to die,
looking backwards. Twisted into the ground.

Night. Soon we are pushing our faces
into the bin of stars. Lamplight
melts the windows of the river houses.
I can feel your bony fingers in your gloves.

This day belongs to Chambers. This
his river, his light. His eyes
that watched your black figure on the river,
sky the blue of veins, air
a translucent skin over everything.

There are three kinds of teachers, you said.
One who teaches by making you afraid,
one who makes you angry.
The third makes you love him.

Mosaic

Jack Chambers:

A Bibliographic Guide

to the Film Literature

Written with the assistance of
Susan Oxtoby and Gayathry Sethumadhavan

1965

1001 **McPherson, Hugo.** "Toronto's New Art Scene." *Canadian Art* 22, no. 1 (Jan.-Feb. 1965): 8–19.
 Enthuses over the diversity of technique among contemporary Toronto painters and applauds the efforts of local dealers to represent trends in contemporary Canadian art. Jack Chambers "is a magic realist who has transformed personal experience into fairytale-like canvasses." Stills from his unfinished childbirth film [*Mosaic*] accompany the article.

1966

1002 **Davis, Rae.** "The Life of Death in London, Ontario." *Canadian Art* 23, no. 3 (July 1966): 20–25, 50–51.
 Death inhabits the paintings of three London, Ontario, artists: Jack Chambers, Tony Urquhart and Greg Curnoe. Chambers' work binds past and present, the dead and the living; still figures, reminiscent of old family photographs, float in large landscapes. In recent work, they "are more closely related to the movie 'still'. . . . Animation of face and gesture are caught; the detached parts and repetitions suggest, too, the movement of movie frames which proceed to a conclusive moment in the film—that strong moment of insight when all elements combine (all that has gone before—the past) to create a flash of recognition or 'epiphany.' Chambers creates an hallucinatory landscape."
1003 **Hale, Barrie.** "Art & Artists: Talk, Talk, Talk: Art, Art, Art." *Telegram* [Toronto] (16 Apr. 1966): 21.
 Chambers is one of local painters involved in filmmaking. His *Mosaic* possesses "the curious and absorbing figurative presences" of his other artwork; it has been shown at an Isaacs Gallery Mixed Media Concert and it has been accepted by the Ann Arbor Film Festival.
1004 "*Mosaic* Film Goes on Tour." *London Free Press* (16 Mar. 1966): 37.
 Ann Arbor selects *Mosaic* for its post-Festival university tour. The film has no obvious story-line. Viewers must make their own connections between the images of birth and death. The

soundtrack is the hum of thirty typewriters electronically modified by Gus Ciamaga, a fellow Londoner now working at the University of Toronto.

1967

1005 Brodzky, Anne. "John Chambers: Recent Work." *Artscanada* 24, no. 111-112 (Aug.-Sept. 1967): pamphlet.

Traces the representation of space, time and motion, and light in Chambers' paintings, poetry and films. Space, in the form of black areas in *Mosaic*, functions as "gathering places for reflection" while the "choreographic placement" of repetitive imagery in *Hybrid* contributes to the sense of metamorphosis. Light in both films alludes to its conflicting roles as a creative and destructive force and participant at birth and death.

1006 Hale, Barrie. "Art: Chambers: Loss of Wonder." *Telegram* [Toronto] (7 Oct. 1967): 76.

Dislikes Chambers' silver paintings because they lack the psychological subtlety of his previous work. Like his film *Mosaic*, "a not-too-interesting lecture," these paintings privilege the process of making over reflection about the nature of experience.

1007 Wherry, Matthew. "The Silence of Jack Chambers." *20 Cents Magazine* [London, Ont.] 1, no. 9 (May 1967): 1–4; reprinted in Benner, Ron, ed. *The Silence of Jack Chambers*. London: London Public Library, 1998: 5pp.

A World War II veteran watches *Hybrid* at a fundraising event for Quaker medical relief in Vietnam and reflects on military leaders' insulation from the horrific experience of battle. The film's juxtapositions of blooming roses and war carnage don't seem odd: "Mussolini could see a bomb exploding on a native village as like a flower unfolding." Notes Chambers' effectiveness as a social artist. No one clapped after the film but donations exceeded all expectations.

1008 Woodman, Ross G. *Chambers: John Chambers Interviewed by Ross G. Woodman.* [Series Editor Dennis Reid] Toronto: Coach House Press, 1967.

Chambers' comments about realism and temporality in his paintings foreshadow his 1969 formal statement on perceptual realism [entry 1020] and demonstrate the conceptual unity of his artwork. He says:

. . . . Painting realistically is creating space, not subject matter. . . . The presence of recognizable objects is incidental to the realism. Using only some portion . . . should be a clue to the observer that there is more here than meets the eye.

A painting gets put together just like experience—in particles.

Painting shouldn't be dictating a particular response, but should be there as a pool of energy to set off reactions.

And about his silver paintings ["instant movies"]:

. . . silver gives a positive-to-negative image reversal depending on the source of light or where you view it from. As you move, the positive forms become negative and vice versa coming back. The shift is to the physical sensation of seeing—as in seeing double when you don't expect it. Space is the dimension created by the observer moving through experience or in *waiting* for the experience when the work is lit by alternating light sources. The time implications are important. Time as a new dimension has come into view. . . . space has become time.

1968

1009 "2 Londoners Show 'Underground' Films." *London Free Press* (24 Feb. 1968): 33.

Chambers and Greg Curnoe, along with Joyce Wieland and Michael Snow, attend a showing of their films at the Canadian Film Institute's program of fifteen Canadian "shorts." The work varied widely, as did the audience's response, from applause to laughter to jeers.

1010 Andrews, Bernadette. "Art: A Double Win for Mixed-Media Man." *Telegram* [Toronto] (27 Nov. 1968): 75.

Chambers receives two awards at *Canadian Artists '68*: $1,500 for a film [*R34*], adjudicated by New York critic Jonas Mekas and $2,000 for a painting [*Regatta*], adjudicated by English artist Richard Hamilton. Neither judge knew of the other's decision.

1011 _____. "Portrait of the Artist as a Winner." *Telegram* [Toronto] (30 Nov. 1968): section 4, 2.

Announces Chambers' inclusion in *The Heart of London*, an eleven-artist touring exhibition,

organized by the National Gallery of Canada. Complains that *R34*, the film that won him recognition at *Canadian Artists '68*, reveals too little about its subject, the London artist Greg Curnoe. Notes that Chambers has begun a new film [*Circle*]: he is recording the daily changes in his back yard, shooting from the same place and using the same camera aperture.

1012 Crawford, Lenore. "Canadian Artists '68." *London Free Press* (30 Nov. 1968): 11.

The work in this nationally juried show is impressive and so is the sponsors' decision to treat film with the same seriousness as painting and sculpture. Jonas Mekas, the film judge, explains in the exhibition catalogue how he chose sixteen finalists (from 126 submissions) and four winners: "The standards I followed were those above nationality—the selection I have been able to make matches the most exciting cinema anywhere." Chambers' *R34* is one of the winners.

1013 Lord, Barry. "Swinging London (Ontario)." *Star Weekly Magazine* [Toronto] (13 Jan. 1968): 18–26.

Surveys the city's range of artistic accomplishments and attributes it partly to the influence of a local teacher and painter, Herb Ariss, but more importantly to a sense of community that created local galleries like 20/20 and improvisational theatres like Alpha Centre. At the latter, Chambers filmed a puppet version of "Little Red Riding Hood" designed by Greg Curnoe. His new film [*Circle*] has a very simple form. It "is a kind of sophisticated home movie—anyone could do it" that makes us sensitive to the daily things we take for granted.

1014 _____. "Let There Be Darkness." *Artscanada* 25, no. 124-127 (Dec. 1968): 21–27.

Observes similarities in the use of light and shadow in the figurative paintings and films of Andy Warhol and Chambers and attributes this to the interest shared by the two artists in the two-dimensional/positive-negative light values of photographic reproductions. The systematic changes that occur in Warhol's *Empire* and Chambers' *Circle* emphasize light's rhythmic quality and revelatory effect on perception. Chambers' films can also be said to recapitulate the evolution of his paintings towards "clarification of content": the superimpositions in *Hybrid* recall cosmic fantasies like *Slaughter of the Lamb* (1962); the subject matter of *R34* and *Mosaic* is reminiscent of the family snapshot era, *Olga near Arva* (1963).

1015 Michener, Wendy. "Underground Movies Begin to See the Light." *Globe and Mail* [Toronto] (6 Jan. 1968): 21.

Accounts for the intense involvement of Canadian painters in filmmaking by a convergence of artistic interest in time and light and describes the public's initial resistance to the work. Chambers is making his fourth film, *Circle Four* [later titled *Circle*], which combines footage of the daily changes in light in his back yard with "death themes, generation themes and growing themes." Remarks on his fondness for found footage: "As he sees it, old films 'should be used like earth that you pick up and use.'"

1016 _____. "*Wavelength* by Michael Snow Is One Long, Slow Zoom." *Globe and Mail* [Toronto] (1 June 1968): 26.

R34, along with *Wavelength*, is shown at the Art Gallery of Ontario's International Museums' Week film festival. Chambers' collage of Greg Curnoe's personal life and artistic endeavours suggests that his art, and by association Chambers', integrates the private and professional.

1017 Webster, Bill. "On Entertainment: Underground Film on London Planned." *London Free Press* (20 Jan. 1968): 43.

Chambers, whose films were shown at Montreal's Expo 67, is looking for any snapshots of London for his new work, *The Heart of London* [sic]. He wants to "take a look at London through a different pair of eyes" but he insists the citizens will be the "stars" of the film.

1018 Woodman, Ross G. "Artists as Filmmakers." *Artscanada* 25, no. 118-119 (June 1968): 35.

Reports on the variety of filmmaking in London, Ontario, including Chambers' organization of a film co-operative and screenings of avant-garde films. Contrasts his "home-made" approach to filmmaking in *R34* with the technical polish of Fraser Boa's *Black and Blue* and attributes Chambers' crudity to his being "more grounded in that distinctive London regionalism that invests the home-made with an aesthetic value that requires much more experimentation before it can be defined." Describes *R34* as:

> . . . integral to the life-style which the film records. What emerges is a rock-beat pacing of stills that deliberately avoids clarity of outline or the use of dissolve in order to underplay the single images and create an all-over image that continues to structure itself in the mind of the viewer long after the film is over.

1019 **Beavers, Bob.** "Films Give Personal Glimpses." *London Free Press* (4 Dec. 1969): 23.

Chambers' *Circle* and Fraser Boa's documentary *Chambers* have their London premiere on four successive evenings in different locations. The response is mixed—people left shaking their heads. *Circle*'s meditation on the changing seasons suggests we should spend more time in contemplation. *Chambers* shows an artist engaged with his surroundings. Finished paintings superimposed over studio scenes indicate Chambers' working methods.

1020 **Chambers, John.** "Perceptual Realism." *Artscanada* 26, no. 136-137 (Oct. 1969): 7–13; reprinted in *Artscanada* 39, no. 244-247 (Mar. 1982): 111–14.

Chambers responds to statements about the negative effects of technology on art by suggesting that North American artists have ignored historical context and adopted European techniques indiscriminately and without regard for their personal creative needs. For him, art is an intuitive but mediated response to the unity underlying all things:

> Perception is a sensory communication that occurs at a primary level between organisms: through the skin to the core and back through the skin again into the exterior world. The intention to imitate is natural to the process in that its own primary pattern spontaneously structures a world of secondary cultural expressions. The pattern or imitation of this process in man's own sensory organism as it responds to the external world, man's art, I call *experience* and the attention to imitate experience by art-craft, I call *perceptual realism*.

Chambers describes how photography is central to this process; unlike a sketch, a photograph preserves the original scene without distortion, and so it is a better memory aid in the studio for representing what accounted for that "wow" experience. He comments further that personal filmmaking is the only other area that successfully integrates technology in the artistic process:

> Where North American artists do embody an historic dimension is in the medium of personal filmmaking. They form a major part of film's "roots" and are making enormous advances in the organic-mind growth of this art.

1021 **Crawford, Lenore.** "Looking at Art: Jack Chambers: All Seasons Man." *London Free Press* (11 Jan. 1969): 3M.

Observes Chambers at work on a large canvas using a colour photograph as an aid. Dispensing with narrative is a challenge for any representational artist. Editing film was the breakthrough for Chambers:

> After I shot hundreds of feet of film and then edited it to eliminate the non-essentials, I realized what I needed and what I could leave out of a painting. . . . A painting doesn't have to tell a story of any kind. It can be appreciated for what's in it. There doesn't even have to be relation of objects."

1022 **Farber, Manny.** "Film." *Artforum* 7, no. 5 (Jan. 1969): 70–73; reprinted in *Negative Space: Manny Farber at the Movies*, New York: Praeger, 1971: 250–55; *Negative Space: Manny Farber at the Movies*, expanded ed., New York: Da Capo, 1998: 250–55; and in Fetherling, Douglas, ed. *Documents in Canadian Film*, Toronto: Broadview, 1988: 242–48.

Highlights from *Canadian Artists '68* include *R34*, which gets a mixed assessment: "The documentary reeks with the idea of this artist [Greg Curnoe], a cool and industrious Gideon of Scotland Yard . . . as a good-guy-husband-worker. . . . [T]here's hardly any wavering, missteps, backtracking."

1023 _____. "Films at *Canadian Artists '68*: Art Gallery of Ontario." *Artscanada* 26, no. 128-129 (Feb. 1969): 28–29.

Farber's opinion of *R34*—"a sluggish" film—remains unchanged although he offers a different description: a "collage film about a collage maker . . . this compartmented documentary is set up with little deep dishes, in which there are steaming, disconnected evidences of an industrious artist's life" done with "a sly sardonicism suggesting that 'all is not heroism and romance.'"

1024 **Mendes, Ross.** "The Language of the Eyes: Windows and Mirrors." *Artscanada* 26, no. 136-137 (Oct. 1969): 20–25.

An overview of the metaphorical use of windows and mirrors in Western art, accompanied by statements from several local artists. Film examples include Jean Cocteau's *Blood of a Poet*, Alfred Hitchcock's *Rear Window*, Michael Snow's *Wavelength* and Chambers' *Circle 4*, a "window diary." Chambers comments:

. . . the intention of painting [is] to give the eye a back and forth sensation while at the same time it is generally taking in the view as a whole and at any moment can do the same thing in detail articulately with the intentional structuring. When I look out a window the frame and inside walls and things are all visible as well as what's outside.

1025 **Webster, Bill.** "On Entertainment: A London Film Centre." *London Free Press* (3 Feb. 1969): 23.

Chambers and Kee Dewdney, another London filmmaker, receive film prizes at *Canadian Artists '68* for *R34* and *The Maltese Cross Movement* respectively; both films are then screened at the Museum of Modern Art in New York on February 4. The London Film Co-op is earning good rental income. All this bolsters Chambers' hope of persuading Canadian and American producers to deposit their titles with the Co-op and securing distribution for London films in Europe.

1026 _____. "They Make Their Own Movies." *London Free Press* (22 Nov. 1969): section 2, M1, M6.

Describes the major role played by London filmmakers in the making and distribution of personal films and announces the local premiere of Chambers' *Circle 4* and Fraser Boa's *Chambers*. Chambers distinguishes personal filmmaking from underground "blue" movies:

They are a creative exercise like poetry, literature, painting or sculpture . . . educational in its esoteric ambiguity for it throws out lots of possibilities for mind stimulation and interpretation. . . . [The filmmaker's] film represents what he sees that is significant to him, in his room, along the street on which he lives, in his family. He always is looking at that which is familiar in a way which is not familiar.

1027 _____. "On Entertainment: A Matter of Context." *London Free Press* (12 Dec. 1969): 39.

Fraser Boa's film on Chambers is being re-edited, following its London premiere. The artist objected to a sequence where boys are shown killing trapped birds. The context implies Chambers prearranged the event so that he could film it. In fact, Chambers was simply documenting what area farmers normally do to protect their fruit crop.

1028 **Woodman, Ross G.** "London: Regional Liberation Front." *Globe and Mail* [Toronto] (13 Dec. 1969): 27.

Reports on the international attention given to local artists whose representation of their urban landscape is an attempt to penetrate the city's conservative shell, attributed to its role as a financial centre. Among these works are Chambers' *Circle 4*, shown at New York's Jewish Museum, and his work in progress, *The Hart of London*. The latter incorporates local television newsreels including the police pursuit of a deer, as well as footage solicited from area residents, and so will confront the city "with an essentially unscripted image of itself that may help to render visible the reality hidden beneath the colonial mask."

1970

1029 **Amaya, Mario.** "Canada: Jack Chambers." *Art in America* 58, no. 5 (Sept.–Oct. 1970): 118–21.

Positive review of Chambers' 1970 retrospective exhibition at the Vancouver Art Gallery and Art Gallery of Ontario; among those who have not been lured away to New York, Chambers is "the most sophisticated Canadian artist of his generation." Describes the domestic subject matter of his paintings, their photographic origins and the techniques Chambers uses to direct attention away from the anecdotal and nostalgic elements to light and tone:

Photos are not only design references, but give me tonal equations. The thing I'm interested in is light, and color is a structuring of light. . . . The mental operation analyzes and scans the information with a general as well as specific intent for the availability of effects of contrast, proportional relationships and color articulation. If enough information is found and the photo is useable then it becomes a plan for a structure.

His films "a series of home-movies (rather than Underground film ventures)" share similar content: *Mosaic* is "collaged shots of birth, motherhood, old age and death, all seen through local and personal events arranged in a non-sequential way." *Circle*'s daily observations of Chambers' back yard "approximates the analysis of changing light on a particular subject that so obsessed Monet."

1030 **Crawford, Lenore.** "Portrait of Jack Chambers." *London Free Press* (14 Nov. 1970): 1M,3M.

Interview with the painter on the occasion of his retrospective at the Art Gallery of Ontario, only the second given to an artist in mid-career. Chambers has finished *The Heart of London* [*sic*] for a 26 November Toronto showing, and he has begun a new film, *Life-Still*, about "the

progress of painting." He ceased practising Catholicism in 1962 and so must rely on his own resources to cope with his cancer diagnosis. Chambers does not dread death—it is an "altogether OTHER experience"—but he opposes random violence, like the war atrocities in Vietnam, and that is why he made *Hybrid*.

1031 _____. "London Artists' Films Show Sharp Contrast." *London Free Press* (28 Nov. 1970): 27.

Connexions, Greg Curnoe's first film, is a "sharp, colourful" look at the London places he and Chambers have inhabited. The commentary precedes or follows the images it describes, with hilarious results. *The Hart of London*, Chambers' meditation on birth and death, is marred by a monotonous soundtrack and poor-quality superimpositions. The lack of visual clarity is disappointing because it diminishes the viewer's ability to see the comparison Chambers is making between the illusion of filmic space and the flat surface of a painting.

1032 *Jack Chambers: A Retrospective.* Vancouver: Vancouver Art Gallery and Toronto: Art Gallery of Ontario, 23 Sept.–18 Oct. and 7 Nov.–6 Dec., 1970.

Features excerpts from the artist's published interview with Ross Woodman [entry 1008] and from a conversation with Dennis Young, curator of contemporary Canadian art, Art Gallery of Ontario, recorded on 29 Apr. 1970. In the interview with Young, Chambers says about *Circle*:

> [It] focuses on the idea that a single day is composed of seconds of time to produce an example of the difference of each day from the other. They are all expressive of the creation of seasons, each different from the other. . . . The four seasons create a single year, expressive of all within it. The expressive gesture each time is multiplicity and unity. . . . The episodes at the end of *Circle* . . . are a series of units of motion that can be seen as a whole; they are like a series of fragments that structure a gesture. . . . If the mind is held on that point, then all the commonplace manifestations reflect the characteristics of the cosmos.

The film section of the catalogue lists five titles, accompanied by a frame enlargement and one-line summary.

1033 [James, Geoffrey.] "Jack Chambers: A Retrospective." *Time* [Canadian edition] 96, no. 14 (5 Oct. 1970): 10–12.

Positive review of the exhibition spanning twenty-two years of Chambers' career; it describes him as "[a] mystically religious man . . . [who] presents critics with a highly individual and almost indecipherable iconography. . . . Light and death are Chambers' chief preoccupations." Although the films are "short and amateurishly put together, they are nevertheless important extensions of his paintings." *Mosaic*, "an unforgettable series of images of birth and death . . . has moments reminiscent of Luis Buñuel's and Salvador Dali's *Un Chien Andalou*"; *R34* is a "witty documentary" about Greg Curnoe; *Circle* is "the most poignant . . . the viewer becomes totally engrossed with changing details and the passing of the seasons."

1034 Lowndes, Joan. "Chambers Show Reveals His Stature and Dissipates Some Myths." *Sun* [Vancouver] (26 Sept. 1970): 31.

Two myths the retrospective dispels are that Chambers is a regional artist and that he is preoccupied with death. The quality of the work and its domestic subject matter give it universal appeal, and death is simply "a natural process in the cosmic cycle. His ghosts are not sad; they simply exist in a different energy state." Attributes the change in his paintings from colour to high-keyed aluminum paint to the influence of the artist's filmmaking.

1035 Youngblood, Gene. "The New Canadian Cinema: Images from the Age of Paradox." *Artscanada* 27, no. 142-143 (Apr. 1970): 7–13; reprinted in Feldman, Seth, and Joyce Nelson, eds. *Canadian Film Reader*. Toronto: Peter Martin, 1977: 323–32.

Chambers is among important artists contributing to a new film practice, "synaesthetic cinema," which reveals the hidden order in things. His significance rests with his ability to "invest his films with that special quality of 'cosmic fantasy' that characterizes his paintings." A good example is *Mosaic*, in which "life and death, regeneration and entropy, is flawlessly evoked in ethereal, timeless, oceanic image-event sequences." *R34* "is a tight, brisk staccato of compact metaphors sprayed across the frame with burp-gun insistence, yet is choreographed so nimbly that the barrage is repeatedly spaced with wedges of oblique insight" about Greg Curnoe's relationship to his environment. *Circle* is a "disarmingly simple" statement about light and photography that accords with structural film principles but it can also be experienced as an extended haiku: "A great metaphysical reality is conveyed with minimal language. . . . [O]ne image in continual metamorphosis."

1036 Walker, Alan. "What Makes Jack Chambers Canada's Top-Priced Painter?" *Canadian Magazine* [*Toronto Star*] (6 Feb. 1971): 18–21.

Interviews the artist at home, remarking on the sense of recognition one experiences encountering Chambers' domestic environment. Observes his modest lifestyle, changes to his daily regimen since a leukemia diagnosis and the effort required to make a painting conform to the memory of the original scene. Chambers demonstrates an appreciation for his painterly accomplishments but not for his filmmaking: it is "'a kind of relaxation—like the piano is for somebody else.'"

1037 Webster, Bill. "On Entertainment: Recognition on Film Front." *London Free Press* (1 Mar. 1971): 24.

Announces several of Chambers' recent film successes: the sale of *The Hart of London*, *R34* and *Circle* to the National Gallery of Canada and a film retrospective there on 11 March; upcoming screenings of *The Hart of London* at Montreal's Museum of Fine Arts and New York's School of Social Sciences, and of *Circle* at the Oberhausen Film Festival.

1972

1038 Chambers, Jack. "Perceptualism, Painting and Cinema." *Art and Artists* 7, no. 9 (Dec. 1972): 28–33.

Chambers expands his ideas about the artistic process:

1. Perception is the instant intake of real energy from objects in the outside world.
2. Experience is the record of that intake on the nervous system and then the process of substantiation of the energy input by the mind into the object "tree."
3. Description is an accurate memory object (colour photo) of the experience to replace invention and style. Style was the hallmark, necessarily, of all painted realisms before the modern camera and colour photo. Without the facsimile they had to try and piece together what they saw by notes and human memory.

Circle is his first filmic expression of these ideas: its form is "circular, the passing of one year, day to day, focused on one point in my beautiful back yard. The aperture remains constant." The observer "must make objective sense of what's shown him. By giving him only the objects out-there to look at, he is led out of himself towards nature rather than inwards to the invented, symbolic or memory meanings."

C.C.C.I., a work in progress, follows an elaborate filming schedule that corresponds to precise views of a specific landscape, with the hope that viewers will discern the pattern and so experience perception as a creative act.

1973

1039 Beattie, Eleanor. "Chambers, Jack." *A Handbook of Canadian Film*. Toronto: Peter Martin, 1973: 41–42.

His films are "investigative in nature, not only in the subject matter but in the possibilities of the medium itself." Includes filmography and four-item bibliography.

1040 Le Grice, Malcolm. "Vision." *Studio International* 185, no. 952 (Feb. 1973): 52.

Announces David Rimmer's upcoming visit to Britain and says he and Chambers are the most exciting filmmakers to emerge from Canada since Michael Snow and Joyce Wieland.

1041 Lowndes, Joan. "The Canadian Presence in Paris." *Artscanada* 30, no. 182-183 (Oct. 1973): 73–80.

The film section of the *Canada-Trajectoires 73* exhibition at the Musée d'Art Moderne de la Ville de Paris was not well attended because the program was too long (20 hours) and the work was unfamiliar to Parisians. *The Hart of London* was also new to her but it is now "engraved in [her] memory." Its complexity makes obvious how difficult it is to appreciate any film after one viewing. In this instance, one "is rolled like a pebble in a torrent."

1042 Webster, Bill. "On Entertainment: From London to London." *London Free Press* (12 Sept. 1973): 55.

Chambers departs for London to show *The Hart of London* at a two-week international festival held at the National Film Theatre of the British Film Institute. He is one of four Canadian participants.

1974

1043 Magidson, Debby. "The Art of Jack Chambers: Photography as Visual Reference." *Artmagazine* 6, no. 19 (Fall 1974): 19–21.

 Describes photographic influences in Chambers' early paintings and the medium's role in Chambers' concept of perceptual realism: it is the visual description of the original perceptual experience and so ensures no distortion in the artist's representation of that experience. Films like *Circle* where "[t]he seasonal textures, colours, shapes and light patterns weave a detailed tapestry of life" are an outgrowth of his painterly interest in the revelatory potential of light.

1044 Rosenberg, Avis Lang. "*The Hart of London*: A Film by Jack Chambers." *Criteria* 1, no. 1 (June 1974): 3–4; reprinted in Graff, Tom, ed. *Jack Chambers Films*. *The Capilano Review* 33 (1984): 65–70.

 Provides a detailed account of the film's content and ranks its significance alongside Stan Brakhage's *Scenes from under Childhood*, Hollis Frampton's *Zorns Lemma* and Michael Snow's *La Région centrale*. Calls the fragmentary and disorienting quality of the imagery in the first section visually chaotic but concludes the experience is necessary to appreciate the universality of the symbolism in the remainder of the film. Chambers affirms his intent in a taped interview: "'If you take a thing in progression . . . and sort of intuitively work your way through it, mould the thing and have it happen again and again in various ways, it means a lot more at the end of it than if it was shortened up and said in two sequences.'"

1976

1045 Feldman, Seth. "*The Hart of London*." *Film Quarterly* 29, no. 4 (Summer 1976): 54–57; reprinted in Feldman, Seth, and Joyce Nelson, eds. *Canadian Film Reader*. Toronto: Peter Martin, 1977: 333–38.

 Presents the film as a "discourse on the evolution of Chambers's modes of perception, the growth of his realization that he could render the multi-sensuous impressions he desired only through precisely reproduced images of the world around him. . . . [It] is about an opening of eyes . . . in a typically Canadian fashion, a chronicle that documents the reconciliation of one man and one place over time." The opening sequence of the deer's escape and recapture overlaid with manipulated archival footage of conservative London suggests the operation of personal memory and is a metaphor for Chambers' artistic situation of the early fifties. Reinforcing a sense of time passing is the repetitive noise of waves washing slowly over a shoreline. This "cinematic winter" is replaced with clear images of spring and representations of the artistic rebirth Chambers experienced in Spain. The remaining footage comprises more news and human interest stories, with references to the earlier archival footage as well as images that suggest survival and so resonate with Olga Chambers' concluding admonition "You have to be very careful."

1977

1046 Wapler, Christian. "Perspectives on British Avant-Garde Film/Hayward Gallery/Arts Council of Great Britain 2.3 bis 24.4.1977." *Das Andere Kino* 3 (Heft 1977): 4–40.

 In German. Comments briefly on each program in this large international screening exhibition. *Circl*e, paired with another landscape film, Larry Gotheim's *Fogline* (1970), makes the more interesting use of the fixed camera stare. Nature reveals its own cyclical patterns and the result is like the haiku experience Chambers claimed it would be.

1978

1047 Chambers, Jack. *Jack Chambers*. [London, Ont.]: Nancy Poole, 1978.

Autobiographical account of his childhood, artistic education and development, and political activity: he led the artists' challenge to galleries and museums for service fees; served as Canadian Artists' Representation first president; and donated revenues from *Hybrid* to London's Aid to Vietnam fund. Regrets that illness prevented his full participation at the 1973 British screening of *The Hart of London*. Says his statement on perceptual realism [entry 1020] was designed to contextualize the classicist influences in his work and summarizes his objective as investing the art object "with the experience of inspiration" so that "it is seen with the heightened awareness of visionary recall." Concludes with "Technical Explanations," a detailed account of his working methods, and with excerpts from his manuscript, *Red and Green: A Journal*.

1048 **Crawford, Lenore.** "Man of Many Media, Artist Jack Chambers Dies." *London Free Press* (14 Apr. 1978): A1+; excerpted by the *Vancouver Sun*, *Calgary Herald*, *Toronto Star*, *Globe and Mail*, *Montreal Star* and *Halifax Chronicle-Herald*.

Among the artist's filmmaking achievements were his $1,500 documentary film award for *R34* at *Canadian Artists '68*, his role in the founding of the London Film-Makers Co-op, and the 1971 sale of three films to the National Gallery of Canada.

1049 **Curnoe, Greg.** "A Tribute to Jack Chambers (1931–1978)." *Artmagazine* 9, no. 38–39 (June 1978): iii; reprinted as "London's Pride," in *Carot* 4, no. 1 (July 1978): 13.

Acknowledges Chambers' contributions to London's cultural life and to the financial situation of fellow artists. Says his interests were wide-ranging and included the writers Carlos Castaneda, Michael Ondaatje and Charles Olson and the filmmaker Stan Brakhage.

1050 **Hoberman, J.** "A Bunch from Ann Arbor." *Village Voice* (11 Dec. 1978): 61.

Reviews *The Hart of London*, shown 8 December at New York's Collective for Living Cinema. Describes it as a "subjective epic . . . an odd blend of Stan Brakhage and Bruce Conner" and says "the long opening movement (a compressed history of the filmmaker's hometown) anticipates the flavor of Brakhage's autobiographical *Sincerity*." Suggests that Chambers' visual manipulations of the deer's capture and murder is a "grand metaphor for the destructive cost of civilization." Praises the skilful juxtaposition of imagery in the opening and concluding sequences but finds the "grab-bag of techniques" in the central section less successful. Expresses surprise at the film's obscurity and regards Chambers' premature death as a significant loss.

1051 **Katz, John Stuart, ed.** "Jack Chambers." *Autobiography: Film/Video/Photography*. Toronto: Art Gallery of Ontario, 1 Nov.–7 Dec. 1978: 38–39.

The entry for *The Hart of London* combines an extensive excerpt from Seth Feldman's review [entry 1045] and a brief excerpt from a 1978 San Francisco Cinematheque program note written by Stan Brakhage in which he compares the neglect of Chambers' film work to that of collage artist Joseph Cornell, and lauds Chambers' originality:

> Jack Chambers has realized the almost opposed aesthetics of paint and film and has created a body of moving pictures so crucially unique as to fright paint buffery. . . . There are no "masters" of film in any significant sense whatsoever. There are only "makers" in the original, or at least medieval, sense of the word. Jack Chambers is a true "maker" of film.

1052 **Lord, Barry.** "Jack Chambers 1931–1978." *Canadian Forum* 58, no. 683 (Aug. 1978): 16–17.

A tribute to Chambers' artistic and political accomplishments that refers to *The Hart of London* as his major film, which, like his paintings, renders universal themes within the context of local experience. "Once again, life and death, light and darkness, innocence and violence, are realized at the same time as concrete and as universal in London, Ontario."

1053 **Thoms, Albie.** "The International Avant-Garde Film Festival: 1973." *Polemics for a New Cinema*. Sydney: Wild and Woolley, 1978: 210–16.

Structural film dominated the British event but there were other highlights like *The Hart of London*, "multiple superimpositions of over exposed snow scenes creating ghost like white on white imagery."

1979

1054 **Hoberman, J.** "The Best of the Apples and Pears." *Village Voice* (1 Jan. 1979): 41.

Ranks *The Hart of London* sixth in his 1978 list of the year's ten best avant-garde films: "Powerful and brooding, though uneven . . . the complexity of Chambers' imagery is brilliantly counterpointed by a hypnotic 'concrete' soundtrack."

1055 Off, Carol. "The Visionary Artist Who Made the Ordinary Extraordinary: Jack Chambers." *This Is London* 34, no. 10 (Nov. 1980): 8–11.

Sets the stage for the 1980 retrospective exhibition of Chambers' perceptualist realist work at the London Regional Art Gallery by providing a survey of his artistic achievements and political activities. His films, "though they are often of an amateur quality," attracted international attention, especially *The Hart of London*.

1056 Elder, R. Bruce. "From Painting into Cinema: A Study of Jack Chambers' *Circle*." *Journal of Canadian Studies* 16, no. 1 (Spring 1981): 60–81.

Establishes Chambers' Romantic aspiration, with examples from the paintings between 1963 and 1968. Ascribes their spatial and temporal discontinuities—tensions between surface and depth, flatness and illusion, foreground and background, present and past, part and whole, which are also characteristic of the photograph—to Chambers' desire to mirror "Visionary Experience" where consciousness apprehends discrete elements as a whole. Links perceptual realism, the next phase of Chambers' career, to his equating the Luminist notion of artistic transcendence with "styleless painting," meticulous realist work that is a construction of light rather than a representation of light. Says film offered Chambers the ideal vehicle for realizing his objective—it is a medium that synthesizes experience and it is a pure construct of light—and that *Circle* embodies these. Three themes, "light, the unity constructed in an act of perception, and the unity of Being or Reality" are evident in the opening sequence: light emerges from a monochrome colour field, emulating the transition from pure being to material object; the title credit denotes the film's circular structure and gives it a self-referential shape; home-movie footage of the filmmaker shooting the titles equates individual film frames to the discrete bits of information that make up the experience of perception as well as the importance of place and memory. Similarly the midsection, with the sudden appearance and disappearance of people and things in successive shots wholly dependent on unaltered light exposures, not only alludes to the transitory nature of existence but also integrates the film's formal structure with the medium's metaphysical properties: with no human intervention, the emulsion records an image of another form of nature thereby realizing the Romantic ideal for a work of art. The film's concluding scenes reiterate the midsection's concern with unity as unrelated newsreel footage depicts things separating: people disembark from a train followed by close-ups of individuals, candies are cut from a long flexible tube, a shot of a single bird follows footage of a flock of birds. Concludes with an admonishment to critics who, preoccupied with the strategies of materialist cinema, have ignored the film's rigorous use of formal analysis for Romantic ends.

1057 _____. "Jack Chambers: Before *Towards London* and After." *Canadian Forum* 61 (Sept.–Oct. 1981): 16–17.

Takes issue with the claim in *Jack Chambers: The Last Decade* that the artist's articulation and practice of his theory of perceptual realism was precipitated by his 1969 cancer diagnosis. While the later paintings display a strong degree of pictorial integration, they also hold together highly diverse elements and so continue the artist's preoccupation with "the way experience involved a fusion of one's self with the world and, in particular, with those moments within experience that brought this fusion to the fore." Chambers' films support this position but are not integral to the exhibition.

1058 Murray, Joan. "The Season in Review: London, Ontario: *Jack Chambers: The Last Decade* at the London Regional Art Gallery." *Artmagazine* 12, no. 53–54 (May-June 1981): 76–77.

Positive review of the exhibition. Attributes the pared-down collage structure and "trickery" of the silver paintings—the image reverses itself as the viewer moves across the painting—to Chambers' exposure to Neo-Dada happenings in the early sixties at the Isaacs Gallery where he exhibited his paintings, and to exchanges there with innovative artists like Michael Snow, rather than to filmmaking.

1059 Woodman, Ross G. "Jack Chambers as Film-Maker." O'Brien, Paddy, ed. *Jack Chambers: The Last Decade*. London: London Regional Art Gallery, 15 Nov. 1980–11 Jan. 1981: 17–25;

edited version reprinted in Graff, Tom, ed. *Jack Chambers Films. Capilano Review* 33 (1984): 47–64.

Says the films are an outgrowth of the paintings and prompted by an interest in art as process rather than product. Like "temporal collages" they explore the dynamics of perception and are edited to resemble "experience—in particles." The objective is to actively engage the viewer in the same process of self-awareness that Chambers experienced as he discovered significance in the details of family and community life. *Mosaic* presents footage of a mother-to-be engaged in normal everyday activities but the sequences are rearranged and juxtaposed with other imagery so that the temporal experience shifts from linear to an "eternal now." *Circle* contains little evidence of human presence: "It is like Eden after the fall, nature in the absence of man continuing its monotonous round," but in its own way it renders as 'is' our forgotten affinity with nature. *Hybrid* and *The Hart of London* contain tougher imagery. In the former, roses unfolding are transposed into photographs of napalmed Vietnamese children; in the latter, slaughterhouse sequences are paired with the shooting of a trapped deer, alluding to the ritual sacrifice that is at the heart of creation and at the heart of a city whose monetary values Chambers tried to escape.

1982

1060 Elder, R. Bruce. "The Persistence of Vision: Jack Chambers' Paintings and Films." *Descant* 34–36 (Winter 1981–1982): 227–43; edited version appeared in pamphlet form as *Jack Chambers: A Tribute.* Toronto: Canadian Filmmakers Distribution Centre, n.d.; excerpted in Kerr, Richard, ed. "*The Hart of London.*" *Practices in Isolation: Canadian Avant-Garde Cinema.* Kitchener: Kitchener-Waterloo Art Gallery, 5–27 Apr. 1986: 6.

Expanded commentary about the shortcomings of the exhibition titled *Jack Chambers: The Last Decade* [entry 1057], focusing on the films in which Chambers dealt directly with the paradoxes of the photograph and its influence on his painting: a photograph is a product of technology, "a selfless impersonal work of art" but it also suggests the presence of a consciousness: "It imitates perception at the same time as it exists as a nature object"; it is an object of light embodying its subject and so promises insights that are never realized, thereby conveying a sense of loss. These ideas are taken up in *Mosaic, Circle* and *The Hart of London,* where birth, death and resurrection are the central themes. *Mosaic* "equates artistic order, perceptual order and metaphysical order" using "icons of birth and death . . . in rhythmic alternation" to suggest balance; *Circle*'s mid-section uses daily changes in light to make the analogy between the cycle of the seasons and death and rebirth; *The Hart of London* is a "multi-image 'symphonic' film" where the optical reworking and abrupt juxtapositions of newsreel and home-movie footage develop a harsher view—perhaps coincident with Chambers' cancer diagnosis—"death sooner or later savages every living thing."

1061 Levine, Richard M. "Jack Chambers' *Hart of London.*" *Millennium Film Journal* 10–11 (Fall–Winter 1981–1982): 181–85.

Gives a detailed account of the film's imagery and symbolic possibilities and concludes that its theme is life's cyclical nature. The opening sequence of the deer's capture together with the superimpositions of the city footage that invoke recollection is a "chronicle of London's spiritual and physical life and death" as well as the initiation of Chambers' personal journey to artistic self-awareness. The juxtaposition of imagery in the second and third parts acknowledges the life/death continuum, but is tempered with a degree of cynicism as Chambers notes the existence of a "natural democracy that makes each London resident (animal, person, body of water, road, etc.) a potential victim of each other."

1062 Nelson, Joyce. "John Walker's *Chambers: Tracks and Gestures.*" *Cinema Canada* 90–91 (Nov.– Dec. 1982): 55.

Praises this documentary film about Chambers for "being grounded in factual reality" rather than dealing "explicitly in philosophical profundities." Observes how its visual style and sense of place echo the artistic transformations undergone by the painter as he matured. Although the film includes short excerpts from *Mosaic, Hybrid* and *The Hart of London,* it fails to acknowledge their role in Chambers' development and their international impact.

1063 Gross, Linda. "Jack Chambers: Linking Life, Death." *Los Angeles Times* (27 June 1983): part VI, 4.

 Reviews *The Hart of London*, presented with *Circle*, at the Pasadena Film Forum: "It is an awesome, provocative and personal final testimony" combining newsreels, home movies and found footage in "a fugal-like pattern that continually conveys a sense of balance and loss. . . . Stylistically the film resembles the work of Stan Brakhage in emotional intensity and its use of jittery camera movement."

1064 Hoberman, J. "Report from Ground Zero." *Village Voice* (6 Dec. 1983): 62–63.

 Reviews *The Hart of London* and *Chambers: Tracks and Gestures* shown 4 December at New York's Collective for Living Cinema. Although the latter is "clichéd and often outrageously banal" it does contextualize Chambers' films. Hoberman acknowledges that his earlier commentary about *The Hart of London* [entry 1050] failed to notice that it was also a "remarkable example of spiritual autobiography."

1984

1065 Elder, R. Bruce. "Experiments: The Photographic Image." *Festival of Festivals*. Toronto: Festival of Festivals, 6–15 Sept. 1984: 156–64; portions reprinted in English and French in Kiely, Michael Sean, ed. *Northern Lights: A Programmer's Guide to the Festival of Festivals Retrospective*. Ottawa: Canadian Film Institute, 1986: 87–103.

 Circle and *The Hart of London* are included in a twenty-part program that examines Canadian avant-garde filmmaking in the context of a realist tradition in Canadian art. The central role that Chambers assigned to photography isolated him from his peers but influenced younger filmmakers.

1066 _____. "Image, Representation and Object: The Photographic Image in Canadian Avant-Garde Film." Feldman, Seth, ed. *Take Two*. Toronto: Irwin, 1984: 246–63; portions first appeared in *Cinema Canada* (Special Supplement) 97 (June 1983): 58–64.

 A catalogue essay written for the 1982 *OKanada* Berlin art exhibition. Proposes that Canadian experimental filmmakers are forerunners in the development of postmodernist forms of cinema because their exploration of photographic paradoxes undermines modernist conceptions of the necessity for purity of artistic media. Comments on the ambiguity of Chambers' paintings: a precise rendering that suggests a material world offset by an intimacy that suggests an internal world, a merging of objectivity and subjectivity, self and world, for which the photograph is a paradigm. Briefly describes some of Chambers' metaphoric strategies—his use of high-level exposures and negative/positive reversals in *Mosaic* and *The Hart of London* to convey memory—and their affinity with and attraction for Stan Brakhage, who praised his work.

1067 _____. "Forms of Cinema, Models of Self: Jack Chambers' *The Hart of London*." Feldman, Seth, ed. *Take Two*. Toronto: Irwin, 1984: 264–74.

 Says the film models the process by which identity is constituted and art is created. It opens with a nearly pure field of white light (nonexistence), followed by juxtapositions of unstable, highly processed newsreel imagery that convey the conflict between nature and civilization as complex and self-destructive. The indefiniteness of this imagery also depicts the uncertainty that characterizes memories and the struggle of consciousness to establish a sense of place. The remainder of the film continues the violent interlocking of man and nature, but with imagery that is conventionally realistic and so parallels the move from within to without in the way the self finds a place in the real world. Intellectual and literal montage constructions relate birth, death, generation and dissolution as well as notions of universality and individuality. Chambers' choice of photographs and newsreel footage as source material is deliberate, for he is acknowledging the parallel with the creative act: the paradox of the photograph is that it can render its subject eternal, but only by turning the object of the photograph into an illusion. And so even in art-making are life and death intimately intertwined.

1068 Graff, Tom. "Foreword." *Jack Chambers Films*. *Capilano Review* 33 (1984): 4–6.

 Published in conjunction with a retrospective curated by Graff for Vancouver's Pacific Cinematheque. Points out the formal organization characteristic of Chambers' films and suggests

Mosaic and *The Hart of London* are the clearest expression of Chambers' concept of perceptual realism because in them he was able to achieve an intensity of collage possibilities unmatched in his canvases.

1069 _____, ed. "Notebook and Ideas." *Jack Chambers Films*. *Capilano Review* 33 (1984): 12–46.

Facsimiles of storyboards and notes for *Mosaic* and *The Hart of London* and stills from *The Hart of London*, *Hybrid*, *R34* and *Circle* suggest the films were carefully plotted in advance. There is also correspondence with filmmaker Daryl Duke regarding distribution of a work in progress [*Mosaic*], with filmmaker Stan Brakhage, who persuaded programmer Edith Kramer to show Chambers' work, and with critic Simon Field, who published Chambers' article on perceptual realism and film [entry 1038] in *Art and Artists*.

1070 Morris, Peter. "Chambers, Jack." *The Film Companion*. Toronto: Irwin, 1984: 62.

The films parallel the paintings in their "commitment to realism . . . religion, and . . . his passionate attachment to a sense of place. Includes filmography, selective bibliography and separate entries for *Circle* (p.68) and *The Hart of London* (p.140).

1071 Testa, Bart. "Experimental Film: Its Past, Its Future." *Globe and Mail* [Toronto] 31 Aug. 1984: E3.

Reports on the comprehensive survey of Canadian experimental film organized by Bruce Elder for the Toronto Festival of Festivals. Chambers "drew inspiration for two films, *Circle* and *The Hart of London*, from the powerful sense of place he had made the subject of his easel art, and he created the richest genre of the Canadian avant-garde—the landscape film."

1986

1072 Elder, R. Bruce. "Aesthetics, Nature and Avant-Garde Film." *Descant* 17, no. 2 (Summer 1986): 135–59.

Gives a history of the theoretical positions regarding the role of the photographic image in innovational cinema, focusing on the differences between the major practitioners of the graphic, phenomenological and modernist schools, and then positions some Canadian filmmakers within this framework. Observes that Chambers' anti-modernist ideas about the photograph were also held by the French film theorist André Bazin: "a photograph is produced by the same energy that produces both the objects of nature and the contents of consciousness, and . . . it therefore mediates between nature and consciousness. [Chambers and Bazin] both view the photograph, a natural object, as embodying the values which, as an image, it makes manifest." While Chambers embraced vanguard ideas and produced radical work, Bazin remained notoriously conservative.

1987

1073 Clandfield, David. "Animated Films and Experimental Film." *Canadian Film*. Toronto: Oxford University, 1987: 112–28.

Includes a brief statement on London filmmaking, represented by Chambers' work. *Circle* and *The Hart of London* demonstrate "his interest as a painter in the ambivalent qualities of the photographic image."

1988

1074 Brakhage, Stan. "Some Words on the North." *American Book Review* 10, no. 2 (May-June 1988): 5, 18.

Describes the rationale for his Canadian experimental film series *The Aesthetic of the North* at the University of Colorado. Brakhage, recalling the warning of the American poet Charles Olson—"Nature? . . . she'll kill you, given the chance!"—shares the filmmakers' respect for the harshness of the natural landscape, and says, in this regard, they are heirs of the Canadian painters the Group of Seven. Observes this feature even in the "suburban" Jack Chambers, who confronted with cancer, dealt with the "rural reverberations of this 'end game' . . . the limits of being human" in his epic work *The Hart of London*.

1075 _____. "Jack Chambers." *Independent Eye* 10, no. 1 (Fall 1988): 12.

Excerpt from a 100-page transcript of a 1987 Regina symposium featuring Stan Brakhage and Bruce Elder, organized by filmmaker Richard Kerr.

Brakhage describes his long-standing admiration for Chambers' work, mentions their correspondence and a brief visit. His favourite film is *The Hart of London*; he apologizes for ignoring *Circle*—it had been taken up by structuralists, an aesthetic for which he had little empathy at the time—and so only later did he appreciate the film's greatness:

> He is to me the master, almost the creator, of what I'm calling the long montage. That is where he creates whole sections. . . . [T]he first cut is from the preparations of himself, photographing himself, preparing the film and then the what-he-does film and then the whole paradigmatic ending sequence.

1076 **Reid, Dennis.** "The Death and Rebirth of Painting." *A Concise History of Canadian Painting*. 2d ed. Toronto: Oxford University, 1988: 315–20.

Attributes the scale and range of artistic activity in the 1960s to government support for Canada's centennial and to ready access to new technologies, i.e., film and video. Many artists abandoned painting for installation, performance and conceptual art. Chambers, worried that people missed the point of his realist work, and feeling the limitations of the two-dimensional painting surface, took up filmmaking. Transferring his synthetic concept of experience to that medium affected his painting so that the "transcendent" quality of *Circle* is also in his canvases of the same period.

1989

1077 **Arthur, Paul.** "No More Causes? The International Experimental Film Congress." *Independent* (Oct. 1989): 22–26.

Critical assessment of the programming objectives of the 1989 Toronto event, where aesthetic ideals took precedence over political expression. A Chambers retrospective was among the highlights: "*The Hart of London* . . . comes as close as any film I know to etching the boundaries of subjective consciousness in its interplay with a public space of ritual." In "the rarely seen *Circle* . . . a proscenium-like space appears to shrink and expand, its multiple bands of dramatically lit depth serving as an epic theater of domestic activity and its physical traces. Chambers' films cause the screen to breathe and shudder and they elicit a meditative response that can tilt in the direction of inchoate terror."

1078 **Dargis, M.** "Counter Currents: The Brood." *Village Voice* (20 June 1989): 92.

Rebukes organizers of the Toronto International Experimental Film Congress for the dominance of abstract work: "no sign of New Narrative; the relative lack of experimental documentaries and films with overt political resonance were astonishing." Appreciated the opportunity to see Chambers' work, particularly *The Hart of London*, but speculates about the symbolism of opening and closing the event with retrospectives of two dead white men [Jack Chambers and Hollis Frampton].

1079 **Elder, R. Bruce.** *Image and Identity: Reflections on Canadian Film and Culture*. Waterloo: Wilfrid Laurier University Press, 1989.

Contextualizes previous commentary on Canadian experimental film and Chambers [entries 1056, 1060, 1066, 1067, 1072] with a detailed analysis of the origins of Canadian philosophical thought in Common Sense philosophy and Absolute Idealism, and their role in the development of the country's realist tradition in painting and film.

1080 **Graff, Tom.** "Tribute to Jack Chambers." *International Experimental Film Congress*. Toronto: Art Gallery of Ontario, 28 May-4 June, 1989: 13–17.

This is the premiere of the Chambers film retrospective first described in 1984 [entry 1068]. Like other great artists, Chambers built a unique cinematic vision from personal necessity. His evolution as a filmmaker paralleled the development of his aesthetic notion of perceptual realism: "Chambers found in the photographic image, first as an aid, then because of its paradoxical past/present, its made/yet given relationship with light, and its miniaturization of the moment, a suggestive metaphor that would lead him to cinema."

1081 **Testa, Bart.** "A Movement through Landscape." *Spirit in the Landscape*. Toronto: Art Gallery of Ontario, 28 Mar.–24 Apr. 1989: 23–28.

Includes *Circle* in a five-part series of Canadian experimental films thematically linked to the writings of Northrop Frye and other cultural commentators about the representation of landscape in Canadian painting and literature. Building on Elder's commentary [entries 1056 and 1079], demonstrates how Chambers' artistic belief in an energy exchange between man and nature sets

the film apart from the other films (and much Canadian painting) where "a massive disproportion between human presence and the landscape looms as a threatening spatial phenomenon, and the framing off of human space expresses a recoil from the scope of nature." In *Circle*:

> the tension between actual space and the temporal scope of the landscape is synthesized by the human shaping of time into a cycle of seasons that . . . takes the form of loss and return. . . . The repetitions of the year's shots forcefully express an enduring and conscious human presence. The montage, linking these shots into a year of seasons, shapes time to the human consciousness of nature's cycle. The pathos of this third section . . . invokes our sense of time passing and us with it, and the vast time-scale of nature. That experience involves nature as an actual inhuman presence on which we work to synthesize the fragments offered by our perception into a whole, of which we are fundamentally a part, but whose unity with us is not given immediately.

1990

1082 **Czernis, Loretta.** "Pourquoi est-ce que la bête est noire? A Brief Meditation on Canadian Experimental Film." *Canadian Journal of Political and Social Theory* 14, no. 1–3 (1990): 215–18.

Circle, "a mystical tragedy," in which "[t]here is no 'me.' There is nothing but light" is among work that fits the author's definition of experimental film as she defends the ongoing validity of the term: "a constellation of perspectives which reflect Hollywood, and nationhood, back upon themselves" that are "conscious visions of a change, a lament, a glorification or a meditative gaze."

1991

1083 **Sherman, Tom.** "Jack's Eye Was a Camera." *Arts Magazine* 65 (Feb. 1991): 44–47.

Describes the inspiration and creative process behind *401 Towards London No. 1* (1968–69), a well-known Chambers painting, and its embodiment of the artist's conception of perceptual realism. Differences between the physical site and the painting are evidence of Chambers' personal reconciliation with that landscape. Says that in his films Chambers took up the challenges offered by the photo-based work of two contemporaries, Stan Brakhage and Michael Snow.

1993

1084 **Testa, Bart.** "Du structurel au néo-narratif: Le cinéma expérimental." Garel, Sylvain, and André Pâquet, eds. *Les cinémas du Canada*. Paris: Centre Georges Pompidou, 1992: 235–41.

Chambers' influence on the evolution of Canadian experimental film was cut short by his untimely death. Although he was a regional artist, his major works, *Circle* and *The Hart of London*, exhibit features of major trends in American filmmaking, but his theory of photographic realism and perception was unique.

1995

1085 **Beauvais, Yann.** "Jack Chambers." Beauvais, Yann, and Jean-Michel Bouhours, eds. *Le je filmé*. Paris: Éditions du Centre Pompidou, 31 May–2 July 1995: 1919–18 [*sic*].

Circle and *The Hart of London* are included in this exhibition celebrating the centenary of cinema. Distinguishes between the films' content and form, but asserts that both realize Chambers' theory of perceptual realism, "la qualité de la perception est une communion qui influe sur le cours de choses et du monde."

1086 **Testa, Bart.** "Il cinema sperimentale canadese." Bisaccia, Antonio, ed. *In Canada: Cinema sperimentale*. Rome: Ente dello Spettacolo, Nov.–Dec. 1995: 11–37.

Reiterates his 1993 commentary about Chambers [entry 1084]. For reasons of space, *Hybrid* is the only example of his work in this exhibition.

1996

1087 **Wise, Wyndham, and Marc Glassman.** "100 Great and Glorious Years of Canadian Cinema: Timelines: 1970." *Take One* 5, no. 12 (Summer 1996): 40.

The Hart of London makes the 1970s list of top ten films and so is among the 250 best Canadian films of the past 100 years.

1997

1088 McSorley, Tom. "Jack Chambers," in Wise, Wyndham, "100 Great and Glorious Years of Canadian Cinema—The Sequel." *Take One* 5, no. 15 (Spring 1997): 26; reprinted in Wise, Wyndham, ed. *Take One's Essential Guide to Canadian Film*. Toronto: University of Toronto, 2001: 40.

A "vastly influential figure in the evolution of experimental film in Canada. . . . Chambers' deceptively simple films contain dizzying combinations of sound and silence, darkness and light, original and archival footage, abstraction and representation. . . . *The Hart of London* continues to haunt and inspire." The 2001 publication includes a separate entry for the film (p. 96).

1998

1089 Benner, Ron. "Biologisms, Metaphor & Answerability." *The Silence of Jack Chambers*. London: London Public Library, 1998: 7 pp.

Intersperses his commentary on *Hybrid* with scientific definitions of the hybridization process. Applauds Chambers' critique of the American industrial/military complex. In the film, a stand-in for a government biologist/U.S. marine coaxes a hybrid rose, itself a patented life form, into producing "strange fruit," Vietnamese children disfigured by napalm. Chambers' warning remains relevant in an era of global economics and genetically modified food.

1090 Coulson, Sandra. "Chambers' Films Given a Voice." *London Free Press* (5 Nov. 1998): C3.

London artists Ron Benner and Jamelie Hassan organize a public film event, *The Silencing of Jack Chambers*, for delegates at the Canadian University Art Association conference so that more educators and curators will know his films.

1091 Hassan, Jamelie. "Notes from Viewing the Jack Chambers Retrospective, London, Ontario 1988." Benner, Ron, ed. *The Silence of Jack Chambers*. London: London Public Library, 1998: 2 pp.

Describes the films as engaged in the pursuit of light and compares Chambers' technique to Jean-Luc Godard's, where actions "simultaneously connect and disconnect." A measure of Chambers' international status for her was hearing Lettrist filmmaker and theorist Maurice Lemaître discuss *The Hart of London* in 1984 at Centre Georges Pompidou.

1092 Patton, Andy. "Painting in His Time." Benner, Ron, ed. *The Silence of Jack Chambers*. London: London Public Library, 1998: 5 pp.

Seeing Chambers' films resolves his own puzzlement with the disjunctive features of the paintings—collages of different materials, times and places—and with Chambers' fascination with photography. Speculates that galleries ignored the films because they complicated the marketing of his paintings.

2000

1093 Camper, Fred. *The Hart of London*. (2000) <http://www.fredcamper.com/Film/Chambers.html>

The film is a difficult and little-known work that benefits from repeat viewings (he disliked it the first time but now rates it a "masterpiece"). The major theme, life and death, is introduced at the beginning with the shooting of a deer trapped in a back yard, and then it is reiterated throughout the film. Interspersed with that is the typically Canadian opposition between a deadly and benign nature, a penetrating critique of newsreel photography and the mystic's reconciliation with the mystery of life. Complex montage, superimpositions, surprising juxtapositions and emphasis on locale defy a simple explanation. In this way the film seems to anticipate the postmodern dismissal of a "master narrative."

2001

1094 Coulson, Sandra. "Rescue Bid Gets Chambers Films New Lease on Life." *London Free Press* (9 Mar. 2001): C5.

Announces the public screenings and presentations around *The Jack Chambers Film Project*, jointly sponsored by the London Regional Art and Historical Museums, the University of Western Ontario and the London Public Library. The event also marks the availability of Chambers' complete film works on video from the Library.

1095 **Goslawski, Barbara.** "Painter Changed the History of Film." *Globe and Mail* [Toronto] (9 Mar. 2001): R11.

The organizers of *The Jack Chambers Film Project* hope to interest a new generation in the work of this "underappreciated" filmmaker by providing a forum for exchanges with Chambers' colleagues, friends, advocates and academics. *The Hart of London* will be introduced by the American avant-garde filmmaker Stan Brakhage. It remains his major work and "affirms the fragility and beauty of existence."

1096 **Juhasz, Alexandra.** "Interview: Carolee Schneemann." *Women of Vision: Histories in Feminist Film and Video*. Minneapolis: University of Minnesota, 2001: 61–75.

Schneemann, a feminist pioneer in the art of the body, describes her artistic education, struggle for recognition and legacy; "you owe me the concept of vulvic space." She advises young women to educate themselves rigorously about aesthetic concepts and says *The Hart of London*, "[v]ery extraordinary and completely neglected," was among the films that served this purpose for her.

1097 **Kite, Mary.** "A Conversation with Nathaniel Dorsky." *Poetry Project Newsletter* [New York] 183 (Feb.–Mar. 2001): 7–9; 15, 18.

Dorsky compares his own attempt in film to achieve the sense of "nowness" that John Ashbery accomplishes in his poetry: "The montage that I am talking about moves from shot to shot outside of any other necessities . . . it's the actuality of being one place and then the other." When the interviewer wonders about other terms—spatial layering or vertical thought—to describe it, Dorsky illustrates what he means with the *The Hart of London*: "There's an area . . . before the birth suggesting a state between incarnations. . . . We're floating . . . [t]hen it goes into the area of the footage where we see an autistic boy with the bird and huge flowers with umbrellas over them? That area of the film is open-ended montage, just moving it through things. It is what we're talking about."

1098 **Rist, Peter.** "*The Hart of London*." *Guide to the Cinema(s) of Canada*. Westport, CT: Greenwood, 2001: 92–93.

Faced with the prognosis of imminent death, Chambers reworks his "life-death-life" cycle into a feature-film format. The extended juxtaposition of childbirth and slaughterhouse footage midway through the film is so jarring that it overwhelms viewers but it also attests to Chambers' will to survive.

Bibliographic Guide:

Author Index

Amaya, Mario. 1029
Andrews, Bernadette. 1010; 1011
Anonymous. 1004; 1009
Arthur, Paul. 1077
Beattie, Eleanor. 1039
Beauvais, Yann. 1085
Beavers, Bob. 1019
Benner, Ron. 1089
Brakhage, Stan. 1051; 1069; 1074; 1075
Brodzky, Anne. 1005
Camper, Fred. 1093
Chambers, Jack. 1008; 1020; 1032; 1038; 1047; 1069
Clandfield, David. 1073
Coulson, Sandra. 1090; 1094
Crawford, Lenore. 1012; 1021; 1030; 1031; 1048
Curnoe, Greg. 1049
Czernis, Loretta. 1082
Dargis, M. 1078
Davis, Rae. 1002
Dorsky, Nathaniel. 1097
Elder, R. Bruce. 1056; 1057; 1060; 1065; 1066; 1067; 1072; 1079
Farber, Manny. 1022; 1023
Feldman, Seth. 1045
Glassman, Marc. 1087
Goslawski, Barbara. 1095
Graff, Tom. 1068; 1069; 1080
Gross, Linda. 1063
Hale, Barrie. 1003; 1006
Hassan, Jamelie. 1091
Hoberman, J. 1050; 1054; 1064
James, Geoffrey. 1033
Juhasz, Alexandra. 1096
Katz, John Stuart. 1051
Kite, Mary. 1097
Le Grice, Malcolm. 1040

Bibliographic Guide:
Film Title Index

Jack Chambers:
Filmography

Little Red Riding Hood
1965, 25 minutes, colour, sound, 16mm

Mosaic
1966, 9 minutes, black-and-white, sound, 16mm

Hybrid
1967, 15 minutes, black-and-white and colour, silent, 16mm

R34
1967, 30 minutes, black-and-white and colour, sound, 16mm

Circle
1968–69, 28 minutes, black-and-white and colour, sound, 16mm

The Hart of London
1968–70, 79 minutes, black-and-white and colour, sound, 16mm

Life-Still (unfinished)

C.C.C.I. (unfinished)

Contributors

Steve Anker is Dean of the School of Film and Television at the California Institute of the Arts. He was formerly Program Director at the San Francisco Cinematheque and professor of Filmmaking and Film History at the San Francisco Art Institute. He has written extensively on experimental film and video and has developed film series for national and international audiences. He curated *Austrian Avant-Garde Film: 1955–1993* and co-curated *Big as Life: An American History of 8mm Films*.

Paul Arthur is a professor of English and Film Studies at Montclair State University. He is a regular contributor to *Film Comment* and *Cineaste*, and is co-editor of *Millennium Film Journal*. A collection of his essays on avant-garde film, *A Line of Sight*, will be published next year by University of Minnesota Press.

Yann Beauvais is a Paris-based film artist and critic. In 1982, he co-founded Light Cone (an experimental film distribution co-operative) with Miles McKane and he has been curator for Scratch Projection since 1983. He is the author of *Poussière d'image: Articles de films (1979–1998)* and co-editor of *Scratch book, 1983/1998* (Light Cone) and *Monter Sampler* (Centre Georges Pompidou).

Stan Brakhage is renowned in avant-garde cinema for his innovations in expressive forms and techniques. He has created more than 300 films and written four books. His honours include retrospectives at New York's Museum of Modern Art (1971, 1977, 1996) and the International Film Festival Rotterdam (2002), the Maya Deren Award for Independent Film and Video (1986) and the MacDowell Colony Medal (1990). From 1981 to 2002, he taught in the Department of Film Studies, University of Colorado at Boulder.

Fred Camper is a writer and lecturer on film, art and photography who lives in Chicago. His art and film reviews have appeared regularly in the *Chicago Reader* since 1989; he has published in a number of specialized art and film periodicals beginning in 1968. His website address is <www.fredcamper.com>.

Gustav Ciamaga is Professor Emeritus, Faculty of Music, University of Toronto. He has been involved with all aspects of electro-acoustic music since the late fifties. His current work involves the use of micro-computers as an aid to musical composition.

R. Bruce Elder is an avant-garde filmmaker and critic who teaches in the Graduate Program in Communications and Culture at Ryerson University, Toronto. He is the author of *Image and Identity, A Body of Vision* and *The Films of Stan Brakhage in the American Tradition of Ezra Pound, Gertrude Stein, and Charles Olson*. The focus of his current writing is film and early-twentieth-century art.

Nina Fonoroff is an independent filmmaker and Assistant Professor of Media Arts at the University of New Mexico, Albuquerque. Her work in experimental film has earned numerous awards, including a Guggenheim Fellowship.

Laurence Kardish is Senior Curator, Department of Film & Media, the Museum of Modern Art, New York.

Brett Kashmere is a Montreal-based filmmaker, writer and M.A. student in Film Studies at Concordia University. Born and raised in southern Saskatchewan, he helped establish the antechamber art gallery & cinematheque in Regina in 1999.

Avis Lang spent fifteen years in Vancouver, where she taught art history, wrote essays on art and curated exhibitions under the name Avis Lang Rosenberg. She now lives in Manhattan and is Associate Managing Editor of *Natural History* magazine.

Deborah Magidson is an award-winning Canadian documentary television producer and director.

Anne Michaels is a poet and novelist who lives in Toronto. *The Weight of Oranges* (1986), in which "The Day of Jack Chambers" originally appeared, won the Commonwealth Prize for the Americas. Her debut novel, *Fugitive Pieces* (1996), won the Trillium Prize, Chapters/Books in Canada First Novel Award and the Orange Prize.

Sarah Milroy is the art critic for the *Globe and Mail*, the former editor and publisher of *Canadian Art* magazine and author of the catalogue essay "Greg Curnoe: Time Machines," in *Greg Curnoe: Life & Stuff* (Art Gallery of Ontario, 2001). She lives in Toronto.

Tony Pipolo teaches in the Film Certificate Program at the Graduate School of the City University of New York, is co-editor of *Millennium Film Journal*, and writes regularly on film for *Cineaste, Film Comment* and other journals. He is completing a book on Robert Bresson and is also a psychoanalyst in private practice.

Carolee Schneemann is a multidisciplinary artist. A retrospective of her video installations, photographs and Iris prints was presented in New York in 2002 at P.P.O.W. Gallery, following her exhibit at the New Museum for Contemporary Art. In 2002 *Imaging Her*

Erotics—Essays, Interviews, Projects was published by MIT Press; previous published books include *More Than Meat Joy: Complete Performance Work and Selected Writing* (1979, 1997); *ABC—We Print Anything—In the Cards*; *Cezanne, She Was a Great Painter* (1976). She lives and works in New Paltz, New York, and New York City.

Tom Sherman is an artist and writer who teaches media art, history, theory and practice in Syracuse University's Department of Art Media Studies. His most recent book, *Before and After the I-Bomb: An Artist in the Information Environment* (Banff Centre Press, 2002) features a text he wrote on Jack Chambers, "Jack's Eye Was a Camera," originally published in *Arts Magazine*.

Michael Snow, Toronto-based painter, photographer, filmmaker, holographer and musician is one of Canada's most important contemporary artists. His work has appeared at exhibitions in every major art centre in Europe and North America. *Wavelength* (1967) established him among the key filmmakers of the North American avant-garde. His recently completed digital video is **Corpus Callosum* (2001).

Bart Testa teaches Cinema and Semiotics at the University of Toronto. He is the author of *Spirit in the Landscape* and *Back and Forth: Early Cinema and the Avant-Garde* and co-editor of *Pier Paolo Pasolini in Contemporary Perspective*. His essays have appeared in several recent anthologies and in journals, including the *Canadian Journal of Film Studies*.

Peter Tscherkassky is a filmmaker who teaches filmmaking at the Academies of Applied Arts in Linz and Vienna. He is a founding member of Sixpack Film, a distributor of Austrian experimental film and video. He has published and lectured on the history and theory of avant-garde film. In 1995, he co-edited *Peter Kubelka* (with G. Jutz). His cinemascope trilogy (*L'Arrivée, Outer Space and Dream Work*) has won more than twenty international awards.

Ross Woodman is Professor Emeritus, Department of English, University of Western Ontario, and author of *The Apocalyptic Vision in the Poetry of Shelley* (University of Toronto Press), *James Reaney* (McClelland & Stewart), *Chambers: John Chambers Inverviewed by Ross G. Woodman* (Coach House Press), and numerous articles on Canadian art, including several on Jack Chambers.

Michael Zryd teaches Film Studies in the Department of English at the University of Western Ontario, London, Ontario, and writes primarily on experimental/avant-garde cinema and documentary film.

Acknowledgements

I would like to thank all the contributors to this volume: without their generosity and co-operation this book would not have been possible.

Several institutions also played important roles in the research process. York University granted me a leave to complete the anthology, and behind-the-scenes assistance was provided by library staff in the University Librarian's Office, Resource Sharing, Microtext, Facilities, Acquisitions, Sound and Moving Images, Archives and Special Collections, and university staff in the Instructional Technology Centre. The help of archival and library staff at Museum London, the Art Gallery of Ontario, the National Gallery of Canada, the Montreal Museum of Fine Arts and the Vancouver Art Gallery was very much appreciated, as was the support of the Canadian Film-makers Distribution Centre, which made Chambers' films available for consultation.

Individuals who contributed to the research process were John Chambers and the Estate of Jack Chambers; Sheila Curnoe and the Estate of London artist Greg Curnoe; Bernice Vincent and the Estate of London photographer Don Vincent; London historians Christopher Doty and Glen Curnoe; Av Isaacs; Nancy Poole; Joan Martyn of Nancy Poole's Studio; Paul Arthur; Bruce Elder; Ross Wood-man; Michael Zryd; filmmakers Christopher Lowry, Yann Beauvais, Nathaniel Dorsky and Mark Webber; and film programmer Mark McElhatten.

At Cinematheque Ontario, I would like to thank Susan Oxtoby, Director of Programming, whose enthusiasm for avant-garde film made a book on Chambers feasible, Catherine Yolles, Manager of Cinematheque Ontario Monographs, whose high standards, constructive feedback and steady hand improved the manuscript considerably; Andréa Picard, Programme Co-ordinator, Scott McLeod, Programme Guide Editor, whose persistence and visual acumen are reflected in the book's illustrations; Caroline Newson; Film Reference Library staff members, Robin Mac-Donald, Systems and Technical Services Manager, and Hubert Toh, who handled the image reproduction process.

I would like to acknowledge the editorial contributions of Doris Cowan, which were appreciated by all the writers, the proofreading assistance of Alison Reid, and the book's designer, Gordon Robertson, whose thoughtful interaction of text and visuals is responsible for the book's elegant appearance.

Financial support for this publication came from several sources: the Canada Council for the Arts and the York University Librarians' Research Fund. A special thanks to Telefilm Canada, which demonstrates its ongoing support of Canadian films through its contribution to the Toronto International Film Festival Group Endowment Fund.

I would like to conclude with an expression of gratitude to the great American filmmaker Stan Brakhage, whose recognition and support of Jack Chambers' achievement over the years ensured an international audience for the films. Brakhage's generous efforts on behalf of a little-known Canadian are not unusual for him, but reflect the warmth of his spirit, his devotion to art and his personal resilience—qualities in him that have inspired me, and many others, to take up the challenge of avant-garde art. And for that I will always be in his debt.

– Kathryn Elder

Text and Illustration Sources

Text Sources

Anker, Steve. "[*The Hart of London*]," copyright © Steve Anker 2002.

Arthur, Paul. "Retinal Skin," copyright © Paul Arthur 2002.

Beauvais, Yann. "[*The Hart of London*]," copyright © Yann Beauvais 2002. English translation © Jo-Anne Elder-Gomes 2002.

Brakhage, Stan. "*The Hart of London*: A Document of the City," copyright © Stan Brakhage 2002.

Camper, Fred. "*The Hart of London*: A Film by Jack Chambers," from *Chicago Reader* (23 July 2000) and <http://www.fredcamper.com/Film/Chambers.html> copyright © Fred Camper 2000. Revised for this edition.

Chambers, John [Jack]. "Perceptual Realism," from *Artscanada* 26, no. 136-137 (Oct. 1969): 7-13. Reprinted in *Artscanada* 39, no. 244-247 (Mar. 1982): 111-14. Reprinted by permission of the Estate of Jack Chambers.

Chambers, Jack. "[*C.C.C.I.*]," from *Jack Chambers* ([London, Ont.:] Nancy Poole, 1978): 154. Reprinted by permission of the Estate of Jack Chambers.

Ciamaga, Gustav. "[*Mosaic*]," copyright © Gustav Ciamaga 2002.

Curnoe, Greg. "A Tribute to Jack Chambers," copyright © the Estate of Greg Curnoe 2002. Printed by permission of the Estate of Greg Curnoe.

Elder, R. Bruce. "Jack Chambers' Surrealism," copyright © R. Bruce Elder 2002. Research for this article was supported by the Social Sciences and Humanities Research Council of Canada and Ryerson University's Faculty of Communication and Design SRC Funding.

Fonoroff, Nina. "[*The Hart of London*]," copyright © Nina Fonoroff 2002.

Kardish, Laurence. "[Jack Chambers]," copyright © Laurence Kardish 2002.

Kashmere, Brett. "Making the Anonymous Familiar: A Reconsideration of Jack Chambers' *Circle*," copyright © Brett Kashmere 2002.

Lang, Avis. "*The Hart of London*: A Film by Jack Chambers," from *Criteria* 1, no. 1 (June 1974): 3-4. Reprinted in *Jack Chambers Films*, edited by Tom Graff, a special issue of *The Capilano Review* 33 (1984): 65-70. Reprinted by permission of the author.

Magidson, Deborah. "The Art of Jack Chambers: Photography as Visual Reference," from *Artmagazine* 6, no. 19 (Fall 1974): 19-21. Reprinted by permission of the author.

Michaels, Anne. "The Day of Jack Chambers," from *The Weight of Oranges/Miner's Pond* (Toronto: McClelland & Stewart Ltd., 1997); *Poems: The Weight of Oranges/Miner's Pond/ Skin Divers* (New York: Knopf, 2000). *The Weight of Oranges*, copyright ©1986 by Anne Michaels; *Miner's Pond*, copyright © 1991 by Anne Michaels; *Skin Divers*, copyright © 1999 by Anne Michaels. Used by permission of McClelland & Stewart Ltd. Toronto; Alfred A. Knopf, a division of Random House Inc., New York; Bloomsbury Publishing, London, UK.

Milroy, Sarah. "Jack Chambers: From Camera to Paint," copyright © Sarah Milroy 2002.

Pipolo, Tony. "[*The Hart of London*]," copyright © Tony Pipolo 2002.

Schneemann, Carolee. "[*The Hart of London*]," copyright © Carolee Schneemann 2002.

Sherman, Tom. "[Jack Chambers]," copyright © Tom Sherman 2002.

Snow, Michael. "Of Jack Chambers," copyright © Michael Snow 2002.

Testa, Bart. "Chambers' Epic: *The Hart of London*, History's Protagonist," copyright © Bart Testa 2002.

Tscherkassky, Peter. "At the Heart of London: Jack Chambers' *The Hart of London*," copyright © Peter Tscherkassky 2002. English translation copyright © Judith Orban 2002.

Woodman, Ross. "Jack Chambers as Filmmaker," from *Jack Chambers: The Last Decade* edited by Paddy O'Brien. (London: London Regional Art Gallery, 1980): 17-25. Reprinted in *Jack Chambers Films*, edited by Tom Graff, a special issue of *The Capilano Review* 33 (1984): 47-64. Reprinted by permission of the author and Museum London.

Woodman, Ross. "The Act of Creation: A Question of Survival," copyright © Ross Woodman 2002.

Zryd, Michael. "Cross/Cut: *Hybrid* as Allegory," copyright © Michael Zryd 2002.

Illustration Sources

Jack Chambers paintings and the photograph "Olga near Madrid" courtesy of the Estate of Jack Chambers and Nancy Poole's Studio.

Photographs of Jack Chambers by Don Vincent courtesy of the Estate of Don Vincent.

Cover photograph courtesy of the *London Free Press* Collection of Photographic Negatives, J. J. Talman Regional Collection, The D. B. Weldon Library, The University of Western Ontario.

The Greg Curnoe painting, *Homage to the R34 (The Dorval Mural)* (1967–68), as it appears in the Jack Chambers film *R34*, copyright © the Estate of Greg Curnoe/SODRAC (Montreal) 2002; reproduced courtesy of the Estate of Greg Curnoe/SODRAC (Montreal) 2002.